VITRUVIUS

ON ARCHITECTURE

I

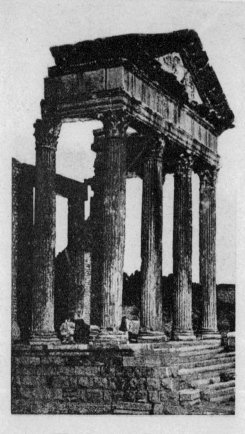

The Capitol Dougga.

VITRUVIUS

ON ARCHITECTURE

EDITED FROM THE HARLEIAN MANUSCRIPT 2767 AND
TRANSLATED INTO ENGLISH BY

FRANK GRANGER, D.Lit., A.R.I.B.A.

PROFESSOR IN UNIVERSITY COLLEGE, NOTTINGHAM

IN TWO VOLUMES

I

LONDON

WILLIAM HEINEMANN LTD

CAMBRIDGE, MASSACHUSETTS

HARVARD UNIVERSITY PRESS

MCMLXII

First printed 1931
Reprinted 1944, 1955, 1962

To Jesse

Lord Trent

Printed in Great Britain

CONTENTS

CONTENTS

ILLUSTRATIONS:

PREFACE

THIS edition has been based upon the oldest MS. of Vitruvius, the Harleian 2767 of the British Museum, probably of the eighth century, and from the Saxon scriptorium of Northumbria in which the Codex Amiatinus was written. The Latin closely resembles that of the workshop and the street. In my translation I have sought to retain the vividness and accuracy of the original, and have not sought a smoothness of rendering which would become a more polished style. The reader, it is possible, may discern the genial figure of Vitruvius through his utterances. In a technical treatise the risks of the translator are many. The help of Dr. Rouse has rendered them less formidable, but he is not responsible for the errors which have survived revision.

The introduction has been limited to such considerations as may enable the layman to enter into the mysteries of the craft, and the general reader to follow the stages by which the successive accretions to the text have been removed. The section upon language indicates some of the relations of Vitruvius to Old Latin generally.

My examination of fourteen MSS. has been rendered possible by the courtesy of the Directors of the MSS. Libraries at the British Museum, the Vatican, the Escorial, the Bibliothèque Nationale

PREFACE

at Paris, the Bodleian, St. John's College, Oxford, and Eton College. A word of special thanks is due to his Excellency the Spanish Ambassador to London, his Eminence the Cardinal Merry del Val and the Secretary of the British Embassy at Paris, for their assistance.

Mr. Paul Gray, M.A., of this College, has given me valuable help in preparing the MS. for the press.

FRANK GRANGER.

UNIVERSITY COLLEGE,
 NOTTINGHAM,
 September, 1929.

viii

INTRODUCTION

Vitruvius and the Architecture of the West

The history of architectural literature is taken by Vitruvius to begin with the theatre of Dionysus at Athens.[1] In earlier times the spectators were accommodated upon wooden benches. According to one account,[2] in the year 500 B.C. or thereabouts, the scaffolding collapsed, and in consequence a beginning was made towards a permanent stone structure. The elaborate stage settings of Aeschylus reached their culmination at the performance of the *Agamemnon* and its associated plays in 458. According to Suidas,[3] the collapse of the scaffolding, which occurred at a performance of one of Aeschylus' dramas, led to the exile of the poet in Sicily, where he died in 456. In that case the permanent construction of the theatre would begin in the Periclean age some time between 458 and 456.

The performance of the Oresteia probably coincided with the first use of scene-painting. Agatharchus,[4] an artist of Samos, who was employed upon this, introduced the method of perspective as a practical expedient, not only in scene-painting but elsewhere. His elder contemporary, Polygnotus,

[1] Vitr. VII., pref. 11.
[2] Suidas, *s.v.* Pratinas.
[3] *s.v.* Aeschylus.
[4] Vitr. VII., pref. 11.

painted the figure without any light and shade and
without a pictorial background. Agatharchus not
only transformed the background of the stage, but
changed the whole method of painting. He was
followed by Zeuxis and Parrhasius. He left a note-
book of a practical character, apparently a series of
workshop recipes, with special reference to per-
spective. An illuminating anecdote recorded by
Plutarch [1] connects the painter with the extra-
ordinary speed with which the architectural schemes
of Pericles were completed. Even the more simple
applications of perspective would enable an artist
to carry out designs with a rapidity, and on a scale,
hitherto unknown.

The practical treatise of Agatharchus suggested
to Anaxagoras and Democritus a theoretic treat-
ment of perspective.[2] Since Anaxagoras belonged
to the circle of Pericles,[3] he forms one contact
between the discoveries of Agatharchus and their
application to the Parthenon. How far the subtle
variations of the stonework in that building, from
the horizontal and the vertical, are to be deduced
from a system of perspective is a matter in dispute.[4]
We probably err in limiting ourselves to geometrical
projection; the *logos opticos* or theory of vision
including other considerations. At any rate, the
authorities upon whom Vitruvius chiefly drew,
Pythius and Hermogenes, often appeal to aesthetic
principles, such as symmetry and congruity, which
go beyond perspective.

If we take the Parthenon as furnishing a type of
the Doric Order, Pythius in the fourth century at
the Mausoleum and Priene, and Hermogenes in the

[1] *Pericles*, xiii. [2] Vitr. VII., pref. 11.
[3] Plut. *Pericles*. [4] Lethaby, *Greek Buildings*, p. 80.

INTRODUCTION

third century at Magnesia, supply guidance for the
Ionic Order not only in the extant remains of their
buildings but in the formal treatises upon which
Vitruvius drew. Surprise has sometimes been
expressed at the long list of authorities quoted by
Vitruvius in the preface to his seventh book. There
is, however, good reason to accept his statement
that he selected from them what was suitable to
the plan of his work. Some of his material may
have come by way of Varro; the greater part seems
to have been taken at first hand.

The descriptions left by architects of their build-
ings seem rather to have been in the form of specifi-
cations than like the formal treatises of Pythius and
Hermogenes. We have not indeed the specification
of the arsenal which Philo built in the Piraeus; but
we have a recital of the works to be undertaken by
the contractors,[1] which is a form of contract also,
including something like a specification. To this
were added the architect's drawings to scale. The
general method of contracting with specification and
drawings went back to what in Vitruvius' time was
already antiquity. When the temple of Apollo at
Delphi was burnt down in 548 B.C., it was rebuilt to
the designs of a Corinthian architect, Spintharos,
and with the funds of the Amphictionic League.[2]
The contract was undertaken by the noble Athenian
family of the Alcmaeonids. In order to gain the
favour of the Delphic oracle, " they executed the
work more splendidly than the plans of the architect
showed, and in particular, whereas the building was
to be of local stone, they carried out the front eleva-
tion in Parian marble." [3] The contract was let to

[1] Dittenberger, *Sylloge IG*, 352. [2] Paus. X. v. 13.
[3] Herod. V. 62.

the Alcmaeonids for 300 talents (£72,000), and the Amphictionic Council demanded from the city of Delphi a contribution of one quarter the amount. The citizens sent missionaries throughout the Greek world to aid in collecting the amount. They were especially successful in Egypt, where the native monarch gave a thousand talents of rock-alum (perhaps for use in making stucco), and the Greek settlers gave 20 minae (£80).[1] I have dealt at some length with the Delphic temple because it furnishes us with some notion of the earlier stages of Greek architectural practice. It also indicates the continuity of this tradition down to the point at which it is taken up by Vitruvius.[2]

We next turn to town-planning, which for Vitruvius[3] begins with Alexandria and the architect Dinocrates. And yet Vitruvius might have found in Italy itself an older precedent. The export trade in pottery from Athens gave employment to a whole quarter of the city, the Ceramicus. A century before the sculpture of Athens became supreme in Greece, her pottery by its fine quality had gained a market in Etruria, Italy and Sicily. In order to secure her trade in the West, Athens determined to form an emporium in Southern Italy and employed the architect Hippodamus of Miletus to lay out the new city of Thurii. When the colonists arrived, they found their new home already partly built. In the time of Vitruvius, four centuries later, it was a cheerful watering-place.

To Vitruvius the main consideration in town-planning was to guard the thoroughfares against the prevailing winds. Consequently he shows a plan

[1] Herod. II. 180. [2] Book VII., pref. 11.
[3] Book I.; Book II., pref. 4.

INTRODUCTION

with the streets radiating from a centre. But his attempt to create a precedent failed. The Roman colonies in the main followed the lay-out of the Roman camp. It has been left to modern times to take up the Greek tradition. Washington is in the line of Thurii and Alexandria.

The form of Greek and Roman architecture was largely determined by the excellent stone and marble quarries which were at their command; just as Egyptian architecture is relevant to the noble igneous rocks of the Nile valley. We have seen Parian marble exported to Delphi. Athens was near the quarries of Pentelicus, Roman buildings were faced with stone from Carrara. Alongside with marble and stone was the use of burnt or sundried brick. The latter continued in Rome till the end of the Republic. The use of burnt brick was customary in Babylon and in regions under Babylonian influence; at Halicarnassus glazed brick also seems to have been used in the fourth century.[1] It was not until the Empire that burnt brick came into use at Rome. The most impressive features of Roman building, the arch and the vault, are associated with this material.

It is at this stage that Vitruvius appears with this treatise. We know almost as much about Vitruvius as we know about Shakespeare. Vitruvius was interested in himself, and informs the reader that he was neither good-looking nor tall. He sought consolation in writing. And familiarity with his treatise gains respect for the writer. Purists may regret his deviations from the canons of Cicero. A deeper feeling will be aroused by the vernacular character of his Latin, which is faithfully recorded by the

[1] Vitr. II. viii. 11.

oldest extant MS. *H.* The Latin of the mason's yard and the carpenter's bench and of Vitruvius' text-book was to be echoed all over Western Europe in the early part of the Middle Ages.

But Vitruvius was the channel of the tradition of science. Greek philosophy in his pages was the coryphaeus of mathematics and the special sciences. For Vitruvius himself seems to have spoken Greek, and to have had a direct acquaintance with Greek literature. In this respect he was, none the less, Roman. Greek began two centuries before Christ to replace Latin as the language of Roman society. It flowed from the dying lips of Caesar. A century later it conveyed to the already venerable church of the capital the masterly exposition of Christian principles by St. Paul, a Semite and a Roman citizen. The affinity of the Western Church with Vitruvius is deeply rooted indeed if we follow the oldest reading,[1] " let no one think I have erred if I believe in the *logos.*" "*Ne putet me erravisse si credam rationem.*" At any rate this manual combines a scientific temper with a rational respect for the numinous.[2]

Vitruvius held an official position in the rebuilding of Rome by Augustus.[3] His treatise, however, never mentions Octavian by his official name Augustus, and presumably was written before 27 B.C., when it was conferred. The Roman plumbers, according to Frontinus, seem to have acted on his instructions in determining the size of their lead pipes.[4] We can perhaps trace in Pliny [5] a reference to the standards imposed by Vitruvius. More general is the use of

[1] *H.* II. i. 8.
[2] *Numen* = " a divine gesture."
[3] Cf. I., pref. 2.
[4] Front. *Aquaed.* 25.
[5] *N.H.* xxxi. 68.

Vitruvius made by the same writer, showing that
the manual of Architecture was already a standard
work. This tradition lasted as far as Sidonius Apol-
linaris in the fifth century. The Parisian MS. 7382
notes by a later hand the quotations from Vitruvius
by these three writers. The scholiast on *h*, perhaps
Fra Giocondo, quotes references to Pliny in which
Vitruvius seems to furnish the material.

More striking still is the influence of Vitruvius
upon the architecture of the Roman colonies which
were founded in the early Empire. His circle of
the winds was marked at many colonies in Africa,
especially at Dougga, where the neighbouring
Capitol [1] is said to follow the proportions of Vitruvius,
probably in the second century A.D.

The eclipse of Rome by Theodoric and Justinian
in the sixth century replaced Vitruvius by the de-
signs of the Byzantine artists.[2] His work, however,
was probably represented in the manuscripts of
Cassiodorus at Squillace and of the Benedictines at
Monte Cassino. He took a new life when Rome
recovered under the Papacy. Along with the Latin
Vulgate, Vitruvius probably was taken by Ceolfrid
to the scriptorium at Jarrow, where Italian scribes
wrote the Codex Amiatinus and—there is reason to
think—the oldest extant MS., the Harleian, of
Vitruvius. The circumstance that strictly speaking
there was no such thing as Saxon architecture, implied
that the " Roman style," as it was called, was
imitated. This did not necessarily involve the use
of the orders, as may be seen by the epitome of

[1] See Frontispiece.

[2] There is a reference to Vitruvius, Book VIII. iii., in Tzet-
zes' commentary on Lycophron, *Alexandra*, 1024. He seems
to have read *Victruvius*.

Faventinus dating from the fourth century. What was followed was the use of building materials in the Roman manner. The Christian architects seized rather upon the basilica of Vitruvius than his pagan temple, a process which had already begun in Africa, where the basilicas of Timgad still retain the columnar style of the temple.

Benedictine missionaries carried religion and architecture of the Roman form from England to Charlemagne. That Germany owed Vitruvius to England appears from the fact that all the extant MSS. go back to *H*. At this point we take up the history of the MSS.

THE HISTORY OF THE MANUSCRIPTS OF VITRUVIUS

The origin and date of the oldest MS. *H*[1] have been variously assigned. Rose in his preface roundly states that it was written in Germany in the time of Charlemagne.[2] But a reconsideration of the origin of *H* has been rendered necessary by the discovery that the Codex Amiatinus was written not, as Tischendorf supposed,[3] in Italy about A.D. 541, but in England at Jarrow (or Wearmouth), to which Ceolfrid brought manuscripts from Italy. Theodore, Archbishop of Canterbury, also, seems to have been the means by which an Italian manuscript of the Latin Vulgate came to the north to furnish the original of the Lindisfarne Gospels, about A.D. 690. This was written by the Bishop of Lindisfarne himself, a Saxon under the influence of Irish scribes.

Now let us turn to *H*. It was not completed, for four pages were left blank, probably for some of the illustrations to which Vitruvius refers. In the

[1] B.M. Harl. 2767. [2] Ed. pref. iv.
[3] *N.T. Amiatinum*, pref. xi.

Parisian manuscript 7227 the diagram of the winds
has a page to itself at the end. *H* puts this diagram
at the side of the text,[1] the only illustration of
Vitruvius which *H* contains. On the last of the
blank pages in the body of the manuscript, however,
there is the sketch of a cross in the same style as
those which precede each of the Lindisfarne Gospels.[2]
This trace of the Celtic tradition helps to define the
origin of *H* in Northumbria.

When we turn to the Codex Amiatinus, we find
that the scribe has added *amen* to each of the four
gospels at the end, but to the Acts of the Apostles
he has affixed at the end *Deo gratias amen*. In the
same way *H* adds to the first book of Vitruvius *dō
gratias amen*, and a similar ending marks the tenth
book. When the script of *H* is considered, there
appears a close resemblance of the rubrication and
the uncial letters to the style of the Amiatinus. In
the letters D and M, however, there is an alternation
between the capital and the uncial forms. The A
sometimes lacks the cross stroke and resembles the
Greek capital lambda. In fact, where *H* differs from
the style of the Amiatinus, so far as the uncial
writing is concerned, it suggests the lapidary style
of Pope Damasus. In fact, where *H* differs from

More will be said about the Latinity of *H* in the
sequel. For the present it is enough for our pur-
pose to note that it was written while Latin was still
vigorous and living. When we turn to Einhard
and Charlemagne, the purist is already at work
removing idioms (sometimes classical and ancient)
because of their apparent contradiction of the gram-
marians. The very excellence of Einhard's Latin is
largely due to its artificial character. In a word, it

[1] Book I. vi. 12. [2] B.M. *Ill. MSS.* iii. 1.

is doubtful whether *H* could have been written after the establishment of the Caroline school. At the same time the remarkable care with which *H* was written encourages us to see in it a faithful transcript of the Italian original and a witness of great value, therefore, for the Latin of the early Empire.

What kind of transformation Vitruvius would probably have undergone is illustrated for us by the text of *G*, which Rose and Krohn consider to represent an independent tradition from the original. A reference to the critical notes will prove, I think, that *G* is merely a recension of *H* carried out in the presumed interests of Latin style, and varying from *H* only in detail, except in the beginning of the first book, where a misunderstanding of the text has led to a wrong punctuation and to the interpolation of an unnecessary phrase. Fra Giocondo went much further than *G* in his divergence from the manuscript tradition. He had this excuse, however, that he treated Vitruvius as an authority of more than antiquarian value.

We can arrange the extant manuscripts, therefore, as follows: first those which derive from *H*, and these are the greater number; second, those which derive from *G*, to which may be added not only the second Gudianus quoted by Rose, but three late manuscripts, one in Paris 7228, the Bodleian F.5.7, and one in the Vatican *Codd. Urbinates Latini* 293; thirdly, a very late Parisian manuscript which has the reading *architectura* for *architecti*, was probably written under the direction of Giocondo, who is otherwise the main authority for this reading.[1]

The spelling of the author's name as Victruvius is found in a group of MSS. belonging to the first class,

[1] Book I. i. 1.

INTRODUCTION

and apparently written in St. Augustine's Abbey, Canterbury. At any rate the Cotton MS., if not written there, was a possession of the Library,[1] and the Laudian MS., now at St. John's College, Oxford, was written at the Abbey in 1316. The origin of the mis-spelling seems to have been due to the carelessness of the rubricator of *c*, who gives yet another spelling, *Victurii*, in Book IX. The same spelling is found in two Harleian MSS.: 3859 *h*, which has *Victruvius*,[2] and 2760, which has *Victimi* (?), perhaps from *Victurii*.

Later on, evidence will be produced to show that *h* was the Blandinian manuscript used by Fra Giocondo; in other words it belonged to the great Benedictine house of St. Peter at Ghent. It is more than a coincidence that *h* is thus associated with two MSS. in the sister house at Canterbury. Further, the spelling *Victruvius* is employed by Sulpitius in the *editio princeps*. He was probably influenced by the bad rubrication of the late Escorial manuscript, which seems to read *Victini*, a manuscript which there is good reason to think Sulpitius used. Last of all there is the addition by a later hand of *Victruvius* on the page facing the illuminated beginning of Paris 7228.

But the three oldest MSS. which have this title are characterised by an important reading which has been overlooked by all those who have collated *H* hitherto, Book VII. pref. 11: *de incerta re incertae imagines.* *c* has *dein certarem*, *h* and the Laudian MS. *de incerta re incertae.* When we examine *H* we find the apparent reading *de incerta re*, but the *e* in *re* has a flourish not unlike the symbol for *m* and

[1] James, *Ancient Libraries of Canterbury and Dover*, p. 519.

[2] Cf. *supra* p. 11, n[3].

justifying *c*'s *dein certarem*. There is a case, there-
fore, for the reading *incertae imagines*, if we suppose
that the scribe of *H* found *in* before him and read
it as *m*. More than this, if we follow Vitruvius' train
of thought, the *incerta res* will carry with it *incertae
imagines*. Hence Mr. Krohn quite consistently
changes *incerta* before *res* to *certa*, on the accepted
assumption that *certae imagines* is the accurate read-
ing. But the uncertain things and the uncertain
images harmonise with the teaching of Democritus,
who, like St. Augustine, found certainty in reason.
For Democritus, " reality consists in space and the
geometrical forms of matter,"[1] *i.e.* in the formal or
rational factor of experience! Hence Vitruvius
correctly states the principles of Democritus in the
passage that we are considering. That these
principles coincide to some extent with St. Augus-
tine's[2] would commend them to an Augustinian,
especially at Canterbury, where the Abbey library
contained the *Hortensius*[3] of Cicero: under this
title we are to understand the *Academica* in which
Cicero expounds the scepticism of Carneades about
sense-experience.[4] But in Augustine's own works
this attitude is widely enough represented. We
might, therefore, almost regard this group of the
Vitruvius MSS. as Augustinian. To this group may
perhaps be added the late Escorial MS. on the
ground of the mis-spelling of the title *Victini*, which
resembles that of the Harleian 2760, *Victimi*. The
latter, further, is followed by the Escorial MS. in
the designs of the initial letters. In these there is
a touch of the Celtic manner which seems to have

[1] Windelband, *Iwan Müller*, V. i. 211.
[2] Martin, *Saint Augustin*, p. 277.
[3] James, *op. cit.*, p. 305. [4] Reid, *Academica*, p. 31 n.

been handed down through the centuries from the scribes of Northumbria.

THE EARLIEST PRINTED EDITIONS OF VITRUVIUS, AND THEIR MS. AUTHORITY

After being engaged for a considerable time in tracing the history of the manuscripts of Vitruvius I met with a striking coincidence.[1] Three years ago I visited the Escorial Library in order to examine two manuscripts there. Of these, one was obviously late, probably of the fifteenth century. It was unusually rich, however, in marginal notes; by the courtesy of the Director I was enabled to have a photographic reproduction made, and with this before me I found two notes, in a much later hand, of considerable interest. The first compared an abbreviation with a similar abbreviation *in Blandiniano* (Book VII., pref.). The second took note of the well-known dislocation of a folio of the archetype later on in the same book, and again referred to a Blandinian manuscript.

Now Fra Giocondo was the first editor of Vitruvius to remedy this dislocation in his text. His name, therefore, at once suggested itself as the writer of these two notes. It is possible, of course, that Fra Giocondo—assuming for a moment him to be the writer—had borrowed the manuscript from the famous Benedictine house of St. Peter at Ghent. But there is an alternative possibility. He might have read it on the spot. When Fra Giocondo was

[1] The personal note in the following section may perhaps be excused in view of the hypothetical character of the material. By the courtesy of the editor, the suggestions contained appeared in the *Times Literary Supplement*, March 21, 1929.

preparing his edition of Caesar, he " sought out many examples throughout Gaul; in which province (because many had always been brought from Italy and were less exposed to loot and war) more accurate manuscripts of every kind are found." [1] He might, therefore, conceivably have visited the neighbouring and famous library of St. Peter. Cruquius, speaking of the Blandinian manuscripts of Horace, says that they were brought from Rome. The manuscripts of Horace disappeared, it would seem, in the iconoclastic riots at Ghent and accompanying fire of 1566. Is it possible that the Blandinian Vitruvius escaped? At any rate it is recorded that as late as 1809 manuscripts from the monastery were seized in Holland.

But there is another line of approach. This same Escorial manuscript which furnished the two scholia turns out to have the closest affinity to the first printed edition of Vitruvius, that of Sulpitius. Sulpitius collated many manuscripts. But he used especially one written for him by a friend Delius; which I am tempted to identify with the Escorial manuscript. *Satis accurate perscripto* implies only a moderate praise in Sulpitius' account of it. The Escorial MS. is rather poorly written. The abbreviations correspond with those used in Sulpitius' text, and many characteristic renderings are found in the MS. which are repeated in the printed edition. The MS. came from the library of Olivares, the famous Spanish statesman, who was born at Rome, where his father was Ambassador to Sixtus V. The Italian origin of the Escorial manuscript would thus be explained. The history of the manuscript would begin with Sulpitius, go on to Giocondo, and then arrive at Olivares after an interval.

[1] *Caesar*, pref., Paris, 1544.

INTRODUCTION

The edition of Sulpitius offers a further clue. As we have seen, he prints the name of the Latin author as Victruvius; we may infer that one of his manuscripts derived from Canterbury.

Let us now examine the Harleian Vitruvius *h*. Again, the margin furnishes two illuminating notes. The same (?) handwriting as that of the Escorial scholiast calls attention in two places (Book VII., pref. and c. i.) to the abbreviation already noted above, *uti s. s. e.* (for *uti supra scriptum est*). This abbreviation was wrongly transcribed in the Escorial manuscript, and misunderstood by Sulpitius. Giocondo, on our supposition, notes the correct text of the Harleian, which duly appears in full in his printed edition, *uti supra scriptum est*. It seems probable then that Giocondo used these two manuscripts in constituting his text. But it is doubtful whether he read the Harleian at Ghent or in Italy. It is also doubtful whether Sulpitius got his reading *Victruvius* from the Harleian or from another descendant of the Cottonian Vitruvius.

It may seem a slight foundation for so large a superstructure of conjecture. But photography has made it possible to put side by side the handwriting on the margins of the two manuscripts. The comparison is convincing.

The inquiry as to the movements of the Vitruvian manuscript is of the first importance for the history of architecture. The case before us exhibits Fra Giocondo at work on the text received by the architects of the Renaissance. It is noteworthy when we see him recording for the first time the dislocation of a folio in the archetype. It is not less memorable when we find him altering the first word that follows upon the preface to the first book; there

can be seen in the Escorial manuscript (I think in Fra Giocondo's writing) the substitution of *architectura* for *architecti*, to be repeated in Barbaro's translation and Philander's edition. This was but the first of many arbitrary changes.

Yet there was one quality in Fra Giocondo's work which compensates for his somewhat cavalier scholarship. He had in view the practical application of the rules of Vitruvius, an aim attempted by Wotton in his *Elements of Architecture*. This attitude to Vitruvius explains the history of the text. The admirable work of another (the present) Provost of Eton, *The Ancient Libraries of Canterbury and Dover*, enables us to see St. Augustine's Abbey library at Canterbury as the centre from which manuscripts were diffused not only by "conveyance" but by lawful copying. The Harleian Vitruvius [1] seems to be a case in point. Whether this is the Blandinian codex or not, the Blandinian Abbey of St. Peter at Ghent held enormous possessions in England from the tenth century onwards, and there is no improbability in the suggestion that the scribes of St. Augustine's, Canterbury, furnished books for the library across the Channel.

The latest Harleian MS. of Vitruvius [2] has the characteristic mis-spelling of the author's name, in this case *Victimi*, which leads us to think of the Augustinian scribes. And when we find at the beginning of the MS. the inscription *iste liber est monasterii* (name erased) we have grounds for thinking that it was part of the loot of the Blandinian monastery of St. Peter.

[1] B.M. 3859.
[2] B.M. 2760.

INTRODUCTION

THE SCHOLIA IN THE MSS. OF VITRUVIUS

We must distinguish between that part of the MS. which is due to the author and the various additions which are found from other sources. Vitruvius never mentions his own name. In this respect he anticipates the writers of the four gospels. His work probably first took shape in ten papyrus rolls kept together in a canister with a slip of parchment attached (titulus or title) giving the name of the author and the work. Hence in many cases where the author's name is not mentioned in the text and the tituli have disappeared, the author's name disappears too. In Vitruvius' case, the fact that he is mentioned by Pliny the Elder secured to some extent the survival of his name.

The divisions of the work into books, and of the separate books into preface and the main part of each book, are the author's own. But he is not responsible for the divisions into chapters, which are due to Fra Giocondo, and the further divisions into paragraphs, which are due to Schneider. The titles of the chapters of the first book alone are given in *H*, but these are neither convenient nor accurate. I have given them English renderings, however, but have excluded them from the Latin text.

Such additions to the text are found in most MSS., and often furnish, as in this case, valuable clues to the history of the MSS. Round the works of authors more frequently read there have gathered the commentaries of scholars, as in the case of Virgil. Vitruvius, however, furnishes, so far as I know, but two MSS. with scholia, the later Escorial and the Harleian *h*. In the belief that by them valuable light would be thrown on the history of the text,

I procured photographic reproductions. To the Escorial MS. are due the references to the Blandinian MS.; the rest of the scholia are in the same hand as the text and seem to be a repetition, on the side, of words from the text with a view to the preparation of an index.

The scholia of *h* are mainly from two hands. The bolder occasionally notes the topics treated in the text. The other, which I have ventured to attribute to Fra Giocondo, annotates the text as if for publication. Chapters and paragraphs are marked much as in his edition. Various readings which correspond with his text are introduced as corrections. σκιογραφία, I. ii. 2; *fontiū nymphis* I. ii. 5; *s = semis* written in full V. i. 6; *eduxerit* is found in *e₂* Sulp. Joc., II. pref. 3, and so on. Reference has already been made to the two notes on *uti supra scriptum est* repeated in *e₂*.

Vasari in his *Lives* says little of Fra Giocondo as an architect, but much of his engineering and scientific attainments. Accordingly, we find two notes which could scarcely have been written by anyone else than Fra Giocondo. Vitruvius, I. vi. 2, describes the heating of water in a bronze sphere with a small aperture at the top, and the consequent rush of air. A note states: *vidi hoc Venetiis saepe fieri,* "I have often seen this done at Venice." Vitruvius, II. ix. 11, remarks that Ravenna was built on piles; *idem nunc Venetiis,* says a note (Cooper's *Thesaurus* correctly gives the Latin name of Venice as *Venetiae*[1]). The principle of the steam-engine was understood, but it had to wait for improvements in metallurgy to be turned to account three centuries

[1] Fra Giocondo uses this spelling in the preface to his *Caesar.*

later. The other note suits the mind of the engineer, who compares the situation of Ravenna with that of Venice, where he had been employed.

I can imagine an impatient critic protesting against these references to the practical use of Vitruvius. Fra Giocondo was one of those universal geniuses whom Pythius had in view,[1] and whose existence Vitruvius denied (*ib.*). He vindicated architectural genius against the commonplace, of which Vitruvius was the prophet.

The Illustrations of the MSS.

Vitruvius seems to have given illustrations at the end of his several books. Of these none have come down except perhaps the diagram of the winds in Book I, and this is found in *H* not at the end of the book, but in the margin opposite the text to which it refers.

The most important MS. in this respect of those which I have seen is p_1. There is a dislocation of leaves due to the binder. After 34 the order should be 36, 35, 38, 37. On 35 obverse there is inserted, in the right-hand margin, a square one inch across with a diagonal from left to right. This is indented a quarter of an inch into the text, and faces the reference to Pythagoras and his famous theorem. At the foot there is a drawing of a water-screw, *turris cochlearis*, which is represented as vertical, but is accompanied by the instruction that it is to be inclined from the perpendicular.

The beautiful illumination of the first page of Par. 7228 contains three portraits presumably of Vitruvius, Octavia and Augustus. In like fashion

[1] Book I. i. 11.

the Eton MS. presents Vitruvius. But these pictures are creatures of the imagination.

The text of Vitruvius would admit of very many illustrations, more indeed than any edition could supply. The reader may be referred to Smith's *Dictionary of Antiquities.* Short of this, the illustrations furnished will explain some of the most characteristic topics.

THE LANGUAGE OF VITRUVIUS

The text of the present edition represents more closely than its predecessors that of *H.* In doing so it disregards many of the corrections and emendations of Rose and Krohn. From the sequel it will appear that the text of *H* has been altered by the editors in many places where it faithfully preserves the ancient, and in some cases the standard, idiom.

For the language of *H* is not so far, as it might sound at first, even from the classical Latin of 30 B.C. ; it is still nearer the vernacular, the spoken Latin of the workshop and the street. Of this unliterary Latin few traces can be expected in literature : yet the casual inscription and the casual scrawl upon the stucco of Pompeii give us hints towards the understanding of Vitruvius. There is help from elsewhere. The Old Latin versions of the Gospels, which were largely used by Jerome in forming the Latin Vulgate, go back probably to the beginning of the second century. Cardinal Wiseman drew attention [1] to the importance of the African versions as containing the oldest Latin text of the New Testament, the reason being that Greek was the language of the Roman Church at the time of Vitruvius and probably as late as A.D. 200. I am

[1] Essays, I. 40 ff.

indebted to Wiseman's essay for some of the parallels
to the language of Vitruvius. Other parallels are
drawn from the Old Latin MS. *k*,[1] which is almost
identical with the biblical quotations of Cyprian.
The later Old Latin MSS. exhibit a recension which
gradually diverges towards a more classical form in
a manner which is illustrated by the history of the
text of Vitruvius. And, generally, the Latin-speak-
ing Africans furnish us with some of the earliest
evidence of the influence of Vitruvius.

Mr. Krohn has improved on the text of Rose in
many places by returning to *H*. From the following
examination of readings it will be seen that we may
go much further.

Punctuation often enables us to recover the
original. The reading of *c*, *dein certarem*, VII.,
pref. 11, gives us *de incerta re* and, in *m certae imagines*,
the *incertae imagines* which the argument demands.
In another case, by retaining the punctuation of *H*
we have the striking and not impossible statement
si credam rationem, which was altered by later scribes
to avoid the grammatical solecism of an accusative
after *credo*, I. i. 8.[2]

Punctuation wrongly used gave a mistaken turn
to the definition of the architect's calling with which
the book begins after the first preface. By post-
poning the stop to *opera*, the scribe of *G* seems to
have found necessary the interpolation *cuius iudicio
probantur omnia*. But if, with the Vatican MS. *v*₁
we punctuate after *perficiuntur*, *opera* recovers the
meaning " personal service " or better " work,"
through which it passed into the French *œuvre*,

[1] *Old Latin Biblical Texts*, II., Oxford, 1886.
[2] Tacitus uses an accusative after *fungor*, *Ann.*, III. ii. 1,
IV. xxxviii. 1.

further giving rise to *operarius* in Latin and thereby
to *ouvrier* in French. The *ea* which follows is equiva-
lent, as so often in Vitruvius, to the article. *Opera
ea = l'œuvre*. It is then analysed into *fabrica*
" handiwork," and *ratiocinatio* " brainwork."

By inserting a comma *uti cuneus*, I. v. 5 becomes
an illustration. I should like to retain *ferroque*
II. viii. 12, with a comma to separate it from *more*.
To the Ciceronian *e duro ferroque* may seem harsh
and forced; but is it beyond the range of Sallust?
A comma after *parvas partes* will imply that a part
of the verb *esse* is supplied with *distributa*. Hence
it is unnecessary with Mr. Krohn to add *non* before
poterit I. v. 7.

As examples of archaic spellings we find *mare* abl.
I. iii. 11 with Lucretius; *ferundo* I. i. 5; *alii* gen.
II. ix. 5; *secuntur* from *sequor*.

I have restored some good spellings from *H: cir-
cuitionibus* I. i. 7; *turrim* and *turrem* are found side
by side, I. vi. 4, reminding us that the rules for
spelling were still flexible. (The great inscription
of Augustus in Ancyra has *conlegio* and *collega* in
the same sentence, IV. 22.) *Mercuri* gen. sing.
should not have been altered by Rose and Krohn,
II. viii. 11; the reading of *H* in V. x. 5 seems to be
*clupe*u_o*m*, the correction of *o* by the first hand to *u*
being made with a letter like *y* (Augustus' inscrip-
tion having *clupei* VI. 34); *praegnates* II. ix. 1 is
found in Plautus and frequently in Pliny, *N.H.*;
reciperantur should stand, II. ix. 2.

H's language is tinged with old technical spellings
natural in builders' specifications. *doleis* V. v. 1 is
supported by Varro, *R.R.* I. 61. Under the same
head come lengthy compounds like *exsuperationibus*
I. iv. 8, and *inambulationes* I. iii. 1. The last example

is instructive. Compounds with *in* are frequent and have sometimes been altered by Krohn unnecessarily, as here, on the ground that the mediaeval scribes often added *in*. The repetition of synonyms is frequent; it is dangerous to remove them as glosses. *gnomon indagator umbrae* I. vi. 6. Another characteristic of specifications is the use of singular for plural: *in tertio et quarto volumine* I. vii. 2; this should have prevented the alteration to the plural of *erit littera e et f*, I. vi. 12. The not infrequent omission of the verb *esse* also characterises early African Latin, as in the N.T. MS. *k*.

The description of the basilica at Fano, V. i. 6, has puzzled some critics. It is obviously taken from something like a specification. The argument from language against its ascription to Vitruvius is unconvincing to an architect who, like the present writer, has written specifications and employed the traditional idiom with its archaic and technical terms. I will allow myself but one reference. Mr. Krohn, pref. v, cites *negotiantes* (for *negotiatores*) as not Vitruvian. The use of the participle as a noun of agency is characteristic of African Latin; *discentes* for *discipuli* in the N.T. MS. *k*. It also occurs in Sallust, Caesar, Cicero, Livy. The reader of the following pages, therefore, may find in the basilica the precedent followed to some extent throughout the Middle Ages, and set by Vitruvius himself.[1]

[1] Scott, *History of English Church Architecture*, p. 4 ff.

BIBLIOGRAPHY

Manuscripts

THE following MSS. have been used in constituting the text and in determining its history. Rose and Krohn agree in referring all the extant MSS. to H and G as representing an unknown original, and have intentionally neglected the later MSS., which they refer to one or other of these sources. I have carried their process one step further, by showing, as I think, that G is a recension of H. For E, G and S, I have availed myself of the collations of Rose and Krohn. The remaining fourteen MSS. I have collated myself, H, h and e_2 minutely. They confirm the derivation of the later MSS. from H and G.

> H. London, British Museum, Harl. 2767 [1] (8th cent.).
>
> S. Selestad. Bibl. 1153 (10th cent.).
>
> E. Wolfenbüttel, Bibl. 132 (10th cent.).
>
> G. Wolfenbüttel, Bibl. 69 (11th cent.), with excerpts from I–III, V–X.

The following MSS. are derived from H: they are sometimes denoted generally as *rec.* (*recentiores*).

> c. London, B.M., Cotton, Cleop. (10th cent.).
> The rubricator gives the author's name as

[1] H inserts some chapter headings in the first book, probably later than the text itself. These headings have been inserted in the translation.

BIBLIOGRAPHY

Victruvius, which is found in the following four MSS.

h. London, B.M., Harl. 3859 (11th cent.).
i. Oxford, St. John's Coll. 66 *B* (1316 A.D.).
e₂. Escorial, II. 5 (15th cent.).
h₂. London, B.M., Harl. 2760 (15th cent.).
p₁. Paris, Bibl. Nat. 7227 (11th cent.).
e₁. Escorial, III. 19 (11th or 12th cent.).
et. Eton College, MSS. 137 (15th cent.).
v₁. Rome, Vatican Codd. Urbin. Lat. III. 1360 (15th cent.).
p₃. Paris, Bibl. Nat. 7382 (15th cent.).

The following MSS. are derived through *E* and *G*:

p₂. Paris, Bibl. Nat. 7228 (14th cent.).
o₂. Oxford, Bodleian, F. v. 7 (15th cent.).
v₂. Rome, Vatican Codd. Urbin. Lat. I. 293 (15th cent.).

Editions

Sulp.: ed. princeps. by Sulpitius, Rome, *c.* 1486, fol.
Ioc.: Fra Giocondo, Florence, Junta, 1522, 8vo.
Phil.: Philander, Rome, 1544, 8vo.
Laet.: Laet, Amsterdam, 1649, fol.
Perr.: Perrault, Paris, 1673, fol.
Schn.: Schneider, Leipzig, 1807–8, 8vo.
Lor.: Lorentzen, Gotha (Books I–V), 1857, 8vo.
Rose.: Rose, Leipzig, 1867 and 1899, 8vo.
Kr.: Krohn, Leipzig, 1912, 8vo.

Translations

Italian: Barbaro, Venice, 1567, 4to., illust.
French: Perrault, Paris, 1673, fol., illust.
Choisy, Paris, 1909, illust.
German: Rivius, Nuremburg, 1548, fol., illust.

xxxiii

BIBLIOGRAPHY

English : Gwilt, London, 1826, large 4to., illust.
Morgan, Harvard, 1914, 8vo., illust.

The Chief Contributions to the Study of Vitruvius [1]

Serlio : *Architettura*, Libri I–IV, Rome, 1559–1562, fol.

Vignola : *Regola della cinque ordini d'Architettura.* Of this there are several French translations.

Palladio : Libri IV *dell' Architettura*, Venice, 1570, fol.

Goujon : Essay contained in Martin's translation of Vitruvius, Paris, 1547.

De Brosse : *Reigle Générale*, Paris, 1619, fol.

Le Clerc : *Architecture*, Paris, 1714. Two vols., 4to.

Inigo Jones : his notes on Vitruvius and Palladio await publication.

Wren : *Parentalia*, London, 1750.

The above works are by architects who applied the rules of Vitruvius to their buildings, and are important for the understanding of Roman architectural practice.

Wotton : *Elements of Architecture*, London, 1624, 12mo.

Polenus : *Exercitationes Vitruvianae*, Patavii, 1739.

Fea : Winkelmann, tr. Rome, 1783–4. Three vols., 4to. (Sulle rovine di Roma.)

Donaldson : Trans. *R.I.B.A.* Vol. I, 1834. (On MSS. of Vitruvius.)

The Harleian MSS. including *H* appear in this list, as also the Wolfenbüttel MSS. including *G*. But Vitruvian studies were almost fruitless for a

[1] Much that has been written on Vitruvius may safely be neglected.

generation until the edition of Rose, 1867. They were overshadowed on the one hand by the renaissance of Greek architecture beginning with Stuart and Revett's *Antiquities of Athens*, 1762–1816, and on the other by the renaissance of Gothic architecture beginning with Horace Walpole. The Greek revival has thrown much light on the authorities followed by Vitruvius and vindicated his accuracy.[1] His influence upon Einhard largely determined the architectural school of Charlemagne and thereby the development of Gothic architecture.

Sanford : Classical Authors in Libri Manuales, *Trans. Amer. Phil. Assoc.*, 1924.

Nohl : *Index Vitruvianus*, Leipzig, 1876, 8vo.
Analecta Vitruviana, Berlin, 1882, 4to.

Stock : *De Vitruvii sermone*, Berlin, 1888, 8vo.

Morgan : *Addresses and Essays*, New York, 1909.

Ussing : *Betragtninger over Vitruvii de architectura*, Copenhagen, 1896. (Maintained that the work was spurious and belonged to the third or fourth century. Against him it was shown that it was written before Actium, B.C. 31, by the two following.)

Dietrich : *Quaestionum Vitruvianarum Specimen*, Leipzig, 1906, 8vo.

Sontheimer : *Vitruvius und seine Zeit.*, Tübingen, 1908, 8vo.

Schmidt, W. : Bursian's *Jahresberichte*, CVIII. 122, 1901. (The description of the Basilica at Fano is treated as an interpolation by a later hand ; he is followed by Krohn.)

[1] Vitruvius' description of the Temple of Zeus Olympios at Athens as octastyle has been proved correct in recent excavations.

BIBLIOGRAPHY

Gardner, E.: The Greek House, *Journal of Hellenic Studies*, XXI. 300–303, 1901.

Dyer, L.: Vitruvius' Account of the Greek Stage, *op. cit.*, XII. 1891.

Dörpfeld: *Das griech. Theater*, Athens, 1896.

Krohn: *De Faventini Epitome*, Berlin, 1896.

Krohn: *Frontinus*, Leipzig, 1922.

Books of General Reference

Terquem: *La science Romaine d'après Vitruve*, Paris, 1885.

Lanciani: *Ruins and Excavations of Ancient Rome*, London, 1897, 8vo.

Schanz: *Römische Literatur*, Munich, 1899, large 8vo.; 2nd ed., 1911.

Richter: *Topographie der Stadt Rom*, Munich, 1901, large 8vo.

Lethaby: *Greek Buildings*, London, 1908, tall 8vo.

Jones, H. S.: *Companion to Roman History*, Oxford, 1912, large 8vo.

Platner and Ashby: *Topographical Dictionary of Ancient Rome*, Oxford, 1929, large 8vo.

Neuburger: *Technical Arts and Sciences of the Ancients*, tr. Brose, London, 1930, large 8vo.

VITRUVIUS
ON ARCHITECTURE

BOOKS I—V

VITRUVII

DE ARCHITECTURA

LIBER PRIMUS

1 CUM divina tua mens et numen, imperator Caesar, imperio potiretur orbis terrarum invictaque virtute cunctis hostibus stratis triumpho victoriaque tua cives gloriarentur et gentes omnes subactae tuum spectarent nutum populusque Romanus et senatus liberatus timore amplissimis tuis cogitationibus consiliisque gubernaretur, non audebam, tantis occupationibus, de architectura scripta et magnis cogitationibus explicata edere, metuens, ne non apto tempore interpellans subirem tui animi offensionem.

2 Cum vero adtenderem te non solum de vita communi omnium curam publicaeque rei constitutionem habere sed etiam de opportunitate publicorum aedificiorum, ut civitas per te non solum provinciis esset aucta, verum etiam ut maiestas imperii publicorum aedificiorum egregias haberet auctoritates, non putavi praetermittendum, quin primo quoque

[1] Augustus' admiral defeated Antony and Cleopatra at Actium 31 B.C.

[2] The young Octavian had shared in the proscription of 42 B.C., but his triumph of 31, was followed by an amnesty.

2

VITRUVIUS

ON ARCHITECTURE

BOOK I

1. When your Highness's divine mind and power, O Caesar, gained the empire of the world,[1] Rome gloried in your triumph and victory. For all her enemies were crushed by your invincible courage and all mankind obeyed your bidding; the Roman people and senate were not only freed from fear[2] but followed your guidance, inspired as it was by a generous imagination. Amid such affairs I shrank from publishing my writings on architecture in which I displayed designs made to a large scale, for I feared lest by interrupting at an inconvenient time, I should be found a hindrance to your thoughts.

2. But I observed that you cared not only about the common life of all men, and the constitution of the state, but also about the provision[3] of suitable public buildings; so that the state was not only made greater through you by its new provinces, but the majesty of the empire also was expressed through the eminent dignity of its public buildings. Hence I conceived that the opportunity

[3] Augustus boasted that he found a Rome of brick, and left one of marble.

3

tempore de his rebus ea tibi ederem, ideo quod primum parenti tuo de eo fueram notus et eius virtutis studiosus Cum autem concilium caelestium in sedibus inmortalitatis eum dedicavisset et imperium parentis in tuam potestatem transtulisset, idem studium meum in eius memoria permanens in te contulit favorem.

Itaque cum M. Aurelio et P. Minidio et Cn. Cornelio ad apparationem balistarum et scorpionum reliquorumque tormentorum refectionem fui praesto et cum eis commoda accepi, quae, cum primo mihi tribuisti recognitionem, per sororis commendationem servasti.

3 Cum ergo eo beneficio essem obligatus, ut ad exitum vitae non haberem inopiae timorem, haec tibi scribere coepi, quod animadverti multa te aedificavisse et nunc aedificare, reliquo quoque tempore et publicorum et privatorum aedificiorum, pro amplitudine rerum gestarum ut posteris memoriae traderentur, curam habiturum. Conscripsi praescriptiones terminatas, ut eas adtendens et ante facta et futura qualia sint opera, per te posses nota habere. Namque his voluminibus aperui omnes disciplinae rationes.

[1] Augustus was the great nephew of Julius Caesar, and was adopted by his will. Augustus' mother Atia belonged to Aricia, near Nemi. The name occurs on tiles found at Nemi. Atia's mother Julia was the sister of Caesar (whose bust was found at Nemi and is now in the Castle Museum, Nottingham).

[2] Artillery described in Book X.

should be taken at once of bringing before you my proposals about these things: the more so, because I had been first known to your father [1] herein, whose virtues I revered. When, however, the Council of Heaven gave him an abode in the mansion of the immortals and placed in your power your father's empire, that same zeal of mine which had remained faithful to his memory found favour also with you.

Therefore, along with M. Aurelius and P. Minidius and Cn. Cornelius, I was put in charge of the construction and repair of *balistae* [2] and *scorpiones* [2] and other engines of war, and, along with my colleagues, received advancement. After first granting me this surveyorship,[3] you continued it by the recommendation of your sister.

3. Since, then, I was indebted to you for such benefits that to the end of life I had no fear of poverty, I set about the composition of this work for you. For I perceived that you have built, and are now building, on a large scale. Furthermore, with respect to the future, you have such regard to public and private buildings, that they will correspond to the grandeur of our history, and will be a memorial to future ages. I have furnished a detailed treatise so that, by reference to it, you might inform yourself about the works already complete or about to be entered upon. In the following books I have expounded a complete system of architecture.

[3] It was in a similar capacity that Vitruvius controlled the plumbing at Rome. Frontin. *Aquaed.* 23.

I

1 ARCHITECTI est scientia pluribus disciplinis et variis eruditionibus ornata, [cuius iudicio probantur omnia] ¹ quae ab ceteris artibus perficiuntur. Opera ea nascitur et fabrica et ratiocinatione. Fabrica est continuata ac trita usus meditatio, quae manibus perficitur e materia cuiuscumque generis opus est ad propositum deformationis. Ratiocinatio autem est, quae res fabricatas sollertiae ac rationis proportione demonstrare atque explicare potest.

2 Itaque architecti, qui sine litteris contenderant, ut manibus essent exercitati, non potuerunt efficere, ut haberent pro laboribus auctoritatem; qui autem ratiocinationibus et litteris solis confisi fuerunt, umbram non rem persecuti videntur. At qui utrumque perdidicerunt, uti omnibus armis ornati citius cum auctoritate, quod fuit propositum, sunt adsecuti.

3 Cum in omnibus enim rebus, tum maxime etiam in architectura haec duo insunt, quod significatur et quod significat. Significatur proposita res, de qua dicitur; hanc autem significat demonstratio rationibus doctrinarum explicata. Quare videtur utraque parte exercitatus esse debere, qui se architectum profiteatur. Itaque eum etiam ingeniosum oportet esse et ad disciplinam docilem.

¹ cuius iudicio probantur omnia *G S* : *om. H.*

¹ The misunderstanding of *opera* as " works " instead of " personal service " led to the erroneous punctuation which puts the period after instead of before *opera*. The reading and punctuation of the text are found curiously enough in the

CHAPTER I

ON THE TRAINING OF ARCHITECTS

1. THE science of the architect depends upon many disciplines and various apprenticeships which are carried out in other arts. His personal service [1] consists in craftsmanship and technology. Craftsmanship is continued and familiar practice, which is carried out by the hands [2] in such material as is necessary for the purpose of a design. Technology sets forth and explains things wrought in accordance with technical skill and method.

2. So architects who without culture aim at manual skill cannot gain a prestige corresponding to their labours, while those who trust to theory and literature obviously follow a shadow and not reality. But those who have mastered both, like men equipped in full armour, soon acquire influence and attain their purpose.

3. Both in general and especially in architecture are these two things found; that which signifies and that which is signified. That which is signified is the thing proposed about which we speak; that which signifies is the demonstration unfolded in systems of precepts. Wherefore a man who is to follow the architectural profession manifestly needs to have experience of both kinds. He must have both a natural gift [3] and also readiness to learn.

very late Vatican MS. Codd. Urbin. 1360 except that *opera eius*, replaces *opera ea*.

[2] The word "hand" scarcely occurs in the index to Plato, and is glorified by Aristotle who defines it as *organon organōn* "the tool which makes tools."

[3] Vitruvius recognises the genius of the craftsman.

Neque enim ingenium sine disciplina aut disciplina [1]
sine ingenio perfectum artificem potest efficere. Et
ut litteratus sit, peritus graphidos, eruditus geo-
metria, historias complures noverit, philosophos
diligenter audierit, musicam scierit, medicinae non
sit ignarus, responsa iurisconsultorum noverit,
astrologiam caelique rationes cognitas habeat.

4 Quae cur ita sint, haec sunt causae. Litteras
architectum scire oportet, uti commentariis me-
moriam firmiorem efficere possit. Deinde gra-
phidis scientiam habere, quo facilius exemplaribus
pictis quam velit operis speciem deformare valeat.
Geometria autem plura praesidia praestat archi-
tecturae; et primum ex euthygrammis circini tradit
usum, e quo maxime facilius aedificiorum in areis
expediuntur descriptiones normarumque et libra-
tionum et linearum directiones. Item per opticen
in aedificiis ab certis regionibus caeli lumina recte
ducuntur. Per arithmeticen vero sumptus aedi-
ficiorum consummantur, mensurarum rationes expli-
cantur, difficilesque symmetriarum quaestiones geo-
metricis rationibus et methodis inveniuntur.

5 Historias autem plures novisse oportet, quod multa
ornamenta saepe in operibus architecti designant,
de quibus argumentis rationem, cur fecerint, quae-
rentibus reddere debent. Quemadmodum si quis
statuas marmoreas muliebres stolatas, quae caria-
tides dicuntur, pro columnis in opere statuerit et
insuper mutulos et coronas conlocaverit, percontanti

[1] aut sine ingenio disciplina *G*.

[1] Note the reference to water-colour drawings.

(For neither talent without instruction nor instruction without talent can produce the perfect craftsman.) He should be a man of letters, a skilful draughtsman, a mathematician, familiar with historical studies, a diligent student of philosophy, acquainted with music; not ignorant of medicine, learned in the responses of jurisconsults, familiar with astronomy and astronomical calculations.

4. The reasons why this should be so are these. An architect must be a man of letters that he may keep a record of useful precedents. By his skill in draughtsmanship he will find it easy by coloured [1] drawings to represent the effect desired. Mathematics again furnishes many resources to architecture. It teaches the use of rule and compass and thus facilitates the laying out of buildings on their sites by the use of set-squares, levels and alignments. By optics,[2] in buildings, lighting is duly drawn from certain aspects of the sky. By arithmetic, the cost of building is summed up; the methods of mensuration are indicated; while the difficult problems of symmetry are solved by geometrical rules and methods. 5. Architects ought to be familiar with history because in their works they often design many ornaments about which they ought to render an account to inquirers. For example, if anyone in his work sets up, instead of columns, marble statues of long-robed women which are called caryatids,[3] and places mutules and cornices above them, he will thus

[2] The science of optics includes perspective to which many references will be found.

[3] The caryatides of the Erechtheum at Athens were first known as *korai* or " maidens."

bus ita reddet rationem. Caria, civitas Peloponnensis,[1] cum Persis hostibus contra Graeciam consensit. Postea Graeci per victoriam gloriose bello liberati communi consilio Cariatibus bellum indixerunt. Itaque oppido capto, viris interfectis, civitate declarata [2] matronas eorum in servitutem abduxerunt, nec sunt passi stolas neque ornatus matronales deponere, uti non una triumpho ducerentur. sed aeterno, servitutis exemplo gravi contumelia pressae poenas pendere viderentur pro civitate. Ideo qui tunc architecti fuerunt aedificiis publicis designaverunt earum imagines oneri ferundo conlocatas, ut etiam posteris nota poena peccati Cariatium memoriae traderetur. Non minus Lacones, Pausania Agesilae [3] filio duce, Plataeeo [4] proelio pauca manu infinitum numerum exercitus Persarum cum superavissent, acto cum gloria triumpho spoliorum et praedae, porticum Persicam ex manubiis, laudis et virtutis civium indicem, victoriae posteris pro tropaeo constituerunt. Ibique captivorum simulacra barbarico vestis ornatu, superbia meritis contumeliis punita, sustinentia tectum conlocaverunt, uti et hostes horrescerent timore eorum fortitudinis effectus, et cives id exemplum virtutis aspicientes gloria erecti ad defendendam libertatem essent parati.

[1] peloponnessis *H.* [2] de *forte sensu privativo.*
[3] Agesilae *Sch.* [4] Plataeeo *Joc*: pitalco *H.*

[1] The legend reported here may perhaps be explained by the traditional enmity of the Carians in Asia Minor, II. viii. 12; IV. i. 5. The spelling of *H. Caria,* throws some doubt upon the usual reference to the Arcadian Caryae. The Cnidians used caryatid figures (of a style similar to the early draped female statues of the Acropolis) in their treasury at Delphi. These may have originated the legend.

render an account to inquirers. Caria,[1] a Peloponnesian state, conspired with the Persian enemy against Greece. Afterwards the Greeks, gloriously freed from war by their victory, with common purpose went on to declare war on the inhabitants of Caria. The town was captured; the men were killed; the state was humiliated. Their matrons were led away into slavery and were not allowed to lay aside their draperies and ornaments. In this way, and not at one time alone, were they led in triumph. Their slavery was an eternal warning. Insult crushed them. They seemed to pay a penalty for their fellow-citizens. And so the architects of that time designed for public buildings figures of matrons placed to carry burdens; in order that the punishment of the sin of the Cariatid women might be known to posterity and historically recorded. 6. Not less the Spartans under the command of Pausanias, son of Agesilas,[2] having conquered with a small force an infinitely large army of Persians, gloriously celebrated a triumph with spoils and plunder, and, from the booty, built the Persian Colonnade[3] to signify the merit and courage of the citizens and to be a trophy of victory to their descendants. There they placed statues of their captives in barbaric dress—punishing their pride with deserved insults—to support the roof, that their enemies might quake, fearing the workings of such bravery, and their fellow-citizens looking upon a pattern of manhood might by such glory be roused and prepared for the defence of freedom. Therefrom many

[2] Herod iv. 81, says Cleombrotus.
[3] At Sparta, Paus. III. xi. 3.

Itaque ex eo multi statuas Persicas sustinentes
epistylia et ornamenta eorum conlocaverunt, et ita
ex eo argumento varietates egregias auxerunt operi-
bus. Item sunt aliae eiusdem generis historiae,
quarum notitiam architectos tenere oporteat.
7 Philosophia vero perficit architectum animo magno
et uti non sit adrogans, sed potius facilis, aequus et
fidelis, sine avaritia, quod est maximum; nullum
enim opus vere sine fide et castitate fieri potest;
ne sit cupidus neque in muneribus accipiendis
habeat animum occupatum, sed cum gravitate suam
tueatur dignitatem bonam famam habendo; et
haec enim philosophia praescribit. Praeterea de
rerum natura, quae graece *physiologia* dicitur,
philosophia explicat. Quam necesse est studiosius
novisse, quod habet multas et varias naturales quaes-
tiones. Ut etiam in aquarum ductionibus. Incursi-
bus enim et circuitionibus et librata planitie ex-
pressionibus spiritus naturales aliter atque aliter
fiunt, quorum offensionibus mederi nemo poterit,
nisi qui ex philosophia principia rerum naturae
noverit. Item qui Ctesibii [1] aut Archimedis et
ceterorum, qui eiusdem generis praecepta con-
scripserunt, leget, sentire non poterit, nisi his rebus
8 a philosophis erit institutus. Musicen autem sciat
oportet, uti canonicam rationem et mathematicam
notam habeat, praeterea balistarum, catapultarum,
scorpionum temperaturas possit recte facere. In

[1] Ctesibii *Joc.*

[1] Vitruvius was acquainted with Lucretius' poem " On the
Nature of Things," IX. iii. 17.
[2] An engineer at Alexandria, *c.* 250 B.C.
[3] An engineer at Syracuse, *c.* 250 B.C.

have set up Persian statues to support architraves and their ornaments. This motive has supplied for their works some striking variations. There are also other narratives of the same kind with which architects should possess acquaintance. 7. Philosophy, however, makes the architect high-minded, so that he should not be arrogant but rather urbane, fair-minded, loyal, and what is most important, without avarice; for no work can be truly done without good faith and clean hands. Let him not be greedy nor have his mind busied with acquiring gifts; but let him with seriousness guard his dignity by keeping a good name. And such are the injunctions of philosophy. Philosophy, moreover, explains the "nature of things"[1] (and this in Greek is *physiologia*), a subject which it is necessary to have studied carefully because it presents many different natural problems, as, for example, in the case of water-supply. For in the case of watercourses, where there are channels or bends or where water is forced along on a levelled plane, natural air-pockets are produced in different ways, and the difficulties which they cause cannot be remedied by anyone unless he has learnt from philosophy the principles of nature. So also the man who reads the works of Ctesibius[2] or Archimedes[3] and of others who have written manuals of the same kind will not be able to perceive their meaning, unless he has been instructed herein by philosophers. 8. A man must know music that he may have acquired the *acoustic*[4] and mathematical relations and be able to carry out rightly the adjustments of *balistae, catapultae* and *scorpiones*. For in the cross-

[4] *Gell.* XVI. xviii. 5.

capitulis enim dextra ac sinistra sunt foramina hemi-
toniorum, per quae tenduntur suculis [1] et vectibus e
nervo torti funes, qui non praecluduntur nec prae-
ligantur, nisi sonitus ad artificis aures certos et
aequales fecerunt. Bracchia enim, quae in eas
tentiones includuntur, cum extenduntur, aequaliter
et pariter utraque [2] plagam mittere debent; quodsi
non homotona [3] fuerint, inpedient directam telorum
9 missionem. Item theatris vasa aerea, quae in cellis
sub gradibus mathematica ratione conlocantur
quae Graeci ēcheia appellant; sonitûm et discrimina
ad symphonias musicas sive concentus componuntur
divisa in circinatione diatessaron et diapente et
disdiapason, uti vox scaenici sonitus conveniens in
dispositionibus tactu cum offenderit, aucta cum
incremento clarior et suavior ad spectatorum per-
veniat aures. Hydraulicas quoque machinas et
cetera, quae sunt similia his organis, sine musicis
10 rationibus efficere nemo poterit. Disciplinam vero
medicinae novisse oportet propter inclinationem
caeli, quae Graeci climata dicunt, et aeris et locorum,
qui sunt salubres aut pestilentes, aquarumque usus;
sine his enim rationibus nulla salubris habitatio
fieri potest. Iura quoque nota habeat oportet, ea
quae necessaria sunt aedificiis communibus parietum
ad ambitum stillicidiorum et cloacarum, luminum.

[1] suculis *Joc.* [2] utraque *rec.*
 [3] homotona *Phil.*

[1] Philander's reading *homotona,* "equal tones," is tempting.
[2] Book V. v. 7. [3] Book X.
[4] These subjects are treated in Hippocrates, *de aere aquis locis.*
[5] "The right of blocking the lights of a neighbour's house,
of running water or dropping water," Gaius, II. 14. Cicero's

beams on right and left are holes " of half-tones "
(*hemitonia*)[1] through which ropes twisted out of
thongs are stretched by windlasses and levers. And
these ropes are not shut off nor tied up, unless they
make clear and equal sounds in the ear of the crafts-
man. For the arms which are shut up under those
strains, when they are stretched out, ought to
furnish an impetus evenly, and alike on either side.
But if they do not give an equal note, they will
hinder the straight direction of the missiles. 9. In
theatres, also, are copper vessels and these are placed
in chambers under the rows of seats in accordance
with mathematical reckoning. The Greeks call
them *echeia*.[2] The differences of the sounds which
arise are combined into musical symphonies or
concords : the circle of seats being divided into
fourths and fifths and the octave. Hence, if
the delivery of the actor from the stage is adapted
to these contrivances, when it reaches them, it
becomes fuller, and reaches the audience with a
richer and sweeter note. Or again, no one who
lacks a knowledge of music can make water-engines[3]
or similar machines. 10. Again, he must know the
art of medicine[4] in its relation to the regions of the
earth (which the Greeks call *climata*) ; and to the
characters of the atmosphere, of localities (wholesome
or pestilential), of water-supply. For apart from
these considerations, no dwelling can be regarded as
healthy. He must be familiar with the rights or
easements which necessarily belong to buildings with
party walls, as regards the range of eaves-droppings,
drains and lighting.[5] The water-supply, also, and other

phrase *iura parietum, luminum, stillicidiorum, de Or.* I. 173,
exactly corresponds to Vitruvius.

Item, aquarum ductiones et cetera, quae eiusmod sunt, nota oportet sint architectis, uti ante caveant quam instituant aedificia, ne controversiae factis operibus patribus familiarum relinquantur, et ut legibus scribendis prudentia cavere possit et locatori et conductori; namque si lex perite fuerit scripta, erit ut sine captione uterque ab utroque liberetur. Ex astrologia autem cognoscitur oriens, occidens, meridies, septentrio, etiam caeli ratio, aequinoctium, solstitium, astrorum cursus; quorum notitiam si quis non habuerit, horologiorum rationem omnino scire non poterit.

11 Cum ergo tanta haec disciplina sit, condecorata et abundans eruditionibus variis ac pluribus, non puto posse iuste repente profiteri architectos, nisi qui ab aetate puerili his gradibus disciplinarum scandendo scientia plerarumque[1] litterarum et artium nutriti pervenerint ad summum templum architecturae.

12 Ac fortasse mirum videbitur inperitis hominibus posse naturam tantum numerum doctrinarum perdiscere et memoria continere. Cum autem animadverterint omnes disciplinas inter se coniunctionem rerum et communicationem habere, fieri posse faciliter credent; encyclios enim disciplina uti corpus unum ex his membris est composita. Itaque qui a teneris aetatibus eruditionibus variis instruuntur, omnibus litteris agnoscunt easdem notas communicationemque omnium disciplinarum, et ea re facilius omnia cognoscunt. Ideoque de veteribus architectis

[1] plerarumque *Frisemann* : plerumque *H.*

[1] *lex* denotes all kinds of contracts.
[2] Book IX.
[3] Cicero groups together medicine, architecture, and teaching as honourable to persons of a lower class. *Off.* I. 151,

related matters, ought to be familiar to architects: so that, before building is begun, precautions may be taken, lest on completion of the works the proprietors should be involved in disputes. Again, in writing the specifications,[1] careful regard is to be paid both to the employer and to the contractor. For if the specification is carefully written, either party may be released from his obligations to the other, without the raising of captious objections. By astronomy we learn the east, the west, the south and the north; also the order of the heavens, the equinox, the solstice, the course of the planets. For if anyone is unfamiliar with these, he will fail to understand the construction of clocks.[2]

11. Since, therefore, so great a profession[3] as this is adorned by, and abounds in, varied and numerous accomplishments, I think that only these persons can forthwith justly claim to be architects who from boyhood have mounted by the steps of these studies and, being trained generally in the knowledge of arts and the sciences, have reached the temple of architecture at the top. 12. But perhaps it will seem wonderful to inexperienced persons that human nature can master and hold in recollection so large a number of subjects. When, however, it is perceived that all studies are related to one another and have points of contact, they will easily believe it can happen. For a general education is put together like one body from its members. So those who from tender years are trained in various studies recognise the same characters in all the arts and see the intercommunication of all disciplines, and by that circumstance more easily acquire general information. And, therefore, one

Pythius, qui Prieni [1] aedem Minervae nobiliter est
architectatus, ait in suis commentariis architectum
omnibus artibus et doctrinis plus oportere posse
facere, quam qui singulas res suis industriis et exer-
citationibus ad summam claritatem perduxerunt.
13 Id autem re non expeditur. Non enim debet nec
potest esse architectus grammaticus, uti fuerit Aris-
tarchus, sed non agrammatus, nec musicus ut Aris-
toxenus, sed non amusos, nec pictor ut Apelles, sed
graphidos non inperitus, nec plastes quemadmodum
Myron seu Polyclitus, sed rationis plasticae non
ignarus, nec denuo medicus ut Hippocrates, sed non
aniatrologicus,[2] nec in ceteris doctrinis singulariter
excellens, sed in is [3] non inperitus. Non enim in
tantis rerum varietatibus elegantias singulares quis-
quam consequi potest, quod earum ratiocinationes
cognoscere et percipere vix cadit in potestatem.
14 Nec tamen non tantum architecti non possunt in
omnibus rebus habere summum effectum, sed etiam
ipsi qui privatim proprietates tenent artium, non
efficiunt,[4] ut habeant omnes summum laudis princi-
patum. Ergo si in singulis doctrinis singuli artifices
neque omnes sed pauci aevo perpetuo nobilitatem
vix sunt consecuti, quemadmodum potest archi-
tectus, qui pluribus artibus debet esse peritus, non
id ipsum mirum et magnum facere, ne quid ex his

<div style="text-align:center">

1 prieni *H* : primus *ł* prieni *G*.
2 aniatrologetus *H*ᶜ*G* : -gecus *H*.
3 his *H*. 4 effiunt *H*.

</div>

[1] Of Alexandria, Librarian of the Museum, *c.* 150 B.C.;
first defined the eight parts of speech.

[2] Book V. iv.

[3] Of Colophon: greatest painter of antiquity, especially
of portraits, *c.* 350 B.C.

of the old architects Pythius, who was the designer of the noble temple of Minerva at Priene, says in his Commentaries that an architect ought to be able to do more in all arts and sciences than those who, by their industry and experience, have advanced individual arts to the highest renown. But that is not in fact established. 13. For an architect ought to be and can be no critic like Aristarchus,[1] yet not without culture; no musician like Aristoxenus,[2] yet not without knowledge of music; no painter like Apelles,[3] yet not unskilled with his pencil; no sculptor like Myron [4] or Polyclitus,[5] yet not ignorant of the plastic art; nor in fine a physician like Hippocrates,[6] yet not unskilled in medicine; nor in other sciences excelling in a singular manner, yet in these not unskilled. For in so great a variety of things no one can in every case attain minute perfection, because it scarcely falls into his power to acquire and understand their methods. 14. Yet while architects are thus not able in every art to achieve the highest perfection, even those who severally possess the qualities of the craftsman do not all succeed in reaching supreme mastery. Therefore, since in each art, single craftsmen, not all, but few throughout the ages have scarcely attained renown, why should not an architect, who has to be skilled in several arts, count it a fine achievement if he is not deficient in anything belonging to them? How can he hope

[4] Of the Attic school, early fifth century B.C., sculptor of the Discobolus.

[5] Of the Argive school, later fifth century B.C., sculptor of the Doryphorus, which established a canon of human proportion.

[6] Hippocrates, born c. 460 B.C., founded a medical school at Cos.

indigeat, sed etiam ut omnes artifices superet qui
singulis doctrinis adsiduitatem cum industria summa
15 praestiterunt? Igitur in hac re Pythius errasse
videtur, quod non animadvertit ex duabus rebus
singulas artes esse compositas, ex opere et eius
ratiocinatione, ex his autem unum proprium esse
eorum qui singulis rebus sunt exercitati, id est
operis effectus, alterum commune cum omnibus
doctis, id est rationem, uti medicis et musicis et
de venarum rythmo[1] ad pedem motus, ut si vulnus
mederi aut aegrum eripere de periculo oportuerit,
non accedet musicus, sed id opus proprium erit
medici; item in organo non medicus sed musicus
modulabitur, ut aures suae cantionibus recipiant
16 iucunditatem. Similiter cum astrologis et musicis
est disputatio communis de sympathia stellarum et
symphoniarum in quadratis et trigonis[2] diatessaron
et diapente, a geometris de visu qui graece *logos
opticos* appellatur; ceterisque omnibus doctrinis
multae res vel omnes communes sunt dumtaxat ad
disputandum. Operum vero ingressus qui manu
aut tractationibus ad elegantiam perducuntur,
ipsorum sunt, qui proprie una arte ad faciendum
sunt instituti. Ergo satis abunde videtur fecisse,
qui ex singulis doctrinis partes et rationes earum
mediocriter habet notas, eas quae necessariae sunt
ad architecturam, uti, si quid de his rebus et artibus
17 iudicare et probare opus fuerit, ne deficiatur. Qui-

[1] pythmo *H*. [2] tridonis *H*.

[1] Geometers as well as those who treat vision from the
psychological standpoint.
[2] This, the reading of *H*, has been wrongly changed by
some editors; cf. *supra*, § 4.
[3] *supra*, § 1.

for so great and remarkable a thing as to surpass craftsmen who have assiduously and with the greatest industry applied themselves to single employments? 15. Therefore in this matter Pythius seems to have erred because he failed to perceive that the several arts are composed of two things—craftsmanship and the theory of it. Of these the one, craftsmanship, is proper to those who are trained in the several arts, namely, the execution of the work; the other, namely, theory, is shared with educated persons. Physician and musician alike deal with the rhythm of the pulse and the movement of the feet. For example, if a man has to heal a wound or to rescue a sick man out of danger, it is not the musician who will come, but it will be the special work of a physician. So also in the case of a musical instrument, a musician and not a physician will be in control so that one's ears may receive the sweetness of a song. 16. Likewise there is a question common to astronomers and musicians about the sympathy of stars and of the concords, fourths and fifths, in quadrants and triangles; and geometers[1] treat about vision, which in Greek is called *logos opticos*[2]; thus throughout all the sciences many things, or indeed all, are in common so far as theory is concerned. But the taking up of work which is finely executed by hand,[3] or technical methods, belongs to those who have been specially trained to work in a single trade. Therefore, he seems to have done quite enough who in the several arts is moderately familiar with the branches and methods which are necessary to architecture, so that he is not at a loss when it is necessary to judge and test any work done in these other departments and trades. 17. But those individuals

21

bus vero natura tantum tribuit sollertiae, acuminis,
memoriae, ut possint geometriam, astrologiam,
musicen ceterasque disciplinas penitus habere notas,
praetereunt officia architectorum et efficiuntur
mathematici. Itaque faciliter contra eas disciplinas
disputare possunt, quod pluribus telis disciplinarum
sunt armati. Hi autem inveniuntur raro, ut ali-
quando fuerunt Aristarchus Samius, Philolaus et
Archytas Tarentini, Apollonius Pergaeus, Eratos-
thenes Cyrenaeus, Archimedes et Scopinas ab
Syracusis, qui multas res organicas, gnomonicas
numero naturalibusque rationibus inventas atque
explicatas posteris reliquerunt.

18 Cum ergo talia ingenia ab naturali sollertia non
passim cunctis gentibus sed paucis viris habere con-
cedatur, officium vero architecti omnibus eruditioni-
bus debeat esse exercitatum, et ratio propter ampli-
tudinem rei permittat non iuxta necessitatem sum-
mas sed etiam mediocris [1] scientias habere dis-
ciplinarum, peto, Caesar, et a te et ab is, qui ea
volumina sunt lecturi, ut, si quid parum ad regulam
artis grammaticae fuerit explicatum, ignoscatur.
Namque non uti summus philosophus nec rhetor
disertus nec grammaticus summis rationibus artis
exercitatus, sed ut architectus his litteris inbutus
haec nisus sum scribere. De artis vero potestate
quaeque insunt in ea ratiocinationes polliceor, uti
spero, his voluminibus non modo aedificantibus sed

[1] mediocris *H*.

[1] Celebrated mathematician at Alexandria, *c.* 275 B.C.
[2] Contemporary of Plato, Pythagorean philosopher.
[3] Followed Euclid at Alexandria.
[4] Encyclopedic mathematician, astronomer and geographer.
Librarian of the Museum at Alexandria, died *c.* 195 B.C.

on whom nature has bestowed so much skill, acumen, retentiveness that they can be thoroughly familiar with geometry, astronomy, music and other studies, go beyond the duties of an architect and are to be regarded as mathematicians. And thus they can easily dispute about those subjects because they are armed with the weapons provided by their studies. Such men, however, are rarely met. We can point to Aristarchus [1] of Samos; Philolaus [2] and Archytas [2] of Tarentum; Apollonius [3] of Perga; Eratosthenes [4] of Cyrene; Archimedes [5] and Scopinas [6] from Syracuse. They have left to after times many treatises on machinery and clocks, in which mathematics and natural laws are used to discover and explain.

18. Yet it is not granted to nations as a whole, but only to few individuals, to have such genius owing to their natural endowment. At the same time the architect in his work ought to be practised in all accomplishments. Yet reason, in view of the scope of the matter, does not permit us, as need demands, to have a complete, but only a moderate, knowledge of the various subjects involved. Hence I beg your Highness and the other readers of these volumes to pardon any explanation that too little agrees with the rules of the literary art. For it is not as a lofty thinker, nor as an eloquent speaker, nor as a scholar practised in the best methods of literary criticism, but as an architect who has a mere tinge of these things, that I have striven to write the present treatise. But in respect to the meaning of my craft and the principles which it involves, I hope and undertake to expound them

[5] Killed at siege of Syracuse, 212 B.C.
[6] Invented a sundial placed in the Circus Flaminius.

etiam omnibus sapientibus cum maxima auctoritate
me sine dubio praestaturum.

II

1　Architectura autem constat ex ordinatione,
quae graece *taxis* dicitur, et ex dispositione, hanc
autem Graeci *diathesin* vocitant, et eurythmia et
symmetria et decore et distributione quae graece
oeconomia dicitur.

2　Ordinatio est modica membrorum operis com-
moditas separatim universeque proportionis [1] ad sym-
metriam comparatio. Haec conponitur ex quanti-
tate, quae graece *posotes* [2] dicitur. Quantitas autem
est modulorum ex ipsius operis sumptio e singulisque
membrorum partibus universi operis conveniens
effectus.

Dispositio autem est rerum apta conlocatio ele-
gansque [3] compositionibus effectus operis cum quali-
tate. Species dispositionis, quae graece dicuntur
ideae, sunt hae: ichnographia, orthographia, scaeno-
graphia. Ichnographia est circini regulaeque modice
continens usus, e qua [4] capiuntur formarum in solis [5]
arearum descriptiones. Orthographia autem est
erecta frontis imago modiceque picta rationibus

[1] proportionis *S*.　　　[2] possotes *H*.
[3] eligans *H*.　　　　　[4] equa *G* : aequa *H*.
[5] solis *G* : soliis *H*.

[1] *taxis* and *oeconomia* are mentioned together by the author
of the treatise *On the Sublime*, I. 4. Vitruvius assembles
terms of aesthetic criticism without clearly distinguishing.
Wordsworth's phrase " proportion and congruity " indicates
the essence of the classical manner (*Prose Works*, II. 127).

with assured authority, not only to persons engaged in building but also to the learned world.

CHAPTER II

OF WHAT THINGS ARCHITECTURE CONSISTS

1. Now architecture consists of Order, which in Greek is called *taxis*,[1] and of Arrangement, which the Greeks name *diathesis*, and of Proportion and Symmetry and Decor and Distribution which in Greek is called *oeconomia*.[2]

2. Order is the balanced adjustment of the details of the work separately, and, as to the whole, the arrangement of the proportion with a view to a symmetrical result. This is made up of Dimension, which in Greek is called *posotes*. Now Dimension is the taking of modules[3] from the parts of the work; and the suitable effect of the whole work arising from the several subdivisions of the parts.

Arrangement, however, is the fit assemblage of details, and, arising from this assemblage, the elegant effect of the work and its dimensions, along with a certain quality or character. The kinds of the arrangement (which in Greek are called *ideae*) are these: ichnography (plan); orthography (elevation); scenography (perspective). Ichnography (plan) demands the competent use of compass and rule; by these plans are laid out upon the sites provided. Orthography (elevation), however, is the vertical image of the front, and a figure slightly

[2] Vitruvius' three terms seem to correspond to Democritus' *ordo positura figurae* given in Lucretius, I. 685.

[3] Units of Measurement.

operis futuri figura. Item scaenographia est frontis
et laterum abscedentium adumbratio ad circinique
centrum omnium linearum responsus. Hae nascun-
tur ex cogitatione et inventione. Cogitatio est cura
studii plena et industriae vigilantiaeque effectus
propositi cum voluptate. Inventio autem est quaes-
tionum obscurarum explicatio ratioque novae rei
vigore mobili reperta. Hae sunt terminationes
dispositionum.

3 Eurythmia est venusta species commodusque in
conpositionibus membrorum aspectus. Haec efficitur,
cum membra operis convenientia sunt altitudinis
ad latitudinem, latitudinis ad longitudinem, et ad
summam omnia respondent [1] suae symmetriae.

4 Item symmetria est ex ipsius operis membris con-
veniens consensus ex partibusque separatis ad uni-
versae figurae speciem ratae [2] partis responsus. Uti
in hominis corpore e cubito, pede, palmo, digito
ceterisque particulis symmetros est eurythmiae
qualitas, sic est in operum perfectionibus. Et
primum in aedibus sacris aut e columnarum crassi-
tudinibus aut triglypho aut etiam embatere, ballista
e foramine, quod Graeci *peritreton* vocitant, navibus
interscalmio, quae *dipechyaia* [3] dicitur, item cete-
rorum operum e membris invenitur symmetriarum
ratiocinatio.

Decor autem est emendatus operis aspectus pro-
batis rebus conpositi cum auctoritate. Is perficitur

[1] respondent *G* : -deant *H*.
[2] ratae *G* : latae *H*.
[3] διπηχυαία *Sch* : dipheciaca *H*.

[1] As in the canon of Polyclitus, Book I. i. 13.
[2] Seems to denote architectural good manners or decorum
in detail as well as generally.

tinted to show the lines of the future work. Sceno-
graphy (perspective) also is the shading of the front
and the retreating sides, and the correspondence of
all lines to the vanishing point, which is the centre
of a circle. These three (plan, elevation and per-
spective) arise from imagination and invention.
Imagination rests upon the attention directed with
minute and observant fervour to the charming effect
proposed. Invention, however, is the solution of
obscure problems; the treatment of a new under-
taking disclosed by an active intelligence. Such
are the outlines of Arrangement.

3. Proportion implies a graceful semblance; the
suitable display of details in their context. This is
attained when the details of the work are of a
height suitable to their breadth, of a breadth suit-
able to their length; in a word, when everything
has a symmetrical correspondence.

4. Symmetry also is the appropriate harmony
arising out of the details of the work itself; the
correspondence of each given detail among the
separate details to the form of the design as a whole.
As in the human body, from cubit, foot, palm, inch
and other small parts comes the symmetric quality
of eurhythmy [1]; so is it in the completed building.
First, in sacred buildings, either from the thickness
of columns, or a triglyph, or the module; of a balista
by the perforation which the Greeks call *peritreton ;*
by the space between the rowlocks in a ship which
is called *dipechyaia :* so also the calculation of
symmetries, in the case of other works, is found from
the details.

5. Decor [2] demands the faultless ensemble of a
work composed, in accordance with precedent, of

VITRUVIUS

statione, quod graece *thematismo* dicitur, seu consuetudine aut natura. Statione, cum Iovi Fulguri et Caelo et Soli et Lunae aedificia sub divo hypaethraque constituentur; horum enim deorum et species et effectus in aperto mundo atque lucenti praesentes vidimus.[1] Minervae et Marti et Herculi aedes doricae fient; his enim diis propter virtutem sine deliciis[2] aedificia constitui decet. Veneri, Florae, Proserpinae, Fonti Lumphis[3] corinthio genere constitutae aptas videbuntur habere proprietates, quod his diis propter teneritatem graciliora et florida foliisque et volutis ornata opera facta augere videbuntur iustum decorem. Iunoni, Dianae, Libero Patri ceterisque diis qui eadem sunt similitudine, si aedes ionicae construentur, habita erit ratio mediocritatis, quod et ab severo more doricorum et ab teneritate corinthiorum temperabitur
6 eorum institutio proprietatis. Ad consuetudinem autem decor sic exprimitur, cum aedificiis interioribus magnificis item vestibula convenientia et elegantia erunt facta. Si enim interiora prospectus[4] habuerint elegantes, aditus autem humiles et inhonestos, non erunt cum decore. Item si doricis epistyliis in coronis denticuli sculpentur aut in pulvinatis columnis et ionicis epistyliis [capitulis][5] exprimentur triglyphi,[6] translatis ex alia ratione proprietatibus in aliud genus operis offendetur aspectus aliis ante ordinis consuetudinibus institutis.

[1] videmus *G* : vidimus *H*.
[2] diliciis (-as *H*) *H G*.
[3] Lumphis *Ro* : fontycumphys *H*.
[4] prospectus *rec* : perfectus *H*.
[5] capitulis *del. Ro*.
[6] triglyphi *Joc* : triglyphis *G* : triclyphis *H*.

approved details. It obeys convention, which in Greek is called *thematismos,* or custom or nature. Convention is obeyed when buildings are put up in the open and hypethral to Jupiter of the Lightning, to Heaven, the Sun, the Moon; for of these gods, both the appearance and effect we see present in the open, the world of light. To Minerva, Mars and Hercules, Doric temples will be built; for to these gods, because of their might, buildings ought to be erected without embellishments. Temples designed in the Corinthian style will seem to have details suited to Venus, Flora, Proserpine, Fountains, Nymphs; for to these goddesses, on account of their gentleness, works constructed with slighter proportions and adorned with flowers, foliage, spirals and volutes will seem to gain in a just decor. To Juno, Diana and Father Bacchus, and the other gods who are of the same likeness, if Ionic temples are erected, account will be taken of their middle quality; because the determinate character of their temples will avoid the severe manner of the Doric and the softer manner of the Corinthian. 6. With reference to fashion, decor is thus expressed; when to magnificent interiors vestibules also are made harmonious and elegant. For if the interior apartments present an elegant appearance, while the approaches are low and uncomely, they will not be accompanied by fitness. Again, if, in Doric entablatures, dentils are carved on the cornices, or if with voluted capitals and Ionic entablatures, triglyphs are applied, characteristics are transferred from one style to another: the work as a whole will jar upon us, since it includes details foreign to the order.[1] 7. There will

[1] This rule is generally observed in modern architecture.

7 Naturalis autem decor sic erit, si primum omnibus templis saluberrimae regiones aquarumque fontes in his locis idonei eligentur, in quibus fana constituantur, deinde maxime Aesculapio, Saluti, et eorum deorum quorum plurimi medicinis aegri curari videntur. Cum enim ex pestilenti in salubrem locum corpora aegra translata fuerint et e fontibus salubribus aquarum usus subministrabuntur, celerius convalescent. Ita efficietur, uti ex natura loci maiores auctasque cum dignitate divinitas excipiat opiniones. Item naturae decor erit, si cubiculis et bybliothecis ab oriente lumina capiuntur, balneis et hibernaculis ab occidente hiberno, pinacothecis[1] et quibus certis luminibus opus est partibus, a septentrione, quod ea caeli regio neque exclaratur neque obscuratur solis cursu sed est certa inmutabilis die perpetuo.

8 Distributio autem est copiarum locique commoda dispensatio parcaque in operibus sumptus ratione temperatio. Haec ita observabitur, si primum architectus ea non quaeret, quae non potuerunt[2] inveniri aut parari nisi magno. Namque non omnibus locis harenae fossiciae nec caementorum nec abietis nec sappinorum nec marmoris copia est, sed aliud alio loco nascitur, quorum conportationes difficiles sunt

¹ pinacothicis *H*. ² potuerunt *H*.

[1] The Temple of Aesculapius on the Isola Tiberina contained votive offerings of limbs in terracotta presented by sick persons.

[2] Cicero's architect justifies the narrowness of windows by reference to a theory of vision based on Democritus or (less probably) Epicurus, *ad. Att.* II. 3.

be a natural decor: first, if for all temples there shall be chosen the most healthy sites with suitable springs in those places in which shrines are to be set up; secondly and especially for Aesculapius [1] and Salus; and generally for those gods by whose medical power sick persons are manifestly healed. For when sick persons are moved from a pestilent to a healthy place and the water supply is from wholesome fountains, they will more quickly recover. So will it happen that the divinity (from the nature of the site) will gain a greater and higher reputation and authority.

OF DOORS AND WINDOWS IN BATHS AND ELSEWHERE

Also there will be natural seemliness if light [2] is taken from the east for bedrooms and libraries; for baths and winter apartments, from the wintry sunset; for picture galleries and the apartments which need a steady light, from the north, because that quarter of the heavens is neither illumined nor darkened by the sun's course but is fixed unchangeable throughout the day.

ON THE QUALITIES OF SITES AND SUPPLIES FOR THE WORKS

8. Distribution or Economy, however, is the suitable disposal of supplies and the site, and the thrifty and wise control of expense in the works. This will be guarded if, in the first place, the architect does not require what can only be supplied and prepared at great cost. For it is not everywhere that there is a supply of quarry sand or hewn stone, or fir or deal or marble. Different things are found in different places, the transport of them may be difficult

et sumptuosae. Utendum autem est, ubi non est
harena fossicia, fluviatica aut marina lota; inopiae
quoque abietis aut sappinorum vitabuntur utendo
cupresso, populo, ulmo, pinu; reliquaque his simi-
9 liter erunt explicanda. Alter gradus erit distri-
butionis, cum ad usum patrum familiarum et ad
pecuniae copiam aut ad eloquentiae dignitatem
aedificia alte disponentur. Namque aliter urbanas [1]
domos oportere constitui videtur, aliter quibus ex
possessionibus rusticis influunt fructus; non idem
feneratoribus, aliter beatis et delicatis; potentibus
vero, quorum cogitationibus respublica gubernatur,
ad usum conlocabuntur; et omnino faciendae sunt
aptae omnibus personis aedificiorum distributiones.

III

1 PARTES ipsius architecturae sunt tres: aedificatio,
gnomonice, machinatio. Aedificatio autem divisa
est bipertito, e quibus una est moenium et com-
munium operum in publicis locis conlocatio, altera
est privatorum aedificiorum explicatio. Publicorum
autem distributiones sunt tres, e quibus est una [2]
defensionis, altera religionis, tertia opportunitatis.
Defensionis est murorum turriumque et portarum
ratio ad hostium impetus perpetuo repellendos
excogitata, religionis deorum inmortalium fanorum

[1] urbanos *G*. [2] est una *H* : una est *G*.

[1] Horace describes the financier in the country, *Epode* II.
[2] Cicero spent enormous sums on his palaces.
[3] *Infra*, c. **v.**

and costly. Now where there is no quarry sand
we must use washed river or sea sand; the need for
fir or deal will be met by using cypress, poplar, elm,
pine; other difficulties will be solved in a like fashion.
9. The second stage in Economy comes, when build-
ings are variously disposed for the use of owners or
with a view to the display of wealth or lofty enough
to suit the most dignified eloquence. For manifestly
houses should be arranged in one way in towns; in
another way for persons whose income arises from
country estates; not the same for financiers;[1] in
another way for the wealthy men of taste; for the
powerful, however, by whose ideas the state is
governed, there must be special adjustment to their
habits.[2] And generally the distribution of buildings
is to be adapted to the vocations of their owners.

CHAPTER III

ON THE PARTS OF ARCHITECTURE

1. THE parts of architecture itself are three:
Building (Books I–VIII), Dialling (Book IX), and
Mechanics (Book X). Building in turn is divided
into two parts; of which one is the placing of city
walls, and of public buildings on public sites (Books
I–V); the other is the setting out of private build-
ings (Books VI–VIII). Now the assignment of
public buildings is threefold: one, to defence; the
second, to religion; the third, to convenience. The
method of defence by walls, towers and gates has
been devised with a view to the continuous warding
off of hostile attacks[3]; to religion belongs the placing
of the shrines and sacred temples of the immortal

aediumque sacrarum conlocatio, opportunitatis communium locorum ad usum publicum dispositio,[1] uti portus, fora, porticus, balinea,[2] theatra, inambulationes ceteraque, quae isdem rationibus in publicis locis[3] designantur.

2 Haec autem ita fieri debent, ut habeatur ratio firmitatis, utilitatis, venustatis. Firmitatis erit habita ratio, cum fuerit fundamentorum ad solidum depressio, quaque e materia, copiarum sine avaritia diligens electio; utilitatis autem, ⟨cum fuerit⟩[4] emendata et sine inpeditione usus[5] locorum dispositio et ad regiones sui cuiusque generis apta et conmoda distributio; venustatis vero, cum fuerit operis species grata et elegans membrorumque commensus iustas habeat symmetriarum ratiocinationes.

IV

1 IN ipsis vero moenibus ea erunt principia. Primum electio loci saluberrimi. Is autem erit excelsus et non nebulosus, non pruinosus regionesque caeli spectans neque aestuosas neque frigidas sed temperatas, deinde sic vitabitur palustris vicinitas. Cum enim aurae matutinae cum sole oriente ad oppidum pervenient et his ortae nebulae adiungentur spiritusque bestiarum palustrium venenatos cum nebula mixtos in habitatorum corpora flatu spargent, efficient locum pestilentem. Item si secundum mare

[1] uti *H* : ut *G*. [2] balinea *H* : balnea *H*ᶜ*G*.
[3] locis *om. H.* [4] *add. Mar.*
[5] usus *rec* : usu *H.*

[1] Books III and IV. [2] Book V.
[3] Vitruvius follows Varro, *de re rustica* (on Farming),

gods[1]; to convenience, the disposal of public sites
for the general use,[2] such as harbours, open spaces,
colonnades, baths, theatres, promenades, and other
things which are planned, with like purposes, in
public situations.

2. Now these should be so carried out that account
is taken of strength, utility, grace. Account will be
taken of *strength* when the foundations are carried
down to the solid ground, and when from each
material there is a choice of supplies without par-
simony; of *utility*, when the sites are arranged
without mistake and impediment to their use, and a
fit and convenient disposition for the aspect of each
kind; of *grace*, when the appearance of the work
shall be pleasing and elegant, and the scale of the
constituent parts is justly calculated for symmetry.

CHAPTER IV

ON THE SALUBRITY OF SITES [3]

1. In the case of the walls these will be the main
points:—First, the choice of the most healthy site.
Now this will be high and free from clouds and hoar
frost, with an aspect neither hot nor cold but tem-
perate. Besides, in this way a marshy neighbour-
hood shall be avoided. For when the morning
breezes come with the rising sun to a town, and
clouds rising from these shall be conjoined, and,
with their blast, shall sprinkle on the bodies of the
inhabitants the poisoned breaths of marsh animals,
they will make the site pestilential. Also if the

I. xii. 2, who says that in marshy places, minute and invisible
animals grow and cause diseases. The anticipation of the
true cause of malaria (mosquitoes) is noteworthy.

erunt moenia spectabuntque ad meridiem aut occidentem, non erunt salubria, quod per aestatem caelum meridianum sole exoriente calescit meridie ardet; item quod spectat ad occidentem, sole exorto
2 tepescit, meridie calet, vespere fervet. Igitur mutationibus caloris et refrigerationis corpora, quae in his locis sunt, vitiantur. Hoc autem licet animadvertere etiam ex is, quae non sunt animalia. In cellis enim vinariis tectis lumina nemo capit a meridie nec ab occidente, sed a septentrione, quod ea regio nullo tempore mutationes recipit sed est firma perpetuo et inmutabilis. Ideo etiam et granaria quae ad solis cursum spectant, bonitatem cito mutant, obsoniaque et poma, quae non in ea parte caeli ponuntur, quae est aversa a solis cursu, non diu
3 servantur. Nam semper calor cum excoquit aeribus firmitatem et vaporibus fervidis eripit exsugendo naturales virtutes, dissolvit eas et fervore mollescentes efficit inbecillas. Ut etiam in ferro animadvertimus, quod, quamvis natura sit durum, in fornacibus ab ignis vapore percalefactum ita mollescit, uti in omne [1] genus formae faciliter fabricetur; et idem, cum molle et candens refrigeretur tinctum frigida, redurescat et restituatur in antiquam pro-
4 prietatem. Licet etiam considerare haec ita esse ex eo, quod aestate non solum in pestilentibus locis sed etiam in salubribus omnia corpora calore fiant inbecilla, et per hiemem etiam quae pestilentissimae sint regiones efficiantur salubres, ideo quod a refrigerationibus solidantur. Non minus etiam quae ab frigidis regionibus corpora traducuntur in calidas,

[1] omni *H*.

walls are along the coast and shall look to the south
or west they will not be wholesome, because through
the summer the southern sky is warmed by the
rising sun and burns at midday. Also that which
looks to the western sun is warm at sunrise, hot at
noon, burns in the evening. 2. Therefore by the
changes of heat and cold, bodies which are in these
places will be infected. We may even perceive this
from those bodies which are not animal. For in
wine stores no one takes light from the south or
west but from the north, because that quarter at no
time admits changes, but is continuously fixed and
unchangeable. So also those granaries which look
towards the sun's course quickly change their good-
ness; and fish and fruit which are not placed in that
quarter which is turned away from the sun's course
do not keep long. 3. For always, when heat cooks
the strength out of the atmosphere and with warm
vapours removes by suction the natural virtues, it
dissolves and renders them weak, as they become
softened by warmth. Moreover, we see the same
thing in iron, which is hard by nature, and yet when
it is heated through in furnaces, by the vapour of
fire becomes so soft that it is easily fashioned into
every kind of shape; and when, being soft and red-
hot, it is chilled and steeped in cold water, it hardens
again and is restored to its previous character.
4. We may also consider that this is so from the
fact that in summer, not only in pestilential, but in
salubrious districts, all bodies become weak by the
heat; and also, through the winter, even the regions
which are most pestilential, are rendered salubrious
because they are rendered solid by freezing. Not
less also the bodies which are transferred from cold

non possunt durare sed dissolvuntur; quae autem
ex calidis locis sub septentrionum regiones frigidas,
non modo non laborant inmutatione loci valitu-
5 dinibus sed etiam confirmantur. Quare cavendum
esse videtur in moenibus conlocandis ab his regioni-
bus quae caloribus flatus ad corpora hominum
possunt spargere. Namque e [1] principiis quae
Graeci *stoicheia* [2] appellant, ut omnia corpora sunt
conposita, id est e calore et umore, terreno et aere,
et ita mixtionibus naturali temperatura figurantur
omnium animalium in mundo generatim qualitates.
6 Ergo in quibus corporibus cum exsuperat e principiis
calor, tunc interficit dissolvitque cetera fervore.
Haec autem vitia efficit fervidum ab certis [3] partibus
caelum, cum insidit in apertas venas plus quam
patitur e mixtionibus naturali temperatura corpus.
Item si umor occupavit corporum venas inparesque
eas fecit, cetera principia ut a liquido [4] corrupta
diluuntur, et dissolvuntur conpositionibus virtutes.
Item haec e refrigerationibus umoris ventorum et
aurarum infunduntur vitia corporibus. Non minus
aeris etiamque terreni in corpore naturalis conpositio
augendo aut minuendo infirmat cetera principia
terrena cibi plenitate, aer gravitate caeli.
7 Sed si qui voluerit diligentius haec sensu percipere,
animadvertat attendatque [5] naturas avium et piscium

[1] e *add. rec* : *om. H.*
[2] stoechia *H.*
[3] certis *ed* : caeteris *H.*
[4] liquido *Kr* : ut aliquida *H,* ut liquida *G.*
[5] attendat *Joc* : tendat *H,* intendat *G.*

[1] flatus = πνεύματα.
[2] Lit. " things in a series or row "; hence *elements* or parts

to warm regions cannot endure but are dissolved; while those which are transferred from warm places under the northern regions not only do not suffer in health by the change of place but even are strengthened. 5. Wherefore in laying out walls we must beware of those regions which by their heat can diffuse vapours [1] over human bodies. For according as from the elements (which the Greeks call stoecheia) [2] all bodies are composed, that is from heat and moisture and earth and air, just so by these mixtures, owing to natural temperament, the qualities of all animals are figured in the world according to their kind. 6. Therefore in whatsoever bodies, one of their principles, heat, is predominant, it then kills them and by its fervency dissolves the rest. Now a hot sky from certain quarters produces these defects; since it settles into the open veins more than the body permits by its natural temperament or admixture. Again, if moisture had filled the veins of bodies and altered their dimensions, the other elements, as though decomposed by liquid, are diluted and the virtues dependent on their proportion are dissolved. So also from the chilling of moisture of winds and breezes, vices are infused into bodies. Not less the natural proportion of air and also of the earthy element by increase or diminution weakens the other elements; the earthy by repletion of food, the aerial, by the heavy climate.

7. But if anyone wishes carefully to apprehend these things by perception, let him regard and attend to the natures [3] of birds and fishes and land

of things. Plato first applied the term to the physical constituents of nature.

[3] St. Paul I. *Cor.* xv. 39 uses an Ionic word *choinos* for earthy, but he is obviously deriving from the same source.

et terrestrium animalium, et ita considerabit [1] dis-
crimina temperaturae. Aliam enim mixtionem habet
genus avium, aliam piscium, longe aliter terrestrium
natura. Volucres minus habent terreni, minus
umoris, caloris temperate,[2] aeris multum: igitur
levioribus principiis conpositae facilius in aeris im-
petum nituntur. Aquatiles autem piscium naturae,
quod temperatae sunt a calido plurimumque et aeris
et terreni sunt conpositae, sed umoris habent oppido
quam paulum, quo minus habent e principiis umoris
in corpore, facilius in umore perdurant; itaque cum
ad terram perducuntur, animam cum aqua relinquunt.
Item terrestria, quod e principiis ab aere caloreque
sunt temperata minusque habent terreni pluri-
mumque umoris, quod abundant umidae partes, non
8 diu possunt in aqua vitam tueri. Ergo si haec ita
videntur, quemadmodum proposuimus, et e principiis
animalium corpora composita sensu percipimus et
exsuperationibus aut defectionibus ea laborare dis-
solvique iudicamus, non dubitamus, quin diligentius
quaeri oporteat, uti temperatissimas caeli regiones
eligamus, cum quaerenda fuerit in moenium conlo-
9 cationibus salubritas. Itaque etiam atque etiam ve-
terem revocandam censeo [3] rationem. Maiores enim
pecoribus immolatis, quae pascebantur in is locis,
quibus aut oppida aut castra stativa constituebantur,

[1] consideravit *H*. [2] temperate *G*: -tae *H*.
 [3] cens & *H*.

[1] Vitruvius' scientific method is both deductive and experi-
mental. The neo-Attic revival in sculpture has a parallel in
the revival of Greek science at Rome.
[2] The fixed camps were to become towns like Chester and
Lincoln.

animals, and he will so consider differences of temperament or admixture. For the race of birds has one temperament, fishes another, far otherwise the nature of land animals. Birds have less of the earthy, less of moisture, moderate heat, much air. Therefore being compounded of the lighter principles, they rise more easily against the onrush of the air. But fishes with their watery nature (because they are tempered by heat and are compounded of much air and earth, but have remarkably little moisture), the less they have of the principles of moisture in their frame, the more easily they persist in moisture; and so when they are brought to land they lose their life along with the water. Terrestrial animals, also, because they have a moderate degree of the elements of air and heat, and have less of the earthy and more moisture, inasmuch as they abound in moisture, cannot keep alive long in water. 8. Therefore if these matters are accepted as we have set forth, and if we apprehend by perception that the bodies of animals are compounded of elements, and if we judge that they suffer and are dissolved by excess or defect of them, we do not doubt that we must diligently seek to choose the most temperate regions of climate, since we have to seek healthiness in laying out the walls of cities.

ON INSPECTING THE LIVERS OF ANIMALS FOR TESTING THE QUALITY OF THE AIR

9. Therefore emphatically I vote for the revival of the old method.[1] For the ancients sacrificed the beasts which were feeding in those places where towns or fixed camps [2] were being placed, and they used to inspect the livers, which if at the first trial

inspiciebant iocinera, et si erant livida et vitiosa primo alia immolabant dubitantes utrum morbo an pabuli vitio laesa essent. Cum pluribus experti erant et probaverant integram et solidam naturam iocinerum ex aqua et pabulo, ibi constituebant munitiones; si autem vitiosa inveniebant, iudicio transferebant idem in humanis corporibus pestilentem futuram nascentem in his locis aquae cibique copiam, et ita transmigrabant et mutabant regiones quae-
10 rentes omnibus rebus salubritatem. Hoc autem fieri, uti pabulo ciboque salubres proprietates terrae videantur, licet animadvertere et cognoscere agris Cretensium, qui sunt circa Pothereum flumen, quod est Cretae inter duas civitates Gnoson et Gortynam.[1] Dextra enim et sinistra eius fluminis pascuntur pecora; sed ex his quae pascuntur proxime Gnoson, si quae autem ex altera parte proxime [2] Gortynam non, habent apparentem splenem. Unde etiam medici quaerentes de ea re invenerunt in his locis herbam, quam pecora rudendo inminuerunt lienes. Ita eam herbam colligendo curant lienosos hoc medicamento, quod etiam Cretenses *asplenon* vocitant. Ex eo licet scire cibo atque aqua proprietates locorum naturaliter pestilentes aut salubres esse.
11 Item si in paludibus moenia constituta erunt, quae paludes secundum mare fuerint, spectabunturque ad septentrionem aut inter septentrionem et orientem, eaeque paludes excelsiores fuerint quam litus mari-

[1] cortynam *H*, cortinam *G*.
[2] proxime *G*[2] : -ma *H*.

[1] This argument from analogy requires the retention of *idem* in the text.
[2] Cnossus, the capital of a pre-Homeric civilisation, which

they were livid and faulty, they went on to sacrifice others, doubting whether they were injured by disease or faulty diet. When they had made trial of many, and had tested the entire and solid nature of the livers in accordance with the water and pasture they established there the fortifications; if, however, they found them faulty, by analogy [1] they judged: that the supply of food and water which was to be found in these places would be pestilential in the case of human bodies. And so they removed elsewhere and changed their quarters, seeking salubrity in every respect. 10. But that it comes about that the salubrious properties of the soil are indicated by fodder and diet, we may take note and learn from the districts of Crete which are about the river Pothereus, which flows between the two towns Cnossus [2] and Gortyna. [3] For cattle feed on the right and left bank of that river. But of these, the cattle which feed next Cnossus have, and those on the other side have not, an enlarged spleen. Whence also physicians inquiring about this matter have found in these places a plant which the cattle bellow for and, by it, lessen their spleens. So they gather this plant and use this medicine to cure the splenetic, which also the Cretans call *asplenon*. Hence we may know by food and water whether the properties of places are pestilential or salubrious.

11. So also if in marshes walls are laid out, and these marshes are along the sea, and they look towards the north or between the north and east, and these marshes are higher than the sea-coast,

covered the islands of the Levant and anticipated the architecture and other arts of later Greece.

[3] Succeeded Cnossus as capital of Crete.

num, ratione videbuntur esse constituta. Fossis enim
ductis aquae exitus ad litus, et mare [1] tempestatibus
aucto in paludis redundantia motionibus concitata
marisque [2] mixtionibus non patitur bestiarum palus-
trium genera ibi nasci, quaeque de superioribus locis
natando proxime litus perveniunt, inconsueta salsi-
tudine necantur. Exemplar autem huius rei Gallicae
paludes possunt esse, quae circum Altinum, Raven-
nam, Aquileiam, aliaque quae in eiusmodi locis muni-
cipia sunt proxima paludibus, quod his rationibus
12 habent incredibilem salubritatem. Quibus autem
insidentes sunt paludes et non habent exitus pro-
fluentes neque [3] flumina neque per fossas, uti Pomp-
tinae, stando putescunt et umores graves et pesti-
lentes in is locis emittunt.

Item in Apulia oppidum Salpia vetus, quod
Diomedes [4] ab Troia rediens constituit sive,
quemadmodum nonnulli scripserunt, Elpias Rho-
dius, in eiusmodi locis fuerat conlocatum, ex
quo incolae quotannis [5] aegrotando laborantes ali-
quando pervenerunt ad M. Hostilium ab eoque pub-
lice petentes impetraverunt, ut his [6] idoneum locum
ad moenia transferenda conquireret elegeretque.
Tunc is moratus non est, sed statim rationibus doc-
tissime quaesitis secundum mare mercatus est pos-
sessionem loco salubri ab senatuque populoque R.[7]
petit, ut liceret transferre oppidum, constituitque

[1] mare *H* : mari *G*. [2] marique *H*.
[3] per (flum.) *om. H*. [4] diomedis *H*.
[5] quodannis *H*. [6] ut his *H*, uti his *G*.
[7] romano *G*, r̄ *H*.

[1] Between Aquileia and Padua.
[2] Ravenna protected by its marshes.
[3] Aquileia, founded 182 B.C., as bulwark on N.E.

they will seem to be reasonably laid out. For if dykes are cut, there is made an outlet of water to the beach; and when the sea is swollen by storms, there is an overflow into the marshes, which being stirred and moved about and mixed with sea salt, does not permit the various kinds of marsh creatures to be born there; moreover, those which, by swimming from higher parts, arrive near the coast, are killed by the unfamiliar saltness. An instance of this may be found in the Gallic marshes which are round Altinum,[1] Ravenna,[2] Aquileia[3] and other townships in like places which are nearest the marshes. For owing to these causes, they have an incredible salubrity. 12. Those places, however, which have stagnant marshes, and lack flowing outlets, whether rivers or by dykes, like the Pomptine marshes, by standing become foul and send forth heavy and pestilent moisture.

ON A FORTIFICATION REMOVED FROM ONE SITE TO ANOTHER

Also in Apulia, the town of Old Salpia (which Diomede returning from Troy established, or, as some have written, Elpias of Rhodes), was situated in such places. Thus the inhabitants suffered every year from various ailments. At length they came [4] to M. Hostilius, and, making a public request, obtained from him that he should seek out and choose a fit site for transferring their walls. Then he delayed not, but forthwith, after fully ascertaining all the conditions, bought a site in a healthy place, and obtained permission from the senate and Roman people to remove the town. He established the walls

[4] c. 200 B.C.

moenia et areas divisit nummoque sestertio singulis
municipibus mancipio dedit. His confectis lacum
aperuit in mare et portum e lacu municipio perfecit.
Itaque nunc Salpini quattuor milia passus progressi ab
oppido veteri[1] habitant in salubri loco.

V

1 Cum ergo his rationibus erit salubritatis moenium[2]
conlocandorum explicatio regionesque electae fuerint
fructibus ad alendam civitatem copiosae, et viarum
munitiones aut opportunitates fluminum seu per
portus marinae subvectionis habuerit ad moenia
conportationes expeditas, tunc turrium murorumque
fundamenta sic sunt facienda, uti fodiantur, si queant
inveniri, ad solidum et in solido, quantum ex ampli-
tudine operis pro ratione videantur,[3] crassitudine
ampliore quam parietum qui supra terram sunt
futuri, et ea impleantur quam solidissima structura.
2 Item turres sunt proiciendae in exteriorem partem,
uti, cum ad murum hostis impetu velit adpropinquare,
a turribus dextra ac sinistra lateribus apertis telis
vulnerentur. Curandumque maxime videtur, ut non
facilis aditus sit ad oppugnandum murum, sed ita
circumdandum ad loca praecipitia et excogitandum,
uti portarum itinera non sint directa sed scaeva.
Namque cum ita factum fuerit, tum[4] dextrum latus
accedentibus, quo[5] scuto non erit tectum proximum

[1] veteri *H* -re *G* ; in *H* : *om. G.*
[2] moenium *Phil* : inmoenium *H*.
[3] videatur *G* : -antur *HS*.
[4] tum *H* : dum *G*. [5] quo *HG*.

and divided the sites and gave formal possession to the individual townsmen for a sesterce each. When this was done he opened the lake into the sea, and made a harbour out of the lake for the municipality. And so the people of Salpia now dwell on a healthy site at a distance of four miles from the old town.

CHAPTER V

ON THE FOUNDATIONS OF WALLS AND THE ESTABLISHMENT OF TOWNS

1. WHEN, therefore, by these methods there shall be ensured healthiness in the laying out of the walls; and districts shall be chosen abounding in fruit to feed the citizens; and roads duly laid out, or convenient rivers, or supplies by sea through the harbours, shall have ready transport to the ramparts: then the foundations of the towers and walls are to be laid. If such foundations can be found, they are to be dug down to the solid and in the solid, as may seem proportionate to the amplitude of the work, of a breadth greater than that of the walls which shall be above the ground; and these foundations are to be filled with as solid structure as possible. 2. Towers, moreover, are to be projected on the outer side, in order that when the enemy wishes to approach the wall in an attack, he may be wounded on his exposed flanks by weapons on the right and left from the towers. And it seems that care must especially be taken that the approach be not easy for an enemy blockading the wall. The approach must be made to wind along the steep places, and so devised that the ways to the gates are not straight, but on the left

47

erit muro. Conlocanda autem oppida sunt non qua-
drata nec procurrentibus angulis sed circuitionibus,
uti hostis ex pluribus locis conspiciatur. In quibus
enim anguli procurrunt, difficiliter defenditur, quod
3 angulus magis hostem tuetur quam civem. Crassi-
tudinem autem muri ita faciendam censeo, uti armati
homines supra obviam venientes alius alium sine inpe-
ditione praeterire possint, dum in crassitudine per-
petuae tabulae oleagineae ustilatae quam creberrime
instruantur, uti utraeque muri frontes inter se,
quemadmodum fibulis, his taleis conligatae aeternam
habeant firmitatem; namque ei materiae nec caries [1]
nec tempestates [2] nec vetustas potest nocere, sed ea
et in terra obruta et in aqua conlocata permanent [3]
sine vitiis utilis sempiterno. Itaque non solum in
muro sed etiam in substructionibus quique parietes
murali crassitudine erunt faciundi, hac ratione reli-
4 gati non cito vitiabuntur. Intervalla autem turrium
ita sunt facienda, ut ne longius sit alia ab alia sagittae
missionis,[4] uti, si qua oppugnetur, tum a turribus,
quae erunt dextra sinistra, scorpionibus reliquisque
telorum missionibus hostes reiciantur. Etiamque
contra inferiores turrium dividendus est murus inter-
vallis tam magnis, quam erunt turres, ut itinera sint
interioribus partibus turrium contignata, neque ea
ferro fixa. Hostis enim si quam partem muri occu-
paverit, qui repugnabunt rescindent et, si celeriter
administraverint, non patientur reliquas partes tur-

[1] nec aries *a. c. G*, necessaries *a. c. H*. [2] tempestas *G*.
[3] permanet *G*: permanent *H*. [4] sagitta emissionis *H*.

[1] Vitruvius follows the general traditions of Roman for-
tification. He is especially confirmed by the walls of Pompeii.

of the wall. For when it is so done, then as the troops approach, their right side will be next the wall and will not be protected by the shield. Moreover, towns are not to be planned square [1] nor with projecting angles, but on the round, so that the enemy be seen from several sides. For when angles run out, defence is difficult, because the angle defends the enemy rather than the townsmen. 3. But I think the width of the wall should be so made that armed men meeting one another above can pass without hindrance. Then, in the width, through-timbers of charred olive wood should be put very frequently, in order that both fronts of the wall, being tied together by these timbers, as though by pins, may have everlasting strength. For such timber cannot be injured by decay or weather or age; even when it is covered with soil or placed in water, it remains unimpaired and useful for ever. And so not only the city wall, but the substructures, and those dividing walls which are made to be of the thickness of fortifications, when united in this manner, will not quickly be decayed. 4. The distances between the towers are so to be made that one is not further from another than a bowshot; so that if a tower is besieged anywhere, then, by "scorpions" and other missile engines from the towers right and left, the enemy may be thrown back. And also opposite the lower part of the towers, the wall is to be divided by intervals as wide as a tower; and these intervals opposite the interior parts of the towers shall be joined with planks. These, however, are not to be fixed with iron nails. For if the enemy occupies any part of the wall, the defenders shall cut them down, and if they manage it quickly, they will

rium murique hostem penetrare, nisi se voluerit
5 praecipitare. Turres itaque rutundae [1] aut poly-
goneae [2] sunt faciendae; quadratas enim machinae
celerius dissipant, quod angulos arietes tundendo
frangunt, in rotundationibus autem, uti cuneus, [3] ad
centrum adigendo laedere non possunt. Item muni-
tiones muri turriumque aggeribus coniunctae maxime
sunt tutiores, quod neque arietes neque suffossiones
6 neque machinae ceterae eis valent nocere. Sed non
in omnibus locis est aggeris ratio facienda, nisi quibus
extra murum ex alto loco plano pede accessus fuerit
ad moenia [4] oppugnanda. Itaque in eiusmodi locis
primum fossae sunt faciendae latitudinibus et alti-
tudinibus quam amplissimis, deinde fundamentum
muri deprimendum est intra alveum fossae et id ex-
truendum est ea crassitudine, ut opus terrenum facile
7 sustineatur. Item interiore parte substructionis
fundamentum distans ab exteriore introrsus amplo
spatio, ita uti cohortes possint quemadmodum in acie
instructae ad defendendum supra latitudinem aggeris
consistere. Cum autem fundamenta ita distantia
inter se fuerint constituta, tunc inter ea alia trans-
versa, coniuncta exteriori et interiori fundamento,
pectinatim disposita quemadmodum serrae dentes
solent [5] esse conlocentur; cum enim sic erit factum,
tunc ita oneris terreni magnitudo distributa in parvas
partes; neque universa pondere [6] premens poterit
8 ulla ratione extrudere muri substructiones. De ipso

[1] rutundae *a. c. H.* [2] polygonea *HG.*
[2] cuneus *H.* [4] munia *H.*
[5] solentes se *G*, solventes se *H.* [6] pondera *G.*

not suffer the enemy to penetrate the rest of the
towers and wall, unless he is willing to throw himself
headlong. 5. The towers therefore are to be made
round or polygonal. For engines more quickly
demolish square towers, because the battering-rams
beat and break the angles; whereas in the case of
rounded surfaces, even when they drive the batter-
ing-rams wedge-fashion towards the centre, they can-
not hurt them. Further, the fortifications of the wall
and towers especially when joined by embankments
are safer, because neither battering-rams nor under-
mining nor other contrivances avail to injure them.
6. But not in all places is the method of embank-
ment to be employed; only where there is an
approach outside the wall from high ground by a
level footway for troops besieging the ramparts.
Therefore in places of this kind, ditches are to be
made of the amplest possible breadth and depth;
then the foundation of the wall is to be carried down
within the hollow of the ditch, and is to be con-
structed of such a thickness that the weight of earth
is easily held up. 7. Also on the inner side of the
substructure another foundation is to be laid, so far
distant from the outer foundation that cohorts can
stand upon the broad rampart for its defence, as when
drawn up in line of battle. Now when the founda-
tions are fixed at such a distance from each other,
then between these let there be placed other trans-
verse walls joined to the outer and inner foundation,
arranged comb-fashion, as the teeth of a saw are
wont to be. For when it shall so be done, then the
greatness of the load of earth being thus distributed
into small parts, will not press with the whole weight,
so as to thrust out the substructures of the wall.

autem muro, e qua materia struatur aut perficiatur,
ideo non est praefiniendum, quod in omnibus locis,
quas optamus copias, eas non possumus habere. Sed
ubi sunt saxa quadrata sive silex seu caementum aut
coctus later sive crudus, his erit utendum. Non
enim, uti Babylone abundantes liquido bitumine pro
calce et harena ex[1] cocto latere factum habent
murum, sic item possunt omnes regiones seu locorum
proprietates habere tantas eiusdem generis utili-
tatis,[2] uti ex his comparationibus ad aeternitatem
perfectus habeatur sine vitio murus.

VI

1 MOENIBUS circumdatis secuntur[3] intra murum area-
rum divisiones platearumque et angiportuum ad
caeli regionem directiones. Dirigentur haec autem
recte, si exclusi erunt ex angiportis venti prudenter.
Qui si frigidi sunt, laedunt; si calidi, vitiant; si
umidi, nocent. Quare vitandum videtur hoc vitium
et avertendum, ne fiat quod in multis civitatibus usu
solet venire. Quemadmodum in insula Lesbo oppi-
dum Mytilenae magnificenter est aedificatum et
eleganter, sed positum non prudenter. In qua civi-

[1] ex *Ro*: et(&) *H*. [2] utilitatis *H*. [3] secuntur *H*.

[1] Vitruvius probably draws upon Herodotus, Book I.
[2] Town-planning was especially studied by the Greek
architects. Hippodamus of Miletus laid out the Piraeus, the
port of Athens, and in 443 B.C. Thurii. Dinocrates laid out
Alexandria. These cities had square blocks with wide streets.

8. Respecting the wall itself and the material of which it is built or finished, there must be laid down no rule beforehand; because we cannot have in all places the supplies which we desire. But where there are squared stones, or concrete or lava or baked brick or unburnt, we must use them. For whereas at Babylon,[1] where they have plenty of liquid pitch instead of lime and sand, they can have their walls built of burnt brick; other regions or useful sites have their special advantages, so that with due preparation a wall can be built perfect for ever and unblemished.

CHAPTER VI

RESPECTING THE DIVISION OF THE WORKS WHICH ARE INSIDE THE WALLS AND THEIR ARRANGEMENT SO THAT THE NOXIOUS BREATH OF THE WINDS MAY BE AVOIDED

1. WHEN the walls are set round the city, there follow the divisions of the sites [2] within the walls, and the layings out of the broad streets and the alleys with a view to aspect. These will be rightly laid out if the winds are carefully shut out from the alleys. For if the winds are cold they are unpleasant; if hot, they infect; if moist, they are injurious. Wherefore this fault must be avoided and guarded against, lest there happen what in many cities is not infrequent. For example in the island of Lesbos, the town of Mytilene is magnificently and elegantly built, but not situated with prudence. For in this city when the South wind

53

tate auster cum flat, homines aegrotant; cum corus,
tussiunt; cum septentrio, restituuntur in salubri-
tatem, sed in angiportis et plateis non possunt con-
2 sistere propter vehementiam frigoris. Ventus autem
est aeris fluens unda cum incerta motus redundantia.
Nascitur cum fervor offendit umorem et impetus
factionis exprimit vim spiritus flatus. Id autem
verum esse ex aeolis [1] aereis [2] licet aspicere et de
latentibus caeli rationibus artificiosis rerum inven-
tionibus divinitatis exprimere veritatem. Fiunt
enim aeoli pilae [3] aereae cavae,—hae habent punctum
angustissimum—quae aqua [4] infunduntur conlocan-
turque ad ignem; et antequam calescant, non habent
ullum spiritum, simul autem ut fervere coeperint,
efficiunt ad ignem vehementem [5] flatum. Ita scire
et iudicare licet e parvo brevissimoque spectaculo de
magnis et inmanibus caeli ventorumque naturae ra-
3 tionibus. Exclusi fuerint; non solum efficient corpori-
bus valentibus locum salubrem, sed etiam si qui morbi
ex aliis vitiis forte nascentur, qui in ceteris salubribus
locis habent curationes medicinae contrariae, in his
propter exclusiones ventorum temperatura [6] expe-
ditius curabuntur. Vitia autem sunt, quae diffi-
culter curantur in regionibus, quae sunt supra scriptae,
haec: gravitudo arteriace, tussis, pleuritis, pthisis,
sanguinis eiectio et cetera, quae non detractionibus
sed adiectionibus curantur. Haec ideo difficulter
medicantur, primum quod ex frigoribus concipiuntur,

[1] acolis *H*. [2] aeris *H*. [3] aeolipilae *H*.
[4] quae aqua *GS*: quae qua *H*. [5] vehementum *H*.
[6] exclusiones v. temperatura *Kr*: temperatura (-am) ex-
clusiones v. *H*.

[1] This experiment anticipated Watt and the kettle, but
led to no practical consequences. The figure must have had
a small opening at the top only.

blows men fall ill; when the North-west, they cough; when the North, they are restored to health; but they cannot stand in the alleys and streets because of the vehemence of the cold. 2. Now the wind is a wave of air flowing with uncertain currents of motion. It rises when heat strikes moisture and the onrush of the force presses out the power of the breath of the blast. That this is true we may see from Aeoluses of bronze,[1] and by the craftsman's inventions of things which express the truth of the divinity, about the causes which lurk in the heavens. Now figures of Aeolus are made of hollow bronze, and they have a very narrow point. These are filled with water and placed on the fire; before they begin to warm, they have no rush of air, but as soon as they begin to boil, they produce on the fire a vehement blast. Thus we may know and judge, from this small and very brief spectacle, about the great and immense causes of the nature of the sky and of the winds. 3. Suppose they are excluded. Not only will this render a place healthy for sound persons; but also if any diseases shall happen to arise from other infections, those who in other healthy places find cure from counteracting medicine, in these, on account of the moderate climate and by the exclusion of the winds, will be still more quickly cured. For the diseases which are cured with difficulty in the regions which are described above are these: cold in the windpipe, cough, pleurisy, phthisis, spitting of blood, and others which are cured by strengthening remedies rather than by purgings. These ailments are treated with difficulty, first because they are caught from chills, secondly because

deinde quod defatigatis morbo viribus eorum aer
agitatus est, ventorum agitationibus extenuatur,[1]
unaque a vitiosis corporibus detrahit sucum et efficit
ea exiliora. Contra vero lenis et crassus aer qui
perflatus non habet neque crebras redundantias,
propter inmotam stabilitatem adiciendo ad membra
eorum alit eos et reficit, qui in his sunt inpliciti
morbis.

4 Nonnullis placuit esse ventos [2] quattuor : ab
oriente aequinoctiali solanum, a meridie austrum, ab
occidente aequinoctiali favonium, ab septentrionali
septentrionem. Sed qui diligentius perquisierunt,
tradiderunt eos esse octo, maxime quidem Andronicus
Cyrrestes, qui etiam exemplum conlocavit Athenis
turrem marmoream octagonon et in singulis lateribus
octagoni singulorum ventorum imagines excalptas [3]
contra suos cuiusque flatus designavit, supraque eam
turrim metam marmoream perfecit et insuper Tri-
tonem aereum conlocavit dextra manu virgam porri-
gentem, et ita est machinatus, uti vento circuma-
geretur et semper contra flatum consisteret supraque
imaginem flantis venti indicem virgam teneret.

5 Itaque sunt conlocati inter solanum et austrum ab
oriente hiberno eurus, inter austrum et favonium ab
occidente hiberno africus, inter favonium et septen-
trionem caurus, quem plures vocant corum, inter
septentrionem et solanum aquilo. Hoc modo videtur
esse expressum, uti capiat numerus et nomina et

[1] extenuatur *Joc* : extenuabitur unaque *H*.
[2] ventus *H*. [3] exscaptas *G*, excalpas *H*.

[1] Usually called *subsolanus* : *salubriores septentrionales
quam subsolani vel austri sunt.* Cels. ii. 1.
[2] Caused storms in the Adriatic. Horace, *Odes*, III. iii. 4–5.
[3] Brought the spring. Horace, *Odes*, I. iv. 1.

when the strength is worn out by disease the air is agitated; it is thinned by the agitation of the winds; at the same time it draws the sap from diseased persons and renders them thinner. On the other hand, a smooth and thick air which is free from the passage of draughts and does not move backwards and forwards, builds up their limbs by its steadiness, and so nourishes and refreshes those who are caught by these diseases.

4. Some have held that there are four winds: the Solanus [1] from the equinoctial east, the Auster [2] from the south, Favonius [3] from the equinoctial west, and Septentrio from the north. But those who have inquired more diligently lay down that there are eight: especially indeed Andronicus of Cyrrha,[4] who also, for an example, built at Athens [5] an octagonal marble tower, and, on the several sides of the octagon, had representations of the winds carved opposite their several currents. And above that tower he caused to be made a marble upright, and above it he placed a bronze Triton holding a rod in his right hand. He so contrived that it was driven round by the wind, and always faced the current of air, and held the rod as indicator above the representation of the wind blowing. 5. Therefore there are placed between the Solanus and the Auster, the Eurus from the winter sunrising; between the Auster and the Favonius, the Africus from the winter sunset; between the Favonius and the Septentrio, the Caurus (which most people call Corus); between the Septentrio and the Solanus, the Aquilo. The diagram [6] seems to be so arranged as to receive the

[4] A town in Syria.
[5] The Tower of the Winds: first century B.C.
[6] See figure.

partes, unde flatus certi ventorum spirent. Quod
cum ita exploratum habeatur, ut inveniantur regiones
6 et ortus eorum, sic erit ratiocinandum. Conlocetur
ad libellam [1] marmoreum amusium [2] mediis moenibus,
aut locus ita expoliatur ad regulam et libellam, ut
amusium non desideretur, supraque eius loci centrum
medium conlocetur aeneus [3] gnomon, indagator
umbrae qui graece *sciotheres* dicitur. Huius ante-
meridiana hora circiter hora quinta sumenda est
extrema gnomonis [4] umbra et puncto signanda,
deinde circino diducto ad punctum, quod est gnomonis
umbrae longitudinis signum, ex eoque a centro cir-
cumagenda linea rotundationis. Itemque observanda
postmeridiana istius gnomonis crescens umbra, et
cum tetigerit circinationis lineam et fecerit parem
antemeridianae umbrae postmeridianam, signanda
7 puncto. Ex his duobus signis circino decusatim
describendum, et per decusationem et medium cen-
trum linea perducenda ad extremum, ut habeatur
meridiana et septentrionalis [5] regio. Tum postea
sumenda est sexta decima pars circinationis lineae
totius rotundationis, centrumque conlocandum in
meridiana linea, qua [6] tangit circinationem, et sig-
nandum dextra ac sinistra in circinatione et meridiana
et septentrionali parte. Tunc ex signis his quattuor
per centrum medium decusatim lineae ab extremis ad
extremas circinationes perducendae. Ita austri et
septentrionis habebitur octavae partis designatio.

[1] libellum *H*. [2] hamusium *G*.
[3] aeneos *H*. [4] gnomonis *H*.
[5] septentrionales *H*. [6] qua *Phil*: quae *H*.

[1] Invented by Anaximander. Dio, L. II. See Plate A.
[2] Carelessly expressed; Vitruvius means the chord of the
arc which is $\frac{1}{16}$ of circumference.

names and the quarters whence the fixed currents of winds blow. Since these may be regarded as ascertained, we must calculate as follows to find the quarters and risings of the winds. 6. Let there be placed to a level a marble dial, somewhere in the middle of the city; or let a space be so polished to rule and level that the marble dial is not wanted. Above the middle point of that place, let there be put a bronze indicator to track the shadow[1] (which in Greek is called *sciotheres*). Before midday, at about the fifth hour, the end of the shadow of the indicator is to be taken and marked with a point. Then a radius being taken from the indicator to the point which marks the length of the shadow, with that, from the indicator as centre, a circumference is to be drawn. After midday the growing shadow of the indicator, when it touches the line of the circle and marks a post-meridian shadow equal to the antemeridian, is to be marked with a point. 7. From these two points, two intersecting circles are to be described. Through the intersection and the centre of the circle first described, a line is to be carried through to the end so that the southern and northern quarters may be indicated. Next we take as radius the sixteenth part[2] of the circumference of the circle. From centres given by the meridian line at the two points where it touches the circle, and with that radius, points are to be marked right and left in the circle, both on the southern and on the northern part. Then from these four points, intersecting lines are to be drawn through the middle centre from one side of the circumference to the other. Thus both for the south wind and for the north wind we shall have marked out the eighth part of the circumference.

Reliquae partes dextra ac sinistra tres, aequales et
tres his distribuendae sunt in tota rotundatione, ut
aequales divisiones octo ventorum designatae sint in
descriptione. Tum per angulos inter duas ventorum
regiones et platearum et angiportorum videntur de-
8 beri [1] dirigi descriptiones. His enim rationibus et
ea divisione exclusa erit [2] ex habitationibus et vicis
ventorum vis molesta.[3] Cum enim plateae contra
derectos [4] ventos [5] erunt conformatae, ex aperto caeli
spatio impetus ac flatus frequens conclusus in fauci-
bus angiportorum vehementioribus viribus pervaga-
bitur. Quas ob res convertendae sunt ab regionibus
ventorum derectiones vicorum, uti advenientes ad
angulos insularum frangantur repulsique dissipentur.
9 Fortasse mirabuntur i qui multa ventorum nomina
noverunt, quod a nobis expositi sunt tantum octo esse
ventis. Si autem animadverterint orbis terrae cir-
cuitionem per solis cursum et umbras gnomonis [6]
aequinoctialis ex [7] inclinatione caeli ab Eratosthene
Cyrenaeo rationibus mathematicis et geometricis
methodis esse inventam ducentorum quinquaginta
duum milium stadium, quae fiunt passus trecenties
et decies quinquies [8] centena milia, huius autem
octava pars quam ventus tenere videtur, est triciens
nongenta triginta septem milia et passus quingenti,
non debebunt mirari, si in tam magno spatio unus
ventus vagando inclinationibus et recessionibus varie-
10 tates mutatione flatus faciat. Itaque dextra et sinis-

[1] debere *G*. [2] excluserit *H*.
[3] molesta vis *G*.
[4] derectos *H* : *minus recte* directos *rec.*
[5] ventus *H*. [6] gnominis *H*.
[7] ex *Joc* : et(&) *H*.
[8] quinquies centena *Kr* : quinquaginta *H*.

The remaining parts in the whole round, three on the right and three on the left, are to be distributed equally, so that equal divisions of the eight winds are marked out in the figure. Then the angles between two quarters of the winds will determine the laying out both of the streets and of the alleys. 8. For by these methods and this division, troublesome winds will be excluded from the dwellings and the streets. For when the quarters of the city are planned to meet the winds full, the rush of air and the frequent breezes from the open space of the sky will move with mightier power, confined as they are in the jaws of the alleys. Wherefore the directions of the streets are to avoid the quarters of the winds, so that when the winds come up against the corners of the blocks of buildings they may be broken, driven back and dissipated.

9. Perhaps those who know many names of the winds will wonder because only eight winds have been described by us to exist. But if they perceive that the circumference of the world, ascertained by the sun's course, and the equinoctial shadows of the gnomon and the inclinations of the sky, have been found by Eratosthenes [1] of Cyrene with mathematical calculations and geometric methods to be 252,000 stades, which give 31,500,000 paces, while of this the eighth part which the wind seems to occupy is 3,937,500 paces, they ought not to wonder, if in so great a space one wind, as it moves with its inclinations and retreats, causes varieties through the change of its current. 10. Therefore on the right

[1] His calculations are remarkably correct in view of his imperfect equipment.

tra austrum leuconotus et altanus flare solet, africum
libonotus et subvesperus, circa favonium argestes et
certis temporibus etesiae, ad latera cauri circias [1] et
corus, circa septentrionem thracias et gallicus, dextra
ac sinistra aquilonem supernas et caecias, circa
solanum carbas et certo tempore ornithiae, euri vero
medias partes tenentis [2] in extremis euricircias et
volturnus.[3] Sunt autem et alia plura nomina flatus-
que ventorum e locis aut fluminibus aut montium
11 procellis tracta. Praeterea aurae matutinae, qua [4]
sol, cum emergit de subterranea parte, versando
pulsat aeris umorem et impetu scandendo prudens [5]
exprimit aurarum antelucano spiritu flatus. Qui cum
exorto sole permanserunt, euri venti tenent partes,
et ea re, quod ex auris procreatur, ab Graecis *euros*
videtur esse appellatus, crastinusque dies propter
auras matutinas *aurion* fertur esse vocitatus. Sunt
autem nonnulli qui negant Eratosthenem potuisse
veram mensuram orbis terrae colligere. Quae sive
est certa sive non vera, non potest nostra scriptura
non veras habere terminationes regionum, unde
12 spiritus ventorum oriuntur. Ergo si ita est, tantum
erit, uti non certam mensurae rationem sed aut
maiores impetus aut minores habeant singuli venti.

Quoniam haec a nobis sunt breviter exposita, ut
facilius intellegatur, visum est mihi in extremo volu-
mine formas [6] sive uti Graeci *schemata* dicunt, duo

[1] circlas *H*. [2] tenentis *Joc* : -tes *H*.
[3] vulturnus *G*. [4] qua *Ro* : quas *H*.
[5] prudens *HG*, procedens *S*.
[6] formas *Phil* : formā *H*.

[1] At Dougga in Tunis, adjoining the Capitol, is a dial of
the winds more than 8 yards in diameter. Twelve winds are
marked closely agreeing with Vitruvius. One of them is
Euroaquilo; the same as *Euracylo*, *Acts* xxvii. 14.

and left of Auster,[1] Leuconotus and Altanus are wont
to blow; of Africus, Libonotus and Subvesperus;
around Favonius, Argestes and at certain times the
Etesian winds[2]; at the sides of Caurus, Circias and
Corus; about Septentrio, Thracias and Gallicus;
right and left of Aquilo, Supernas and Caecias;
around Solanus, Carbas and at a definite time
Ornithiae; on the distant parts, when Eurus holds
the middle, Euricircias and Volturnus. There are
also many other names and breezes of winds, drawn
from places, or rivers, or from mountain storms.
11. Moreover there are morning airs, when the sun,
emerging from the subterranean part, tosses and
beats the damp in the air, and rising with a rush
looks forward and thrusts forth the breezes with the
breath that comes before the light. And when these
have remained after sunrise, they hold the region of
the east wind. Because this is generated from
aurae (breezes) it seems to be called *euros* by the
Greeks, and because of morning breezes the morrow
is said to have been called *aurion*. But there are
some who deny that Eratosthenes could infer the
true measure of the earth. Whether this is certain
or not, our writing cannot fail to furnish true outlines
of the regions whence arise the breezes of the winds.
12. Therefore if it is so, it will have this consequence,
that the several winds will have, not a fixed and
measured amount, but either greater or less impetus.

Since these matters have been briefly set forth
by us, in order that it may be more easily under-
stood I have decided at the end of the book to furnish
two plans, or as the Greeks say *schemata*: one[3] so

[2] Lucr. V. 742: *etesia flabra aquilonum.*
[3] Plate A, fig. 1.

VITRUVIUS

explicare, unum ita deformatum, ut appareat, unde
certi ventorum spiritus oriantur, alterum, quem-
admodum ab impetu eorum aversis derectionibus
vicorum et platearum eviteutur nocentes flatus. Erit
autem in exaequata planitie centrum, ubi est littera
A, gnomonis autem antemeridiana umbra, ubi est B,
et a centro, ubi est A, diducto circino ad id signum
umbrae, ubi est B, circumagatur linea rotundationis.
Reposito autem gnomone ubi antea fuerat, expec-
tanda est, dum decrescat faciatque iterum crescendo
parem [1] antemeridianae umbrae postmeridianam
tangatque lineam rotundationis, ubi erit littera C.
Tunc a signo, ubi est B, et a signo, ubi est C, circino
decusatim describatur, ubi erit D; deinde per decu-
sationem et centrum, ubi est D, perducatur linea ad [2]
extremum, in qua linea erit [3] littera E et F. Haec linea
erit index meridianae et septentrionalis [4] regionis.
13 Tunc circino totius rotundationis sumenda est pars XVI,
circinique centrum ponendum est in meridiana linea,
qua [5] tangit rotundationem, ubi est littera E, et sig-
nandum dextra sinistra, ubi erunt litterae G H. Item
in septentrionali parte centrum circini ponendum in
rotundationis et septentrionali linea, ubi est littera F,
et signandum dextra ac sinistra, ubi sunt litterae I
et K, et ab G ad K et ab H ad I per centrum lineae
perducendae. Ita quod erit spatium ab G ad H, erit
spatium venti austri et partis meridianae: item quod
erit spatium ab I ad K, erit septentrionis. Reliquae
partes dextra tres [6] ac sinistra tres dividendae sunt
aequaliter, quae sunt ad orientem, in quibus litterae

[1] parem *G* : partem *H*. [2] ad *S* : ab *HG*.
[3] erunt litterae *S* : erit littera *HG*.
[4] septentrionales *H*. [5] qua *Gal* : quae *H*.
[6] dextra tres ac sinistra tres *H*.

mapped out that it may appear whence the certain
breezes of the winds arise; the second,[1] how by
layings out of quarters and streets turned away
from their violence, dangerous currents may be
avoided. Now there shall be on a levelled surface
a centre with the letter A; the shadow before midday
of the indicator, with B; and from the centre marked
A the compass is opened to the point of shadow
marked B, and a circle is to be drawn. The indicator
being replaced where it was before, we must wait
until the shadow diminishes, and again by increasing
makes the shadow after midday equal to that before
midday and touches the circle at the letter c. Then
from B and from c let the intersection D be described
with the compasses; then through the intersection
D and the centre, let a line be carried through to the
furthest limit, where will be the letter E and also F,
and on this line will be the index of the southern
and northern regions. 13. Then the sixteenth part
of the whole circle is to be taken with the
compass, and the point of the compass is to be put
on the meridian line where it touches the circum-
ference at E, and a mark is to be made right and left
at GH. Also in the northern part, the point of the
compass is to be placed on the circumference and the
northern line where is the letter F, and a mark is to
be made right and left at I and K. And from G and
K and from H to I, lines are to be drawn through the
centre. So the space from G to H will be the space
of the Auster and of the southern region; likewise
the space from I to K will be of the Septentrio. The
remaining parts, on the right three, and the left
three, are to be divided equally; those which are to

[1] Plate A, fig. 2. Vitruvius had probably experienced the
Mistral at Marseilles.

L M, et ab occidente, in quibus sunt litterae N et O.
Ab M ad O et ab L ad N perducendae sunt lineae decu-
satim. Et ita erunt aequaliter ventorum octo spatia
in circumitionem.[1] Quae cum ita descripta erunt, in
singulis angulis octagoni, cum a meridie incipiemus,
inter eurum et austrum in angulo erit littera G, inter
austrum et africum H, inter africum et favonium N,
inter favonium et caurum O, inter caurum et septen-
trionem K, inter septentrionem et aquilonem I, inter
aquilonem et solanum L, inter solanum et eurum M.
Ita his confectis inter angulos octagoni gnomon
ponatur, et ita dirigantur angiportorum divisiones.

VII

1 Divisis angiportis et plateis constitutis arearum
electio ad opportunitatem et usum communem civi-
tatis est explicanda aedibus sacris, foro reliquisque
locis communibus. Et si erunt moenia secundum
mare, area ubi forum constituatur, eligenda proxime
portum, sin autem mediterraneo, in oppido medio.
Aedibus vero sacris, quorum deorum maxime in
tutela civitas videtur esse, et Iovi et Iunoni et
Minervae, in excelsissimo loco unde moenium maxi-
ma pars conspiciatur, areae distribuantur. Mercurio

[1] circumitione *G*, -nem *H*.

[1] As at Halicarnassus. Book II. viii. 11.
[2] As at Athens, Pompeii, Timgad and other Roman towns
in North Africa.
[3] There were three shrines side by side; Jupiter in the
middle, Juno on his right, Minerva on his left. The Capitol

the east at L and M, and at the west at N and o.
From M to o and from L to N intersecting lines are to
be drawn. And so there will be eight equal spaces
of winds in the circumference. When these are so
marked out, at the single angles of the octagon
when we begin from the south, in the angle between
Eurus and Auster there will be G, between Auster
and Africus there will be H, between Africus and
Favonius N, between Favonius and Caurus o, between
Caurus and Septentrio K, between Septentrio and
Aquilo I, between Aquilo and Solanus L, between
Solanus and Eurus M. When these things are done,
let the gnomon be set upon the angles of the octagon
and let the division of the alleys be directed
accordingly.

CHAPTER VII

ON THE SITES OF PUBLIC BUILDINGS

1. AFTER apportioning the alleys and settling the
main streets, the choice of sites for the convenience
and common use of citizens has to be explained;
for sacred buildings, the forum, and the other public
places. And if the ramparts are by *the sea*,[1] a site
where the forum is to be put is to be chosen next the
harbour; but if *inland*,[2] in the middle of the town.
But for sacred buildings of the gods under whose
protection the city most seems to be, both for
Jupiter and Juno and Minerva,[3] the sites are to be
distributed on the highest ground from which the
most of the ramparts is to be seen. To Mercury,

at Dougga in Tunis is said to follow the rules of Vitruvius,
except that the order is Corinthian.

autem in foro, aut etiam ut Isidi et Serapi in empo-
rio; Apollini Patrique Libero secundum theatrum;
Herculi, in quibus civitatibus non sunt gymnasia
neque amphitheatra, ad circum: Marti extra urbem
sed ad campum; itemque Veneri ad portum.

Id autem etiam Etruscis haruspicibus disciplinarum
scripturis ita est dedicatum, extra murum Veneris,
Volcani, Martis fana ideo conlocari, uti non insu-
escat[1] in urbe adulescentibus, seu matribus famili-
arum veneria libido, Volcanique vi[2] e moenibus re-
ligionibus et sacrificiis evocata ab[3] timore incendiorum
aedificia videantur liberari. Martis vero divinitas
cum sit extra moenia dedicata, non erit inter cives
armigera dissensio, sed ab hostibus ea defensa[4] a
2 belli periculo conservabit. Item Cereri[5] extra
urbem loco, quo nomine semper homines, nisi per
sacrificium, necesse habeant adire; cum religione,
caste sanctisque moribus is locus debet tueri. Ceter-
isque diis ad sacrificiorum rationes aptae templis
areae sunt distribuendae.

De ipsis autem aedibus sacris faciundis et de
arearum symmetriis in tertio et quarto volumine
reddam rationes, quia in secundo visum est mihi
primum de materiae copiis quae in aedificiis sunt
parandae, quibus sint virtutibus et quem habeant
usum, exponere, commensus aedificiorum et ordines
et genera singula symmetriarum peragere et in
singulis voluminibus explicare.

[1] insuescat S^2: -cant H. [2] vi Joc: vis H.
[3] a timore G. [4] defensa G^2: -si H. [5] cerei H.

[1] At Pompeii adjoins the theatre.
[2] Outside Porta Capena at Rome, Platner, 327.
[3] The scribe of H adds: The first book ends, Thank the
Lord: Amen.

however, in the forum, or also, as to Isis and Serapis,[1] in the business quarter; to Apollo and Father Bacchus against the theatre; to Hercules, in cities which have no gymnasia nor amphitheatres, at the circus; to Mars outside the walls but in the parade ground; and also to Venus near the harbour.

Now with Etruscan haruspices in the writings of their disciplines, the dedication is as follows: that the shrines of Venus, Volcanus, Mars are therefore to be situated outside the wall, so that venereal pleasure may not be customary to young men and matrons in the city, and, by summoning the power of Volcanus outside the ramparts with ritual and sacrifices, the buildings may seem to be freed from fear of fires. But since the divinity of Mars[2] is dedicated outside the ramparts, there will not be armed quarrels among citizens, yet he will keep the ramparts defended from the danger of war. 2. So also to Ceres in a place outside the city, under which name (*i.e.* Ceres extra urbem) men (unless by sacrifice) must always approach her; since that place must be kept religiously, purely and with strict manners. And to the other gods sites fit for temples with a view to the methods of sacrifice are to be arranged.

Now about building temples and about symmetrical arrangement of sites I will give an account in the third and fourth books, because in the second I purpose, first, with reference to the supplies of material which are to be prepared in buildings, to set forth of what virtues they are possessed, and what uses they have; subsequently to treat of the dimensions of buildings, the orders and the several kinds of symmetry and to explain them in the several books.[3]

BOOK II

LIBER SECUNDUS

1 DINOCRATES architectus cogitationibus et sollertia
fretus, cum Alexander rerum potiretur, profectus est
e Macedonia [1] ad exercitum regiae cupidus com-
mendationis. Is e patria a propinquis et amicis tulit
ad primos ordines et purpuratos litteras, aditus
haberet faciliores, ab eisque exceptus humane petit,
uti quamprimum ad Alexandrum perduceretur. Cum
polliciti essent, tardiores fuerunt idoneum tempus
expectantes. Itaque Dinocrates ab his se existimans [2]
ludi ab se petit praesidium. Fuerat enim amplissima
statura, facie grata, forma dignitateque summa. His
igitur naturae muneribus confisus vestimenta posuit
in hospitio et oleo corpus perunxit caputque coronavit
populea fronde, laevum umerum pelle leonina texit,
dextraque clavam tenens incessit contra tribunal
2 regis ius dicentis. Novitas populum cum avertisset,
conspexit eum Alexander. Admirans ei iussit [3]
locum dari, ut accederet, interrogavitque, quis esset.
At ille : "Dinocrates," inquit, "architectus Macedo
qui ad te cogitationes et formas adfero dignas tuae
claritati. Namque Athon montem formavi in statuae
virilis figuram, cuius manu laeva designavi civitatis
amplissimae moenia, dextera [4] pateram, quae exci-
peret omnium fluminum, quae sunt in eo monte,

[1] e (macedonia) *H* : a m. *G.* [2] exestimans *H.*
[3] ei iussit *H* : iussit ei *G.* [4] dextra *G.*

[1] Dinocrates was also architect of the new temple of Diana
(Artemis) at Ephesus to replace the one burnt down.

[2] He seems, by his club and lion's skin, to have personified
Hercules (Herakles).

BOOK II

PREFACE

1. WHEN Alexander was master of the world, the architect Dinocrates,[1] confident in his ideas and his skill, set out from Macedonia to the army, being desirous of the royal commendation. He brought from home to the officers and high officials, a letter from his relatives and friends that he might have more easy access; and being courteously received by them, he asked to be introduced as soon as possible to Alexander. After promising this they were somewhat slow, waiting for a suitable occasion. Therefore Dinocrates, thinking he was mocked by them, sought a remedy from himself. Now he was of ample stature, pleasing countenance, and the highest grace and dignity. Trusting then in these gifts of nature, he left his clothes in the inn, and anointed himself with oil; he wreathed his head with poplar leaves, covered his left shoulder with a lion's skin, and holding a club in his right hand,[2] he walked opposite the tribunal where the king was giving judgment. 2. When this novel spectacle attracted the people, Alexander saw him. Wondering, he commanded room to be made for him to approach, and asked who he was. And he replied: "Dinocrates, a Macedonian architect, who brings you ideas and plans worthy of you, illustrious prince. For I have shaped Mount Athos into the figure of the statue of a man, in whose left hand I have shown the ramparts of a very extensive city; in his right a bowl to receive the water of all

73

3 aquam, ut inde in mare profunderetur." Delectatus
Alexander natione [1] formae statim quaesiit, si essent
agri circa, qui possint [2] frumentaria ratione eam
civitatem tueri. Cum invenisset non posse nisi
transmarinis subvectionibus: "Dinocrates," inquit,
"adtendo egregiam formae compositionem et ea
delector. Sed animadverto, si qui deduxerit [3] eo
loco coloniam, forte [4] ut iudicium eius vituperetur. Ut
enim natus infans sine nutricis lacte non potest ali
neque ad vitae crescentis gradus perduci, sic civitas
sine agris et eorum fructibus in moenibus affluentibus
non potest crescere nec sine abundantia cibi fre-
quentiam habere populumque sine copia tueri.
Itaque quemadmodum formationem puto proban-
dam, sic iudicio locum inprobandum; teque volo esse
4 mecum, quod tua opera sum usurus." Ex eo
Dinocrates ab rege non discessit et in Aegyptum est
eum persecutus. Ibi Alexander cum animadvertisset
portum naturaliter tutum, emporium egregium,
campos circa totam Aegyptum frumentarios, inmanis
fluminis Nili magnas utilitates, iussit eum suo nomine
civitatem Alexandriam constituere. Ita Dinocrates
a facie dignitateque [5] corporis commendatus ad eam
nobilitatem pervenit. Mihi autem, imperator,
staturam non tribuit natura, faciem deformavit aetas,
valetudo detraxit vires. Itaque quoniam ab his
praesidiis sum desertus, per auxilia [6] scientiae
scriptaque, ut spero, perveniam ad commendationem.

[1] ratione *G* : natione *H*, *sc.* genere, *cf. Plin. N.H.*
[2] possent *G* : possint *H*.
[3] siquid eduxerit *H*. loci *Phil* : loco *H*.
[4] fore *G²* : forte *H*. [5] dignitatisque *H*.
[6] auxilia *H* : auxilium *G*.

[1] Alexandria was laid out in streets at right angles to one
another. There were two main streets, one the famous

74

the rivers which are in that mountain." 3. Alexander, delighted with his kind of plan, at once inquired if there were fields about, which could furnish that city with a corn supply. When he found this could not be done, except by sea transport, he said: "I note, Dinocrates, the unusual formation of your plan, and am pleased with it, but I perceive that if anyone leads a colony to that place, his judgment will be blamed. For just as a child when born, if it lacks the nurse's milk cannot be fed, nor led up the staircase of growing life, so a city without cornfields and their produce abounding within its ramparts, cannot grow, nor become populous without abundance of food, nor maintain its people without a supply. Therefore, just as I think your *planning* worthy of approval, so, in my judgment, the *site* is worthy of disapproval; yet I want you to be with me, because I intend to make use of your services." 4. After that, Dinocrates did not leave the king, and followed him into Egypt. There when Alexander had observed a port naturally protected, an excellent market, cornfields all over Egypt, the great advantages of the huge Nile river, he ordered Dinocrates to lay out a city in his name, Alexandria.[1] Thus, Dinocrates, commended by his face and the dignity of his person, reached to this distinction. But nature has not given me stature, my countenance is uncomely with age, ill-health has taken away my strength. Therefore, although I am deserted by these defences, by the help of science and by my writings I shall, I hope, gain approval.

Canopic Street running east and west. These were 46 feet wide, bordered with columns. The others mostly 23 feet. The chief temple—the Serapeum—corresponding to the Roman Capitol, was on rising ground. The splendid banqueting hall of Ptolemy Philadelphus is described in Athenaeus, p. 196.

5 Cum autem primo volumine de officio archi-
tecturae terminationibusque artis perscripsi, item de
moenibus et intra moenia arearum divisionibus, in-
sequatur ordo de aedibus sacris et publicis aedificiis
itemque privatis, quibus proportionibus et symmetriis
debeant esse, uti explicentur, non putavi ante ponen-
dum, nisi prius de materiae copiis, e quibus conlatis
aedificia structuris et materiae rationibus perficiuntur,
quas habeant in usu virtutes, exposuissem, quibusque
rerum naturae principiis essent temperata, dixissem.
Sed antequam naturales res incipiam explicare, de
aedificiorum rationibus, unde initia ceperint [1] et uti
creverint eorum inventiones, ante ponam, et inse-
quar ingressus antiquitatis rerum naturae et eorum qui
initia humanitatis [2] et inventiones perquisitas
scriptorum praeceptis dedicaverunt. Itaque quem-
admodum ab his sum institutus, exponam.

I

1 HOMINES vetere more ut ferae in silvis et speluncis
et nemoribus nascebantur ciboque agresti vescendo
vitam exigebant. Interea quondam in loco ab [3]
tempestatibus et ventis densae crebritatibus arbores
agitatae et inter se terentes ramos ignem excita-
verunt, et eius [4] flamma vehementi perterriti, qui circa

[1] coeperint *H.* [2] humanitates *H.*
[3] a temp. *G* [4] eius *Sch* : eos *H.*

5. Now since in the first book I have written on the services of architecture, and the definitions of the craft, also about ramparts and the allotments of sites within the ramparts, there should follow the arranging of temples and public buildings and also private ones, in order to explain of what proportions and symmetries they ought to be. Yet I thought I ought to put nothing before, until I had first considered the supplies of building material, from the assemblage of which buildings are completed in their structure and the appropriate treatment of the materials. Afterwards I shall expound what virtues they have when employed, and I shall declare of what natural elements they are blended. But before I begin to explain natural objects, I will preface somewhat respecting the methods of building, whence they took their beginnings and how inventions grew; and I will follow the approaches of antiquity to Nature herself, and in particular of those writers who have committed to their manuals the beginnings of the humanities, and the record of inventions. Therefore I will set forth the matter as I have been instructed by them.

CHAPTER I

THE ORIGIN OF BUILDING

1. MEN, in the old way, were born like animals in forests and caves and woods, and passed their life feeding on the food of the fields. Meanwhile, once upon a time, in a certain place, trees, thickly crowded, tossed by storms and winds and rubbing their branches together, kindled a fire. Terrified by the raging flame, those who were about that place were put to

eum locum fuerunt, sunt fugati. Postea re quieta [1]
propius [2] accedentes cum animadvertissent com-
moditatem esse magnam corporibus ad ignis teporem,
ligna adicientes et id conservantes alios adducebant
et nutu monstrantes ostendebant, quas haberent ex
eo utilitates. In eo hominum congressu cum pro-
funderentur aliter e spiritu voces, cotidiana con-
suetudine vocabula, ut optigerant,[3] constituerunt,
deinde significando res saepius in usu ex eventu fari
fortuito coeperunt et ita sermones inter se procrea-
2 verunt. Ergo cum propter ignis inventionem conven-
tus initio apud homines et concilium et convictus esset
natus, et in unum locum plures convenirent habentes
ab natura praemium praeter reliqua animalia, ut non
proni sed erecti ambularent mundique et astrorum
magnificentiam aspicerent, item manibus et articulis
quam vellent rem faciliter tractarent, coeperunt in eo
coetu alii de fronde facere tecta, alii speluncas fodere
sub montibus, nonnulli hirundinum nidos et aedifica-
tiones earum imitantes de luto et virgulis facere loca
quae subirent. Tunc observantes aliena tecta et
adicientes suis cogitationibus res novas, efficiebant
3 in dies meliora genera casarum. Cum essent autem
homines imitabili docilique natura, cotidie inven-
tionibus gloriantes alios alii ostendebant aedificiorum
effectus, et ita exercentes ingenia certationibus in

[1] re quieta S^c: requieta H, requie data G.
[2] proprius H.
[3] obtigerant S G^c: optegerent H.

[1] The invention of language is dealt with by Lucr. V.
1028; of fire, V. 1091. Cf. Darwin, *Descent of Man*, Part I.
[2] The importance of handiwork and craftsmanship is
emphasised throughout this treatise and gives it a unique
importance.

flight. Afterwards when the thing was quieted down, approaching nearer they perceived that the advantage was great for their bodies from the heat of the fire. They added fuel, and thus keeping it up, they brought others; and pointing it out by signs they showed what advantages they had from it. In this concourse of mankind, when sounds were variously uttered by the breath, by daily custom they fixed words as they had chanced to come. Then, indicating things more frequently and by habit, they came by chance to speak according to the event, and so they generated conversation with one another.[1] 2. Therefore, because of the discovery of fire, there arose at the beginning, concourse among men, deliberation and a life in common. Many came together into one place, having from nature this boon beyond other animals, that they should walk, not with head down, but upright, and should look upon the magnificence of the world and of the stars. They also easily handled with their hands [2] and fingers whatever they wished. Hence after thus meeting together, they began, some to make shelters of leaves, some to dig caves under the hills, some to make of mud [3] and wattles places for shelter, imitating the nests of swallows and their methods of building. Then observing the houses of others and adding to their ideas new things from day to day, they produced better kinds of huts. 3. Since men were of an imitative and teachable nature, they boasted of their inventions as they daily showed their various achievements in building, and thus, exercising their talents in rivalry, were rendered

[3] Wattle-work was used by the Romans in England, following the British precedent.

dies melioribus iudiciis efficiebantur. Primumque furcis erectis et virgulis interpositis luto parietes texerunt. Alii luteas glaebas arefacientes struebant parietes, materia eos iugumentantes, vitandoque imbres et aestus tegebant harundinibus et fronde. Posteaquam per hibernas tempestates tecta non potuerunt imbres sustinere, fastigia facientes, luto inducto proclinatis tectis, stillicidia deducebant.

4 Haec autem ex is, quae suprascripta sunt, originibus instituta esse possumus sic animadvertere, quod ad hunc diem nationibus exteris ex his rebus aedificia constituantur,[1] uti Gallia, Hispania,[2] Lusitania, Aquitania scandalis[3] robusteis aut stramentis. Apud nationem Colchorum in Ponto propter silvarum abundantiam arboribus perpetuis planis dextra ac sinistra in terra positis, spatio inter eas relicto quanto arborum longitudines patiuntur, conlocantur in extremis partibus earum supra alterae transversae, quae circumcludunt medium spatium habitationis. Tum[4] insuper alternis trabibus ex quattuor partibus angulos iugumentantes et ita parietes arboribus statuentes ad perpendiculum imarum educunt ad altitudinem turres, intervallaque, quae relinquuntur propter crassitudinem materiae, schidiis et luto obstruunt. Item tecta, recidentes ad extremos transtra, traiciunt gradatim contrahentes, et ita ex quattuor partibus ad altitudinem educunt medio metas, quas fronde et luto tegentes

[1] constituuntur *G* : antur *H*. [2] spania *HG*.
[3] scandulis *G* : scandalis *H*. [4] tunc *G*.

[1] The name of the neighbouring *Mossynoikoi* means "dwellers in towers" from *mossyn*, a tower. Xenophon, *Anabasis*, V. 4; Ap. Rh. II. 1019.

[2] The beams run alternately from front to back, and from

of better judgment daily. And first, with upright forked props and twigs put between, they wove their walls. Others made walls, drying moistened clods which they bound with wood, and covered with reeds and leafage, so as to escape the rain and heat. When in winter-time the roofs could not withstand the rains, they made ridges, and smearing clay down the sloping roofs, they drew off the rain-water.

4. That these things were so practised from the beginnings above described we can observe, seeing that to this day buildings are constructed for foreign nations of these materials, as in Gaul, Spain, Portugal, Aquitaine, with oak shingles or thatch. In Pontus among the nation of the Colchi,[1] because of their rich forests, two whole trees are laid flat, right and left, on the ground, a space being left between them as wide as the lengths of the trees allow. On the furthest parts of them, two others are placed transversely, and these four trees enclose in the middle the space for the dwelling. Then, laying upon them alternate beams from the four sides, they join up the angles.[2] And so constructing the walls with trees, they raise up towers [3] rising perpendicular from the lowest parts. The gaps which are left by the thickness of the timber they block up with splinters and clay. Further, they raise the roofs by cutting off the cross-beams at the end and gradually narrowing them. And so, from the four sides they raise over the middle a pyramid on high. This they cover with leafage and clay, and, barbarian fashion, construct

side to side, meeting at the corners. Thus a space is left between each beam and the beam above it.

[3] The farmhouses of the East were often in the form of towers for security's sake. "A man . . . built a tower and let it out to husbandmen." Mark xii. 1.

efficiunt barbarico more testudinata turrium tecta.
5 Phryges vero, qui campestribus locis sunt habitantes,
propter inopiam silvarum egentes materiae [1] eligunt
tumulos naturales eosque medios fossura [2] detinentes[3]
et itinera perfodientes dilatant spatia, quantum natura
loci patitur. Insuper autem stipitis inter se religantes
metas efficiunt, quas harundinibus et sarmentis
tegentes exaggerabant supra habitationis [4] e terra
maximos grumos.[5] Ita hiemes calidissimas, aestatis
frigidissimas efficiunt [6] tectorum rationes. Nonnulli
ex ulva palustri componunt tiguria tecta. Apud
ceteras quoque gentes et nonnulla loca pari similique
ratione casarum perficiuntur constitutiones. Non
minus etiam Massiliae animadvertere possumus sine
tegulis subacta cum paleis terra tecta. Athenis
Areopagi antiquitatis exemplar ad hoc tempus luto
tectum. Item in Capitolio commonefacere potest et
significare mores vetustatis [7] Romuli casa et in arce
6 sacrorum stramentis tecta. Ita his signis de antiquis
inventionibus aedificiorum, sic ea fuisse ratiocinantes,
possumus iudicare.

Cum autem cotidie faciendo tritiores [8] manus ad
aedificandum perfecissent et sollertia ingenia exer-
cendo per consuetudinem ad artes pervenissent, tum
etiam industria in animis eorum adiecta perfecit, ut,

[1] materia *G*.
[2] fossura *G^c*: forsura *G*, fossurae *H*.
[3] detegentes *Sch* : detinentes *H*.
[4] habitationis *H*.
[5] crumos *H*. [6] efficit *H*.
[7] vetustates *H*. [8] tritores *H*.

[1] The primitive character of their civilisation was proverbial.
[2] Marseilles was besieged by Caesar's troops 49 B.C. Vitruvius
speaks as an observer.

the coved roofs of their towers. 5. But the Phrygians,[1] who are dwellers in the plains, owing to the absence of forests, lack timber. Hence they choose natural mounds, and dividing them in the middle by a trench and digging tracks through, open out spaces as far as the nature of the place allows. They fasten logs together at the upper end, and so make pyramids. These they cover with reeds and brushwood and pile up very large hillocks from the ground above their dwellings. This arrangement of their dwellings makes the winter quite warm, and the summer cool. Some construct covered huts from the sedge of the marshes. Among other nations, also, in many places, the erection of huts is carried out in a parallel and similar manner. Not less also at Marseilles[2] we can observe roofs without tiles, made of earth and kneaded with straw. At Athens there is an ancient type of building, on the Areopagus, to this day[3] covered with mud. Also in the Capitolium the Hut of Romulus,[4] and in the Citadel, shrines covered with straw, can remind us, and signify the customs and the antiquities of Rome. 6. Thus by these examples we can infer concerning the ancient invention of buildings, reasoning that they were similar.

When, however, by daily work men had rendered their hands more hardened for building, and by practising their clever talents they had by habit acquired craftsmanship, then also the industry, which rooted itself in their minds, caused those who were

[3] Vitruvius frequently makes use of contemporary information which may be relied upon. He correctly describes the great temple of Jupiter (Zeus) as octastyle, Book III. ii. 8.

[4] Virg. *Aen.* VIII. 654. There were two, Lanciani, *R.E.* 131.

qui fuerunt in his studiosiores, fabros esse se pro-
fiterentur. Cum ergo haec ita fuerint primo con-
stituta et natura non solum [1] sensibus ornavisset
gentes quemadmodum reliqua animalia, sed etiam
cogitationibus et consiliis armavisset mentes et
subiecisset cetera animalia sub potestate, tunc vero
et fabricationibus aedificiorum gradatim progressi
ad ceteras artes et disciplinas, e fera agrestique vita'
7 ad mansuetam perduxerunt humanitatem. Tum
autem instruentes animo se eprospicientes [2] maiori-
bus cogitationibus ex varietate artium natis, non casas
sed etiam domos fundatas et latericiis parietibus aut
e lapide structas materiaque et tegula tecta perficere
coeperunt, deinde observationibus studiorum e
vagantibus iudiciis et incertis ad certas symmetriarum
perduxerunt rationes. Posteaquam animadverter-
unt profusos esse partus ab natura et materiam abun-
dantem copiarum [3] ad aedificationes ab ea compara-
tam, tractando nutrierunt et auctam per artes
ornaverunt voluptatibus elegantiam vitae. Igitur de
his rebus, quae sunt in aedificiis ad usum idoneae,
quibusque sunt qualitatibus et quas habeant virtutes,
ut potuero, dicam.
8 Sed si qui de ordine huius libri disputare voluerit,
quod putaverit eum primum institui oportuisse, ne
putet me erravisse, si credam rationem. Cum corpus
architecturae scriberem, primo volumine putavi,
quibus eruditionibus et disciplinis esset ornata, ex-

[1] solum *H* : plus *G*.
[2] ae prosp. *ante ras. H*, eprosp. *G*.
[3] ab naturae materia & abundantē copiarum *H*, naturę ad
materiam et abundantem copiam *G*.

[1] Vitruvius seems to have circulated copies of his first
book separately.

more eager herein to profess themselves craftsmen.
When, therefore, these matters were so first ordained
and Nature had not only equipped the human races
with perceptions like other animals, but also had armed
their minds with ideas and purposes, and had put
the other animals under their power, then from the
construction of buildings they progressed by degrees
to other crafts and disciplines, and they led the way
from a savage and rustic life to a peaceful civilisation.
7. Then, however, building up themselves in spirit, and
looking out and forward with larger ideas born from
the variety of their crafts, they began to build, not
huts, but houses, on foundations, and with brick walls,
or built of stone; and with roofs of wood and tiles.
Then by the observations made in their studies they
were led on from wandering and uncertain judgments
to the assured method of symmetry. When they
observed that Nature brought forth profusely, and
provided materials abounding in usefulness for build-
ing, they handled them with fostering care, and
equipped with delights the refinement of life,
increased as it was by their several crafts. Therefore,
concerning the things which are fit for use in buildings,
of what qualities they are and what virtues they
possess, I will speak as I am able.

8. But if anybody raises objections about the
arrangement of the whole work, because he thinks
that this book should have come first,[1] let him not
think I have erred, if I believe in Reason.[2] When I
wrote this comprehensive treatise on architecture, I
thought in the first book to set forth with what
trainings and disciplines architecture was equipped,

[2] H. retains his creed: *credo rationem*; *credo* with the acc.
is found in some early creeds.

ponere finireque terminationibus eius species et, e quibus rebus esset nata, dicere. Itaque quid oporteat esse in architecto, ibi pronuntiavi. Ergo in primo de artis officio, in hoc de naturalibus materiae rebus, quem habeant usum, disputabo. Namque hic liber non profitetur, unde architectura nascatur, sed unde origines aedificiorum sunt institutae et quibus rationibus enutritae et progressae sint gradatim ad 9 hanc finitionem. Ergo ita suo ordine et loco huius erit voluminis constitutio.

Nunc revertar ad propositum et de copiis, quae aptae sunt aedificiorum perfectionibus, quemadmodum videantur esse ab natura rerum procreatae quibusque mixtionibus principiorum congressus temperentur, nec obscura sed perspicua legentibus sint, ratiocinabor. Namque nulla materiarum genera neque corpora neque res sine principiorum coetu nasci neque subici intellectui possunt, neque aliter natura rerum praeceptis physicorum veras patitur habere explicationes, nisi causae, quae insunt in his rebus quemadmodum et quid ita sint, subtilibus rationibus habeant demonstrationes.

II

1 THALES[1] primum aquam putavit omnium rerum esse principium; Heraclitus Ephesius, qui propter obscuritatem scriptorum a Graecis *scoteinos*[2] est appellatus, ignem; Democritus quique est eum

[1] Tales *H*. [2] scotinos *H*.

and to determine by definitions its species and to say from what things it sprang. And so I there pronounced what there ought to be in an architect. Therefore in the first book I discussed the office of the architect. In this book I will treat of the material things of nature, and what uses they have. For this book does not declare whence architecture arises, but whence the kinds of building have originated, and by what ways they have been fostered and, by degrees, advanced to their present finish. 9. So therefore the arrangement of this book is in its order and place.

Now I will return to my undertaking and will deal with the materials which are adapted to the execution of buildings; how they seem to be generated by Nature, and in what mixtures the assemblages of elements are blended. These, indeed, are not obscure but obvious to my readers. For no kinds of materials, nor bodies, nor things can arise or be subject to the intelligence without the coming together of elements, nor does Nature allow them to have true explanations in the precepts of physicists, unless the causes which are present in these things find proofs, how and why they are so, by accurate demonstrations.

CHAPTER II

ON THE PRINCIPLES OF THINGS

1. First, Thales [1] thought that *water* was the principle of all things. Heraclitus of Ephesus (who because of the obscurity of his writings was called Dark by the Greeks), *fire*; Democritus, and Epicurus

[1] Vitruvius' list of philosophers was probably taken from Varro, who in turn drew upon a late Greek compilation of the opinions of philosophers, Diels, *Doxographi Graeci*, 94, 200.

secutus Epicurus *atomos*, quas [1] nostri insecabilia corpora, nonnulli individua vocitaverunt; Pythagoreorum vero disciplina adiecit ad aquam et ignem aera [2] et terrenum. Ergo Democritus, etsi non proprie res nominavit sed tantum individua corpora proposuit, ideo ea ipsa dixisse videtur, quod ea, cum sint disiuncta, nec laeduntur [3] nec interitionem recipiunt nec sectionibus dividuntur, sed sempiterno aevo perpetuo 2 infinitam retinent in se soliditatem. Ex his ergo congruentibus cum res omnes coire nascique videantur et hae in infinitis generibus rerum natura essent disparatae, putavi oportere de varietatibus et discriminibus usus earum quasque haberent in aedificiis qualitates exponere, uti, cum fuerint notae, non habeant qui aedificare cogitant errorem, sed aptas ad usum copias aedificiis conparent.

III

1 ITAQUE primum de lateribus, qua de terra duci eos oporteat, dicam. Non enim de harenoso neque calculoso luto neque sabulonoso luto sunt ducendi, quod, ex his generibus cum sint ducti, primum fiunt graves, deinde, cum ab inbribus [4] in parietibus sparguntur, dilabuntur et dissolvuntur paleaeque in

[1] quas *Ro* : quos *H*. [2] aera *G* : aerea *H*.
[3] nec laeduntur *rec* : nec leguntur *H G*.
[4] intribus *H*.

[1] *insecabilia* : found in Seneca and Quintilian.
[2] *individua* : Cicero.
[3] "Things" were uncertain in Democritus' system. Book VII. pref. 11.

who followed him, *atoms*, which our writers have called unbreakables,[1] some *indivisibles*.[2] But the school of the Pythagoreans added *air* and the *earthy* to water and fire. Therefore Democritus, although he did not name " things "[3] as such, but supposed " atoms " only, seems to have spoken of them as such because although they may be separated out, they are not damaged nor destroyed, nor cut up into parts, but retain in themselves for ever a perfect solidity. 2. Since therefore from these, being in correspondence, all things seem to come together and be born, and since by Nature they have been divided into infinite kinds, I thought I ought first to deal with the varieties and differences of the use of them, and what qualities they show in buildings; so that when they are familiar, those who think of building may not make mistakes but get supplies fit for use.

CHAPTER III

ON BRICKS

1. THEREFORE, first I will speak about bricks, and from what kind of clay they ought to be brought. For they ought not to be made from sandy nor chalky soil nor gravelly soil: because when they are got from these formations, first they become heavy, then, when they are moistened by rain showers in the walls, they come apart and are dissolved. And the straw does not stick in them[4]

[4] The addition of straw to bricks increased their breaking strength by 244 per cent. Straw was used along with leaves of plants and parts of grasses in Egypt. Neuburger, *tr.* 137.

his non cohaerescunt propter asperitatem. Faciendi
autem sunt ex terra albida cretosa sive de rubrica
aut etiam masculo sabulone; haec enim genera
propter levitatem habent firmitatem et non sunt in
2 opere ponderosa et faciliter aggerantur. Ducendi
autem sunt per vernum tempus et autumnale, ut
uno tempore[1] siccescant. Qui enim per solstitium
parantur, ideo vitiosi fiunt, quod, summum corium[2]
sol acriter cum praecoquit, efficit ut videatur aridum,
interior autem sit non siccus; et cum postea sicces-
cendo se contrahit, perrumpit ea quae erant arida.
Ita rimosi facti efficiuntur imbecilli. Maxime autem
utiliores erunt, si ante biennium fuerint ducti;
namque non ante possunt penitus siccescere. Itaque
cum recentes et non aridi sunt structi, tectorio
inducto rigidoque obsolidati permanent; ipsi sidentes[3]
non possunt eandem altitudinem qua est tectorium,
tenere, contractioneque moti non haerent cum eo,
sed ab coniunctione eius disparantur; igitur tectoria
ab structura seiuncta propter tenuitatem per se stare
non possunt, sed franguntur, ipsique parietes fortuito
sidentes vitiantur. Ideo etiam Uticenses laterem,
si sit aridus et ante quinquennium ductus, cum
arbitrio magistratus fuerit ita probatus, tunc utuntur
3 in parietum structuris. Fiunt autem laterum genera
tria: unum, quod graece Lydium appellatur, id est

[1] tenore *Joc* : tempore *H*. [2] chorium *H*.
[3] sidentes *S²* : sedentes *H*.

[1] Sun-dried bricks, *lateres*, used under the republic; kiln-
baked bricks under Early Empire, *testae*. Stuart Jones,
Companion to Roman History, 56.

[2] In Tunis, about 25 miles from Carthage. Vitruvius
probably speaks from direct knowledge. He was a friend

because of their roughness. But bricks are to be made of white clayey earth or of red earth, or even of rough gravel. For these kinds, because of their smoothness, are durable. They are not heavy in working, and are easily built up together. 2. Now bricks are to be made either in the spring or autumn, that they may dry at one and the same time. For those which are prepared at the summer solstice become faulty for this reason: when the sun[1] is keen and overbakes the top skin, it makes it seem dry, while the interior of the brick is not dried. And when afterwards it is contracted by drying, it breaks up what was previously dried. Thus bricks crack and are rendered weak. But, most especially, they will be more fit for use if they are made two years before. For they cannot dry throughout before. Therefore when they are built in fresh and not dry, and the plaster is put on and becomes rigid, they remain solid only on the surface. Hence they settle and cannot keep the same height as the plaster. For by contraction and the consequent movement they cease to stick to the plaster, and are separated from their union with it. Therefore the wall-surfaces are separated from the wall itself, and because of their thinness cannot stand of themselves and are broken, and the walls settling haphazard, become faulty. That is why the citizens of Utica[2] use no bricks for building walls, unless the magistrate has approved them as being dry and made five years before. 3. Now there are three kinds of bricks: one which in Greek is called

of a neighbouring landowner, Book VIII. iv. 25. In Roman towns, building operations were controlled by the aediles. Even villages had their aedile. Arnold, *Roman Provincial Administration*, 217.

quo nostri utuntur, longum sesquipede, latum pede.
Ceteris duobus Graecorum aedificia struuntur;
ex his unum *pentadoron*, alterum *tetradoron* dicitur.
Doron autem Gracei appellant palmum, quod
munerum datio graece *doron* appellatur, id autem
semper geritur per manus palmum. Ita quod est
quoquoversus quinque [1] palmorum, pentadoron, quod
quattuor, tetradoron dicitur, et quae sunt publica
opera, *pentadorōs*, quae privata, *tetradorōs* struuntur.
4. Fiunt autem cum his lateribus semilateria. Quae
cum struuntur, una parte lateribus ordines, altera
semilateres ponuntur. Ergo ex utraque parte ad lineam
cum struuntur,[2] alternis coriis parietes alligantur et
medii lateres supra coagmenta conlocati et firmitatem
et speciem faciunt utraque parte non invenustam.

Est autem in Hispania ulteriore civitas Maxilua [3] et
Callet[4] et in Asia Pitane,[5] ubi lateres cum sunt ducti et
arefacti, proiecti natant in aqua. Natare autem eos
posse ideo videtur, quod terra est, de qua ducuntur,
pumicosa. Ita cum est levis, aere solidata non
recipit in se nec combibit liquorem. Igitur levi
raraque cum sit proprietate, nec patiantur penetrare
in corpus umidam potestatem, quocumque pondere
fuerit, cogitur ab rerum natura, quemadmodum
pumex, uti ab aqua sustineatur, sic autem magnas

[1] quinque *G* : equinque *H*.
[2] cum str. *H* : construuntur *G*.
[3] Maxilua *Voss* : maxima *H*.
[4] Callet *Plin.* 35, 171 : in galliis *H*.
[5] Pitane *Joc* : ita ne *H*.

Lydion, that is the one which we use, a foot and a half
long, a foot wide. Greek buildings are constructed
with the other two. Of these, one is called *pentadoron,*
the other *tetradoron.* Now the Greeks call the palm
doron, because the giving of gifts is called *doron,* and
this is always done by means of the palm of the hand.
Thus the brick that is of five palms every way is called
pentadoron; of four palms, tetradoron. Public
buildings are erected with the former; private build-
ings with the latter. 4. Along with these bricks,
half-bricks also are made. When these are built to the
line of the face, on one side courses [1] are laid with
bricks, on the other side half-bricks are laid. The
walls are bound together by the alternate facings [2];
and the middle of the bricks, being placed above the
joints, produces firmness, and a not unpleasing appear-
ance on either side.

Now in Further Spain there is a town Maxilua, and
also Callet, in Asia there is Pitane,[3] where bricks,
when they have been made and dried, swim in water
if they are thrown in. Now it seems that they are
able to swim because the soil from which they are
drawn is like pumice. Thus, since it is light, when
made solid by the air it does not admit nor drink up
moisture into itself. Therefore since these bricks
are of a light and open property, and do not allow the
humid potency to penetrate into the body, of what-
ever weight the body shall be, it is compelled by
Nature to be upheld by water like pumice-stone.

[1] *ordo* = course. *Vulg.* III. *Reg.* vi. 36 : *Tres ordines lapidum.*
[2] *Corium,* like skin or leather; then it comes to mean
facing. The wall is 1½ bricks thick. The whole bricks over-
lap half in the middle of the wall.
[3] In Mysia.

habent utilitates, quod neque in aedificationibus sunt
onerosi et cum ducuntur a tempestatibus non
dissolvuntur.

IV

1 In caementiciis autem structuris primum est de
harena quaerendum, ut ea sit idonea ad materiem
miscendam neque habeat terram commixtam.
Genera autem harenae fossiciae sunt haec: nigra,
cana, rubra, carbunculum. Ex his, quae in manu
confricata, vel icta fecerit stridorem, erit optima;
quae autem terrosa fuerit, non habebit asperitatem.
Item si in vestimentum candidum ea contecta fuerit,
postea excussa aut icta id non inquinarit neque ibi
2 terra subsiderit, erit idonea. Sin autem non erunt
harenaria, unde fodiatur, tum de fluminibus aut e
glarea erit excernenda, non minus etiam de litore
marino. Sed ea in structuris haec habet vitia:
difficulter siccescit,[1] neque onerari se continenter
recipit; paries patitur, nisi intermissionibus requiescat,
neque concamerationes recipit. Marina autem hoc
amplius, quod etiam parietes, cum in is tectoria facta
fuerint, remittentes salsuginem eorum dissolvuntur.
3 Fossiciae vero celeriter in structuris siccescunt, et
tectoria permanent, et concamerationes patiuntur,
sed hae, quae sunt de harenariis recentes. Si enim
exemptae diutius iacent, ab sole et luna et pruina

[1] siccescit *S* : siccessit *H*.

[1] *Caementum* = concrete according to Stuart Jones, *op. cit.*
55.
[2] As in arched ceilings of concrete.

So indeed they have great advantages because they are not heavy in buildings, and when they are being made, they are not dissolved by storms.

CHAPTER IV

ON SAND

1. Now in rubble [1] structures we must first inquire about the sand, that it be suitable for mixing material into mortar, and without the admixture of earth. Now the kinds of quarried sand are these: black, white, red, and from lignite. Of these, that which makes a noise when rubbed in the hand will be best; but that which is earthy will not have a like roughness. Also, if it is covered up in a white cloth, and afterwards shaken up or beaten, and does not foul it, and the earth does not settle therein, it will be suitable. 2. But if there are no sand-pits whence it may be dug, then it must be sifted out from the river bed or from gravel, not less also from the sea-shore. But such sand has these faults in buildings: it dries with difficulty, nor does the wall allow itself to be loaded continuously without interruptions for rest, nor does it allow of vaulting.[2] But in the case of sea sand, when plastered surfaces [3] are laid upon walls, the walls discharge the salt of the sands and are broken up. 3. But quarry sand quickly dries in buildings, and the surface lasts; and it admits of vaulting, but only that which is fresh from the pit. For if after being taken out it lies too long, it is weathered by the sun and the moon and the hoar

[3] *Opus tectorium* = stucco.

concoctae resolvuntur et fiunt terrosae. Ita cum in structuram coiciuntur, non possunt continere caementa, sed ea¹ ruunt et labuntur oneraque parietes non possunt sustinere. Recentes autem fossiciae cum in structuris tantas habeant virtutes, eae in tectoriis ideo non sunt utiles, quod pinguitudini eius calx palea commixta, propter vehementiam non potest sine rimis inarescere. Fluviatica vero propter macritatem uti signinum liaculorum subactionibus in tectorio recipit soliditatem.

V

1 DE harenae copiis cum habeatur explicatum, tum etiam de calce diligentia est adhibenda, uti de albo saxo aut silice coquatur²; et quae erit ex spisso et duriore, erit utilis in structura, quae autem ex fistuloso, in tectoriis. Cum ea erit extincta, tunc materia ita misceatur, ut, si erit fossicia, tres harenae et una calcis infundatur; si autem fluviatica aut marina, duo harenae una calcis coiciatur. Ita enim erit iusta ratio mixtionis temperaturae. Etiam in fluviatica aut marina si qui testam tunsam et succretam ex

¹ ea ruunt *G* : earunt *H*. ² quoquatur *H*.

¹ Cow-dung is used to-day in pargetting chimneys, probably because of the vegetable matter contained in it.
² A town of Latium.

frost, and is dissolved and becomes earthy. Thus
when it is thrown into the rubble, it cannot bind
together the rough stones, but these collapse and the
loads give way which the walls cannot maintain. But
while fresh pit sand has such virtues in buildings,
it is not useful in plaster work; because owing to its
richness, the lime when mingled with straw [1] cannot,
because of its strength, dry without cracks. But
river sand because of its fineness (like that from
Signia [2]), when it is worked over with polishing
tools,[3] acquires solidity in the plaster.

CHAPTER V

ON LIME

1. AFTER furnishing an account of the supply of
sand, we must next be careful about *lime*, to burn it
out of white stone or lava [4]; the lime which shall be
out of thick and harder stone will be useful in the
main structure; that which shall be of porous material,
in plaster work. When it is slaked, then let it be
mingled with the sand in such a way that if it is pit
sand, three of sand and one of lime is poured in;
but if the sand is from the river or sea, two of sand and
one of lime is thrown together. For in this way there
will be the right proportion of the mixture and blend-
ing. Also in the case of river or sea sand, if anyone
adds crushed and sifted potsherds in the proportion

[3] Tertullian describes plasterer's work : *scit albarius
tector et tecta sarcire et tectoria inducere et cisternam liare et
cymatia distendere.* *Idol.* 8.
[4] Silex, quarried from four lava streams, under the charge
of the *Procurator ad silices.* Lanciani, *R.E.* 37.

tertia parte adiecerit, efficiet materiae temperaturam
2 ad usum meliorem. Quare autem cum recipit aquam
et harenam calx, tunc confirmat structuram, haec esse
causa videtur, quod e principiis, uti cetera corpora,
ita et saxa sunt temperata. Et quae plus habent
aeris, sunt tenera; quae aquae, lenta sunt ab umore;
quae terrae, dura[1]; quae ignis, fragiliora. Itaque ex
his saxa si, antequam coquantur, contusa minute
mixta harenae in instructuram coiciantur, non solide-
scunt nec eam poterunt continere. Cum vero coniecta
in fornacem ignis vehementi fervore correpta amiserint
pristinae soliditatis virtutem, tunc exustis atque ex-
haustis eorum viribus relinquuntur patentibus forami-
3 nibus et inanibus. Ergo liquor, qui est in eius lapidis
corpore, et aer cum exustus et ereptus fuerit, habue-
ritque in se residuum calorem latentem, intinctus
in aqua, prius quam ex igni vim recepit umore pene-
trante in foraminum raritates, confervescit et ita
refrigeratus reicit ex calcis corpore fervorem. (Ideo
autem, quo pondere saxa coiciuntur in fornacem,
cum eximuntur, non possunt ad id respondere, sed
cum expenduntur, permanente ea magnitudine,
excocto liquore circiter tertia parte ponderis inminuta
esse inveniuntur.) Igitur cum patent foramina
eorum et raritates, harenae mixtionem in se corripiunt
et ita cohaerescunt siccescendoque cum caementis
coeunt et efficiunt structurarum soliditatem.

[1] durae *H*.

[1] Cato, *Agri.cult.* XXXVIII. 1. Still in use. Neuburger, 407.

of one to three, he will produce a blending of material which is better for use. 2. And so when lime receives water and sand and then strengthens the structure, the following seems to be the cause: just as other bodies, so also stones are blended of the elements. And those which have more air are soft; more water, are pliant from the moisture; more earth, are hard; more fire, are more fragile. Therefore if stones of this last quality are crushed before they are burnt, and mixed with sand, and thrown into the work, they do not become solid, nor can they hold the building together. But when they are thrown into the kiln,[1] they are seized by the violent heat of the fire and lose the virtue of their former solidity. Their strength is burnt out and exhausted and they are left with open and empty pores. 3. Therefore when the moisture which is in the body of that stone, and the air, are burnt out and removed, and the stone retains the remaining latent heat, on being plunged into water (before it recovers power from fire), the moisture penetrates into the open pores, and it seethes and thus, being cooled again, it rejects the heat from the substance of the lime. Thus, moreover, whatever weight the stone possesses when it is thrown into the kiln, it cannot answer to that[2] when it is taken out; but when it is weighed, the bulk remaining the same, it is found to lose about one-third of its weight when the moisture is burnt out. Therefore, when the pores and attenuations of the lime are open, it catches up into itself the mixture of the sand; thus it coheres and, as it dries, joins with the rubble and produces solid walling

[2] This anticipation of the discovery of oxygen is noteworthy.

VI

1 EST etiam genus pulveris, quod efficit naturaliter
res admirandas. Nascitur in regionibus Baianis in
agris municipiorum, quae sunt circa Vesuvium mon-
tem. Quod conmixtum cum calce et caemento non
modo ceteris aedificiis praestat firmitates, sed etiam
moles cum struuntur in mari, sub aqua solidescunt.
Hoc autem fieri hac ratione videtur, quod sub his
montibus et terrae ferventes sunt et fontes crebri,
qui non essent si non in imo haberent aut e sulpure
aut alumine aut bitumine ardentes maximos ignes.
Igitur penitus ignis et flammae vapor per intervenia
permanans et ardens efficit levem eam terram, et ibi
quod nascitur tofus exsurgens,[1] est sine liquore. Ergo
cum tres res consimili ratione ignis vehementia
formatae [2] in unam pervenerint mixtionem, repente
recepto liquore una cohaerescunt et celeriter umore
duratae solidantur, neque eas fluctus neque vis aquae
2 potest dissolvere. Ardores autem esse in his locis
etiam haec res potest indicare, quod in montibus
Cumanorum [3] Baianis sunt loca sudationibus ex-
cavata, in quibus vapor fervidus ab imo nascens ignis
vehementia perforat eam terram per eamque ma-
nando [4] in his locis oritur et ita sudationum egregias

[1] exurgens *H* : exsurgens *G*.
[2] foratae *Nohl* : formatae *H*.
[3] cumannorum *H S.*
[4] *post* manando, fervidus ab imo nascens *repetit H.*

[1] Baiae on the Bay of Naples, near the northern end. It
was a luxurious watering-place visited in April for the hot
medicinal springs.

CHAPTER VI

ON POZZOLANA

1. THERE is also a kind of powder which, by nature, produces wonderful results. It is found in the neighbourhood of Baiae[1] and in the lands of the municipalities round Mount Vesuvius. This being mixed with lime and rubble, not only furnishes strength to other buildings, but also, when piers[2] are built in the sea, they set under water. Now this seems to happen for this reason: that under these mountainous regions there are both hot earth and many springs. And these would not be unless deep down they had huge blazing fires of sulphur, alum or pitch. Therefore the fire and vapour of flame within, flowing through the cracks, makes that earth light. And the tufa which is found to come up there is free from moisture. Therefore, when three substances formed in like manner by the violence of fire come into one mixture, they suddenly take up water and cohere together. They are quickly hardened by the moisture and made solid, and can be dissolved neither by the waves nor the power of water. 2. But that there are fervent heats in these districts may be proved by this circumstance. In the hills of Baiae which belong to Cumae[3] sites are excavated for sweating-rooms.[4] In these hot vapour rising deep down perforates the soil by the violence of its heat, and passing through it rises in these places, and so produces striking advantages in sweating-

[2] *Contracta pisces aequora sentiunt iactis in altum molibus.* Hor. *Odes*, III. i. 33.

[3] Cumae north of Baiae, across the promontory of Misenum.

[4] Also called Laconicum.

efficit utilitates. Non minus etiam memorentur [1]
antiquitus crevisse ardores et abundavisse sub
Vesuvio monte et inde evomuisse circa agros flam-
mam. Ideoque tunc quae spongia sive pumex
Pompeianus vocatur excocto ex alio genere lapidis in
3 hanc redacta esse videtur generis qualitatem. Id
autem genus spongiae, quod inde eximitur, non in
omnibus locis nascitur nisi circum Aetnam et collibus
Mysiae, quae a Graecis *Catacecaumene* nominatur, et si
quae eiusdem modi sunt locorum proprietates. Si
ergo in his locis aquarum ferventes inveniuntur fontes
et omnibus excavatis calidi vapores ipsaque loca ab
antiquis memorantur pervagantes in agris habuisse
ardores, videtur esse certum ab ignis vehementia ex
tofo terraque, quemadmodum in fornacibus et a
4 calce, ita ex his ereptum esse liquorem. Igitur
dissimilibus et disparibus rebus correptis et in
unam potestatem conlatis, calida umoris ieiunitas
aqua [2] repente satiata communibus corporibus latenti
calore confervescit et vehementer efficit ea coire
celeriterque unam soliditatis percipere virtutem.

Relinquetur desideratio, quoniam ita sunt in
Etruria ex aqua calida crebri fontes, quid ita non
etiam ibi nascitur pulvis, e quo eadem ratione sub
aqua structura solidescat. Itaque visum est, ante-
quam desideraretur, de his rebus, quemadmodum
5 esse videantur, exponere. Omnibus locis et regioni-
bus non eadem genera terrae nec lapides nascuntur,
sed nonnulla sunt terrena, alia sabulosa itemque
glareosa,[3] aliis locis harenosa, non minus materia, et

[1] memorantur *G* : memorentur *H*. [2] aquae *H*.
[3] glareosa *G* : glariosa *H*.

[1] Burnt land.

rooms. Not less also let it be recorded, that heats in antiquity grew and abounded under Mount Vesuvius, and thence belched forth flame round the country. And therefore now that which is called " sponge-stone " or Pompeian pumice seems to be brought to this general quality from another kind of stone when it is subjected to heat. 3. But that kind of sponge stone which is taken thence is not found in all places, only round Etna and on the hills of Mysia (which is called *Catacecaumene* [1] by the Greeks), and if there are in any other places properties of that kind. If, therefore, in these places there are found hot springs, and in all excavations, warm vapours, and if the very places are related by the ancients to have had fires ranging over the fields, it seems to be certain that by the violence of fire, moisture has been removed from the tufa and earth just as from lime in kilns. 4. Therefore, when unlike and unequal substances are caught together and brought into one nature, the hot desiccation, suddenly saturated with water, seethes together with the latent heat in the bodies affected, and causes them to combine vehemently and to gain rapidly one strong solidity.

Since in Etruria [2] also there are frequent springs of hot water, there will remain the inquiry why there also the powder is not found, from which in the same manner walling may set under water. Therefore it seemed good, before inquiry was made on these matters, to set forth how they seemed to come about. 5. Neither the same kinds of soil nor the same rocks are found in all places and regions, but some are earthy, others of gravel, others pebbly, in other places sandy material; and generally there are

[2] Etruria distinguished from Italy.

omnino dissimili disparique genere in regionum
varietatibus qualitates insunt in terra. Maxime
autem id sic licet[1] considerare, quod, qua mons
Appenninus regionis Italiae Etruriaeque circa cingit,
prope in omnibus locis non desunt fossicia harenaria,
trans Appenninum vero, quae pars est ad[2] Adriati-
cum mare, nulla inveniuntur, item Achaia, Asia,
omnino trans mare, nec nominatur quidem. Igitur
non in omnibus locis, quibus effervent aquae calidae
crebri fontes, eaedem[3] opportunitates possunt simili-
ter concurrere, sed omnia, uti natura rerum constituit,
non ad voluntatem hominum, sed ut fortuito dis-
6 parata procreantur. Ergo quibus locis non sunt
terrosi montes sed genere materiae, ignis vis per eius
venas egrediens adurit eam. Quod est molle et
tenerum, exurit, quod autem asperum, relinquit.
Itaque uti Campania exusta terra cinis, sic in Etruria
excocta materia efficitur carbunculus. Utraque
autem sunt egregia in structuris, sed alia in terrenis
aedificiis, alia etiam in maritimis molibus habent
virtutem. Est autem materiae potestas mollior quam
tofus, solidior quam terra, quo penitus ab uno
vehementia vaporis adusto, nonnullis locis procreatur
id genus harenae quod dicitur carbunculus.

VII

1 DE calce et harena, quibus varietatibus sint et
quas habeant virtutes, dixi. Sequitur ordo de lapi-

[1] sic licet *rec* : scilicet *H*. [2] ad *om. H.*
[3] edem oportunitatis *H.*

[1] Province including most of modern Greece.
[2] Province of Asia Minor.

found in the earth qualities of unlike and unequal kind with the various regions. But we may regard the matter especially in this way : almost everywhere, where the Apennine range encloses the regions of Italy and Etruria, sand-pits are found; whereas across the Apennines, where the land adjoins the Adriatic, none are found. Generally also it is not indeed even named across the sea in Achaia[1] and Asia.[2] Therefore not in all places in which frequent hot springs boil up can the same conveniences arise; but all things are generated as the Nature of Things has determined, not for the pleasure of man, but disparate as though by chance. 6. Therefore wherever mountains are not of earth but of a woody kind, the force of fire escaping through the veins burns it up. It burns out what is soft and tender, but leaves what is rough. Therefore just as in Campania, burnt-out earth becomes ashes, so in Etruria, charred stone becomes carbuncular. Both are excellent in walling. But some materials have advantages in buildings on land, and others in piers built into the sea. The nature of wood is softer than tufa, more solid than the earth[3]; and when this is burnt deep down by the violence of vapour, there is generated in some places that kind of sand which is called lignite (carbunculus).

CHAPTER VII

ON STONE

1. I HAVE spoken of lime and sand, both of what varieties they are and what virtues they possess. Next in order comes the description of the quarries

[3] This statement is possible on Vitruvius' principles.

dicinis explicare, de quibus et quadrata saxa et
caementorum ad aedificia eximuntur copiae et
conparantur. Haec autem inveniuntur esse dis-
paribus et dissimilibus virtutibus. Sunt enim aliae
molles, uti sunt circa urbem Rubrae, Pallenses,
Fidenates, Albanae; aliae temperatae, uti Tibur-
tinae,[1] Amiterninae, Soractinae et quae sunt his
generibus; nonnullae durae, uti siliceae.[2] Sunt
etiam alia genera plura, uti in Campania rubrum
et nigrum tofum, in Umbria et Piceno et in Venetia
2 albus, quod etiam serra dentata uti lignum secatur. Sed
haec omnia quae mollia sunt, hanc habent utilitatem,
quod ex his saxa cum sunt exempta, in opere faciliter
tractantur. Et si sunt in locis tectis, sustineant
laborem, si autem in apertis et patentibus, gelicidiis
et pruina congesta friantur[3] et dissolvuntur. Item
secundum oram maritimam[4] ab salsugine exesa[5] dif-
fluunt neque perferunt aestus. Tiburtina vero et quae
eodem genere sunt omnia, sufferunt et ab oneribus et
a tempestatibus iniurias, sed ab igni non possunt esse
tuta, simulque sunt ab eo tacta, dissiliunt et dissi-
pantur, ideo quod temperatura naturali parvo sunt
umore itemque non multum habent terreni, sed
aeris plurimum et ignis. Igitur cum et umor et

[1] tibertinae *H*. [2] siliciae *H*.
[3] friantur *H* : fricantur *G*.
[4] oram maritimam *rec* : ora maritima *H*.
[5] exesa *ed. Fl* : exea *H*.

[1] Of tufa, in the city. [2] Not known.
[3] Castel Giubileo, 5 m. north of Rome, hill of tufa.
[4] Lapis Albanus or Peperino of grey colour.
[5] Lapis Tiburtinus or Travertine, yellowish-white limestone.
Up to Sulla's time, little used.
[6] In Sabine country.

from which both squared stone and supplies of rubble
are taken and furnished for buildings. Now these
are found to be of unequal and unlike virtues. For
some are soft, as they are in the neighbourhood of the
city at Grotta Rossa,[1] Palla[2], Fidenae[3] and Alba[4];
others are medium, as at Tivoli,[5] Amiternum,[6]
Soracte,[7] and those which are of these kinds; some
hard, like lava. There are also many other kinds, as
red and black tufa in Campania[8]; in Umbria and
Picenum and in Venetia, white stone which indeed is
cut, like wood, with a toothed saw.[9] 2. But all these
quarries which are of soft stone have this advantage:
when stones are taken from these quarries they are
easily handled in working, and if they are in covered
places, they sustain their burden, but if they are in
open and exposed places, they combine with ice and
hoar frost, are turned to powder and are dissolved:
along the sea-coast, also, being weathered by the
brine, they crumble and do not endure the heat.
Travertine, however, and all stones which are of the
same kind, withstand injury from heavy loads and
from storms; but from fire they cannot be safe[10]; as
soon as they are touched by it they crack and break
up. And the reason is that by the nature of their
composition they have little moisture and also not
much earth, but much air and fire. Therefore, since

[7] Limestone ridge north of Rome.
[8] The tufa period at Pompeii preceded the sending of a
colony of Roman soldiers, 80 B.C.
[9] Saws were used in Egypt worked by hand; later also in
Rome. Sawmills worked by water-power were used on the
Moselle in the fourth cent. A.D. Cf. *trahens per levia marmora
serras.* Auson. *Mosella*, 363.
[10] Lapis Albanus, peperino, as resisting fire was ordered to
be used by Nero, after the fire at Rome. Tac. *Ann.* XV. 43.

terrenum[1] in his minus inest, tum etiam ignis, tactu
et vi vaporis ex his aere fugato, penitus insequens
interveniorum[2] vacuitates occupans fervescit et
3 efficit a suis ardentia corporibus similia. Sunt vero
item lapidicinae conplures in finibus Tarquiniensium,
quae dicuntur Anicianae, colore quemadmodum
Albanae, quorum officinae maxime sunt circa lacum
Vulsiniensem, item praefectura Statonensi. Haec
autem habent infinitas virtutes; neque enim his geli-
cidiorum tempestas neque ignis tactus potest nocere,
sed est firma et ad vetustatem ideo permanens, quod
parum habet e naturae mixtione aeris et ignis,
umoris autem temperate plurimumque terreni. Ita
spissis conparationibus solidata neque ab tempestati-
4 bus neque ab ignis vehementia nocetur. Id autem
maxime iudicare licet e monumentis, quae sunt circa
municipium Ferenti[3] ex his facta lapidicinis. Nam-
que habent et statuas amplas factas egregie et
minora sigilla floresque et acanthos eleganter
scalptos[4]; quae, cum sint vetusta, sic apparent
recentia, uti si sint modo facta. Non minus etiam
fabri aerarii de his lapidicinis in aeris flatura formas[5]
conparatas[6] habent; ex his ad aes fundendum
maximas utilitates. Quae si prope urbem essent,
dignum esset, ut ex his officinis omnia opera per-
5 ficerentur. Cum ergo propter propinquitatem

[1] terrenum *ed* : -nus *H.*
[2] interveniorum *Joc* : inter venarum *H.*
[3] Ferenti *Mar* : ferentis *H.* [4] scalptos *H* : sculptos *G.*
[5] formas *G.* [6] comparatis *rec* : conparatas *H.*

[1] Corneto on the coast, 60 miles n. of Rome.
[2] Cf. Dennis, *Cities and Cemeteries of Etruria*, C. XIII.
The Anician house was represented by a praetor in the third

there is less moisture and earth in these, then also
the fire, when the air has been expelled by the con-
tact and violence of the heat, following far within
and seizing upon the empty spaces of the fissures,
seethes and produces, from its own substance, similar
burning bodies. 3. But there are also several
quarries in the neighbourhood of Tarquinii,[1] known
as the Anician,[2] in colour like those of Alba, of which
the workings are mostly round the lake of Bolsena,[3]
and also in the prefecture of Statonia.[4] These also
have infinite virtues; for they can neither be injured
by weathering under frost nor by the approach of
fire. But the stone is firm and wears well over a long
time, because it has little air and fire in its natural
mixture, a medium amount of moisture, and much of
the earthy. Thus solidified by its close composition,
it is injured [5] neither by weathering nor by the
violence of fire. 4. Now this we may especially
judge from the monuments, which are about the
municipality of Ferentum,[6] made from these quarries.
For they have large statues strikingly made, and lesser
figures and flowers and acanthus finely carved. These,
old as they are, appear as fresh as if they were just
made. None the less also, coppersmiths in their
bronze castings get moulds from these quarries, and
find great advantages from them for casting bronze.
And if these were near the city, it would be worth
while to execute all works from these stoneyards.
5. Since then, because of their nearness, necessity

Macedonian war, by friends of Cicero; later it became the
first family in Rome.
[3] Dennis, *op. cit.* C. XXVII. [4] Dennis, *op. cit.* C. XXIV.
[5] *nocetur :* a striking solecism.
[6] Near Viterbo; not to be confused with town of same name
in Apulia. The monuments were probably in part sarcophagi.

necessitas cogat ex Rubris lapidicinis et Pallensibus
et quae sunt urbi proximae copiis uti, si qui voluerit
sine vitiis perficere, ita erit praeparandum. Cum
aedificandum fuerit, ante biennium ea saxa non
hieme sed aestate eximantur et iacentia permaneant
in locis patentibus. Quae autem eo biennio a tem-
pestatibus tacta laesa fuerint, ea in fundamenta
coiciantur; cetera, quae non erunt vitiata, ab natura
rerum probata durare poterunt supra terram aedifi-
cata. Nec solum ea in quadratis lapidibus sunt
observanda, sed etiam in caementiciis structuris.

VIII

1 STRUCTURARUM genera sunt haec: reticulatum quo
nunc omnes utuntur, et antiquum quod incertum
dicitur. Ex his venustius est reticulatum, sed ad
rimas faciendas ideo paratum, quod in omnes partes
dissoluta habet cubilia et coagmenta. Incerta vero
caementa alia super alia sedentia inter seque in-
bricata non speciosam sed firmiorem quam reticulata
2 praestant structuram. Utraque autem ex minutis-
simis sunt instruenda, uti materia ex calce et harena
crebriter parietes satiati diutius contineantur.
Molli enim et rara potestate cum sint, exsiccant
sugendo e materia sucum; cum autem superarit et
abundarit copia calcis et harenae, paries [1] plus habens

[1] paries *rec*: partes *H*.

[1] The *opus incertum* was given up about the time of Sulla,
and replaced by the *opus reticulatum*, made of tufa prisms in
imitation of network. Lanciani, *R.E.* 45. This lasted till the
time of the Antonines.

compels the use of supplies from the quarries of Grotta Rossa and Palla, and others which are nearest to the city, we must take precautions if we wish to complete our work without faults. When we have to build, let the stone be got out two years before, not in winter but in summer, and let it lie and stay in exposed places. Those stones, however, which in the two years suffer damage by weathering, are to be thrown into the foundations. Those which are not faulty are tested by Nature, and can endure when used in building above ground. And these precautions are to be taken not only in the case of squared stones, but also for rough stone or rubble walling.

CHAPTER VIII

ON WALLING

1. THERE are two kinds of walling; one like net-work, *opus reticulatum*,[1] which all use now, and the old manner which is called *opus incertum*.[1] Of these the reticulatum is more graceful, but it is likely to cause cracks because it has the beds and joints in every direction. The "uncertain" rough work, *opus incertum*, lying course above course and breaking joints, furnishes walling which is not pleasing but is stronger than the reticulatum. 2. Both kinds of walling are to be built with very minute stones; so that the walls, thoroughly saturated with mortar of lime and sand, may hold longer together. For since the stones are of a soft and open nature, they dry up the moisture by sucking it out of the mortar. But when the supply of lime and sand is abundant, the wall having more moisture will not quickly become

umoris non cito fiet evanidus, sed ab his continetur.
Simul autem umida potestas e materia per caemen-
torum raritatem fuerit exsucta[1] calxque ab harena
discedat et dissolvatur, item caementa non possunt
cum his cohaerere, sed in vetustatem parietes effi-
3 ciunt ruinosos.[2] Id autem licet animadvertere etiam
de nonnullis monumentis, quae circa urbem facta
sunt e marmore seu lapidibus quadratis intrinsecus-
que medio calcata: structuris vetustate evanida
facta materia caementorumque exstructa raritate,
proruunt et coagmentorum ab ruina dissolutis
4 iuncturis dissipantur. Quodsi qui noluerit in id
vitium incidere, medio cavo servato secundum ortho-
statas[3] intrinsecus ex rubro[4] saxo quadrato aut ex
testa aut ex silicibus ordinariis struat bipedales
parietes, et cum his ansis ferreis et plumbo frontes
vinctae sint. Ita enim non acervatim,[5] sed ordine
structum opus poterit esse sine vitio sempiternum,
quod cubilia et coagmenta eorum inter se sedentia et
iuncturis alligata non protrudent opus neque ortho-
statas inter se religatos labi patiuntur.
5 Itaque non est contemnenda Graecorum structura;
utuntur e molli caemento polita, sed cum discesserunt
a quadrato, ponunt de silice seu lapide duro ordinaria,
et ita uti latericia struentes alligant eorum alternis

[1] exsucta *rec* : exsuta *H*. [2] ruinosos *H* : rimosos *G*.
[3] orchostatas *H*. [4] robro *H*.
[5] acervatim *rec* : acervati *H*.

[1] The tombs outside Rome along the Appian Way furnished
examples by which intending builders could judge the
durability of materials.

perishable, but holds together. When once, also, the moist power has been sucked out of the mortar, through the loose structure of the rubble, and the lime separates from the sand and is dissolved, the rubble also cannot cohere with them, but renders the walls ruinous with lapse of time. 3. This we may observe from some tombs which are built near [1] the city, faced with marble or squared stone, and, in the interior, constructed with walling material pressed down. The mortar becomes perishable in time and is drawn out through the loose joints of the rubble. Hence the tombs collapse and disappear when the union of the joints is broken by settlement. 4. But if anyone does not wish to fall into this fault, let him keep the middle hollow behind the facings, and, on the inside, build walls two feet thick of red square stone [2] or of baked brick [3] or of lava,[4] laid in proper courses, and let the facings be tied to these by iron clamps [5] run in with lead. For thus the work is not built all of a heap but in order, and can last; because the beds and joints settling together and bound by ties do not thrust the work forward nor allow the facings bound in this way to give.

5. Therefore the walling of the Greeks is not to be made light of. For they do not employ walling of soft rubble with stucco facing, but when they depart from ashlar,[6] they lay courses of lava or hard stone, and, as with brick buildings, they bind their joints in

[2] Tufa.

[3] *testa*—note the gradual improvement in building methods.

[4] *silex*—c. v. 1.

[5] Re-invented by Brunelleschi. *Orthostata*, Greek word for Latin *frons* = facing. Vitruvius probably used Greek as his vernacular.

[6] Squared stones.

coriis coagmenta, et sic maxime ad aeternitatem firmas perficiunt virtutes. Haec autem duobus generibus struuntur; ex his unum isodomum,[1]
6 alterum pseudisodomum[2] appellatur. Isodomum dicitur, cum omnia coria aequa crassitudine fuerint structa; pseudisodomum, cum inpares et inaequales ordines coriorum diriguntur. Ea utraque sunt ideo firma, primum quod ipsa caementa sunt spissa et solida proprietate neque de materia possunt exsugere liquorem, sed conservant ea in suo umore ad summam vetustatem; ipsaque eorum cubilia primum plana et librata posita non patiuntur ruere materiam, sed perpetua parietum crassitudine religata continent
7 ad summam vetustatem. Altera est quam *enplecton*[3] appellant, qua etiam nostri rustici utuntur. Quorum[4] frontes poliuntur, reliqua ita, uti sunt nata, cum materia conlocata alternis alligant coagmentis. Sed nostri celeritati studentes, erecta conlocantes frontibus serviunt et in medio faciunt fractis[5] separatim cum materia caementis. Ita tres suscitantur in ea structura crustae, duae frontium et una media farturae. Graeci vero non ita, sed plana conlocantes et longitudines eorum alternis in crassitudinem instruentes, non media farciunt, sed e suis frontatis perpetuam et unam[6] crassitudinem parietum consolidant. Prae caetera interponunt singulos crassi-

[1] hisodomum *H.* [2] speudisodomum *H.*
[3] enplecton *H.*
[4] quorum *i. marg. suppl. S^c.*
[5] fractis *Joc* : factis *H.*
[6] et unam *Schn* : et in unam *H.*

[1] That is, with "bond"; cf. English and Flemish bond in modern brickwork. In English bond, there are alternate courses of headers and stretchers; in Flemish, headers and

alternate courses,[1] and so they produce strength firm
enough to last. Well, these are built in two kinds.
Of these one is called *isodomum*, the other is called
pseudisodomum. 6. It is called isodomum when all
the courses are built of an equal thickness; pseudi-
sodomum when the courses are unequal and unlike.
Both are firm, for the reason especially that the
rubble itself is of a thick and solid property, and can-
not suck out the moisture from the mortar; the rubble
preserves the mortar with its moisture for a long
time; and the bed-joints of the stone, being laid flat
and levelled, do not allow the mortar to sink down;
but the stones being bonded in the unbroken thick-
ness of the walls, keep the mortar together for a long
time. 7. The second is that which they call *enplecton*,
which our country people still use. In this the faces
are dressed[2]; the rest of the stones are laid with
mortar in their natural state, and they bond them
with alternating joints. But people nowadays, being
eager for speedy building, attend only to the facing,
setting the stones on end, and fill it up in the middle
with broken rubble and mortar.[3] Thus three slices
are raised in this walling, two of the facings, and a
middle one of the filling in. Not so the Greeks who
lay the stones level and put the headers and stretchers
alternately. Thus they have not to fill in the middle,
but with their through facing stones they render
solid the unbroken and single thickness of the walls.
In addition to the rest, they insert special stones

stretchers alternate in the same course. Hence the joints in
the course above do not come over the joints in the course
below.

[2] *columnae politae sunt.* Cic. *Q. Fr.* III. i. 1.

[3] *materia*, cementing material.

tudine perpetua utraque parte[1] frontatos, quos
diatonous[2] appellant, qui maxime religando con-
firmant parietum soliditatem.

8 Itaque si qui voluerit ex his commentariis animad-
vertere et elegere genus structurae, perpetuitatis
poterit rationem habere. Non enim quae sunt e
molli caemento subtili facie venustatis, non eae
possunt esse in vetustate[3] non ruinosae. Itaque
cum arbitrio[4] communium parietum sumuntur, non
aestimant eos quanti facti fuerint, sed cum ex tabulis
inveniunt eorum locationes, pretia praeteritorum
annorum singulorum deducunt octogesimas et ita—
ex reliqua summa parte reddi pro his parietibus—
sententiam pronuntiant eos non posse plus quam
9 annos LXXX durare. De latericiis vero, dummodo ad
perpendiculum sint stantes, nihil deducitur, sed
quanti fuerint olim facti, tanti esse semper aestiman-
tur. Itaque nonnullis civitatibus et publica opera et
privatas domos etiam regias a latere structas licet
videre: et primum Athenis murum, qui spectat ad
Hymettum[5] montem et Pentelensem;[6] item Patris[7]
in aede Iovis et Herculis latericias cellas, cum circa
lapideae in aede epistylia sint et columnae; in Italia

[1] partes *H*. [2] diatonos *H*.
[3] vetustate *h*: venustate *H*.
[4] arbitri *Polenus*: arbitrio *H*.
[5] hymectiū *H*. [6] tentelensem *H*.
[7] item Patris *Gal*: item paries *H*.

[1] For building laws : see I. i. 10.
[2] This could only come in when the improved methods of
brick building were established under the empire.
[3] Unbaked bricks were used in Greece until the time of
Alexander.
[4] To the east. [5] To the north.

facing on either front of unbroken thickness. These they call *diatonos* (through-stones), and they, by bonding, especially strengthen the solidity of the wall.

8. Therefore if anyone will from these commentaries observe and select a style of walling, he will be able to take account of durability. For those which are of soft rubble with a thin and pleasing facing cannot fail to give way with lapse of time. Therefore when arbitrators[1] are taken for party-walls, they do not value them at the price at which they were made, but when from the accounts they find the tenders for them, they deduct as price of the passing of each year the 80th part, and so—in that from the remaining sum repayment is made for these walls—they pronounce the opinion that the walls cannot last more than 80 years. 9. There is no deduction[2] made from the value of brick walls provided that they remain plumb; but they are always valued at as much as they were built for. Therefore in some cities we may see both public works and private houses and even palaces built of brick:[3] and first, the wall at Athens which looks to Mount Hymettus[4] and Pentelicus[5]; also at Patrae,[6] brick cellae in the temple of Jupiter[7] and Hercules, while round the temple there are entablatures and columns of stone; in Italy at Arezzo[8] there is an old

[6] Augustus made this a colony. It became the chief city of the Peloponnese. "It was the most Roman town in Greece." Tyrrell and Purser, *ad* Cic. *Epp.* 512. 1.

[7] There was a temple of Olympian Jupiter (Zeus) in the forum, Paus. VII. 20. 2.

[8] Arezzo was the chief source of the *terra sigillata,* red "Samian" ware. Oswald and Pryce's *Terra Sigillata* may be consulted with advantage. The technical process of making this ware has been rediscovered. Neuburger, 147.

Arretio vetustum egregie factum murum. Trallibus[1]
domus regibus Attalicis facta, quae ad habitandum
semper datur ei, qui civitatis gerit sacerdotium.
Item Lacedaemone e quibusdam parietibus etiam
picturae excisae intersectis lateribus inclusae sunt in
ligneis formis et in comitium ad ornatum aedilitatis
10 Varronis et Murenae fuerunt adlatae. Croesi
domus, quam Sardiani civibus ad requiescendum
aetatis otio seniorum collegio gerusiam dedicaverunt;
item Halicarnasso potentissimi[2] regis Mausoli domus,
cum Proconnensio marmore omnia haberet ornata,
parietes habet latere structos, qui ad hoc tempus
egregiam praestant firmitatem ita tectoriis operibus
expoliti, uti vitri perluciditatem videantur habere.
Neque is rex ab inopia id fecit; in infinitis enim
vectigalibus erat fartus, quod imperabat Cariae toti.
11 Acumen autem eius et sollertiam ad aedificia paranda
sic licet considerare. Cum esset enim natus My-
lasis[3] et animadvertisset Halicarnasso locum[4]
naturaliter esse munitum, emporiumque idoneum
portum utile, ibi sibi domum constituit. Is autem

[1] tralibus *H*.　　[2] alicarnasso *H*.　potentissimae *H*.
[3] mylasis *H^c G* : mylasus *H G^c*.
[4] locum *G* : loco cum *H*.

[1] In Asia Minor, S. of Ionia.
[2] The kings of Pergamus.
[3] The Priest of the City was the chief magistrate. He was
usually called Asiarch. *Acts* xix. 31.
[4] Frescoes on the brickwork.
[5] Ancient meeting-place of citizens, N.E. of forum.
Murena was probably aedile 68 B.C. with Varro, the famous
scholar.
[6] King of Lydia 560–546 B.C.
[7] Sardis: a fourth-century B.C. temple of Artemis was
excavated 1910–1912; stamped brick with winged Artemis
probably contemporary with Croesus, *J.H.S.* XXIX. 299.

brick wall excellently built. At Tralles [1] there is a
palace built for the Attalid kings,[2] which now is
always given for a house to him who is the Priest of
the City [3] : also at Lacedaemon the bricks were cut
through from certain walls, the paintings [4] were
removed and enclosed in wooden frames, and brought
into the Comitium [5] as an ornament for the aedileship
of Varro and Murena. 10. There is the palace of
Crocsus,[6] which the people of Sardis [7] dedicated to
their fellow-citizens for repose in the leisure of their
age, as an Almshouse [8] for the College of the Elders.
At Halicarnassus [9] also, although the palace of the
mighty king Mausolus [10] had all parts finished with
Proconnesian [11] marble, it has walls built of brick.[12]
And these to this day maintain a striking firmness,
being so finished with plaster work that they seem to
have the translucency of glass. Nor was it for lack
of means that the king did this. For he was enriched
by enormous revenues because he ruled over all Caria.
11. We may thus consider his shrewdness and skill in
providing buildings. For although he was born at
Melisso,[13] he observed at Halicarnassus a place
naturally fortified, a suitable market, and a useful
harbour, and he there established his palace.[14] Now

[8] Lat. *senaculum*. Festus, *s.v.*

[9] Over against Cos, on the mainland; excavated by Sir
Charles Newton 1852–1858. The remains are in the British
Museum.

[10] Mausolus, King of Caria, 377–353 B.C. Vitruvius'
description of his monument guided the excavations of
Newton.

[11] Black and white marble from island of Marmora (hence
its name). It was used largely at Ravenna under the Empire.

[12] Baked brick was found at Halicarnassus.

[13] Mylasa, north of Halicarnassus, old capital of Caria.

[14] Newton, *Plans and Discoveries*, Vol. II. Pl. I.

locus est theatri curvaturae similis. Itaque in
imo secundum portum forum est constitutum; per
mediam autem altitudinis curvaturam praecinction-
emque platea ampla latitudine facta, in qua media
Mausoleum ita egregiis operibus est factum, ut in
septem spectaculis nominetur. In summa arce media
Martis fanum habens statuam colossicam *acrolithon*
nobili manu Leocharis [1] factam. Hanc autem
statuam alii Leocharis, alii Timothei putant esse. In
cornu autem summo dextro Veneris et Mercuri [2]
12 fanum ad ipsum Salmacidis fontem. Is autem falsa
opinione putatur venerio morbo inplicare eos, qui ex
eo biberint. Sed haec opinio quare per orbem terrae
falso rumore [3] sit pervagata, non pigebit exponere.
Non enim quod dicitur molles et inpudicos ex ea aqua
fieri, id potest esse, sed est eius fontis potestas
perlucida saporque egregius. Cum autem Melas et
Areuanias ab Argis et Troezene [4] coloniam com-
munem eo loci deduxerunt, barbaros Caras et Lelegas
eiecerunt. [5] Hi autem ad montes fugati inter se

[1] Leocharis *Rode*: telocharis *H*. [2] mercuri *H*.
[3] falso rumore *Joc*: falsorum ore *H*.
[4] Troezene *Joc*: troezen *H*. [5] eicerunt *H G*.

[1] Literally: "about the middle of the curvature of the
height."

[2] Sculpture in B.M.

[3] *Spectacula*: usually the Pyramids; the Gardens of
Babylon; the Temple of Diana (Artemis) at Ephesus; Phidias'
statue of Jupiter (Zeus) at Olympia; the Colossus of Rhodes;
the Pharos (lighthouse) of Alexandria; the Mausoleum.

[4] Newton, *op. cit.*, II. 137. [5] *Ibid.*, II. 141.

[6] *acrolithon*: *i.e.* a herm with head, hands, feet of marble.

[7] Leochares carved a bust, it is said, of the youthful
Alexander. There is a fine copy of his Ganymede in the
Vatican. He carved the sculptures on the west side of the
Mausoleum.

that place is like the curvature of a theatre. The forum is placed at the lowest level along the harbour. But about the middle of the natural amphitheatre[1] and, as it were, in a cross gangway, a street is constructed of ample width, in the middle of which the Mausoleum[2] is built of such splendid workmanship that it is named among the Seven Sights of the world.[3] In the middle of the top of the citadel[4] is a temple of Mars[5] having a statue of a colossus with marble extremities[6] made by the famous hand of Leochares.[7] This statue some think is by Leochares, others by Timotheus.[8] On the right wing at the top is a temple of Venus and Mercury[9] against Salmacis'[10] fountain itself. 12. This fountain, however, by a mistaken opinion, is thought to afflict with an aphrodisiac disease[11] those who drink of it. And why this opinion has wandered over the world through mistaken rumour it will not be inconvenient to set forth. For this cannot be because, as it is said, people are made effeminate and shameless by that water; the virtue of the spring is clearness and its flavour is excellent. Now when Melas and Arevanias led thither a joint colony from Argos and Troezen, they cast out the barbarians, Carians and Leleges. But these being driven to the hills, gathered together

[8] Timotheus carved the sculpture on the south side of the Mausoleum.

[9] Newton found no traces of this temple, II. 144.

[10] The native town of Salmacis adjoined Halicarnassus. The two towns had one assembly, but their several magistrates for each town. Newton found no fountain answering to the description in the text. Dittenberger, *Sylloge*, 5. The main street runs east and west.

[11] Vitruvius' scientific attitude to medicine renders this reference noteworthy.

congregantes discurrebant et ibi latrocinia facientes
crudeliter eos vastabant. Postea de colonis unus
ad eum fontem propter bonitatem aquae quaestus
causa tabernam omnibus copiis instruxit eamque
exercendo eos barbaros allectabat. Ita singillatim
decurrentes et ad coetus convenientes e duro ferro-
que [1] more commutati in Graecorum consuetudinem
et suavitatem sua voluntate reducebantur. Ergo ea
aqua non inpudico morbi vitio, sed humanitatis
dulcedine mollitis animis barbarorum eam famam est
adepta.

13 Relinquitur nunc, quoniam ad explicationem
moenium eorum sum invectus, totam [2] uti sunt defi-
niam. Quemadmodum enim in dextra parte
fanum est Veneris et fons supra scriptus, ita in
sinistro cornu regia domus, quam rex Mausolus [3]
ad suam rationem conlocavit. Conspicitur enim ex
ea ad dextram partem forum et portus moeniumque [4]
tota finitio, sub sinistram secretus sub montibus [5]
latens portus, ita ut nemo posset, quid in eo geratur,
aspicere nec scire, ut rex ipse de sua domo remigibus
et militibus sine ullo sciente quae opus essent, spec-
14 taret. [6] Itaque post mortem Mausoli Artemisiam
uxorem eius regnantem Rhodii indignantes mulierem
imperare civitatibus Cariae totius, armata classe
profecti sunt, uti id regnum occuparent. Tum
Artemisiae cum esset id renuntiatum, in eo portu

[1] ferroque *H.* [2] tota *G* : totā *H G*c.
[3] manu solus *H.* [4] portus *H*c *S* : portum *H G.*
[5] moenibus *Ross (rec)* : montibus *H.*
[6] spectaret *e₂ Sulp* : spirarent *H G.*

[1] *Si ager secundum viam et opportunus viatoribus locus,
aedificandae tabernae diversoriae.* Varro, *R.R.* I. ii. 23.

and made raids, and by brigandage they devastated the Greeks cruelly. But afterwards one of the colonists,[1] for the sake of profit, fitted up an inn with complete supplies, near the spring, on account of the goodness of the water, and running the inn, he began to attract the barbarians. So coming down one by one, and mixing with society, they changed of their own accord from their rough and wild habits to Greek customs and affability. Therefore this water obtained such a reputation, not by the plague of an immodest disease, but through the softening of savage breasts by the delights of civilisation.

13. Since now I am brought to the description of these walls,[2] it remains to outline it completely as they are. For just as on the right side there are the temple of Venus and the spring above described, so on the left wing is the royal palace which King Mausolus had built to his own plan. From it there is seen on the right side the forum and harbour and the whole circuit of the walls; under the left there is a secret harbour lying hid under high ground, in such a way that no one can see or know what is going on in it, so that the king from his own palace could see [3] what was necessary for his sailors and soldiers, without anyone else knowing. 14. Therefore when, after the death of Mausolus, his wife Artemisia [4] began to reign, the Rhodians were indignant that a woman should rule over the cities throughout Caria, and equipping a fleet they set out to seize the kingdom. It was reported to Artemisia. She hid the

[2] Mention is made of a brick wall. Arrian, *Anabasis*, I. xxii. 1.

[3] The reading in the text is an emendation made in a late MS.

[4] Artemisia, sister and wife of Mausolus, reigned 353–350 B.C.

abstrusam classem celatis remigibus et epibatis
conparatis, reliquos autem cives in muro esse iussit.
Cum autem Rhodii ornata classe in portum maiorem
exposuissent, plausum iussit ab muro his darent[1]
pollicerique se oppidum tradituros. Qui cum pene-
travissent intra murum relictis navibus inanibus,
Artemisia repente fossa facta in pelagum eduxit
classem ex portu minore et ita invecta est in maiorem.
Expositis autem militibus classem Rhodiorum inanem
abduxit in altum. Ita Rhodii non habentes, quo se
reciperent, in medio conclusi in ipso foro sunt
15 trucidati. Ita Artemisia in navibus Rhodiorum suis
militibus et remigibus inpositis Rhodum est profecta.
Rhodii autem, cum prospexissent suas naves laureatas
venire, opinantes cives victores reverti hostes
receperunt. Tum Artemisia Rhodo capta principibus
occisis tropaeum in urbem Rhodo suae victoriae
constituit aeneasque duas statuas fecit, unam
Rhodiorum civitatis, alteram suae imaginis, et ita
figuravit Rhodiorum civitati stigmata inponentem.
Id autem postea Rhodii religione inpediti, quod nefas
est tropaea dedicata removeri, circa eum locum
aedificium struxerunt et id erecta Graia statione
texerunt, ne qui possit aspicere, et id *abaton* vocitari
iusserunt.

16 Cum ergo tam magna potentia reges[2] non contemp-
serint latericiorum parietum structuras, quibus et
vectigalibus et praeda saepius licitum fuerat non
modo caementicio aut quadrato saxo sed etiam

[1] dare *G* : darent *H*. [2] abathon.
[3] reges *Joc* : regis.

[1] Mark set upon slaves. [2] Plut. *Rom. Q.* 37.
[3] *statio*, a guardhouse.

fleet in the harbour, concealing the rowers and the
marines she had got together, and ordered the rest
of the citizens to man the walls. Now when the
Rhodians had landed, with a fleet well equipped, in
the greater harbour, she commanded the citizens to
greet them from the walls and to promise to surrender
the town. These left their ships unmanned and
penetrated within the wall. Artemisia, using an
artificial outlet into the sea, suddenly led out her fleet
from the lesser harbour and thus sailed into the
greater. She then landed her soldiers and took the
empty Rhodian fleet away to sea. So the Rhodians,
having no place of retreat, were surrounded and
killed in the forum itself. 15. So Artemisia, placing
her own troops and rowers in the ships of the Rhodians
sailed for Rhodes. But when the Rhodians saw their
own ships come wreathed with laurel, they thought
their fellow-citizens returned victorious and let the
enemy in. Then Artemisia took Rhodes, killed the
leading citizens, and set up a trophy of her
victory in the city of Rhodes, having two bronze
statues made, one of the city of Rhodes, the other
in her own likeness. She had the latter figured as
setting a brand [1] upon the city of Rhodes. But
afterwards the Rhodians, being restrained by a
religious scruple because it is forbidden for trophies
once dedicated to be removed,[2] erected a building
round the spot and protected it with a Greek out-
post [3] to prevent anyone seeing, and ordered this
to be called " unapproachable " (*abaton*).

16. Since, therefore, kings of very great power
have not disdained walls built of brick (in cases where
wealth gained by taxation and plunder allowed the
use not only of rubble or squared stone, but even

marmoreo habere, non puto oportere inprobare quae
sunt e latericia structura facta aedificia, dummodo
recte sint tecta. Sed id genus quid ita populo
Romano in urbe fieri non oporteat, exponam, quaeque
sunt eius rei causae et rationes, non praetermittam.

17 Leges publicae non patiuntur maiores crassitudines
quam sesquipedales constitui loco communi; ceteri
autem parietes, ne spatia angustiora fierent, eadem
crassitudine conlocantur. Latericii vero, nisi diplinthii
aut triplinthii fuerint, sesquipedali crassitudine non
possunt plus [1] unam sustinere contignationem. In
ea autem maiestate urbis et civium infinita fre-
quentia innumerabiles habitationes opus est explicare.
Ergo cum recipere non possit [2] area planata tantam
multitudinem ad habitandum in urbe, ad auxilium
altitudinis aedificiorum res ipsa coegit devenire.
Itaque pilis lapideis structuris testaceis, parietibus
caementiciis [3] altitudines [4] extructae contignationibus
crebris coaxatae cenaculorum ad summas utilitates
perficiunt despectationes. Ergo moenibus e con-
tignationibus variis alto spatio multiplicatis populus
Romanus egregias habet sine inpeditione habitationes.

18 Quoniam ergo explicata ratio est, quid ita in urbe
propter necessitatem angustiarum non patiuntur
esse latericios parietes, cum extra urbem opus erit
his uti, sine vitiis ad vetustatem, sic erit facien-
dum. Summis parietibus structura testacea sub

[1] plus quam unam *G* : plus unam *H*.
[2] possint *Kr* : possunt. [3] caementaciis *H*.
[4] altitudinis *H*.

[1] Plin. *N.H.* XXXV. 173. This refers to sun-dried bricks,
lateres.

of marble), I do not think that buildings which are made of brick walls are to be disregarded so long as they are duly roofed. But why this fashion ought not to be followed out by the Roman people in the city I will set forth, and will not omit the causes and reasons of this. 17. Public statutes do not allow a thickness of more than a foot and a half to be used for party walls. But other walls also are put up of the same thickness lest the space be too much narrowed. Now brick walls of a foot and a half—not being two or three bricks thick—cannot sustain more than one story.[1] Yet with this greatness of the city and the unlimited crowding of citizens, it is necessary to provide very numerous dwellings. Therefore since a level site could not receive such a multitude to dwell in the city, circumstances themselves have compelled the resort to raising the height of buildings. And so by means of stone pillars, walls of burnt brick, party walls of rubble, towers [2] have been raised, and these being joined together by frequent board floors produce upper stories with fine views over the city to the utmost advantage. Therefore walls are raised to a great height through various stories, and the Roman people has excellent dwellings without hindrance.

18. Now, therefore, the reason is explained why, because of the limited space in the city, they do not allow walls to be of sun-dried bricks. When it shall be necessary to use them, outside the city, such walls will be sound and durable after the following manner. At the top of the walls let

[2] These blocks of tenements were five and six stories high. Augustus limited the height to 70 feet.

127

tegula subiciatur altitudine circiter sesquipedali
habeatque proiecturas coronarum. Ita vitari poterunt
quae solent in his fieri vitia; cum enim in tecto
tegulae fuerint fractae aut a ventis deiectae, qua
possint ex imbribus aqua perpluere, non patietur
lorica testacea laedi laterem, sed proiectura corona-
rum reiciet extra perpendiculum stillas et ea ratione
servaverit integras parietum latericiorum structuras.

19 De ipsa autem testa, si sit optima seu vitiosa ad
structuram, statim nemo potest iudicare, quod in
tempestatibus et aestate in tecto cum est conlocata,
tunc, si est firma, probatur; namque quae non
fuerit ex creta bona aut parum erit cocta, ibi se
ostendit [1] esse vitiosam gelicidiis et pruina tacta.
Ergo quae non in tectis poterit pati laborem, ea non
potest in structura oneri ferendo esse firma. Quare
maxime ex veteribus tegulis tecta structa; parietes
firmitatem poterunt habere.

20 Craticii [2] vero velim quidem ne inventi essent;
quantum enim celeritate et loci laxamento prosunt,
tanto maiori et communi sunt calamitati, quod ad
incendia uti faces sunt parati. Itaque satius esse
videtur inpensa testaceorum in sumptu, quam
compendio craticiorum esse in periculo. Etiamque [3]
in tectoriis operibus rimas in his faciunt arrec-
tariorum et transversariorum dispositione. Cum
enim linuntur, recipientes umorem turgescunt,
deinde siccescendo [4] contrahuntur et ita extenuati

[1] ostendet *G* : -dit *H*. [2] graticii *H*,
[3] etiamque *Schn* : etiam qui *H*. [4] sicciscendo *H*.

[1] Wattlework, Innocent, *English Building Construction*,
70, etc.
[2] Fires occurred at Rome frequently. A fire brigade,
cohors vigilum, was established A.D. 6.

walling of burnt brick be put beneath the tiles, and let it have a projecting cornice. So the faults which usually happen here can be avoided. For when tiles in the roof are broken or thrown down by the wind (where rain-water could pass through from showers), the burnt brick shield will not allow the brickwork to be damaged; but the projection of the cornices will throw the drippings outside the facing line, and in that way will keep intact the structure of brick walls. 19. But whether the baked brick itself is very good or faulty for building, no one can judge its strength offhand, because only when it is laid as a coping is it tested by weathering and lapse of time. For brickwork that is not made of good clay or is too little baked shows its faults on the work when weathered by ice and hoar-frost. Therefore the brickwork which cannot stand the strain in the coping courses cannot be strong enough in the walling to carry loads. Wherefore the coping courses are specially built from old tiles, and the walls will be strong enough.

20. I could wish that walls of wattlework [1] had not been invented. For however advantageous they are in speed of erection and for increase of space, to that extent are they a public misfortune, because they are like torches ready for kindling. [2] Therefore it seems better to be at greater expense by the cost of burnt brick than to be in danger by the convenience of wattlework walls: for these also make cracks in the plaster covering owing to the arrangement of the uprights and cross-pieces. For when the plaster is applied, they take up the moisture and swell, then when they dry they contract, and so they are rendered thin, and break the

disrumpunt tectoriorum soliditatem. Sed quoniam
nonnullos celeritas aut inopia aut in pendenti loco
dissaeptio cogit, sic erit faciundum.[1] Solum sub-
struatur, ut sit intactum ab rudere et pavimento;
obruta enim in his cum sunt, vetustate marcida fiunt;
deinde subsidentia proclinantur et disrumpunt
speciem tectoriorum.

De parietibus et apparitione generatim materiae
eorum, quibus sint virtutibus et vitiis, quemadmodum
potui, exposui; de contignationibus autem et copiis
earum, quibus conparentur, et ad vetustatem non
sint infirmae, uti natura rerum monstrat, explicabo.

IX

1 MATERIES caedenda est a primo autumno ad id
tempus, quod erit antequam flare incipiat favonius.
Vere enim omnes arbores fiunt praegnates et omnes
suae proprietatis virtutem efferunt in frondem anni-
versariosque fructus. Cum ergo inanes et umidae
temporum necessitate [2] eorum fuerint, vanae fiunt
et raritatibus inbecillae; uti etiam corpora muliebria,
cum conceperint, ad foetus a partu non iudicantur
integra, neque in venalibus ea, cum sunt praegnantia,
praestantur sana, ideo quod in corpore praeseminatio
crescens ex omnibus cibi potestatibus detrahit
alimentum in se, et quo firmior efficitur ad maturi-
tatem partus, eo minus patitur esse solidum id ex

 [1] faciendum *G*. [2] necessitate *rec* : -tes *H*.

 [1] The subject of this chapter is treated by Theophrastus,
Hist. Plant. V. i.

solidity of the plaster. But since haste, or lack of means, or partitions made over an open space, sometimes require this construction, we must proceed as follows. Let the foundation be laid high up, so that it is untouched by the rough stones of the pavement; for when they are fixed in these, they become rotten in time; then they settle, and falling forward they break through the surface of the plaster.

With respect to walls and the use of material after its kinds, I have explained their excellences and faults as I have been able. Now with respect to floors and the material from which they are provided, so that they may not be weakened by lapse of time, I will explain as nature shows.

CHAPTER IX

ON TIMBER

1. WOOD [1] is to be felled from the beginning of autumn to the time which comes before the blowing of the west wind. For in spring all trees become pregnant and discharge all the excellence of their own property into their foliage and yearly fruit. When, therefore, they are rendered empty and moist in their season, they become void and weak by their open structure. Females also, when they have conceived offspring, are not adjudged sound until delivery; and in the case of slaves, they are not guaranteed sound when they are pregnant, because the fertilisation as it spreads in the body draws nourishment to itself from the potencies of the food; and the stronger the offspring is rendered for its ripening, the less solid does it allow that to be

quo ipsum procreatur. Itaque edito foetu, quod
prius in aliud genus incrementi detrahebatur,
cum a disparatione[1] procreationis est liberatum,
inanibus et patentibus venis in se recipient. Lam-
bendo sucum etiam solidescit et redit in pristinam
2 naturae firmitatem. Eadem ratione autumnali tem-
pore maturitate fructuum flaccescente fronde, et
terra recipientes radices arborum in se sucum
reciperantur et restituuntur in antiquam soliditatem.
At vero aeris hiberni vis conprimit et consolidat eas
per id, ut supra scriptum est, tempus. Ergo si ea
ratione et eo tempore, quod est supra scriptum,
3 caeditur materies, erit tempestiva. Caedi autem
ita oportet, uti incidatur arboris crassitudo ad med-
iam medullam, et relinquatur, uti per eam ex-
siccescat stillando sucus. Ita qui inest in his inutilis
liquor effluens per torulum non patietur emori in eo
saniem nec corrumpi[2] materiae aequalitatem. Tum
autem, cum sicca et sine stillis erit arbor, deiciatur
4 et ita erit optima in usu. Hoc autem ita esse licet
animum advertere etiam de arbustis. Ea enim cum
suo quoque tempore ad imum perforata castrantur,
profundunt e medullis quae habent in se superantem
et vitiosum, per foramina liquorem, et ita siccescendo
recipiunt in se diuturnitatem. Quae autem non
habent ex arboribus exitus umoris, intra concrescentes
putrescunt, et efficiunt inanes eas vitiosas. Ergo si
stantes et vivae siccescendo non senescunt, sine
dubio cum eae[3] ad materiam deiciuntur, cum ea
ratione curatae fuerint, habere poterunt magnas
in aedificiis ad vetustatem utilitates.

[1] a disparatione *Perrault*: ad disperatione *H*.
[2] necorrumpi *H*.
[3] eae (*Ro*) ad materiam *Joc*: eadem materiam *H*.

from which it is engendered. And so when the
offspring is brought forth, what previously was
withdrawn to another kind of growth, the body
will receive into itself through the empty and
open pores. By taking up juices it becomes solid,
and returns to the strength of its former nature.
2. Likewise in autumn the leaves wither when the
fruits are ripe. The roots of the trees receive
into themselves the sap from the earth, and are
recovered and restored to their old solidity. But
the power of the winter air compresses and con-
solidates them through that time as is written above.
Therefore if the wood is cut in the manner and at
the time described above, it will be in season,
3. Now it ought to be cut so that the thickness of
the tree is cut to the middle of the pith, and left,
that the sap may dry out by dripping. Thus the
useless fluid which is in the veins flows out through
the sapwood, and does not let the watery part die
away in it, nor the quality of the wood to be cor-
rupted. But when the tree is dry and does not
drip, let it be cut down, and so it will be best in use.
4. This, moreover, we can perceive about shrubs
also. When they are bored through at the base
in their proper season and pruned, they pour forth
from the pith, through the openings, the excessive
and diseased fluid which they contain; and thus
by drying they gain durability. But those trees
which have no outlets of moisture, swell inside and
rot, and are rendered hollow and diseased. There-
fore, if by draining when they are standing and
alive trees are saved from decay, doubtless when
they are felled for timber, if they are treated in the
same way, they will have great advantages in
buildings for durability.

5 Hae[1] autem inter se discrepantes et dissimiles habent virtutes, uti robur, ulmus, populus, cupressus, abies ceteraque, quae maxime in aedificiis sunt idonea. Namque non potest id robur quod abies, nec cupressus quod ulmus, nec cetera easdem habent inter se natura rerum similitates, sed singula genera principiorum proprietatibus conparata alios alii 6 generis praestant in operibus effectus. Et primum abies aeris habens plurimum et ignis minimumque umoris et terreni, levioribus rerum naturae potestatibus conparata non est ponderata.[2] Itaque rigore naturali contenta non cito flectitur ab onere, sed directa permanet in contignatione. Sed ea, quod habet in se plus caloris, procreat et alit cariem[3] ab eaque vitiatur, etiamque ideo celeriter accenditur, quod quae inest in eo corpore aeris raritas et est patens, accipit ignem et ita vehementem ex se 7 mittit flammam. Ex ea autem, antequam est excisa, quae pars est proxima terrae, per radices recipiens ex proximitate umorem enodis et liquida efficitur; quae vero est superior, vehementia caloris eductis in aera per nodos ramis, praecisa alte circiter pedes xx et perdolata propter nodationis duritiem dicitur esse fusterna. Ima autem, cum excisa quadrifluviis disparatur, eiecto torulo ex eadem arbore ad intestina opera conparatur et ab infima fusterna[4] sappinea 8 vocatur. Contra vero quercus terrenis principiorum

[1] hae G : ea $H S$. [2] ponderata H.
[3] cariem *ed. Fl* : partem H.
[4] et ab infima fusterna Kr : et intima fusternea H.

[1] *alii* as gen. of *alius* is found in Cic. and Varro.
[2] The Baltic fir of to-day runs to about 35 feet without knots.
[3] The diameter is divided into four parts, and perpendiculars are set up ¼ of the diameter from either end. These intersect

5. Now trees have virtues varying and unlike one with another; for example, oak, elm, poplar, cypress, fir, and the rest which are most suitable in buildings. For the oak has not the same power as the fir, nor the cypress as the elm, nor have the rest by nature the same resemblances one with another. But the several kinds furnished with the properties of their first principles provide in the work various [1] effects. 6. And first, the fir has most air and fire and least moisture and earth. Being thus furnished with the lighter powers of Nature, it is not weighed down. It is held together by a natural stiffness, and is not quickly bent by a load, but remains straight in the flooring. But timber which has more heat generates and feeds decay and is diseased by it. Fir is also soon kindled because the rarefaction of the air which is present in this body, and is porous, receives the fire, and so sends forth a vehement flame. 7. Of the tree before it is cut down, the part which is nearest the earth receives the moisture from the neighbourhood through the roots and is rendered free from knots and moist. The upper part (since by the vehemence of the heat the branches are carried into the air through the knots) is cut off about twenty feet up.[2] It is rough-axed and because of the hardness of the knotted portion is called " knotwood." The lowest portion, however, when it is cut and divided in four directions,[3] and the sapwood [4] is rejected from the same tree, is used for inside work, and is called " deal." 8. The oak (*quercus robur*), on the other hand, abounds

the circumference, and lines are drawn to both ends of the diameter so as to form a rectangle, *Builder's Work*, 137.

[4] The sapwood is the outside ring of soft wood.

satietatibus abundans parumque habens umoris
et aeris et ignis, cum in terrenis operibus obruitur,
infinitam habet aeternitatem. Ex eo cum tangitur
umore, non habens foraminum raritates propter
spissitatem non potest in corpus recipere liquorem,
sed fugiens ab umore resistit et torquetur et efficit,
9 in quibus est operibus, ea rimosa. Aesculus vero,
quod est omnibus principiis temperata, habet in
aedificiis magnas utilitates; sed ea, cum in umore
conlocatur, recipiens penitus per foramina liquorem
eiecto aere et igni operatione umidae potestatis
vitiatur. Cerrus quercus fagus, quod pariter habent
mixtionem umoris et ignis et terreni, aeris plurimum,
provisa [1] raritates umoris penitus recipiendo celeriter
marcescunt. Populus alba et nigra, item salix, tilia
vitex ignis et aeris habendo satietatem, umoris
temperate, parum autem terreni habens [2] leviore
temperatura comparata, egregiam habere videtur
in usu rigiditatem. Ergo cum non sint dura terreni
mixtione propter raritatem sunt candida et in sculp-
10 turis commodam praestant tractabilitatem. Alnus
autem, quae proxima fluminum ripis procreatur et
minime materies utilis videtur, habet in se egregias
rationes. Etenim aere et igni plurimo temperata, non
multum terreno, umore paulo. Itaque in palustribus [3]

[1] puisa *H* : provisa *Gr.* [2] habentes *H* : habens *G.*
[3] itaque in palustribus *Schn.*: itaque non minus habent
in corpore umoris in plaustribus *H.*

[1] Oak lasts for indefinite periods when buried in the ground
and is known as "bog oak."
[2] It is almost impossible to guarantee the best oak against
warping.
[3] *Quercus sessiliflora,* a variety of the preceding, was sacred
to Jupiter and is tall.

in earthy saturations of the elements, and has little moisture and air and fire. When it is buried in foundations, it has unlimited duration.[1] Hence, when it is touched by moisture, not having open pores, it cannot because of its density admit fluids into its substance, but, shrinking from moisture, it stands and is warped [2] and causes cracks in the work.

9. But the winter oak (*quercus aesculus*[3]), because it is blended with all the elements, has great advantages in building. Yet when it is placed in water, it admits the fluid within, through the pores, and losing air and fire is damaged by the operation of the humid potency. The Turkey oak [4] and the beech, because they have a mixture of the humid, the fiery and the earthy, and an excess of air, being furnished with open pores, admit moisture and quickly decay. The white and black poplar, the willow also, the lime, the agnus castus,[5] having the fire and air to saturation, the humid in moderation, too little of the earthy, are composed of a lighter mixture, and seem to have unusual firmness in use. Although, therefore, they are not hard owing to the mixture of the earthy, they are rendered white by their porous structure and are convenient to handle in the case of carving. 10. But the alder, which grows next the banks of rivers, and seems a useless timber, has nevertheless some remarkable applications. For it is blended with much air and fire, not much earth, little of the humid. And so frequently

[4] The Turkey oak grows more quickly, but does not produce such good timber.

[5] A tall tree, like the willow.

locis infra fundamenta aedificiorum palationibus
crebre fixa, recipiens in se quod minus habet in corpore
liquoris, permanet inmortalis ad aeternitatem et
sustinet inmania pondera structurae et sine vitiis
conservat. Ita quae[1] non potest extra terram
paulum tempus durare, ea in umore obruta per-
11 manet ad diuturnitatem. Est autem maximum id
considerare Ravennae, quod ibi omnia opera et
publica et privata sub fundamentis eius generis
habeant palos. Ulmus vero et fraxinus maximos
habent umoris minimumque aeris et ignis, terreni
temperate mixtione comparatae. Sunt in operibus,
cum fabricantur, lentae et ab pondere umoris non
habent rigorem et celeriter pandant; simul autem
vetustate sunt aridae factae aut in agro perfecto qui
est eis liquor stantes emoriuntur, fiunt duriores et in
commissuris et coagmentationibus ab lentitudine
12 firmas recipiunt catenationes. Item carpinus, quod
est minima ignis et terreni mixtione, aeris autem et
umoris summa continetur temperatura, non est
fragilis, sed habet utilissimam tractabilitatem.
Itaque Graeci, quod ex ea materia iuga iumentis
conparant, quod apud eos iuga *zyga* vocitantur,
item *zygian* eam[2] appellant. Non minus est
admirandum de cupresso et pinu, quod eae habentes
umoris abundantiam aequamque ceterorum mix-
tionem, propter umoris satietatem in operibus solent
esse pandae, sed in vetustatem sine vitiis conservan-
tur, quod is liquor, qui inest penitus in corporibus
earum, habet amarum saporem qui propter acri-

[1] itaq, *H* (*corr. Joc.*) [2] Ζυγιαν eam *Joc* : zigaeam *H*.

[1] In modern times usually replaced by concrete.
[2] The alternative name " yoke-elm " is parallel to the Greek

alder stakes, being fixed in marshy ground below
the foundations of buildings, admit fluid because
they have a less quantity in their substance. Hence
they remain imperishable to eternity, uphold
immense weights of walling, and preserve them
without decaying. Thus a timber which cannot
endure even a short time above ground, when it is
buried in moisture abides for long periods. 11.
Now we can best consider this at Ravenna; because
there all works both public and private have piles [1]
of this kind under their foundations. But the elm
and the ash have an excess of moisture, very little
air and fire, and are provided moderately with a
mixture of the earthy. When they are wrought
for buildings they are pliant, and, owing to the
weight of moisture, they are without stiffness and
quickly bend. In time, however, they become
dried up, or the moisture which is in them being
cast forth, they are allowed to die off, standing in
the open. At the same time they become harder,
and owing to their pliability they make good joints,
both upright and horizontal. 12. The hornbeam [2]
has a slight mixture of fire and earth, and is com-
pounded with a full supply of air and moisture;
it is not fragile, but is most convenient to handle.
And so the Greeks, because they prepare yokes for
cattle from this wood, and because among them
yokes are called *zyga*, also call it *zygia*. There is
not less cause for wonder in the cypress and the
pine. They have abundance of moisture, equal
to the whole mixture of the rest. Because of their
saturation with moisture, they usually warp in use,
but they last for a long time without decay. For
the moisture which is within the timber has a bitter

tudinem non patitur penetrare cariem neque eas
bestiolas quae sunt nocentes. Ideoque quae ex his
generibus opera constituuntur, permanent ad aeter-
13 nam diuturnitatem. Item cedrus et iuniperus easdem
habent virtutes et utilitates; sed quemadmodum
ex cupressu et pinu resina, ex cedro oleum quod
cedrium [1] dicitur, nascitur, quo reliquae res cum [2]
sunt unctae, uti etiam libri, a tineis et carie non
laeduntur. Arboris [3] autem eius sunt similes
cupresseae foliaturae; materies vena directa.
Ephesi [4] in aede simulacrum Dianae ex ea,[5] lacunaria
et ibi et in ceteris nobilibus fanis propter aeterni-
tatem sunt facta. Nascuntur autem eae arbores
maxime Cretae et Africae et nonnullis Syriae
14 regionibus. Larix vero, qui non est notus nisi is
municipalibus qui sunt circa ripam fluminis Padi
et litora maris Hadriani, non solum ab suco vehementi
amaritate ab carie aut tinea non nocetur, sed etiam
flammam ex igni non recipit, nec ipse per se potest
ardere, nisi uti saxum in fornace ad calcem coquen-
dam aliis lignis uratur; nec tamen tunc flammam
recipit nec carbonem remittit, sed longo spatio
tarde comburitur. Quod est minima ignis et aeris
e principiis temperatura, umore autem et terreno
est spisse solidata, non habet spatia foraminum, qua
possit ignis penetrare, reicitque eius vim nec patitur
ab eo sibi cito noceri, propterque pondus ab aqua

[1] cedrium *Plin.* 16, 52 : cidreum *H*.
[2] corelique res cum *H*. [3] arboris *Phil* : -res *H*.
[4] aephesi *H*. [5] ex ea *Kr* : etiam *H*.

[1] The paper received a yellow tinge. Papyrus began to be
replaced at Rome by vellum at the end of the republic.

flavour. Because of its bitterness it prevents the entrance of decay and of those small creatures which are injurious. And so the works which are executed from these kinds of trees endure an unlimited time. 13. Cedar and juniper, also, have the same virtues and advantages. Just as resin comes from cypress and pine, so from cedar comes the oil which is called oil of cedar. When other things, as, for example, books, are soaked with this,[1] they escape injury from worms and dry rot. The tree is like the cypress in foliage; the wood is of a straight vein. In the temple at Ephesus, the image of Diana, the coffers of the ceiling also, are made of these trees[2]—as also in other famous temples—because of their durability. Now these trees are found especially in the regions of Crete and Africa and parts of Syria. 14. The larch is known only to the provincials on the banks of the river Po and the shores of the Adriatic Sea. Owing to the fierce bitterness of its sap, it is not injured by dry rot or the worm. Further, it does not admit flame from fire, nor can it burn of itself; only along with other timber it may burn stone in the kiln for making lime. Nor even then does it admit flame or produce charcoal, but is slowly consumed over a long interval. For there is the least admixture of fire and air, while the moist and the earthy principles are closely compressed. It has no open pores by which the fire can penetrate, and repels its force and prevents injury being quickly done to itself by fire. Because of its weight it is not sus-

[2] Cedar was largely used in Solomon's temple. Another authority affirms that the image of Diana was of ebony. Plin. *N.H.* XVI. 213.

non sustinetur, sed cum portatur, aut in navibus aut supra abiegnas rates conlocatur.

15 Ea autem materies quemadmodum sit inventa, est causa cognoscere. Divus Caesar cum exercitum habuisset circa Alpes imperavissetque municipiis praestare commeatus, ibique esset castellum munitum, quod vocaretur Larignum, tunc, qui in eo fuerunt, naturali munitione confisi noluerunt imperio parere. Itaque imperator copias iussit admoveri. erat autem ante eius castelli portam turris ex hac materia alternis trabibus transversis uti pyra inter se composita alte, uti posset[1] de summo sudibus et lapidibus accedentes repellere. Tunc vero cum animadversum est alia eos tela praeter sudes non habere neque posse longius a muro propter pondus iaculari, imperatum est fasciculos ex virgis alligatos et faces ardentes ad eam munitionem accedentes

16 mittere. Itaque celeriter milites congesserunt. Posteaquam flamma circa illam materiam virgas comprehendisset, ad caelum sublata[2] efficit opinionem, uti videretur iam tota moles concidisse. Cum autem ea per se extincta esset et re quieta turris intacta apparuisset, admirans Caesar iussit extra telorum missionem eos circumvallari. Itaque timore coacti oppidani cum se dedidissent, quaesitum, unde essent ea ligna quae ab igni non laederentur. Tunc ei demonstraverunt eas arbores, quarum in his locis maximae sunt copiae. Et ideo id castellum Larignum, item materies larigna est appellata. Haec autem per

[1] possent *Lor* : posset *H*. [2] sublata *G* : -tam *H*.

[1] This seems to have been based on direct observation.
[2] The provincial war tax, *annona militaris*, usually in kind.

tained by water; but when it is carried, it is placed on board ship, or on pine rafts.

15. We have reason to inquire how this timber was discovered.[1] After the late emperor Caesar had brought his forces into the neighbourhood of the Alps, and had commanded the municipalities to furnish supplies,[2] he found there a fortified stronghold which was called Larignum. But the occupants trusted to the natural strength of the place and refused obedience. The emperor therefore commanded his forces to be brought up. Now before the gate of the stronghold there stood a tower of this wood with alternate cross-beams bound together like a funeral pyre, so that it could drive back an approaching enemy by stakes and stones from the top. But when it was perceived that they had no other weapons but stakes, and because of their weight they could not throw them far from the wall, the order was given to approach, and to throw bundles of twigs and burning torches against the fort. And the troops quickly heaped them up. 16. The flame seizing the twigs around the wood, rose skyward and made them think that the whole mass had collapsed. But when the fire had burnt itself out and subsided. and the tower appeared again intact, Caesar was surprised and ordered the town to be surrounded by a rampart outside the range of their weapons. And so the townspeople were compelled by fear to surrender. The inquiry was made where the timber came from which was unscathed by the fire. Then they showed him the trees, of which there is an abundant supply in these parts. The fort was called Larignum following the name of the larch wood.

Padum Ravennam deportatur. In colonia Fanestri, Pisauri, Anconae reliquisque, quae sunt in ea regione, municipiis praebetur. Cuius materies si esset facultas adportationibus ad urbem, maximae haberentur in aedificiis utilitates, et si non in omne, certe tabulae in subgrundiis circum insulas si essent ex ea conlocatae, ab traiectionibus incendiorum aedificia periculo liberarentur, quod ea neque flammam nec carbonem possunt recipere nec facere 17 per se. Sunt autem eae arbores foliis similibus pini; materies earum prolixa, tractabilis ad intestinum opus non minus quam sappinea, habetque resinam liquidam mellis Attici colore, quae etiam medetur phthisicis.

De singulis generibus, quibus proprietatibus e natura rerum videantur esse conparatae quibusque procreantur rationibus, exposui. Insequitur animadversio, quid ita quae in urbe supernas dicitur abies, deterior est, quae infernas, egregios in aedificiis ad diuturnitatem praestat usus, et de his rebus, quemadmodum videantur e locorum proprietatibus habere vitia aut virtutes, uti ea sint[1] considerantibus apertiora, exponere.[2]

X

1 MONTIS Appennini primae radices ab Tyrrenico mari in Alpis et in extremas Etruriae regiones oriuntur. Eius vero montis iugum se circumagens

[1] ea (*Kr*) sint *Joc* : essent *H*.
[2] exponere *Ro* : exponerem *H*.

[1] Probably floated down the stream on rafts of pine.
[2] Coupled with Pisaurum, Wilmann's *Inscr. Lat.* 1215, and Ancona, *op. cit.* 674.

Now this is brought down the Po to Ravenna [1]; there are also supplies at the Colony [2] of Fanum, at Pisaurum and Ancona and the municipia in that region. And if there were a provision for bringing this timber to Rome, there would be great advantages in building; and if such wood were used, not perhaps generally, but in the eaves round the building blocks, these buildings would be freed from the danger of fires spreading. For this timber can neither catch fire nor turn to charcoal, nor burn of itself. 17. Now these trees have leaves like those of the pine, the timber is tall, and for joinery work not less handy than deal. It has a liquid resin coloured like Attic honey. This is a cure for phthisical persons.

Concerning the several kinds of trees, I have set forth the properties of which they seem to be naturally composed, and the manner in which they come to grow. The inquiry follows why the pine called Highland in Rome is inferior, whereas the so-called Lowland pine furnishes striking advantages for durability in buildings. On this topic I will set forth how they seem to acquire defects or excellences from the properties of their localities, so that they may be more obvious to the inquirer.

CHAPTER X

HIGHLAND AND LOWLAND FIR

1. THE first roots of the Apennines rise from the Tyrrhenian sea towards the Alps [3] and the borders of Etruria. But the ridge of the range bends

[3] The Maritime Alps.

et media curvatura prope tangens oras maris
Hadriani pertingit circumitionibus contra fretum.
Itaque citerior eius curvatura quae vergit ad
Etruriae Campaniaeque regiones, apricis est potes-
tatibus; namque impetus habet perpetuos ad
solis cursum. Ulterior autem, quae est proclinata
ad superum mare, septentrionali regioni subiecta
continetur umbrosis et opacis perpetuitatibus. Ita-
que quae in ea parte nascuntur arbores, umida
potestate nutritae non solum ipsae augentur am-
plissimis magnitudinibus, sed earum quoque venae
umoris copia repletae urgentis [1] liquoris abundantia
saturantur. Cum autem excisae et dolatae vitalem
potestatem amiserunt, venarum rigore permanente
siccescendo propter raritatem fiunt inanes et evanidae,
ideoque in aedificiis non possunt habere diuturnita-
2 tem. Quae autem ad solis cursum spectantibus
locis procreantur, non habentes interveniorum [2]
raritates siccitatibus exsuctae solidantur, quia sol
non modo ex terra lambendo sed etiam ex arboribus
educit umores. Itaque, sunt in apricis regionibus,
spissis venarum crebritatibus solidatae non habentes
ex umore raritatem; quae, cum in materiem
perdolantur, reddunt magnas utilitates ad vetu-
statem. Ideo infernates, quod ex apricis locis
adportantur, meliores sunt, quam quae ab opacis
de supernatibus advehuntur.
3 Quantum animo considerare potui, de copiis quae
sunt necessariae in aedificiorum conparationibus,

[1] turgentes *rec* : urgentes *H*.
[2] interveniorum *Joc* : inter venarum *H*.

round and in the middle of the curve almost touches the shores of the Adriatic. In its circuit it reaches the opposite straits.[1] The nearer slope, which turns to the regions of Etruria and Campania, has a sunny aspect. For it has an unbroken direction towards the sun's course. But the further slope, which inclines to the Adriatic, lies towards the northern quarter, and is bounded by unbroken tracts of land overshadowed and gloomy. And so the trees which grow in that part absorb a humid element. Not only do they grow to an immense size, but their pores, being filled with a supply of moisture, are saturated with an abundance of pressing fluid. But when they are cut down and axed they lose their vital force: remaining with the pores stiff and open, they dry, become hollow and perishable, and so cannot last in buildings. 2. But those which grow in places facing the sun's course, lacking the open spaces of the pores, are drained by dryness and solidified. For the sun licks up and draws moisture not only from the ground but also from trees. And so the trees in sunny regions are solidified by the closeness of their pores, and are free from the attenuation which is caused by moisture. When they are hewn into timber they furnish great advantages for durability. Therefore the lowland pine because it is brought from sunny districts is better than that which is brought from sunless districts in the highlands.

3. As far as I have been able to consider them in my mind I have set forth the supplies which are necessary in the erection of buildings, the natural

[1] The Apennines go from north to south almost to Brindisi.

VITRUVIUS

et quibus temperaturis e rerum natura principiorum habere videantur mixtionem quaeque insunt in singulis generibus virtutes et vitia, uti non sint ignota aedificantibus, exposui. Ita, qui potuerint eorum praeceptorum sequi praescriptiones, erunt prudentiores singulorumque generum usum eligere poterunt in operibus. Ergo quoniam de apparitionibus est explicatum, in ceteris voluminibus de ipsis aedificiis exponitur; et primum de deorum inmortalium aedibus sacris et de earum symmetriis et proportionibus, uti ordo postulat, insequenti perscribam.

combinations by which they seem to have their elements mixed, the excellences and defects which are present in their several kinds, so that they may not be unknown to persons engaged in building. Thus, if anyone can follow out the instructions laid down, he will be wiser and more able in his work to choose the use of the several kinds of material. Since then we have explained the modes of preparation, in the remaining books we set forth the kinds of building. And first, as order demands, I will describe in the following book the temples of the immortal gods, their symmetries and proportions.

BOOK III

LIBER TERTIUS

1 DELPHICUS Apollo Socratem omnium sapientissimum Pythiae responsis est professus. Is autem memoratur prudenter doctissimeque dixisse, oportuisse hominum pectora fenestrata et aperta esse, uti non occultos haberent sensus sed patentes ad considerandum. Utinam vero rerum natura sententiam eius secuta explicata et apparentia ea constituisset ! Si enim ita fuisset, non solum laudes aut vitia animorum ad manum aspicerentur, sed etiam disciplinarum scientiae sub oculorum consideratione subiectae non incertis iudiciis probarentur, sed et doctis et scientibus auctoritas egregia et stabilis adderetur. Igitur quoniam haec non ita, sed uti natura rerum voluit, sunt constituta, non efficitur ut possint homines obscuratis sub pectoribus ingeniis scientias artificiorum penitus latentes, quemadmodum sint, iudicare. Ipsique artifices pollicerentur suam prudentiam, si non pecunia sint copiosi sed vetustate officinarum habuerint notitiam ; aut etiam gratia forensi et eloquentia cum fuerint parati, pro industria studiorum auctoritates possunt habere, ut eis, quod 2 profitentur scire, id crederetur. Maxime autem id animadvertere possumus ab antiquis statuariis et pictoribus, quod ex his, qui dignitates notas et

¹ The Greeks used *technites*, the Romans *artifex*, for all handworkers whether artists or artisans.

BOOK III

1. DELPHIC Apollo, by the replies of the Pythian priestess, declared Socrates the wisest of all men. He is recorded to have said with wisdom and great learning that the hearts of men ought to have had open windows so that they might not keep their notions hidden, but open for inspection. Would that Nature had followed his opinion, and made them explicit and manifest! For if it had been so, not only would the merits or defects of human minds be seen at once, but the knowledge of disciplines also, lying under the view of the eyes, would be tested by no uncertain judgments; and a distinguished and lasting authority would be added both to learned and to accomplished men. Therefore since these things have been ordained otherwise, and as Nature willed, it is impossible for other men, when talent is concealed in the breast, to judge how such deeply hidden knowledge of the arts really stands. Yet those craftsmen [1] themselves would offer their skill who while they lack wealth yet have the knowledge based on workshop experience; or indeed when they are equipped with the graceful eloquence of the pleader, they can gain the authority corresponding to their industry, and have the credit of knowing what they profess. 2. Now we can best observe this in the case of ancient statuaries and painters; for of these, those who have a recognised dignity and the influence

153

commendationis gratiam habuerunt, **aeterna memoria**
ad posteritatem sunt permanentes, uti Myron,
Polycletus, Phidias, Lysippus ceterique, qui nobili-
tatem ex arte sunt consecuti. Namque ut civitatibus
magnis aut regibus aut civibus nobilibus opera
fecerunt, ita id sunt adepti. At qui non minori [1] studio
et ingenio sollertiaque fuerunt nobilibus et humili for-
tuna civibus non minus egregie perfecta fecerunt opera,
nullam memoriam sunt adsecuti, quod hi non ab
industria neque artis sollertia sed a Felicitate fuerunt
decepti,[2] ut Hegias [3] Atheniensis, Chion Corinthius,
Myagrus Phocaeus, Pharax Ephesius, Boedas Byzan-
tius etiamque alii plures. Non minus item, pictores,
uti Aristomenes Thasius, Polycles et Androcydes [4]
⟨Cyzice⟩[5]ni, Theo Magnes [6] ceterisque, quos neque
industria neque artis studium neque sollertia defecit,
sed aut rei familiaris exiguitas aut inbecillitas
fortunae seu in ambitione certationis contrariorum
3 superatis [7] obstitit eorum dignitati. Nec tamen est
admirandum, si propter ignotitiam artis virtutes
obscurantur, sed maxime indignandum, cum etiam
saepe blandiatur gratia conviviorum a veris iudiciis
ad falsam probationem. Ergo, uti Socrati placuit, si

[1] minori H. [2] decepti e_2: desepti H.
[3] Hegias Ro (cf. *Plin.* 34, 49 *et* 78) : hellas H.
[4] Androcydes Kr (cf. *Plin.* 35, 64) : andramithes H.
[5] Cyziceni Kr (cf. *Plut. Pelop.* 25) : ni H.
[6] Magnes Mar : magnis H.
[7] superatis Joc : superati H.

[1] Book I. i. 13.
[2] The sculptor of the Parthenon : the work was carried out
under his general direction. He was the actual sculptor of
the Images of Athena at Athens, and of Jupiter (Zeus) at
Olympia.

based on commendation abide to after times in an everlasting remembrance : Myron,[1] Polyclitus,[1] Phidias,[2] Lysippus [3] and others who from their art have attained renown. For they got it by working for great states or kings or famous citizens. But those who had not less eagerness, and were distinguished by talent and skill, but being of humble fortune executed for their fellow-citizens works not less perfect, gained no reputation. For they were left behind not in perseverance or in skill but by Good Fortune: for example, Hegias [4] of Athens, Chion of Corinth, Myagrus the Phocean,[5] Pharax of Ephesus, Boedas of Byzantium [6] and many others also; painters also not less, such as Aristomenes the Thasian, Polycles and Androcydes [7] of Cyzicus, Theo [8] the Magnesian, and others to whom neither industry nor craftsman's zeal nor skill was lacking : but their reputation was hindered, either by scanty possessions, or poor fortune, or the victory of rivals in competitions. 3. Yet we must not be surprised if excellence is in obscurity through the public ignorance of craftsmanship. But we ought to be specially indignant when also, as often happens, social influence beguiles men from exact judgments to a feigned approval. Therefore, as Socrates

[3] The sculptor of the Apoxyomenus, represented by the Vatican copy.

[4] Rival of Phidias. His "Horse-riders" was a famous piece.

[5] Carved athletes, Plin. *N.H.* XXXIV. 91.

[6] Pupil of Lysippus, Plin. *N.H.* XXXIV. 66, carved figure praying, *ib.* 73.

[7] Contemporary and rival of Zeuxis, Plin. *N.H.* XXXV. 64.

[8] Painted the madness of Orestes, Plin. *N.H.* XXXV. 144.

ita sensus et sententiae scientiaeque disciplinis auctae
perspicuae et perlucidae fuissent, non gratia neque
ambitio valeret, sed si qui veris certisque laboribus
doctrinarum pervenissent ad scientiam summam, eis
ultro opera traderentur. Quoniam autem ea non
sunt inlustria neque apparentia in aspectu, ut putamus
oportuisse, et animadverto potius indoctos quam
doctos gratia superare, non esse certandum iudicans
cum indoctis ambitione, potius his praeceptis editis
ostendam nostrae scientiae virtutem.

4 Itaque, imperator, in primo volumine tibi de arte et
quas habeat ea virtutes quibusque disciplinis oporteat
esse auctum architectum, exposui et subieci causas,
quid ita earum oporteat eum esse peritum, rationesque
summae architecturae partitione distribui finitioni-
busque terminavi. Deinde, quod erat primum et
necessarium, de moenibus, quemadmodum eligantur
loci[1] salubres, ratiocinationibus explicui, ventique
qui sint et e quibus ⟨regionibus⟩[2] singuli spirant,
deformationibus grammicis[3] ostendi, platearumque et
vicorum uti emendate fiant distributiones in moeni-
bus, docui et ita finitionem primo volumine constitui.
Item in secundo de materia, quas habeat in operibus
utilitates et quibus virtutibus e natura rerum est com-
parata, peregi. Nunc in tertio de deorum inmor-
talium aedibus sacris dicam et, uti oporteat, per-
scriptas exponam.

 [1] loci *rec* : locis *H*. [2] *add. Joc.*
 [3] grammicis *Joc* : grammaticis *H*.

thought, if human notions and opinions and knowledge increased by study were manifest and transparent, neither influence nor intrigue would avail; but commissions would be entrusted to such persons as had attained the highest knowledge by their genuine and assured professional labour. Since, however, these things are not conspicuous nor apparent to the sight, as we think they ought to have been, and I perceive the ignorant excel in influence rather than the learned, I judge that we must not rival the ignorant in their intrigues; but I will rather display the excellence of our knowledge by the publication of these rules.

4. Therefore, your Highness, in the first book, I set before you our craft and its excellences and the studies by which the architect should improve himself; I furnished the reasons why he ought to be skilled in them; I analysed the methods of architecture generally, and assigned their limits by my definitions. Then, as matter of prime necessity, I explained by argument with reference to walled cities, how healthy sites are chosen and showed by geometrical figures the various winds, and the quarters from which they severally blow. I taught the way to distribute in an accurate manner the main and side streets within the walls, and so completed my first book. In the second book I dealt with the employment of materials in building and with the excellences which they naturally possess. Now in the third book I will speak of the temples of the Gods and will set them out in detail in a proper manner.

I

1 AEDIUM compositio constat ex symmetria, cuius
rationem diligentissime architecti tenere [1] debent.
Ea autem paritur a [2] proportione, quae graece
analogia dicitur. Proportio est ratae partis mem-
brorum in omni opere totiusque [3] commodulatio,
ex qua ratio efficitur symmetriarum. Namque non
potest aedis ulla sine symmetria atque proportione
rationem habere compositionis, nisi uti ad hominis
bene figurati membrorum habuerit exactam rationem.
2 Corpus enim hominis ita natura composuit, uti os
capitis a mento ad frontem summam et radices imas
capilli esset decimae partis, item manus palma ab
articulo ad extremum medium digitum tantundem,
caput a mento ad summum verticem octavae,[4] cum
cervicibus imis ab summo pectore ad imas radices
capillorum sextae, ⟨a medio pectore⟩ [5] ad summum
verticem quartae. Ipsius autem oris altitudinis
tertia est pars ab imo mento ad imas nares, nasum
ab imis naribus ad finem medium superciliorum
tantundem, ab ea fine ad imas radices capilli [6] frons
efficitur item tertiae partis. Pes vero altitudinis
corporis sextae,[7] cubitum quartae, pectus item
quartae. Reliqua quoque membra suas [8] habent
commensus proportiones, quibus etiam antiqui

[1] teneri *H*. [2] paritur a *rec* : paritura pr. *H*.
[3] totiusque *Joc* : totaque *H*. [4] octae *H*.
[5] *add. Gal.* [6] capillis *H*.
[7] extae *H*. [8] suas *Lor* : suos *H*.

[1] The Greek and Roman artists treated the human body as
the standard of beauty. The statement in the fourth Gospel
ii. 21 refers to the body as the abode of the Spirit.

CHAPTER I

THE PLANNING OF TEMPLES

1. THE planning of temples depends upon symmetry: and the method of this architects must diligently apprehend. It arises from proportion (which in Greek is called *analogia*). Proportion consists in taking a fixed module, in each case, both for the parts of a building and for the whole, by which the method of symmetry is put into practice. For without symmetry and proportion no temple can have a regular plan; that is, it must have an exact proportion worked out after the fashion of the members of a finely-shaped human body.[1] 2. For Nature[2] has so planned the human body that the face from the chin to the top of the forehead and the roots of the hair is a tenth part; also the palm of the hand from the wrist to the top of the middle finger is as much; the head from the chin to the crown, an eighth part; from the top of the breast with the bottom of the neck to the roots of the hair, a sixth part; from the middle of the breast to the crown, a fourth part; a third part of the height of the face is from the bottom of the chin to the bottom of the nostrils; the nose from the bottom of the nostrils to the line between the brows, as much; from that line to the roots of the hair, the forehead is given as the third part. The foot is a sixth of the height of the body; the cubit a quarter, the breast also a quarter. The other limbs also have their own proportionate measurements. And by using

[2] Here the intention of Nature is thought to appear in a type or canon such as that of Polyclitus, or, later, of Lysippus.

pictores et statuarii nobiles usi magnas et infinitas
3 laudes sunt adsecuti. Similiter vero sacrarum aedium
membra ad universam totius magnitudinis summam
ex partibus singulis convenientissimum debent habere
commensus responsum. Item corporis centrum me-
dium naturaliter est umbilicus. Namque si homo
conlocatus fuerit supinus [1] manibus et pedibus pansis
circinique conlocatum centrum in umbilico eius,
circumagendo rotundationem utrarumque manuum
et pedum digiti linea tangentur. Non minus
quemadmodum schema [2] rotundationis in corpore
efficitur, item quadrata designatio in eo invenietur.
Nam si a pedibus imis ad summum caput mensum
erit eaque mensura relata fuerit ad manus pansas,[3]
invenietur eadem latitudo uti altitudo, quemad-
modum areae quae ad normam sunt quadratae.
4 Ergo si ita natura conposuit corpus hominis, uti
proportionibus membra ad summam figurationem
eius respondeant, cum causa constituisse videntur
antiqui, ut etiam in operum perfectionibus singulorum
membrorum ad universam figurae speciem habeant
commensus exactionem. Igitur cum in omnibus
operibus ordines traderent, maxime in aedibus
deorum, operum et laudes et culpae aeternae solent
permanere.
5 Nec minus mensurarum rationes, quae in omnibus
operibus videntur necessariae [4] esse, ex corporis
membris collegerunt, uti digitum, palmum, pedem,
cubitum, et eas distribuerunt in perfectum numerum,
quem Graeci *teleon* dicunt. Perfectum autem antiqui

[1] sopinus *H*.		[2] scaema *H*.
[3] spansas *H*.		[4] necessaria *H*.

[1] The explanation of the orders by reference to the pro-
portions of the human body follows : Book IV. i.

these, ancient painters and famous sculptors have
attained great and unbounded distinction. 3. In
like fashion the members of temples ought to have
dimensions of their several parts answering suitably
to the general sum of their whole magnitude. Now
the navel is naturally the exact centre of the body.
For if a man lies on his back with hands and feet
outspread, and the centre of a circle is placed on
his navel, his figure and toes will be touched by the
circumference. Also a square will be found de-
scribed within the figure, in the same way as a
round figure is produced. For if we measure from
the sole of the foot to the top of the head, and apply
the measure to the outstretched hands, the breadth
will be found equal to the height, just like sites
which are squared by rule. 4. Therefore if Nature
has planned the human body so that the members
correspond in their proportions to its complete
configuration, the ancients seem to have had reason
in determining that in the execution of their works
they should observe an exact adjustment of the
several members to the general pattern of the plan.
Therefore, since in all their works they handed down
orders,[1] they did so especially in building temples,
the excellences and the faults of which usually
endure for ages.

5. Moreover, they collected from the members
of the human body the proportionate dimensions
which appear necessary in all building operations;
the finger or inch, the palm, the foot, the cubit.
And these they grouped into the perfect number[2]
which the Greeks call *teleon*.[3] Now the ancients

[2] Plato's *Republic*, 546.
[3] *Teleon* is a better spelling than *teleion* and is found in *H*.

instituerunt numerum qui decem dicitur; namque
ex manibus digitorum numerum; ab palmo pes est
inventus. Si autem in utrisque palmis ex articulis
ab natura decem sunt perfecti, etiam Platoni placuit
esse eum numerum ea re perfectum, quod ex singu-
laribus rebus, quae *monades* apud Graecos dicuntur,
perficitur decusis.[1] Qui simul autem undecim aut
duodecim sunt facti, quod superaverint, non possunt
esse perfecti, donec ad alterum decusis perveniant;
singulares enim res particulae sunt eius numeri.
6 Mathematici vero contra disputantes ea re perfectum
dixerunt esse numerum qui sex dicitur, quod is
numerus habet partitiones eorum rationibus sex
numero convenientes sic : sextantem unum, trientes
duo,[2] semissem tria, besem quem *dimoeron* dicunt
quattuor, quintarium quem *pentemoeron* dicunt
quinque, perfectum sex. Cum ad supplicationem [3]
crescat, supra sex adiecto asse *ephectum*; cum facta
sunt octo, quod est tertia adiecta, tertiarium alterum,[4]
qui *epitritos* dicitur; dimidia adiecta cum facta sunt
novem, sesquialterum, qui *hemiolius* appellatur; duabus
partibus additis et decusis facto bes alterum, quem
epidimoerum vocitant; in undecim numero quod
adiecti sunt quinque, quintarium, quem *epipempton*
dicunt; duodecim autem, quod ex duobus numeris
7 simplicibus est effectus, *diplasiona*. Non minus
etiam, quod pes hominis altitudinis sextam habet

<hr>

[1] decusisq *H*. [2] (trientem) duo *Joc* : trientes duos *H*.
[3] supplicationem *H* = ὑποπλέκειν (subnectere).
[4] alterum *Mar* : autem *H*.

<hr>

[1] The mathematical notion of "elegance" is here seen in
an early form. The Pythagoreans distinguished between
the "esoteric" mathematics of elegance, and the "exoteric"

determined as perfect the number which is called
ten.[1] For from the hands they took the number of
the inches; from the palm, the foot was discovered.
Now while in the two palms with their fingers, ten
inches are naturally complete, Plato considered
that number perfect, for the reason that from the
individual things which are called *monades* among
the Greeks, the decad [2] is perfected. But as soon
as they are made eleven or twelve, because they
are in excess, they cannot be perfect until they reach
the second decad. For individual things are minor
parts of that number. 6. But mathematicians,
disputing on the other side, have said that the
number called six [3] is perfect for the reason that
this number has divisions which agree by their
proportions with the number six. Thus a sixth is
one; a third is two; a half is three; two-thirds,
which they call *dimoeros*, four; five-sixths, which
they call *pentemoeros*, five; the perfect number, six.
When it grows to the double, a twelfth added above
six makes *ephectos*; when eight is reached, because
a third is added, there is a second third, which is
called *epitritos*; when half is added and there are
nine, there is half as much again, and it is called
hemiolios; when two parts are added and a decad
is made, we have the second two-thirds, which they
call *epidimoeros*: in the number eleven, because five
are added, we have five-sixths, which they call
epipemptos; twelve, because it is produced from
two simple numbers, they call *diplasios*. 7. Not
less also because the foot has the sixth part of a

or applied mathematics of daily practice. They regarded
10 as the perfect number.
[2] $10 = 1 + 2 + 3 + 4$. Plato follows the Pythagoreans.
[3] On perfection of number 6, Aug. *Civ. Dei*, XI. 30.

partem, (ita etiam, ex eo quod perficitur pedum numero, corporis sexies [1] altitudinis terminavit) eum perfectum constituerunt, cubitumque animadverterunt ex sex palmis constare digitisque XXIIII. Ex eo etiam videntur civitates Graecorum fecisse, quemadmodum cubitus est sex palmorum, in drachma qua nummo [2] uterentur, aereos signatos uti asses ex aequo [3] sex, quos obolos appellant, quadrantesque obolorum, quae alii dichalca, nonnulli trichalca dicunt, pro digitis viginti quattuor in drachma constituisse.

8 Nostri autem primo fecerunt antiquum numerum et in denario denos aeris constituerunt, et ea re conpositio nominis ad hodiernum diem denarium retinet. Etiamque quarta pars quod efficiebatur ex duobus assibus et tertio semisse, sestertium vocitaverunt. Postea quam animadverterunt utrosque numeros esse perfectos, et sex et decem, utrosque in unum coiecerunt et fecerunt perfectissimum decusis sexis. Huius autem rei auctorem invenerunt pedem. E cubito enim cum dempti sunt palmi duo, relinquitur pes quattuor palmorum, palmus autem habet quattuor digitos. Ita efficitur, ut habeat pes sedecim digitos et totidem asses aeracius denarius.

9 Ergo si convenit ex articulis hominis numerum inventum esse et ex membris separatis ad universam corporis speciem ratae partis [4] commensus fieri responsum, relinquitur, ut suscipiamus eos, qui etiam

[1] seies *H.* [2] num(m)o *Schn* : numero *H.*
[3] ex aequo *Joc* : ex quo *H.* [4] partes *H.*

[1] The *as* was a Roman bronze coin successively reduced from 1 lb. (12 oz.) to 4 oz., 2 oz., 1 oz. and ½ oz. The reductions took place at financial crises probably in 268 B.C. after war with Pyrrhus, 242 B.C. end of 1st Punic war, 217 beginning of 2nd Punic war, 89 in Social war. The *Lex Valeria* of 86 B.C.

man's height, and also because six times, that is
the number six, in that it is completed by the
number of feet, determined the height of the body,
they fixed that number as perfect, observing that
the cubit consists of six palms and twenty-four
fingers. Hence also the cities of the Greeks seem
to have made in a like fashion (just as the cubit
is of six palms) six parts of the *drachma*, the coin
which they use, stamped bronze coins like *asses*,[1]
which they call *obols*; and to have fixed twenty-
four quarter obols, called by some *dichalca*, by others
trichalca to correspond to the fingers. 8. We,
however, at first followed the ancient number, and
in the *denarius* fixed ten bronze coins; whence to
this day the derived name keeps the number ten
(denarius). And also because the fourth part was
made up of two asses and a half, they called it
sestertius.[2] But afterwards they perceived that
both numbers were perfect, both the six and the
ten; and they threw both together, and made the
most perfect number sixteen. Now of this they
found the origin in the foot. For when two palms
are taken from the cubit, there is left a foot of four
palms, and the palm has four fingers. So it comes
that the foot has sixteen fingers, and the bronze
denarius as many asses.

9. Therefore, if it is agreed that number is found
from the articulation of the body, and that there is
a correspondence of the fixed ratio of the separate
members to the general form of the body, it remains
that we take up those writers who in planning the

allowed debtors to take advantage of the last reduction so
that they only had to pay one-fourth of their debts.

[2] *i.e.* semis tertius.

aedes deorum inmortalium constituentes ita membra operum ordinaverunt, ut proportionibus et symmetriis separatae atque universae convenientesque efficerentur eorum distributiones.

II

1 AEDIUM autem principia sunt, e quibus constat figurarum aspectus; et primum in antis, quod graece *naos en parastasin* dicitur, deinde prostylos, amphiprostylos, peripteros, pseudodipteros, hypaethros.[1] Horum exprimuntur formationes his rationi-

2 bus.[2] In antis erit aedes, cum habebit in fronte antas parietum qui cellam circumcludunt, et inter antas in medio columnas duas supraque fastigium symmetria ea conlocatum, quae in hoc libro fuerit perscripta. Huius autem exemplar erit ad tres Fortunas ex tribus

3 quod est proxime portam Collinam. Prostylos omnia habet quemadmodum in antis, columnas autem contra antas angulares duas supraque epistylia, quemadmodum et in antis, et dextra ac sinistra in versuris singula. Huius exemplar est in insula

4 Tiberina in aede Iovis et Fauni. Amphiprostylos omnia habet ea, quae prostylos, praetereaque habet in postico ad eundem modum columnas et fastigium.

[1] hypetros *H*
[2] *post* rationibus *in H* quemadmodum et . . . exemplar, *del. Joc.*

[1] "Temple in pilasters." [2] "With columns in front."
[3] "With columns on both fronts."
[4] "With columns all round."

temples of the immortal gods so ordained the parts of the work that, by the help of proportion and symmetry, their several and general distribution is rendered congruous.

CHAPTER II

ON THE KINDS OF TEMPLES

1. IT is from the plan of a temple that the effect of its design arises. And first *in antis*, which in Greek is called *naos en parastasin*[1]; next, prostyle,[2] amphiprostyle,[3] peripteral,[4] pseudodipteral,[5] hypaethral.[6] The designs of these are formulated in the following manner. 2. A temple will be *in antis* when it has in front, pilasters terminating the walls which enclose the shrine, and in the middle, between the pilasters, two columns, and above, a gable, built with the symmetry to be set forth in this book. An example of this will be the Temple of Fortune, nearest of the three to the Colline Gate[7] 3. The *prostyle* has everything like the temple *in antis*, except two angle columns over against the pilasters; and above, entablatures as *in antis* which return at the angles on either side. An example of this is on the island in the Tiber, namely, the Temple of Jupiter and Faunus.[8] 4. The *amphiprostyle* has everything like the prostyle, and besides has columns and a pediment at the back.

[5] "With columns all round set at a distance from the temple walls."

[6] "With interior open to the sky."

[7] Lanciani, *R.E.* 421; Platner, 216.

[8] Ovid, *Fasti*, I. 293. Liv. XXXIII. 42; XXXIV. 53; XXXV. 41. Platner, 205.

5 Peripteros autem erit, quae habebit in fronte et postico senas columnas, in lateribus cum angularibus undenas. Ita autem sint hae columnae conlocatae, ut intercolumnii latitudinis intervallum sit a parietibus circum ad extremos ordines columnarum, habeatque ambulationem circa cellam aedis, quemadmodum est in porticu Metelli Iovis Statoris Hermodori[1] et ad Mariana Honoris et Virtutis sine

6 postico a Mucio facta. Pseudodipteros autem sic conlocatur, ut in fronte et postico sint columnae octonae, in lateribus cum angularibus quinae denae. Sint autem parietes cellae contra quaternas columnas medianas in fronte et postico. Ita duorum intercolumniorum et unae crassitudinis columnae spatium erit ab parietibus[2] circa ad extremos ordines columnarum. Huius exemplar Romae non est, sed Magnesiae Dianae Hermogenis Alabandei et Apollinis

7 a Menesthe facta. Dipteros autem octastylos et pronao et postico, sed circa aedem duplices habet ordines columnarum, uti est aedis Quirini dorica et Ephesi Dianae ionica a Chersiphrone constituta.

8 Hypaethros vero decastylos est in pronao et postico. Reliqua omnia eadem habet quae dipteros, sed interiore parte columnas in altitudine duplices, remotas a parietibus ad circumitionem ut porticus peristy-

[1] Hermodori *Turnebus*: hermodi *H.*
[2] ab par. *G*: appar. *H.*

[1] Liv. I. 12; Lanciani, *R.E.* 200; Platner, 304.
[2] Cic. *de Oratore*, I. 62. [3] Cic. *Verr.* IV. 121.
[4] VII. *pref.* 17.
[5] Burn, *Rome*, 193; Platner, 258. [6] Plate B.

5. The *peripteral* will be that which shall have six columns in front and six at the back, and on either side eleven, counting in the angle columns. Now these columns are to be so placed that there is all round a distance the width of an intercolumniation, between the walls and the outer rows of the columns, This provides a walk round the cell of the temple, such as there is at the temple of Jupiter Stator [1] by Hermodorus [2] in the Portico of Metellus, and the temple of Honor and Virtus [3] built without a posticum, by Mucius [4] near the Monument of Marius.[5] 6. The *pseudodipteros* [6] is so planned that there are eight columns both in front and at the back, and fifteen on each side, including the angle columns. But the walls of the cella are to face the four middle columns in front and at the back. Thus there will be a space all round, from the walls to the outside rows of the columns, of two intercolumniations and the thickness of one column. There is no example of this at Rome; but there is at Magnesia the temple of Diana built by Hermogenes of Alabanda, and the temple of Apollo by Menesthes. 7. The *dipteros* [7] has eight columns in front and at the back, but it has double rows of columns round the sanctuary, like the Doric temple of Quirinus,[7] and the Ionic temple of Diana at Ephesus built by Chersiphron. 8. The *hypaethral* temple has ten columns in front and at the back. For the rest it has everything like the dipteral, except that in the interior it will have two stories of columns, at a distance from the walls all round like the colonnade of a peristyle. The centre has

[7] At Rome, Cic. *ad Att.* XII. 45; XIII. 28. Burn, *Rome*, 249; Platner 439. Plate B.

liorum. Medium autem sub divo est sine tecto.
Aditus valvarum et utraque parte in pronao et postico.
Huius item exemplar Romae non est, sed Athenis
octastylos et templo Olympio.

III

1 SPECIES autem aedium sunt quinque, quarum ea
sunt vocabula : pycnostylos, id est crebris columnis ;
systylos paulo remissioribus ; diastylos [1] amplius
patentibus ; rare [2] quam oportet inter se diductis
araeostylos [3] ; eustylos [4] intervallorum iusta distribu-
2 tione. Ergo pycnostylos est, cuius intercolumnio
unius et dimidiatae columnae crassitudo interponi
potest, quemadmodum est divi Iulii et in Caesaris
foro Veneris et si quae aliae sic sunt compositae.
Item systylos [5] est, in quo duarum columnarum
crassitudo in intercolumnio poterit conlocari, et
spirarum plinthides aeque magnae sint et spatio,
quod fuerit inter duas plinthides, quemadmodum
est Fortunae Equestris ad theatrum lapideum reliquae-
que,[6] quae eisdem rationibus sunt conpositae.
3 Haec utraque genera vitiosum habent usum. Matres
enim familiarum cum ad supplicationem gradibus
ascendunt, non possunt per intercolumnia amplexae
adire, nisi ordines fecerint ; item valvarum adspectus [7]
abstruditur columnarum crebritate ipsaque signa

[1] diastylos *ed. Ven* : interestylos *H.*
[2] *rare* for *rarius* H.
[3] spatiis intercolumniorum *add. G* : *om. H.*
[4] eustylos *ed. Fl* : et stilos *H.* [5] sistilos *G*, stylos *H.*
[6] reliquae quaeque *H.* [7] abspectus *H.*

[1] Lanciani, *R.E.* 269. [2] *Op. cit.* 302 ; Platner, 226.

no roof and is open to the sky. There are folding doors in front and at the back. Of this there is no example at Rome; but there is the Octastyle at Athens, in the Olympian temple.

CHAPTER III

ON THE ELEVATIONS OF TEMPLES

1. THERE are five elevations of temples, of which the names are as follows: pycnostyle, that is with close columns; systyle, with the spaces of the intercolumniations a little more open; diastyle, wider still; with intercolumniations more open than they should be, araeostyle; eustyle, with the just distribution of intervals. 2. So then pycnostyle is that in the intercolumniations of which the thickness of a column and a half can be interposed, as in the temple of Julius,[1] and of Venus[2] in the Forum of Caesar, and any others which are so arranged. The systyle also is that in which the thickness of two columns can be placed in the intercolumniations, and the plinths of the bases are equally great with the space between two plinths, as is the temple of Fortuna Equestris[3] against the Stone Theatre,[4] and the others which are arranged in the same proportions. 3. These two kinds are objectionable in use. For when matrons come up by the steps to give thanks, they cannot approach between the columns arm in arm but in single file; further, the view of the doors is taken away by the numerous columns, and the statues themselves are

[3] Liv. XL. 40; XLII. 3; Tac., *Ann.* III. 71; Platner, 215.
[4] Lanciani, *R.E.* 461; Platner, 515.

obscurantur; item circa aedem propter angustias
4 inpediuntur ambulationes. Diastyli autem haec erit
conpositio, cum trium columnarum crassitudinem
intercolumnio interponere possumus, tamquam est
Apollinis et Dianae aedis. Haec dispositio hanc
habet difficultatem, quod epistylia propter inter-
5 vallorum magnitudinem franguntur. In araeostylis
autem nec lapideis nec marmoreis epistyliis uti datur,
sed inponendae de materia trabes perpetuae. Et
ipsarum aedium species sunt varicae,[1] barycephalae,[2]
humiles, latae, ornanturque signis fictilibus aut aereis
inauratis earum fastigia tuscanico more, uti est ad
Circum Maximum Cereris [3] et Herculis Pompeiani,
item Capitoli.[4]
6 Reddenda nunc est eustyli [5] ratio, quae maxime
probabilis et ad usum et ad speciem et ad firmitatem
rationes habet explicatas. Namque facienda sunt
in intervallis spatia duarum columnarum et quartae
partis columnae crassitudinis, mediumque inter-
columnium unum, quod erit in fronte, alterum, quod
in postico, trium columnarum crassitudine. Sic
enim habebit et figurationis aspectum venustum
et aditus usum sine inpeditionibus et circa cellam
7 ambulatio auctoritatem. Huius autem rei ratio explica-
bitur sic. Frons loci quae in aede constituta fuerit, si
tetrastylos [6] facienda fuerit, dividatur in partes xi s [7]
praeter crepidines et proiecturas spirarum; si sex

[1] varicae *Turnebus* : baryce *H.* [2] parycefale *H.*
[3] ca&eris *H.* [4] capituli *H.*
[5] estyli *H.* [6] &trastylos *H.*
[7] xi s *Joc* : decusas semis *H.*

[1] On the Palatine. The only instance of the double name,
Platner, 17 n.

obscured; walking round the temple is hindered on account of the narrow intervals. 4. Of the diastyle, the arrangement is as follows: when we can interpose the thickness of three columns in the intercolumniation, as in the case of the Temple of Apollo and Diana.[1] Such a disposition presents this difficulty, that the architraves break because of the wide openings. 5. In araeostyle buildings it is not given to use stone or marble architraves, but continuous wooden beams are to be employed. And the designs of the buildings themselves are straddling, top-heavy, low, broad. The pediments are ornamented with statues of terra-cotta or gilt bronze in the Etruscan fashion, as is the Temple of Ceres [2] at the Circus Maximus, Pompey's Temple of Hercules,[3] and the Capitoline Temple.[4]

6. We must now render an account of the eustyle, which is specially to be approved, and has proportions set out for convenience, beauty and strength. For in the intervals the width of two and a quarter columns is to be made, and the middle intercolumniation, one in the front and one in the back, is to be three columns wide. For so the building will have both a graceful appearance in its configuration, and a convenient approach; and the walk round the sanctuary will have dignity. 7. The method of this arrangement is to be explained as follows. The front of the site which has been set out in the building is to be divided, if it is to be tetrastyle, into $11\frac{1}{2}$ parts, excluding the plinths and the projections of the

[2] Plin. *N.H.* XXXV. 154; Tac. *Ann.* II. 49; Burn, *Rome*, 292.

[3] Plin. *N.H.* XXXIV. 57; Burn, *Rome*, 40; Lanciani, *R.E.* 458; Platner, 255.

[4] Burn, *Rome*, xxvi.; Platner, 297.

erit columnarum, in partes XVIII[1]; si octostylos
constituetur, dividatur in XXIV[2] et semissem. Item
ex his partibus sive tetrastyli sive hexastyli sive
octostyli una pars sumatur, eaque erit modulus.
Cuius moduli unius erit crassitudinis columnarum.
Intercolumnia singula, praeter media,[3] modulorum
duorum et moduli quartae partis; mediana in fronte
et postico singula ternum modulorum. Ipsarum
columnarum altitudo modulorum habebunt iustam
8 rationem. Huius exemplar Romae nullum habemus,
sed in Asia Teo hexastylon[4] Liberi Patris.

Eas autem symmetrias constituit Hermogenes, qui
etiam primus *exo stylon*[5] pseudodipterive rationem.[6]
Ex dipteri enim aedis symmetriae[7] distulit interi-
ores ordines columnarum XXXIV[8] eaque ratione
sumptus operasque compendii fecit. Is in medio
ambulationi laxamentum egregie circa cellam fecit
de aspectuque nihil inminuit, sed sine desiderio super-
vacuorum conservavit auctoritatem totius operis
9 distributione. Pteromatos enim ratio et columnarum
circum aedem dispositio ideo est inventa, ut aspectus
propter asperitatem intercolumniorum habeat[9] auc-
toritatem, praeterea, si ex imbrium[10] aquae vis
occupaverit et intercluserit hominum multitudinem,
ut habeat in aede circaque cellam cum laxamento
liberam moram. Haec autem ut explicantur in

[1] XVIII *Joc* : decem novem *H.*
[2] XXIV *Joc* : viginti quinque *H.*
[3] media *Lor* : mediam *H.*
[4] theo *H* : exastilon *H.* [5] exostylum *H : exo stylon Gr.*
[6] speudo dipteri uerationem *H.*
[7] symmetriae *H*, ex *c. gen. Graecism; cf.* ex *c. acc.* repro-
missionem *Gal.* III. 18, *Am.*
[8] XXXIV *Phil* : XXXVIII *H.* [9] habeat *G* : hab& *H.*
[10] ex imbrium *H.*

bases; if the building is hexastyle, into 18 parts; if it shall be octastyle, into $24\frac{1}{2}$ parts. Further, of these parts, whether for tetrastyle, hexastyle, or octastyle, let one be taken, and that will be the module or unit. And of this module, one will be the thickness of the column. The several intercolumniations except those in the middle will be of two modules and a quarter; the middle intercolumniations at the front and at the back will be severally of three modules. The height of the columns will have a just proportion of modules.[1] 8. Of this we have no instance at Rome; but in Asia there is the hexastyle temple of Father Bacchus in Teos.

These proportions Hermogenes[2] determined, and he also was the first to use the exostyle or pseudodipteral arrangement. For from the plan of the dipteral temple he removed the interior rows of the thirty-four columns, and in that manner abridged the expense and the work. He made an opening for the ambulatory round the cella in a striking fashion, and in no respect detracted from the appearance. Thus without letting us miss the superfluous parts, he preserved the impressiveness of the whole work by his arrangement.[3] 9. For the columns round the temple were so devised that the view of them was impressive, because of the high relief given to the intercolumniations; moreover, if a number of people have been unexpectedly cut off by showers of rain, they have plenty of room to linger in the building space. Thus far as is ex-

[1] *H* omits a passage interpolated here.
[2] Hermogenes was one of V.'s authorities.
[3] A good instance of architectural criticism.

pseudodipteris aedium dispositionibus. Quare videtur
acuta magnaque sollertia effectus operum Hermo-
genis fecisse reliquisseque fontes, unde posteri
possent haurire disciplinarum rationes.

10 Aedibus araeostylis columnae sic sunt faciendae,
uti crassitudines earum sint partis octavae ad alti-
tudines. Item in diastylo dimetienda est altitudo
columnae in partes octo et dimidium, et unius partis
columnae crassitudo conlocetur. In systylo altitudo
dividatur in novem et dimidiam partem, et ex eis
una ad crassitudinem columnae detur. Item in
pycnostylo dividenda est altitudo in decem, et eius
una pars facienda est columnae crassitudo. Eustyli [1]
autem aedis columnae, uti systyli, in novem partibus [2]
altitudo dividatur et dimidiam partem, et eius una
pars constituatur in crassitudine imi scapi. Ita
habebitur pro rata parte intercolumniorum ratio.

11 Quemadmodum enim crescunt spatia inter columnas,
proportionibus adaugendae sunt crassitudinis [3] scapo-
rum. Namque si in araeostylo [4] nona aut decima
pars crassitudinis fuerit, tenuis et exilis apparebit,
ideo quod per latitudinem intercolumniorum aer
consumit et inminuit aspectu scaporum crassitudinem.
Contra vero pycnostylis si octava pars crassitudinis
fuerit, propter crebritatem et angustias intercolum-
niorum tumidam et invenustam efficiet speciem.
Itaque generis operis oportet persequi symmetrias.

[1] custyli *H*. [2] partes *Joc* : partibus *H*.
[3] crassitudines *G* : *nom. in* is *Am. H.*
[4] simareostylo *H*.

[1] The Renaissance architects in Rome, *e.g.* Vignola and
Palladio, combined the measurements of ancient buildings
with the study of Vitruvius.

plained in the pseudodipteral plans of temples. Hence there must have been great and subtle skill to produce the works of Hermogenes, and it has left sources from which posterity could draw their methods of study.[1]

10. For araeostyle temples, the columns are to be so made that their diameters are one-eighth the height. Also in the diastyle, the height of the column is to be measured out into eight and a half parts, and let the diameter of the column be of one part. In the systyle let the height be divided into nine and a half parts, let one of those be given for the diameter of the column. Also in the pycnostyle, the height is to be divided into ten, and of that one part is to be made the diameter of the column. Now of the eustyle temple, as of the systyle, let the height be divided into nine and a half parts, and of that let one part be set up for the diameter of the bottom of the shaft. In this way the relation of the intercolumniations will be observed proportionately. 11. For in the measure by which the spaces between the columns grow, the diameters of the shafts are to be increased. For if in the araeostyle there shall be the ninth or tenth part of a diameter, it will appear thin and scanty; because through the width of the intercolumniations the air consumes and lessens in appearance the diameter of the shafts.[2] On the other hand, in pycnostyle temples if there shall be the eighth part of a diameter, because of the frequency and narrowness of the intercolumniations, it will produce a swollen and displeasing appearance. Therefore we must follow the symmetries required by the style of the work. The

[2] Reference to optics.

Etiamque angulares columnae crassiores faciendae
sunt ex suo diametro quinquagesima parte, quod
eae ab aere circumciduntur et graciliores videntur
esse aspicientibus. Ergo quod oculus fallit, ratio-
12 cinatione est exequendum.[1] Contracturae autem in
summis columnarum hypotracheliis [2] ita faciendae
videntur, uti, si columna sit ab minimo ad pedes
quinos denos, ima crassitudo dividatur in partes sex
et earum partium quinque summa constituatur.
Item [3] quae erit ab quindecim pedibus ad pedes
viginti, scapus [4] imus in partes [5] sex et semissem
dividatur, earumque partium quinque et semisse
superior crassitudo columnae fiat. Item quae erunt
a pedibus viginti ad pedes triginta, scapus imus [6]
dividatur in partes septem, earumque sex summa
contractura perficiatur. Quae autem ab triginta
pedibus ad quadraginta alta erit, ima dividatur in
partes septem et dimidiam; ex his sex et dimidiam
in summo habeat contracturae rationem. Quae
erunt ab quadraginta pedibus ad quinquaginta, item
dividendae sunt in octo partes, et earum septem in
summo scapo sub capitulo contrahantur. Item si
quae altiores erunt, eadem ratione pro rata consti-
13 tuantur [7] contracturae. Haec autem propter alti-
tudinis intervallum scandentis oculi species [8] adici-
untur crassitudinibus temperaturae. Venustates
enim persequitur visus, cuius si non blandimur
voluptati proportione et modulorum adiectionibus,
uti quod fallitur temperatione adaugeatur, vastus et

[1] exaequendum H. [2] hypotrachelis H.
[3] itemq; H. [4] viginti capus H.
[5] *post* partes *add.* H, septem superior crassitudo columnae
del. Joc.
[6] imus G: is H. [7] constituantur *ed*: -atur H.
[8] oculi *rec*: oculis H: species H: *genit.* Kr.

angle columns also must be made thicker by the
fiftieth part of their diameter, because they are
cut into by the air and appear more slender to the
spectators. Therefore what the eye cheats us of,
must be made up by calculation. 12. The con-
tractions, however, in the topmost necking of the
columns, it seems, should be so made that from the
smallest dimension up to fifteen feet, the lowest
diameter should be divided into six parts and the
top should be of five of those parts. Also in those
which shall be from fifteen feet to twenty feet, the
lowest part of the shaft is to be divided into six
and a half parts; and of those parts five and a half
are to be the upper diameter of the column. Also
in those which shall be from twenty feet to thirty
feet, let the lowest part of the shaft be divided into
seven parts, and let the top contraction be made
six of them. In the column which shall be from
thirty to forty feet, let the lowest diameter be
divided into seven and a half parts; of these let the
column have six and a half at the top as the amount
of contraction. Those which shall be from forty to
fifty feet are also to be divided into eight parts, and
these are to be contracted to seven at the top of the
shaft under the capital. Further, if any are higher,
let the contractions be determined proportionately
in the same way. 13. It is on account of the varia-
tion in height that these adjustments are added to
the diameters to meet the glance of the eye as it
rises. For the sight follows gracious contours;
and unless we flatter its pleasure, by proportionate
alterations of the modules (so that by adjustment
there is added the amount to which it suffers
illusion), an uncouth and ungracious aspect will be

invenustus conspicientibus remittetur aspectus. De
adiectione, quae adicitur in mediis columnis, quae
apud Graecos *entasis* appellatur, in extremo libro
erit formata ratio eius, quemadmodum mollis et
conveniens efficiatur, subscripta.

IV

1 FUNDATIONES eorum operum fodiantur, si queat
inveniri, ab solido et in solidum, quantum ex ampli-
tudine operis pro ratione videbitur, extruaturque
structura totum solum quam solidissima. Supraque
terram parietes extruantur sub columnas dimidio
crassiores quam columnae sunt futurae, uti firmiora
sint inferiora superioribus; quae stereobates [1] appel-
lantur, nam excipiunt onera. Spirarumque proiec-
turae non procedant extra solium; item supra
parietis [2] ad eundem modum crassitudo servanda est.
Intervalla autem concamaranda aut solidanda festu-
2 cationibus, uti distineantur.[3] Sin autem solidum non
invenietur, sed locus erit congesticius [4] ad imum aut
paluster,[5] tunc is locus fodiatur exinaniaturque et
palis alneis [6] aut oleagineis ⟨aut⟩ robusteis ustilatis
configatur,[7] sublicaque [8] machina adigatur quam
creberrime, carbonibusque expleantur intervalla

[1] est ereobates *H*.　　　[2] parietis *Joc*: -tes *H*.
[3] distineantur *Joc*: destineantur *H*.
[4] congesticius *G*: coniesticius *H*.
[5] paluster *G*: plai | ter *H*.　　　[6] alneis *Joc*: saligneis *H*.
[7] configatur *G*: configuratur *H*.　　　[8] subligaque *H*.

[1] Hence the ornaments of a building should follow the lines
of the structure in such a way as to support the proportions.
[2] Without a slight swelling of the shaft of a column, the
straight upright line would strike the eye as hollowed inwards.

presented to the spectators.[1] As to the swelling [2] which is made in the middle of the columns (this among the Greeks is called *entasis*), an illustrated formula will be furnished at the end of the book to show how the entasis may be done in a graceful and appropriate manner.

CHAPTER IV

ON THE FOUNDATIONS OF TEMPLES

1. LET the foundations of those works be dug from a solid site and to a solid base if it can be found, as much as shall seem proportionate to the size of the work; and let the whole site be worked into a structure as solid as possible. And let walls be built, upon the ground under the columns, one-half thicker than the columns are to be, so that the lower portions are stronger than the higher; and these are called the *stereobate*,[3] for they receive the loads. And let not the projections of the base mouldings proceed beyond the bed. Further, the thickness of the wall is to be kept above in the same manner. The spaces between the columns are to be arched over, or made solid by being rammed down, so that the columns may be held apart. 2. But if a solid foundation is not found, and the site is loose earth right down, or marshy, then it is to be excavated and cleared and re-made with piles [4] of alder or of olive or charred oak, and the piles are to be driven close together by machinery, and the intervals between are to be filled with charcoal.

[3] The platform on which the columns rest.
[4] Piles at Ravenna, II. ix. 11.

palorum, et tunc structuris solidissimis fundamenta
impleantur. Extructis autem fundamentis ad libra-
3 mentum stylobatae sunt conlocandae. Supra stylo-
batas columnae disponendae, quemadmodum supra
scriptum est, sive in pycnostylo, quemadmodum
pycnostyla, sive systylo aut diastylo aut eustylo,
quemadmodum supra scripta sunt et constituta. In
araeostylis enim libertas est quantum cuique libet
constituendi. Sed ita columnae in peripteris conlo-
centur, uti, quot [1] intercolumnia sunt in fronte,
totidem bis intercolumnia fiant in lateribus; ita enim
erit duplex longitudo operis ad latitudinem. Nam-
que qui columnarum duplicationes fecerunt, erravisse
videntur, quod unum intercolumnium in longitudine
4 plus quam oporteat procurrere videtur. Gradus in
fronte constituendi ita sunt, uti sint [2] semper inpares;
namque cum dextro pede primus gradus ascendatur,
item in summo templo primus erit ponendus. Crassi-
tudines autem eorum graduum ita finiendas censeo,
ut neque crassiores dextante [3] nec tenuiores dodrante
sint conlocatae; sic enim durus non erit ascensus.
Retractationes autem graduum nec minus quam ses-
quipedales nec plus quam bipedales faciendae videntur.
Item si circa aedem gradus futuri sunt, ad eundem
5 modum fieri debent. Sin autem circa aedem ex
tribus lateribus podium faciendum erit, ad id con-
stituatur, uti quadrae, spirae, trunci, coronae, lysis
ad ipsum stylobatam, qui erit sub columnarum [4]

[1] quod H. [2] sunt G : sint H.
[3] dextante G : extantae H ? xtante Gr.
[4] columnarum Rode : columna H.

[1] The stylobate is that part of the platform or stereobate on
which the columns are erected.

Then the foundations are to be filled with very
solid structures. The foundations being built to
a level, the stylobates [1] are to be laid. 3. Above
the stylobates the columns are to be erected as
described above; whether in pycnostyle (as are the
pycnostyle temples), or in systyle, or diastyle or
eustyle, as it has been described and determined
above. For in araeostyle there is freedom to
determine as everybody pleases. But let the
columns be so disposed in peripteral temples that
the intercolumniations on the sides are twice as
many as on the front. For then the length of the
work will be twice the breadth. For those who
made double the number of the columns seem to be
at fault because in the length one more inter-
columniation than is necessary seems to occur.
4. The steps are to be so placed in front that they
are always of an uneven number. For since the
first step is ascended on the right foot, the right
foot must also be set on the top of the temple steps.
And the risers of the steps must be of such dimens-
ions that they are neither deeper than ten inches
nor shallower than nine. For thus the ascent will
not be hard. But the treads of the steps, it seems,
should be made not less than eighteen inches or
more than two feet. Also, if steps are to be round
the temple, they ought to be made after the same
measure. 5. But if a platform is to be made round
the temple on three sides, it is to be planned in such
a way [2] that the plinths, bases, dados, cornices and
cymatium conform to the pedestal which is under

[2] These parts of the pedestal have a certain correspondence
to the parts of the column and entablature.

spiris, conveniant. Stylobatam ita oportet exaequari,
uti habeat per medium adiectionem per scamillos
inpares; si enim ad libellam dirigetur, alveolatum
oculo videbitur. Hoc autem, ut scamilli ad id con-
venientes fiant, item in extremo libro forma et
demonstratio erit descripta.

V

1 His perfectis in suis locis spirae conlocentur, eaeque
ad symmetriam sic perficiantur, uti crassitudo cum
plintho sit columnae ex dimidia crassitudine proiectu-
ramque, quam Graeci εκφοραν [1] vocitant, habeant
sextantem; ita tum lata et longa erit columnae
2 crassitudinis unius et dimidiae. Altitudo eius, si
atticurges erit, ita dividatur, ut superior pars tertia
parte sit crassitudinis columnae, reliquum plintho
relinquatur. Dempta plintho reliquum dividatur in
partes quattuor, fiatque superior torus [quartae;
reliquae tres aequaliter dividantur, et una sit inferior
torus,] [2] altera pars cum suis quadris scotia, quam
3 Graeci *trochilon* [3] dicunt. Sin autem ionicae erunt
faciendae, symmetriae earum sic erunt constituendae,
uti latitudo spirae quoqueversus sit columnae
crassitudinis adiecta crassitudine quarta et octava.
Altitudo ita uti atticurges; ita ut eius plinthos;
reliquumque praeter plinthum, quod erit tertia [4] pars
crassitudinis columnae, dividatur in partes septem:

[1] *Graecis literis primum servatis = ecphoran H.*
[2] quartae . . . torus *G: om. H.*
[3] trochilon *H.* [4] erit tertia *Joc:* ei ad tertia *H.*

[1] *Scamillus* seems to mean the riser or height of a step.
[2] Plate C. [3] Refers probably to the torus of the base.

the bases of the columns. The stylobate must be
so levelled that it increases towards the middle
with unequal risers [1]; for if it is set out to a level
it will seem to the eye to be hollowed. The method
of making the risers suitable to this will be set out
with a figure and demonstration at the end of the
book.

CHAPTER V

ON THE IONIC ORDER [2]

1. WHEN this is done, let the bases be put in
position, and let them be so finished in proportion
that the thickness with the plinth amounts to half
the thickness of the column, and have a projection
(which the Greeks call *ecphora*) of one-sixth.[3] The
bases will be one and a half thicknesses of a column,
front and side. 2. The height, if it is to be an
Attic base, is to be thus divided: that the upper
part is to be one-third of the thickness of the
column, and the remainder left to the plinth.
Taking the plinth away, the remainder is to be
divided into four parts, and the upper torus is to be
one-fourth: the remaining three-fourths are to be
equally divided so that one is the lower torus [4]
and the other the scotia [5] (which the Greeks call
trochilus) with its fillets. 3. But if the bases are to
be Ionic, their proportions are to be so fixed that
the breadth of the base each way is one and three-
eighths of the thickness of a column. The height is
to be like the Attic base; so also its plinth. The
remainder beside the plinth, which will be the third
part of the column's diameter, is to be divided into

[4] A convex moulding. [5] A hollow moulding.

inde trium partium torus qui est in summo; reliquae
quattuor partes dividendae sunt aequaliter, et una
pars fiat cum suis astragalis et supercilio superior
trochilus, altera pars inferiori [1] trochilo relinquatur;
sed inferior maior apparebit, ideo quod habebit ad
extremam plinthum [2] proiecturam. Astragali faciendi
sunt octavae partis trochili; proiectura erit spirae pars
octava et sexta decuma pars [3] crassitudinis columnae.

4 Spiris perfectis et conlocatis columnae sunt
medianae in pronao et postico ad perpendiculum
medii centri conlocandae, angulares autem quaeque
e regione earum futura sunt in lateribus aedis dextra
ac sinistra, uti partes interiores, quae ad parietes
cellae spectant, ad perpendiculum latus habeant
conlocatum, exteriores autem partes uti dicant se
earum contracturam. Sic enim erunt figurae con-
positionis aedium contractura eius tali ratione exactae.

5 Scapis columnarum statutis capitulorum ratio si
pulvinata erunt, his symmetriis conformabuntur,
uti, quam crassus imus scapus fuerit addita octava
decuma parte scapi, abacus habeat longitudinem et
latitudinem; crassitudinem cum volutis eius
dimidiam. Recedendum autem est ab extremo
abaco in interiorem partem frontibus volutarum parte
duodevicensima et eius dimidia. Tunc crassitudo
dividenda est in partes novem et dimidiam, et
secundum abacum in quattuor partibus volutarum

[1] inferiori *G*: inferior *H.*
[2] plinthum *G*: plinthuum *H.* [3] decuma apars *H.*

[1] Rounded fillet.
[2] Lit. " so as to declare themselves to be a contraction of
the others."
[3] These adjustments characterise the whole of the
Parthenon.

seven parts: of these the torus at the top is to be three parts; the remaining four are to be equally divided; one half to the upper hollow with its astragals [1] and top moulding, the other half is to be left to the lower trochilus; but the lower will seem greater because it will have a projection to the edge of the plinth. The astragals are to be one-eighth part of the scotia. The projection of the base will be three-sixteenths of the thickness of the column.

4. When the bases are complete and in position, the middle columns in front and at the back are to be set up to a perpendicular, but the corner columns and those which are in line with them on the flanks of the temple right and left are to be set up so that the inside parts which look to the sanctuary, have their faces perpendicular, but the outside parts so as to declare their diminution.[2] In this way the intention of the design of the temple will be completed by such contraction.[3]

5. When the shafts of the columns are fixed, the proportions of the Ionic capitals [4] are to be conformed to these symmetries: namely, that, adding the eighteenth part to the thickest part of the shaft, the abacus may find its length and breadth; the height of the capital with the volutes, half of that. There must be a set-back from the edge of the abacus inwards on the front of the volutes of an eighteenth part and a half. Then the height of the capital is to be divided into nine and a half parts, and lines (which are called *cathetoe*) are to be let fall down the abacus, at the four corners of the

[4] See illustration.

187

secundum extremi abaci quadram lineae dimittendae,
quae cathetoe dicuntur. Tunc ex novem partibus
et dimidia una pars et dimidia abaci crassitudo
relinquatur, reliquae octo volutis constituantur.
6 Tunc ab linea quae secundum abaci extremam
partem dimissa erit, in interiorem partem ⟨alia⟩
recedat unius et dimidiatae partis latitudine. Deinde
hae lineae dividantur ita, ut quattuor partes et
dimidia sub abaco reliquatur. Tunc in eo loco, qui
locus dividit quattuor et dimidiam et tres et dimidiam
partem, centrum oculi; signeturque ex eo centro
rotunda circinatio tam magna in diametro, quam
una pars ex octo partibus est. Ea erit oculi magni-
tudine, et in ea catheto [1] respondens diametros
agatur. Tunc ab summo sub abaco inceptum in
singulis tetrantorum actionibus dimidiatum oculi
spatium minuatur, donique [2] in eundem tetrantem
7 qui est sub abaco, veniat. [3] Capituli autem crassitudo
sic est facienda, ut ex novem partibus et dimidia tres
partes praependeant infra astragalum summi scapi;
cymatio, adempto [4] abaco et canali, reliqua sit pars.
Proiectura autem cymatii habet extra abaci quadram
oculi magnitudinem. Pulvinorum baltei abaco hanc
habeant proiecturam, uti circini centrum unum cum
sit positum in capituli tetrante et alterum deducatur
ad extremum cymatium, circumactum balteorum
extremas partes tangat. Axes volutarum nec crassi-
ores sint quam oculi magnitudo, volutaeque ipsae

[1] catheto *Joc* : cathecton *H*.
[2] donique *Lachm* : denique *H*.
[3] qui est sub abconveniat *H*.
[4] adempto *ed* : adepto *H*.

[1] See figure.

volutes, following a perpendicular from the edge of the abacus. Then of nine parts and a half, one part and a half are to be left as the thickness of the abacus, and the remaining eight parts are to be allotted to the volutes. 6. Then within a vertical line which is let fall at the extreme corner of the abacus, let fall another line at the distance of one part and a half. Next let these lines be so divided that four parts and a half are left under the abacus. Then that point which divides the four and a half and the three and a half is the centre of the eye of the volute: and let there be drawn from that centre a complete circle with a diameter of one part out of the eight parts. That will be the magnitude of the eye. Through the centre let there be drawn a vertical diameter. Then, beginning from the top under the abacus, let the radius be successively diminished by half the diameter of the eye in describing the quadrants, until it comes into the quadrant which is under the abacus.[1] 7. Now the height of the capital is to be so arranged that of the nine and a half parts, three parts are below the astragal at the top of the shaft. The remaining part is for the cymatium, when the abacus and channel are taken away. The projection of the cymatium beyond the abacus is to be the size of the eye. Let the bands of the pillows [2] have the following projection: one point of the compasses is placed in the centre of the eye, and the other point is taken to the top of the cymatium; the circle thus described will mark the furthest part of the pillow band. The axes of the volutes should not be further apart than the diameter of the eye, and the volutes

[2] *Pulvinus.*

sic caedantur [1] altitudinis suae duodecimam partem.
Haec erunt symmetriae capitulorum, quae [2] columnae
futurae sunt ab minimo ad pedes xxv. Quae supra
erunt, reliqua habebunt ad eundem modum sym-
metrias, abacus autem erit longus et latus, quam
crassa columna est ima adiecta parte viiii, uti, quo
minus habuerit altior columna contractum, eo ne
minus habeat capitulum suae symmetriae proiecturam
8 et in altitudine [3] suae partis [4] adiectionem. De
volutarum descriptionibus, uti ad circinum sint recte
involutae, quemadmodum describantur, in extremo
libro forma et ratio earum erit subscripta.

Capitulis perfectis deinde columnarum non ad
libellam sed ad aequalem modulum conlocatis, ut,
quae adiectio in stylobatis facta fuerit, in superioribus
membris respondeat symmetria epistyliorum. Episty-
liorum ratio sic est habenda, uti, si columnae fuerint a
minima xii pedum ad quindecim pedes, epistylii sit
altitudo dimidia crassitudinis imae columnae; item
ab xv pedibus ad xx, columnae altitudo demetiatur
in partes tredecim, et unius partis altitudo epistylii
fiat; item si a xx ad xxv pedes, dividatur altitudo in
partes xii et semissem, et eius una pars epistylium
in altitudine fiat; item si ab xxv pedibus ad xxx,
dividatur in partes xii, et eius una pars altitudo fiat.
Item ratam partem ad eundem modum ex altitudine
columnarum expediendae sunt altitudines epi-
9 styliorum. Quo altius enim scandit oculi species,
non facile persecat aeris crebritatem; dilapsa itaque

[1] sic cedantur *H*.
[2] capitulorumque *H*.
[3] latitudine *rec*: altitudine *H*.
[4] suae partis *H*ᶜ: repartis *H G*.

themselves are to be channelled to the twelfth part of their height. These will be the proportions of capitals when the columns shall be up to twenty-five feet. Those which are more will have their other proportions after the same fashion. The length and breadth of the abacus will be the thickness of the column at its base with the addition of one-ninth: inasmuch as its diminution is less as the height is greater, the capital must not have less addition in projection and height. 8. At the end of the book a diagram and formula will be furnished for the drawing of the volutes so that they may be correctly turned by the compass.

When the capitals are completed they are to be set, not level through the range of columns, but with a corresponding adjustment; so that the architraves in the upper members may correspond to the addition in the stylobates. The proportion of the architraves should be as follows: if the columns are from twelve to fifteen feet, the height of the architrave should be half the thickness of the column at the bottom; from fifteen to twenty feet let the height of the column be divided into thirteen parts, and the height of the architrave be one part; from twenty to twenty-five feet, let the height be divided into twelve parts and a half, and let the architrave be one part of that in height; also from twenty-five to thirty let it be divided into twelve parts, and let the height be made of one part. Thus the heights of the architraves are to be determined in accordance with the height of the columns. 9. For the higher the glance of the eye rises, it pierces with the more difficulty the denseness of the air; therefore it fails owing to the

altitudinis spatio et viribus, extructam incertam
modulorum renuntiat sensibus quantitatem. Quare
semper adiciendum est rationi supplementum in
symmetriarum membris, ut, cum fuerint aut [1]
altioribus locis opera aut etiam ipsa colossicotera,[2]
habeant magnitudinum rationem. Epistylii latitudo
in imo, quod supra capitulum erit, quanta crassitudo
summae columnae sub capitulo erit, tanta fiat ;
10 summum, quantum imus scapus. Cymatium epi-
stylii [3] septima parte suae altitudinis est faciendum,
et in proiectura tantundem. Reliqua pars praeter
cymatium dividenda est in partes XII, et earum trium
ima [4] fascia est facienda, secunda IIII, summa V. Item
zophorus supra epistylium quarta parte minus quam
epistylium ; sin autem sigilla designari oportuerit,
quarta parte altior [5] quam epistylium, uti auctori-
tatem habeant scalpturae. Cymatium suae alti-
tudinis partis septimae ; proiecturae cymatium
11 quantum [6] crassitudo. Supra zophorum denticulus
est faciendus tam altus quam epistylii media fascia [7] ;
proiectura eius quantum altitudo. Intersectio, quae
Graece *metope* [8] dicitur, sic est dividenda, uti denticu-
lus altitudinis suae dimidiam partem habeat in
fronte, cavus autem intersectionis [9] huius frontis e
tribus duas partes ; huius cymatium altitudinis eius
sextam partem. Corona cum suo cymatio, praeter

[1] ut cum fuerint aut *Joc* : cum fuerint ut aut *H*.
[2] colossicotera *Joc* : colossi caetera *H*.
[3] cymatium epistylii *ed* : cymatii epystilii *H*.
[4] ima *Polenus* : iam *H*. [5] altior *Phil* : altiore *H*.
[6] quantum *Mar* : quam *H*. [7] fascia *Joc* : fastigia *H*.
[8] metoce *H*. [9] intersectionis *G* : -nes *H*.

amount and power of the height, and reports to the senses the assemblage of an uncertain [1] quantity of the modules. And so we must always add a supplement to the proportion in the case of the symmetrical parts, so that works which are either in higher positions or themselves more grandiose may have proportionate dimensions. The breadth of the architrave at the bottom where it rests upon the capital should equal the diameter of the top of the column under the capital: the top of the architrave should be as wide as the lower diameter of the shaft. 10. The cymatium [2] of the architrave should be made one-seventh of its height and the projection of it the same. The remainder apart from the cymatium is to be divided into twelve parts of which the lowest fascia [3] is to have three; the second, four; the top, five. The frieze also above the architrave is to be a fourth less than the architrave; but if figures are to be introduced, a fourth higher, so that the carvings may be effective. The cymatium a seventh part of its height; the projection of the cymatium as much as the thickness. 11. Above the frieze the dentil [4] is to be made as high as the middle fascia of the architrave; its projection as much as its height. The interval, which in Greek is called *metope*,[5] is to be arranged so that the dentil is half as wide as it is high; the hollow of the interval is two-thirds of the front of the dentil; the cymatium of this, one-sixth its height. The cornice with its cymatium, but without the

[1] Cf. "uncertain images," VII. *pref.* 11.
[2] See illustration. [3] A plain perpendicular band.
[4] Small blocks projecting from the lower part of the cornice.
[5] These are not to be confused with the larger square members which come between the triglyphs of the Doric order.

simam, quantum media fascia epistylii; proiectura
coronae cum denticulo facienda est, quantum erit
altitudo a zophoro ad summum coronae cymatium;
et omnino omnes ecphorae venustiorem habeant spe-
ciem, quae quantum altitudinis [1] tantundem habeant
12 proiecturae. Tympani autem, quod est in fastigio,
altitudo sic est facienda, uti frons coronae ab extremis
cymatiis tota dimetiatur in partes novem et ex eis
una pars in medio cacumine tympani constituatur,
dum contra epistylia [2] columnarumque hypotrachelia
ad perpendiculum respondeant. Coronaeque supra
aequaliter imis praeter simas sunt conlocandae.
Insuper coronas simae, quas Graeci *epaietidas* [3] dicunt,
faciendae sunt altiores octava parte coronarum
altitudinis. Acroteria angularia tam alta, quantum
est tympanum medium, mediana altiora octava parte
quam angularia.

13 Membra omnia, quae supra capitula columnarum
sunt futura, id est epistylia, zophora, coronae,[4]
tympana, fastigia, acroteria, inclinanda sunt in frontis
suae cuiusque altitudinis parte xii, ideo quod, cum
steterimus contra frontes, ab oculo lineae duae si
extensae fuerint et una tetigerit imam operis partem,
altera summam, quae summam tetigerit, longior fiet.
Ita quo longior visus linea in superiorem partem
procedit, resupinatam facit eius speciem. Cum
autem, uti supra scriptum est, in fronte inclinata

[1] altitudinis *G* : -nes *H*. [2] epistylia *Joc* : -lii *H*.
[3] epitidas *H* (*corr. Bötticher*).
[4] coronae *Joc* : corona & *x*.

[1] Moulding above cornice.
[2] Neckings.
[3] Small pedestals on which statues are placed.

sima,[1] is to be equal to the middle fascia of the
architrave. The projection of the cornice with the
dentil is to be made equal to the height from the
frieze to the top of the cymatium of the cornice;
and generally all projections have a more graceful
appearance when they are equal to the height of
the feature. 12. The height of the tympanum
which is in the pediment is to be such, that the
whole front of the cornice from the outside of the
cymatia is to be measured into nine parts; and
of these one is to be set up in the middle for the
summit of the tympanum. The architraves and
hypotrachelia[2] of the columns are vertically under
it. The cornices above the tympana are to be
made equal to those below, omitting the simae.
Above the cornices the simae, which the Greeks
call *epaietides*, are to be made higher by one-eighth
than the coronae. The angle acroteria[3] are to be
as high as the middle of the tympanum; the middle
ones are to be one-eighth higher than those at the
angles.
13. All the features which are to be above the
capitals of the columns, that is to say, architraves,
friezes, cornices, tympana, pediments, acroteria, are
to be inclined towards their fronts by a twelfth part
of their height; because when we stand against the
fronts, if two lines are drawn from the eye,[4] and one
touches the lowest part of the work, and the other
the highest, that which touches the highest, will be
the longer. Thus because the longer line of vision
goes to the upper part, it gives the appearance of
leaning backwards. When however, as written
above, the line is inclined to the front, then the

[4] Optical consideration involves a reference to perspective.

fuerit, tunc in aspectu videbuntur esse ad perpendi-
14 culum et normam. Columnarum striae faciendae
sunt xxiiii ita excavatae, uti norma in cavo striae
cum fuerit coniecta, circumacta anconibus striarum
dextra ac sinistra tangat acumenque normae
circum rotundationem tangendo pervagari possit.
Crassitudines striarum faciendae sunt, quantum
adiectio in media columna ex descriptione invenietur.
15 In simis, quae supra coronam in lateribus sunt
aedium, capita leonina sunt scalpenda, disposita ⟨ita⟩,
uti contra columnas singulas primum sint designata,
cetera aequali modo disposita, uti singula singulis
mediis tegulis respondeant. Haec autem, quae erunt
contra columnas, pererebrata sint ad canalem, qui
excipit e tegulis aquam caelestem; mediana autem
sint solida, uti, quae cadit vis aquae per tegulas in
canalem, ne deiciatur per intercolumnia neque
transeuntes perfundat,[1] sed quae sunt contra
columnas, videantur emittere vomentia ructus
aquarum ex ore.

Aedium ionicarum, quam apertissime potui, dis-
positiones hoc volumine scripsi; doricarum autem et
corinthiarum quae sint proportiones, insequenti libro
explicabo.

[1] perfundant *H*.

parts will seem vertical and to measure. 14. The flutes of the columns are to be twenty four, hollowed out in such a way that if a set square is placed in the hollow of a flute and moved round its ends, it will touch the fillets on the right and left, and the point of the square will touch the curve as it moves round. The width of the flutes is to be altered so as to suit the addition produced by the swelling [1] of the column. 15. On the mouldings, which are above the cornice on the sides of temples, lions' heads are to be carved, and arranged firstly so as to be set over against the tops of the several columns; the others at equal intervals so as to answer to the middle of the roof tiling. But these which will be against the columns are to be pierced for a gutter which takes the rainwater from the tiles. The intervening heads are to be solid so that the water which falls over the tiles into the gutter, may not fall down through the intercolumniations upon the passers by. But those which are against the columns are to seem to vomit and let fall streams of water from their mouths.

In this book I have written about the arrangements of Ionic temples as clearly as I could: I will unfold in the next book the proportions of Doric and Corinthian temples.

[1] Entasis; see above c. iii. 13.

BOOK IV

LIBER QUARTUS

1 Cum animadvertissem, imperator, plures de architectura praecepta voluminaque commentariorum non ordinata sed incepta, uti particulas, errabundos [1] reliquisse, dignam et utilissimam rem putavi antea disciplinae corpus ad perfectam ordinationem perducere et praescriptas in singulis voluminibus singulorum generum qualitates explicare. Itaque, Caesar, primo volumine tibi de officio eius et quibus eruditum esse rebus architectum oporteat, exposui. Secundo de copiis materiae, e quibus aedificia constituuntur, disputavi; tertio autem de aedium sacrarum dispositionibus et de earum generum varietate quasque et quot [2] habeant species earumque 2 quae sunt in singulis generibus distributiones. Ex tribus generibus quae subtilissimas haberent proportionibus modulorum quantitates ionici generis moribus, docui; nunc hoc volumine de doricis corinthiisque constitutis (et) [3] omnibus dicam eorumque discrimina et proprietates explicabo.

[1] errabundas *Joc* : -dos *H.* [2] quod *H.*
[3] *om. Gr.*

BOOK IV

Preface

1. When I perceived, your Highness, that many persons had stated the rules of Architecture, and had written commentaries casually, not set in due order but merely inchoate (like atoms) I thought it a worthy and most useful task first of all to reduce the encyclopedia of architecture to a perfect order, and in the several books to explain the qualities[1] of the several objects assigned to them. Therefore, Caesar, in the first book I expounded the function of the architect and the subjects in which he should be trained; in the second I discussed the supplies of the materials, of which buildings are constructed; in the third, the arrangements of temples, their different kinds, how many styles of design there were, and the details which belong to them severally. 2. Of the three orders, I taught, in reference to the Ionic order, those rules which, by the use of proportion, furnish the most exact adjustment of the modules. In this book I will proceed to speak of the Doric and Corinthian orders generally, their distinctions and properties.

[1] As distinct from quantity.

I

1 COLUMNAE corinthiae praeter capitula omnes
symmetrias habent uti ionicae, sed capitulorum alti-
tudines efficiunt eas pro rata excelsiores et graciliores,
quod ionici capituli altitudo tertia pars est cras-
situdinis columnae, corinthii[1] tota crassitudo scapi.
Igitur quod duae partes e crassitudine corinthiarum[2]
adiciuntur, efficiunt excelsitate speciem earum
2 graciliorem. Cetera membra quae supra columnas
inponuntur, aut e doricis symmetriis aut ionicis
moribus in corinthiis columnis conlocantur, quod
ipsum corinthium genus propriam[3] coronarum
reliquorumque ornamentorum non habuerat institu-
tionem, sed aut e triglyphorum[4] rationibus mutuli in
coronis et epistyliis guttae dorico more disponuntur,
aut ex ionicis institutis zophoroe scalpturis ornati
3 cum denticulis et coronis distribuuntur. Ita e
generibus duobus capitulo interposito tertium genus
in operibus est procreatum. E columnarum enim
formationibus trium generum factae sunt nomina-
tiones, dorica, ionica, corinthia, e quibus prima et
antiquitus dorica est nata.

Namque Achaia Peloponnessoque tota Dorus,
Hellenos[5] et Phthiados[6] nymphae filius, regnavit,

[1] corinthii *Joc* : -thie *H*.
[2] corinthiarum *Schn* : -orum *H*.
[3] propria *H*. [4] &rygiliphorum *H*.
[5] Hellenos *Polenus* : helenidos *H*.
[6] Exptidos *H* : Phthiados *Gr*. Eur. *Hec*. 451.

[1] The Porticus Octavia was the first work built in the
Corinthian style at Rome, in 168 B.C., and was also called
Porticus Corinthia. Lanciani *RE* 469, Platner 426.

CHAPTER I

ON THE CORINTHIAN CAPITAL

1. CORINTHIAN [1] columns have all their proportions like the Ionic, with the exception of their capitals. The height of the capitals renders them proportionately higher and more slender, because the height of the Ionic capital is one third of the thickness of the column, that of the Corinthian is the whole diameter of the shaft. Therefore because two-thirds of the diameter of the Corinthian columns are added to the capitals they give an appearance of greater slenderness owing to the increase in height. 2. The remaining features which are fixed above the columns are placed upon them in accordance either with Doric proportions or in the Ionic manner; because the Corinthian order has not separate rules for the cornices and the other ornaments, but, on the one hand, the mutules [2] in the cornices and the guttae in the architraves, are disposed in the Doric fashion; or, on the other hand following the Ionic arrangement, the friezes are adorned with carving and are combined with dentils and cornices. 3. Thus from the two orders, a third is produced by the introduction of a new capital. From the formation of the columns, come the names of the three styles, Doric, Ionic, Corinthian; of which the Doric came first and from early ages.[3]

For in Achaea and over the whole Peloponnese, Dorus, the son of Hellen and the nymph

[2] Mutule = projecting bracket.
[3] It is anticipated in the buildings of Cnossus in Crete; see Plate E.

isque Argis, vetusta civitate, Iunonis templum
aedificavit, eius generis fortuito formae fanum,
deinde isdem generibus in ceteris Achaiae civitatibus,
cum etiamnum non esset symmetriarum ratio nata.
4 Postea autem quam Athenienses ex responsis Apol-
linis Delphici, communi consilio totius Hellados,
XIII colonias uno tempore in Asiam deduxerunt
ducesque in singulis coloniis constituerunt et summam
imperii potestatem Ioni, Xuthi[1] et Creusae[2] filio,
dederunt, quem etiam Apollo Delphis suum filium
in responsis est professus, isque eas colonias in Asiam
deduxit et Cariae fines occupavit ibique civitates
amplissimas constituit Ephesum, Miletum, Myunta[3]
(quae olim ab aqua est devorata; cuius sacra et
suffragium Milesiis[4] Iones adtribuerunt), Prienen,[5]
Samum, Teon, Colophona, Chium, Erythras,[6]
Phocaeam,[7] Clazomenas,[8] Lebedon, Meliten[9] (haec
Melite propter civium adrogantiam ab his civitatibus
bello indicto communi consilio est sublata; cuius loco
postea regis Attali et Arsinoes beneficio Zmyrnae-
orum civitas inter Ionas est recepta): hae civitates,
cum Caras et Lelegas eiecissent, eam terrae regionem
a duce suo Ione appellaverunt Ioniam ibique deorum
inmortalium templa constituentes coeperunt fana
5 aedificare. Et primum Apollini[10] Panionio[11] aedem,

[1] ionix uthi *H.* [2] Creusae *Ioc* : ereuso *H.*
[3] myanta *H.* [4] milesius *H.* [5] prenem *H.*
[6] erytras *H.* [7] phocea *H.*
[8] glazomenum *H.* [9] meletenis *H.*
[10] appollini *H.* [11] Panionio *Ioc* : pandionio *H.*

[1] Euripides' play *Ion* is probably alluded to here. Vitruvius
quotes from his *Phaethon* and has preserved an otherwise
unknown fragment Book IX. i. 13.
[2] *Aqua* refers to the encroachment of the sea.

Phthia was king; by chance he built a temple
in this style at the old city of Argos, in the
sanctuary of Juno, and, afterwards, in the other
cities of Achaea after the same style, when as yet
the determination of the exact proportions of the
order had not begun. 4. Afterwards the Athenians,
in accordance with the responses of Apollo, and by
the general consent of all Greece, founded thirteen
colonies in Asia at one time. They appointed chiefs
in the several colonies, and gave the supreme
authority to Ion, the son of Xuthus and Creusa
(whom Apollo, in his responses at Delphi, had
declared to be his son).[1] He led the colonies into
Asia and seized the territory of Caria. There he
established the large cities of Ephesus, Miletus,
Myus [2] (of which, being swallowed up in marshy
ground, the worships and vote in the League were
transferred to Miletus), Priene, Samos, Teos, Colo-
phon, Chios, Erythrae, Phocaea, Clazomenae, Lebe-
dos, Melite. Against Melite, because of the inso-
lence of its citizens, war was declared by the other
cities, and it was destroyed by general consent. In
its place, afterwards,[3] the city of the Smyrnaeans
was received among the Ionians by the kindness
of King Attalus and Arsinoe. 5. These cities
drove out the Carians and Leleges and named
that region of the earth Ionia from their leader
Ion, and establishing there sanctuaries of the im-
mortal gods, they began to build temples in them.
First, to Panionian [4] Apollo they established a temple

[3] 3rd century B.C.
[4] The Panionium at Mycale was dedicated to Neptune
(Poseidon). There was another Panionium dedicated to
Apollo C. I. A. III. 175.

uti viderant in Achaia, constituerunt et eam Doricam
appellaverunt, quod in Dorieon [1] civitatibus primum
6 factam eo genere viderunt. In ea aede cum voluissent
columnas conlocare, non habentes symmetrias earum
et quaerentes quibus rationibus efficere possent, uti
et ad onus ferendum essent idoneae et in aspectu
probatam haberent venustatem, dimensi sunt
virilis pedis vestigium et id retulerunt in alti-
tudinem. Cum invenissent pedem sextam partem
esse altitudinis in homine, item in columnam trans-
tulerunt et, qua crassitudine fecerunt basim scapi,
tanta sex cum capitulo in altitudinem extulerunt.
Ita dorica columna virilis corporis proportionem et
firmitatem et venustatem in aedificiis praestare
coepit.

7 Item postea Dianae constituere aedem, quaerentes
novi generis speciem isdem vestigiis ad muliebrem
transtulerunt gracilitatem, et fecerunt primum
columnae crassitudinem octava parte, ut haberet
speciem excelsiorem. Basi spiram subposuerunt pro
calceo, capitulo volutas uti capillamento concrispatos
cincinnos praependentes dextra ac sinistra conloca-
verunt et cymatiis et encarpis pro crinibus dispositis
frontes ornaverunt truncoque toto strias [2] uti stolarum
rugas [3] matronali more dimiserunt, ita duobus dis-
criminibus columnarum inventionem, unam virili sine
8 ornatu nudam speciem, alteram muliebri. Subtili-
tateque iudiciorum progressi et gracilioribus modulis
delectati septem crassitudinis diametros in altitudi-
nem columnae doricae, ionicae novem constituerunt.
Id autem quod Iones fecerunt primo, Ionicum est
nominatum.

[1] Dorieon *Joc* : dorichon *H*. [2] istrias *H*.
 [3] rugas *G* : rugus *H*.

as they had seen in Achaia. Then they called it
Doric because they had first seen it built in that
style. 6. When they wished to place columns in
that temple, not having their proportions, and seek-
ing by what method they could make them fit to
bear weight, and in their appearance to have an
approved grace, they measured a man's footstep
and applied it to his height. Finding that the foot
was the sixth part of the height in a man, they
applied this proportion to the column. Of whatever
thickness they made the base of the shaft they
raised it along with the capital to six times as much
in height. So the Doric column began to furnish the
proportion of a man's body, its strength and grace.[1]

7. Afterwards also seeking to plan a temple of
Diana in a new kind of style, they changed it to a
feminine slenderness with the same measurement
by feet. And first they made the diameter of the
column the eighth part of it, so that it might appear
taller. Under the base they placed a convex mould-
ing as if a shoe; at the capital they put volutes, like
graceful curling hair, hanging over right and left.
And arranging cymatia and festoons in place of
hair, they ornamented the front, and, over all the
trunk (*i.e.* the shaft), they let fluting fall, like the
folds of matronly robes; thus they proceeded to the
invention of columns in two manners; one, manlike
in appearance, bare, unadorned; the other feminine.
8. Advancing in the subtlety of their judgments
and preferring slighter modules, they fixed seven
measures of the diameter for the height of the
Doric column, nine for the Ionic. This order because
the Ionians made it first, was named Ionic.

[1] This theory is of late origin.

Tertium vero, quod Corinthium dicitur, virginalis [1]
habet gracilitatis imitationem, quod virgines propter
aetatis teneritatem gracilioribus membris figuratae
9 effectus recipiunt in ornatu venustiores. Eius autem
capituli prima inventio sic memoratur esse facta.
Virgo civis Corinthia iam matura nuptiis inplicata
morbo decessit. Post sepulturam eius, quibus ea
virgo viva poculis delectabatur, nutrix collecta et
conposita in calatho pertulit ad monumentum et in
summo conlocavit et, uti ea permanerent diutius
subdiu, tegula texit. Is calathus fortuito supra
acanthi radicem fuerit conlocatus. Interim pondere
pressa radix acanthi [2] media folia et cauliculos circum
vernum tempus profudit, cuius cauliculi secundum
calathi latera crescentes et ab angulis tegulae pon-
deris necessitate expressi flexuras in extremas partes
10 volutarum facere sunt coacti. Tunc Callimachus
qui propter elegantiam et subtilitatem artis marmo-
reae ab Atheniensibus *catatechnos* fuerat nominatus,
praeteriens hoc monumentum animadvertit eum
calathum et circa foliorum nascentem teneritatem,
delectatusque genere et formae novitate ad id
exemplar columnas apud Corinthios fecit symmetri-
asque constituit; ex eo in operis perfectionibus
11 Corinthii generis distribuit rationes. Eius autem
capituli symmetria sic est facienda, uti, quanta fuerit
crassitudo imae columnae, tanta sit altitudo capituli
cum abaco. Abaci latitudo ita habeat rationem, ut,
quanta fuerit altitudo, tanta duo sint diagonia ab

[1] virginales *H*. [2] achanti *H*.

[1] Frontispiece.

But the third order, which is called Corinthian,[1] imitates the slight figure of a maiden; because girls are represented with slighter dimensions because of their tender age, and admit of more graceful effects in ornament. 9. Now the first invention of that capital is related to have happened thus. A girl, a native of Corinth, already of age to be married, was attacked by disease and died. After her funeral, the goblets which delighted her when living, were put together in a basket by her nurse, carried to the monument, and placed on the top. That they might remain longer, exposed as they were to the weather, she covered the basket with a tile. As it happened the basket was placed upon the root of an acanthus. Meanwhile about spring time, the root of the acanthus, being pressed down in the middle by the weight, put forth leaves and shoots. The shoots grew up the sides of the basket, and, being pressed down at the angles by the force of the weight of the tile, were compelled to form the curves of volutes at the extreme parts. 10. Then Callimachus, who for the elegance and refinement of his marble carving was nick-named *catatechnos* by the Athenians, was passing the monument, perceived the basket and the young leaves growing up Pleased with the style and novelty of the grouping, he made columns for the Corinthians on this model and fixed the proportions. Thence he distributed the details of the Corinthian order throughout the work. 11. The proportions of the capital are to be arranged thus. The height of the capital with the abacus is to equal the diameter of the bottom of the column. The width of the abacus is to be so proportioned: the diagonal lines from angle to angle are to equal twice

angulo ad angulum; spatia enim ita iustas habebunt
frontes quoquoversus latitudinis. Frontes simentur
introrsus ab extremis angulis abaci suae frontis
latitudinis nona.[1] Ad imum capituli tantam habeat
crassitudinem, quantam habet summa columna
praeter apothesim et astragalum. Abaci [2] crassitudo
12 septima capituli altitudinis. Dempta abaci crassitu-
dine dividatur reliqua pars in partes tres, e quibus
una imo folio detur; secundum folium mediam
altitudinem teneat; coliculi [3] eandem habeant
altitudinem, e quibus folia nascuntur proiecta, uti
excipiant quae ex coliculis natae procurrunt ad
extremos angulos volutae; minoresque helices intra
suum medium, qui est in abaco; flores subiecti
scalpantur. Flores in quattuor partibus, quanta
erit abaci crassitudo, tam magni formentur. Ita
his symmetriis corinthia capitula suas habebunt
exactiones.

Sunt autem, quae isdem columnis inponuntur,
capitulorum genera variis vocabulis nominata, quorum
nec proprietates symmetriarum nec columnarum
genus aliud nominare possumus, sed ipsorum vocabula
traducta et commutata ex corinthiis et pulvinatis et
doricis videmus, quorum symmetriae sunt in novarum
scalpturarum translatae subtilitatem.

[1] nona *Joc* : non *H*.
[2] astragalum. Abaci *Joc* : abaci astragalum *H*.
[3] coaliculi *H*.

the height of the capital. Thus the front elevations in every direction, will have the right breadth. Let the faces be curved inward from the extreme angles of the abacus the ninth part of the breadth of the face. At the lowest part, let the capital have the diameter of the top of the column, excluding the curving away of the column into the capital, and the astragal.[1] The thickness of the abacus is one seventh of the height of the capital. 12. Taking away the thickness of the abacus, let the remainder be divided into three parts, of which let one be given to the lowest leaf. Let the second leaf have two thirds. Let the stalks have the same height, and let leaves arise from these, projecting to receive the volutes which rise from the stalks and run out to the extreme angles. Let smaller spirals be carved running up to the flower which is in the middle of the abacus. On the four sides let flowers be carved, their width being equal to the height of the abacus. With these proportions, Corinthian capitals will have their appropriate execution.

There are other[2] kinds of capitals variously named which are placed upon these same columns. We cannot name their special proportions nor the style of the columns in any other manner. We observe that even their names are transferred and changed from the Corinthian, Pulvinate and Doric styles, the proportions of which are transferred to the refinements of these novel sculptures.

[1] See Plate D.

[2] The varieties of the Corinthian capital passed by easy stages to the Gothic capital. Timgad in the second cent. A.D. shows many forms. The Byzantine sculptors gave a convex form to the Corinthian capital as at San Vitale, Ravenna.

II

1 Quoniam autem de generibus columnarum origines
et inventiones supra sunt scriptae, non alienum mihi
videtur isdem rationibus de ornamentis eorum, quem-
admodum sunt prognata et quibus principiis et
originibus inventa, dicere. In aedificiis omnibus
insuper conlocatur materiatio variis vocabulis nomi-
nata. Ea autem uti in nominationibus, ita in res
varias habet utilitates. Trabes enim supra columnas
et parastaticas et antas ponuntur; in contignationibus
tigna et axes; sub tectis, si maiora spatia sunt, et
transtra et capreoli,[1] si commoda, columen, et can-
therii prominentes ad extremam suggrundationem;
supra cantherios templa; deinde insuper sub tegulas
asseres ita prominentes, uti parietes protecturis
2 eorum tegantur. Ita unaquaeque res et locum et
genus et ordinem proprium tuetur. E quibus rebus
et a materiatura fabrili in lapideis et marmoreis
aedium sacrarum aedificationibus artifices disposi-
tiones eorum sculpturis sunt imitati et eas inventiones
persequendas putaverunt. Ideo, quod antiqui fabri
quodam in loco aedificantes, cum ita ab interioribus
parietibus ad extremas partes tigna prominentia
habuissent conlocata, inter tigna struxerunt supraque
coronas et fastigia venustiore specie fabrilibus operi-
bus ornaverunt, tum proiecturas tignorum, quantum

[1] capreoli *G* : -lis *H*.

[1] Cf. Book I. i. 5.
[2] The influence of wood details upon stonework is un-
doubted.

CHAPTER II

ON THE DETAILS OF THE ORDERS

1. Now since the origins and discovery of the orders of columns have been described above, it does not seem foreign to my purpose if I speak in the same way about their ornaments: how they came about, and from what principles and origins they were invented.[1] In all buildings timbering,[2] called by various names, is used in the upper parts; as in name, so in practice, it has uses for various things. Beams are placed on columns, pilasters and responds. In floors there are joists and planks. Under roofs, if the spans are considerable, both cross pieces and stays; if of moderate size, a ridge piece with rafters projecting to the edge of the eaves. Above the principal rafters, purlins; then above, under the tiles, rafters which overhang so that the walls are covered by the eaves.[3] 2. So each scantling preserves its proper place and style and arrangement. In view of these things and of carpenter's work generally, craftsmen imitated such arrangements in sculpture when they built temples of stone and marble. For they thought these models worth following up. Thus workmen of old, building in various places, when they had put beams reaching from the inner walls to the outside parts, built in the spaces between the beams; above through their craftsmanship, they ornamented the cornices and gables with a more graceful effect. Then they cut off the projections of the beams, as far as they came

[3] *Protectura* for eaves is probably right: *protectum* is used in this sense.

eminebant, ad lineam et perpendiculum parietum
praesecuerunt, quae species cum invenusta is visa
esset, tabellas ita formatas, uti nunc fiunt triglyphi,
contra tignorum praecisiones in fronte fixerunt et
eas cera caerulea depinxerunt, ut praecisiones tigno-
rum tectae non offenderent visum ita divisiones
tignorum tectae triglyphorum dispositionem et inter
tigna metoparum [1] habere in doricis operibus coe-
3 perunt. Postea alii in aliis operibus ad perpendiculum
triglyphorum cantherios prominentes proiecerunt
eorumque proiecturas simaverunt. Ex eo, uti
tignorum dispositionibus triglyphi, ita e cantheriorum
proiecturis mutulorum sub coronulis [2] ratio est inventa.
Ita fere in operibus lapideis et marmoreis mutuli
inclinatis scalpturis deformantur, quod imitatio est
cantheriorum; etenim necessario propter stillicidia
proclinati conlocantur. Ergo et triglyphorum et
mutulorum in doricis operibus ratio ex [3] ea imitatione
inventa est.

4 Non enim, quemadmodum nonnulli errantes dixe-
runt fenestrarum imagines esse triglyphos, ita potest
esse, quod in angulis contraque tetrantes columnarum
triglyphi constituuntur, quibus in locis omnino non pati-
tur res fenestras fieri. Dissolvuntur enim angulorum
in aedificiis iuncturae, si in is fenestrarum fuerint
lumina relicta. Etiamque ubi nunc triglyphi consti-
tuuntur, si ibi luminum spatia fuisse iudicabuntur,
isdem rationibus denticuli [4] in ionicis fenestrarum
occupavisse loca videbuntur. Utraque [5] enim, et
inter denticulos et inter triglyphos quae sunt inter-
valla, metopae [6] nominantur. *Opas* enim Graeci

[1] intertignum et oparum *H* : inter tigna *Gr.*
[2] coronulis *H* : *cf. Vulg.* [3] ex *G* : & *H.*
[4] denticuli *ed. Fl* : denticulis *H.*

214

forward, to the line and perpendicular of the walls. But since this appearance was ungraceful, they fixed tablets shaped as triglyphs now are, against the cut-off beams, and painted them with blue wax, in order that the cut-off beams might be concealed so as not to offend the eyes. Thus in Doric structures, the divisions of the beams being hidden began to have the arrangement of the triglyphs, and, between the beams, of metopes. 3. Subsequently other architects in other works carried forward over the triglyphs the projecting rafters, and trimmed the projections. Hence just as triglyphs came by the treatment of the beams, so from the projections of the rafters the detail of the mutules under the cornices was invented. Thus generally in buildings of stone and marble the mutules are modelled with sloping carving; and this imitates the rafters. For they are necessarily put sloping because of the rainfall. Therefore in the Doric style the detail both of the triglyphs and of the mutules arose from this imitation of timber work.

4. For it cannot be that triglyphs are representations of windows (as some have mistakenly said). For triglyphs are placed at the angles of the front, and over the centre of columns; where generally it is impossible for windows to be made. For the bond at the angles of buildings is destroyed, if window lights are left there. And also if window lights are considered to have been where now triglyphs are placed, in the same way dentils in Ionic buildings will seem to have taken the place of windows. For the intervals, which are both between dentils and between triglyphs, are called *metopae*. For the

⁵ utraque *Joc* : utrique *H*. ⁶ metophe *H*.

tignorum cubicula et asserum appellant, uti nostri ea
cava [1] columbaria. Ita quod inter duas opas est
intertignium,[2] id *metope* est apud eos nominata.

5 Ita uti autem in doricis triglyphorum et mutu-
lorum est inventa ratio, item in ionicis denticulorum
constitutio propriam in operibus habet rationem, et
quemadmodum mutuli cantheriorum proiecturae
ferunt [3] imaginem, sic in ionicis denticuli [4] ex pro-
iecturis asserum habent imitationem. Itaque in
graecis operibus nemo sub mutulo denticulos consti-
tuit; non enim possunt subtus cantherios asseres
esse. Quod ergo supra cantherios et templa in veri-
tatem debet esse conlocatum, id in imaginibus si
infra constitutum fuerit, mendosam habebit operis
rationem. Etiam quod antiqui non probaverunt,
neque instituerunt in fastigiis ⟨mutulos aut⟩[5] denti-
culos fieri sed puras coronas, ideo quod nec cantherii
nec asseres contra fastigiorum frontes distribuuntur
nec possunt prominere, sed ad stillicidia [6] proclinati
conlocantur. Ita quod non potest in veritate fieri,
id non putaverunt in imaginibus factum posse certam
6 rationem habere. Omnia enim certa proprietate et
a veris naturae deducta [7] moribus transduxerunt in
operum perfectiones, et ea probaverunt, quorum ex-
plicationes in disputationibus rationem possunt
habere veritatis. Itaque ex eis originibus symme-
trias et proportiones uniuscuiusque generis constitu-

[1] cava *rec* : caba *H*.
[2] opas est intertignium *Joc* : ophas et intertignum *H*.
[3] ferunt *G* : fuerunt *H*.
[4] denticuli ex *Joc* : denticulis et *H*.
[5] *add. Phil.* [6] stillicia *H*.
[7] deducta *rec* : -tis *H*.

[1] This rule is specially insisted on by critics of architecture.

Greeks give the name of *opae* to the beds of beams and rafters; as our people call them hollow mortices. So the space between the two opae is called *metopa* among the Greeks.

5. In the Doric order, the detail of the triglyphs and mutules was invented with a purpose. Similarly in Ionic buildings, the placing of the dentils, has its appropriate intention. And just as in the Doric order the mutules have been the representation of the projecting principal rafters, so, in the case of Ionic dentils, they also imitate the projection of the ordinary rafters. Therefore in Greek works no one puts dentils under a mutule.[1] For ordinary rafters cannot be put beneath principals. For if what ought to be placed above principals and purlins in reality is placed below them in the imitation, the treatment of the work will be faulty.[2] Further, as to the ancients neither approving nor arranging that in the pediments there should be either mutules or dentils, but plain cornices, this was because neither principals nor rafters are fixed to project on the front of gables, but are placed sloping down to the eaves. Thus what cannot happen in reality cannot (they thought) be correctly treated in the imitation. 6. For, by an exact fitness deduced from the real laws of nature, they adapted everything to the perfection of their work, and approved what they could show by argument, to follow the method of reality. And so they handed down the symmetry and proportions of each order as deter-

[2] Vitruvius holds that Symbolism should be consistent. It is because the later architects of the Renaissance used architectural forms without regard to their meaning that the purists denounced some lovely buildings.

tas reliquerunt. Quorum ingressus persecutus de
ionicis et corinthiis institutionibus supra dixi; nunc
vero doricam rationem summamque eius speciem
breviter exponam.

III

1 NONNULLI antiqui architecti negaverunt dorico
genere aedes sacras oportere fieri, quod mendosae
et disconvenientes in his symmetriae conficiebantur.
Itaque negavit Arcesius,[1] item Pythius,[2] non minus
Hermogenes. Nam is cum paratam habuisset mar-
moris copiam in doricae aedis perfectionem, commu-
tavit ex eadem copia et eam ionicam Libero Patri
fecit. Sed tamen non quod invenusta est species
aut genus aut formae dignitas, sed quod inpedita
est distributio et incommoda in opere triglyphorum
2 et lacunariorum distributione. Namque necesse est
triglyphos constitui contra medios tetrantes columna-
rum, metopasque, quae inter triglyphos fient, aeque
longas esse quam altas. Contraque in angulares
columnas triglyphi in extremis partibus constituuntur
et non contra medios tetrantes. Ita metopae quae
proximae ad angulares triglyphos fiunt, non exeunt
quadratae sed oblongiores triglyphi dimidia latitu-
dine.[3] At qui metopas aequales volunt facere, inter-
columnia extrema contrahunt triglyphi dimidia lati-
tudine.[4] Hoc autem, sive in metoparum longitudini-

[1] Arcesius *Ro* : tarchesius *H*.
[2] pytheus *H*. [3] latitudine *Phil.*
[4] latitudine *H^c* : altitudine *H*.

[1] Arcesius wrote upon the Corinthian order Book VII.
pref. 12.

mined from these beginnings. Following their foot-
steps I have spoken above of the Ionic and Corinthian
orders, but now I shall briefly set forth the Doric
manner and its general form.

CHAPTER III

ON THE DORIC ORDER

1. SOME ancient architects have said that temples
should not be constructed in the Doric style, because
faulty and unsuitable correspondence arose in them;
for example Arcesius,[1] Pythius,[2] and especially
Hermogenes. For the last named after preparing
a supply of marble for a temple in the Doric style,
changed over, using the same marble, and built
an Ionic temple to Father Bacchus[3] not because
the form or style or dignity of the plan is dis-
pleasing, but because the distribution of the
triglyphs and soffits is confused and inconvenient.
2. For it is necessary that the triglyphs should be
placed over the middle quadrants of the columns,
and that the metopes which are constructed between
the triglyphs should be as broad as they are high.
On the other hand, the triglyphs against the corner
columns are placed at their furthest edge, and not
against the middle of the columns. Thus the metopes
which are made next to the corner triglyphs do not
come out square but oblong by half the breadth of
a triglyph. But those who wish to make the metopes
equal contract the extreme intercolumniations by
half the breadth of a triglyph. Whether the work

[2] Vitruvius' chief authorities were Pythius and Hermogenes.
[3] At Teos, Book VII. pref. 12.

bus sive intercolumniorum contractionibus efficietur,
est mendosum. Quapropter antiqui vitare visi sunt
in aedibus sacris doricae symmetriae rationem.

3 Nos autem exponimus, uti ordo postulat, quem-
admodum a praeceptoribus accepimus, uti, si qui
voluerit his rationibus adtendens ita ingredi, habeat
proportiones explicatas, quibus emendatas et sine
vitiis efficere possit aedium sacrarum dorico more
perfectiones. Frons aedis doricae in loco, quo
columnae constituuntur, dividatur, si tetrastylos erit,
in partes xxvII, si hexastylos, xxxxII.[1] Ex his pars
una erit modulus, qui Graece *embater* [2] dicitur, cuius
moduli constitutione ratiocinationibus efficiuntur
4 omnis operis distributiones. Crassitudo columnarum
erit duorum modulorum, altitudo cum capitulo
xIIII. Capituli crassitudo unius moduli, latitudo
duorum et moduli sextae partis. Crassitudo capituli
dividatur in partes tres, e quibus una plinthus cum
cymatio fiat, altera echinus cum anulis, tertia hypo-
trachelion.[3] Contrahatur columna ita, uti in tertio
libro de ionicis est scriptum. Epistylii altitudo unius
moduli cum taenia et guttis; taenia moduli septima;
guttarum longitudo sub taenia contra triglyphos alta
cum regula parte sexta moduli praependeat. Item
epistylii [4] latitudo ima respondeat hypotrachelio
summae columnae. Supra epistylium conlocandi
sunt triglyphi cum suis metopis, alti unius ⟨et⟩ [5]

[1] xxvII . . . xxxxII *Phil*: xxvIII . . . xxxII *H*.
[2] *cf*. I. ii. 4 : embates *H*.
[3] hypotrachelion *Phil*: ypotrachelio *H*.
[4] epistyliis *H*. [5] *add. Joc*.

[1] Sometimes the diameter equals one module, III. iii. 7.

proceeds by lengthening the metopes or contracting the intercolumniations, it is faulty. Hence the ancients, as it seems, avoided the Doric order in temples.

3. Now we, following the arrangement demanded in accordance with the instruction of our masters, proceed in such a way that, if the reader will conform to our methods, he may find those proportions set forth by which he can carry out temples in the Doric style faultless and without blemish. The front of a Doric temple is to be divided along the line where columns are set, into 27 parts if it is tetrastyle, into 42 parts if it is hexastyle. Of these one part will be the module (which in Greek is called *embater*) and when this is determined, the distribution of all the work is produced by multiples of it. 4. The diameter of the columns will be two modules,[1] the height including the capital 14, the height of the capital is one module, the width two modules and a sixth. The height of the capital is to be divided into three parts, of which one is to be the abacus with the cymatium; the second the echinus with fillets; the third the necking. The column is to be diminished as directed for the Ionic order in the third book. The height of the architrave is to be one module including the taenia and guttae; the taenia is to be the seventh part of a module; the length of the guttae under the taenia corresponds to the triglyphs, and is to hang down, including the fillet, the sixth part of a module. The breadth also of the architrave at the soffit is to correspond to the necking of the column at the top. Above the architrave are to be placed the triglyphs with the metopes; the triglyphs being a module

dimidiati moduli, lati in fronte unius moduli, ita
divisi, ut in angularibus columnis et in mediis contra
tetrantes medios sint conlocati, et intercolumniis
reliquis bini,[1] in mediis pronao et postico terni. Ita
relaxatis mediis intervallis sine inpeditionibus aditus
5 accedentibus erit ad deorum simulacra. Triglypho-
rum latitudo dividatur in partes sex, ex quibus
quinque partibus in medio, duae dimidiae dextra ac
sinistra designentur regula. Una in medio de-
formetur femur, quod Graece *meros* [2] dicitur; secun-
dum eam canaliculi ad normae cacumen inprimantur;
ex ordine eorum [3] dextra ac sinistra altera femina
constituantur; in extremis partibus semicanaliculi
intervertantur. Triglyphis ita conlocatis, metopae
quae sunt inter triglyphos,[4] aeque altae sint quam
longae; item in extremis angulis semimetopia [5] sint
inpressa dimidia moduli latitudine. Ita enim erit,
ut omnia vitia et metoparum et intercolumniorum et
lacunariorum, quod aequales divisiones factae erunt,
6 emendentur. Triglyphi capitula sexta parte moduli
sunt faciunda. Supra triglyphorum capitula corona
est conlocanda in proiectura dimidiae et sextae
partis [6] habens cymatium doricum in imo, alterum
in summo. Item cum cymatiis corona crassa ex
dimidia moduli. Dividendae autem sunt in corona [7]
ima ad perpendiculum triglyphorum et medias meto-
pas viarum derectiones et guttarum distributiones,

[1] bini *Joc* : binis *H.* [2] μηρός *Joc* : eros *H.*
[3] eorum *Joc* : earum *H.* [4] inter glyphos *H.*
[5] semimetopia *Joc* : semi memphia *H.*
[6] sextae partis *rec* : sextae parte *H G.*
[7] corona : columna *H.*

[1] The meaning of *via* is uncertain; it probably denotes the
spaces between the mutules.

and a half high and one module wide in front, and
so distributed that in the columns both at the corners
and in the middle, they are placed over the centres.
In the middle intercolumniations of the front and
back there are to be three, in the other intercolumnia-
tions there are to be two triglyphs. The middle
intercolumniations are to be thus widened so that
for those who are approaching the statues of the
gods there may be an uninterrupted approach.
5. The width of the triglyphs is to be divided into
six parts, of which five parts are to be in the
middle, and two halves right and left are to be
marked by the length of the fillet. The part in the
middle is to be shaped flat as the *thigh* (which in
Greek is called *mēros*). Parallel channels are to be
sunk with sides meeting in a right angle. To the
right and left of them, in order, other flat surfaces
or thighs are to be put. At the furthest edges,
half channels are to be put. After placing the
triglyphs, the metopes which separate them, are
to be made as high as they are long. Further,
at the extreme corners, half metopes are to be
made half a module wide. Hence the divisions
will be made uniform and all the faults, both of
metopes and intercolumniations and soffits, will be
removed. 6. The capitals of the triglyphs are to be
made of the sixth part of a module. Above the
capitals of the triglyphs, the cornice is to be placed
projecting two thirds of a module, with a Doric
cymatium below and another at the top. Further,
with the cymatia, the cornice will be half a module
high. Now in the lowest part of the cornice, above
the triglyphs and the middle of the metopes, the
lines of the *viae* [1] and the rows of the guttae are to

ita uti guttae sex in longitudinem, tres in latitudinem pateant. Reliqua spatia, quod latiores sint metopae quam triglyphi, pura relinquantur aut numina [1] scalpantur, ad ipsumque mentum coronae incidatur linea quae scotia dicitur. Reliqua omnia, tympana, simae,[2] coronae, quemadmodum supra scriptum est in ionicis, ita perficiantur.

7 Haec ratio in operibus diastylis [3] erit constituta. Si vero systylon et monotriglyphon opus erit faciundum, frons aedis, si tetrastylo erit, dividatur in partes xviiii s,[4] si hexastylos erit, dividatur in partes xxviiii s. Ex his pars una erit modulus, ad quem, 8 uti supra scriptum est, dividantur. Ita supra singula epistylia et metopae [5] et triglyphi bini erunt conlocandi; in angularibus hoc amplius, quantum dimidiatum est spatium hemitriglyphi, id accedit. In mediano [6] contra fastigium trium triglyphorum et trium metoparum spatium distabit, quod latius medium intercolumnium accedentibus ad aedem habeat laxamentum et adversus simulacra deorum aspectus dignitatem.

9 Columnas autem striari xx striis oportet. Quae si planae erunt, angulos habeant xx designatos. Sin autem excavabuntur, sic est forma facienda, ita uti quam magnum est intervallum striae, tam magnis striaturae paribus lateribus quadratum describatur;

[1] numina *Gr* : flumina *H cf.* numinum simulacra Tac. *A.* I 73, effigies numinum, *A.* I 10; III 71.
[2] simae *Joc* : et imae *H.* [3] diastylis *ed* : -liis *H.*
[4] xviiii s . . . xxviiii s *Barbarus* : xviii . . . xxviiii *H.*
[5] metopae *Joc* : metopha *H.*
[6] [habens—perpendiculum] *H ex* 6 *supra,* moduli *om. H.*

be divided so that there are six guttae in the length
and three in the breadth. The remaining spaces,
because the metopes are broader than triglyphs, are
to be left plain, or divine images are to be carved;
and at the very edge of the cornice a line is to be
cut in which is called the scotia. All the rest—
namely the field of the pediment, the cymas, the
cornices—are to be finished as prescribed above for
Ionic buildings.

7. Such is the method that will be appointed for
diastyle works. But if the work is to be systyle and
with single triglyphs, the front of a tetrastyle temple
is to be divided into nineteen and a half parts; of a
hexastyle temple into twenty nine and a half parts.
Of these one part will be the module according to
which they are to be divided, as written above.[1]
8. Thus above the single architraves, two metopes
and two triglyphs are to be placed. At the angles [2]
in addition, as much as is half a triglyph is put.
Against the middle of the pediment, a space will
intervene of three triglyphs and three metopes, in
order that the middle intercolumniation, being
broader, may give room to persons approaching the
temple, and furnish a dignified appearance as one
goes to meet the Image of the God.

9. The columns ought to be fluted with 20 flutes.[3]
If the flutes are flat, the columns must have 20
vertical edges marked. But if the flutes are hollow,
we must fix their form in this way: draw a square
with equal sides as great as is the width of the fluting.

[1] The module for Doric buildings is half a diameter, § 3.
[2] See Plate E.
[3] The old, and present, Parthenon have 20 flutes on the
shafts.

in medio autem quadrato circini centrum [1] conlocetur
et agatur linea rotundationis, quae quadrationis
angulos tangat, et quantum erit curvaturae inter
rotundationem et quadratam descriptionem, tantum
ad formam excaventur. Ita dorica columna sui
10 generis striaturae habebit perfectionem. De adiec-
tione eius, qua media adaugetur, uti in tertio volu-
mine de ionicis est perscripta, ita et in his trans-
feratur.

Quoniam exterior species symmetriarum et corin-
thiorum et doricorum et ionicorum est perscripta,
necesse est etiam interiores cellarum pronaique
distributiones explicare.

IV

1 DISTRIBUITUR autem longitudo aedis, uti latitudo
sit longitudinis dimidiae partis, ipsaque cella parte
quarta longior sit, quam est latitudo, cum pariete
qui paries valvarum habuerit [2] conlocationem. Reli-
quae tres partes pronai ad antas parietum procurrant,
quae antae columnarum crassitudinem habere de-
bent. Et si aedes erit latitudine maior quam
pedes xx, duae columnae inter duas antas inter-
ponantur, quae disiungant pteromatos [3] et pronai
spatium. Item intercolumnia tria quae erunt inter
antas [4] et columnas, pluteis marmoreis sive ex in-

[1] centrum *S E* : centum *H.*
[2] habuerit *G* : hab&erit *H.*
[3] pteromotos *H.* [4] inter interantas *H.*

Now in the middle of the square the centre of a circle is to be placed, and let a circle be described which touches the angles of the square ; and the curve which comes between the circumference and the side of the square, will give the hollow of the flutes. Thus the Doric column will have the fluting proper to its order. 10. Concerning the entasis of the column by which it is increased in the middle, the method prescribed in the third book for the Ionic order is to be imitated in the case of the Doric order.

Inasmuch as the external appearance of the symmetries of the Corinthian and Doric and Ionic orders has been described, we must proceed to explain the interior distribution of the apartments of the temple, and also of the approach to the temple.

CHAPTER IV

ON THE INTERIOR OF THE TEMPLE, AND THE PRONAOS

1. THE length of the temple is so arranged that the breadth is half the length. The cella itself is to be a fourth part longer than its breadth, including the wall which contains the doors. The remaining three parts, that is, the portico, are to run forward to the antae of the walls. The antae ought to have the thickness of the columns. If the temple be more than 20 feet in breadth, between the two antae two columns are to be placed and these columns are to separate the portico and the *pteroma*.[1] Between the three intercolumniations, which will come between the antae and the columns, let there

[1] Book III. iii. 9; the colonnade which surrounds the temple.

testino opere factis intercludantur, ita uti fores
2 habeant, per quas itinera pronao fiant. Item si
maior erit latitudo quam pedes XL, columnae contra
regiones [1] columnarum, quae inter antas sunt,
introrsus conlocentur. Et hae altitudinem habeant
aeque quam quae sunt in fronte, crassitudines autem
earum extenuentur his rationibus, uti, si octava
parte erunt quae sunt in fronte, hae fiant x parte,
sin autem VIIII aut decima, pro rata parte.[2] In
concluso enim aere si quae extenuatae erunt, non
discernentur. Sin autem videbuntur graciliores,
cum exterioribus fuerint striae ⟨xx aut⟩ [3] XXIIII, in
his faciendae erunt XXVIII aut XXXII. Ita quod detra-
hitur de corpore scapi, striarum numero adiecto
adaugebitur ratione, quo minus videtur, et ita
exaequabitur dispari ratione columnarum crassitudo.
3 Hoc autem efficit ea ratio, quod oculus plura et
crebriora signa [4] tangendo maiore visus circuitione
pervagatur. Namque si duae columnae aeque
crassae lineis circummetientur, e quibus una sit non
striata, altera striata, et circa striglium cava et
angulos striarum linea corpora tangat, tametsi colum-
nae aeque crassae fuerint, lineae, quae circumdatae
erunt, ⟨non erunt⟩ [5] aequales, quod striarum et stri-
glium circuitus maiorem efficit lineae longitudinem.
Sin autem hoc ita videbitur, non est alienum in
angustis locis et in concluso spatio graciliores colum-
narum symmetrias in opere constituere, cum habe-
4 amus adiutricem striatarum [6] temperaturam. Ipsius

[1] regiones *rec* : religiones *H*. [2] parte *Ro* : partes *H*.
[3] *add. Meister.* [4] signa *rec* : signat *H*.
[5] *add. Joc.* [6] striarum *ed* : striatarum *H*.

[1] Varro *R.R.* III. i. 10; Plin. *N.H.* XVI. 225.

be a fence of marble or of fine joinery [1] with gates [2] by which the portico may be entered. 2. Also if the breadth be more than 40 feet, columns are to be placed towards the inner part, in a direct line with those which are between the pilasters. These other columns are to have the same height as those in front, but their diameters are to be lessened in the following manner: if the diameter of the front columns is one eighth of their height, the side diameters are to be one tenth; if the front diameter is one ninth or one tenth, then proportionately. For being diminished in an enclosed space, they will not be remarked. But if they should seem too slender they may have 28 or 32 flutes against the outside 20 or 24. Thus what is taken from the diameter of the shaft will be added by the extra number of the flutes, so as not be observed. In this way the varying diameter of the columns will be balanced. 3. This effect is produced for the following reason. The eye thus touches a greater number of points,[3] and ranges over a larger circumference of vision. For if two columns of equal diameter, of which one is fluted and the other is not, have a line measured round them and one line touches the shafts of the columns round the flutes and their fillets, although the columns are of equal diameter, the bounding lines will not be equal because the circuit of the fillets and the flutes produces a greater length of line. Now if this shall seem to be the case, it is not inappropriate, in narrow places and a confined space, to use in building more slender proportions for the columns, since we have the adjustment of the fluting to help us. 4. The thickness of the walls

[2] Not doors. [3] Perspective again.

autem cellae parietum crassitudinem pro rata parte
magnitudinis [1] fieri oportet, dum antae eorum crassi-
tudinibus columnarum sint aequales. Et si ex-
tructi futuri sunt, quam minutissimis caementis
struantur, sin autem quadrato saxo aut marmore,
maxime modicis paribusque videtur esse faciundum,
quod media coagmenta medii lapides continentes
firmiorem facient omnis operis perfectionem. Item
circum coagmenta et cubilia eminentes expressiones
graphicoteran efficient in aspectu delectationem.

V

1 REGIONES autem, quas debent spectare aedes
sacrae deorum inmortalium, sic erunt constituendae,
uti, si nulla ratio inpedierit liberaque fuerit potestas,
aedis signumque quod erit in cella [2] conlocatum,
spectet ad vespertinam caeli regionem, uti, qui
adierint ad aram immolantes [3] aut sacrificia facientes,
spectent ad partem caeli orientis et simulacrum,
quod erit in aede, et ita vota suscipientes contue-
antur aedem [4] et orientem caelum ipsaque simulacra
videantur exorientia contueri supplicantes et sacri-
ficantes, quod aras omnes deorum necesse esse
2 videatur ad orientem spectare. Sin autem loci
natura interpellaverit, tunc convertendae sunt earum
regionum constitutiones, uti quam plurima pars
moenium e templis eorum conspiciatur. Item si
secundum flumina aedis sacra fiet, ita uti Aegypto

[1] magnitudines *H*. [2] cella *rec* : cellae *H*.
[3] immolantis *H*. [4] eadem *H* : aedem *G*.

[1] Caelus is masc. and a god. Cic. *N.D.* III. 55 ff.

of the cella itself ought to be proportionate to its dimensions, provided that the antae (front pilasters) are equal to the diameter of the columns, and if the walls are continued into the pilasters, they are to be of very small stones. But if the antae are built of square stone or marble, the pieces should be of moderate and equal size. For the middle of the stones in the course above will bind together the joints below them and will strengthen the execution of the whole work. Further, the raised pointing about the upright and bed joints will produce a more picturesque effect in the general view.

CHAPTER V

ON THE ASPECT OF A TEMPLE

1. THE aspects which the sacred temples of the immortal gods ought to regard are so to be appointed (if no reason hinders, and the opportunity is presented) that the temple and the Statue which is in the shrine look towards the western quarter of the sky, so that those who come to the altar to sacrifice or make offerings may look towards the eastern Heaven [1] and the image in the temple. In like fashion persons undertaking vows may look upon the temple and the eastern Heaven. And the very images may seem to rise up and gaze upon those who make vows and sacrifices. For all the altars of the gods should look to the east. 2. But if the nature of the site interferes, the aspect of the temple must be so altered that the greatest possible part within the walls of the city may be visible from the temples of the gods. Also if a sacred temple is raised along

circa Nilum, ad fluminis ripas videantur [1] spectare debere. Similiter si circum vias publicas erunt aedificia deorum, ita constituantur, uti praetereuntes possint respicere et in conspectu salutationes facere.

VI

1 OSTIORUM autem et eorum antepagmentorum in aedibus hae sunt rationes, uti primum constituantur, quo genere sint futurae. Genera sunt enim thyromaton haec: doricum, ionicum, atticurges.

Horum symmetriae conspiciuntur his rationibus, uti corona summa, quae supra antepagmentum superius inponetur, aeque librata sit capitulis summis columnarum quae in pronao fuerint. Lumen autem hypaethri constituatur sic, uti quae altitudo aedis a pavimento ad lacunaria fuerit, dividatur in partes tres semis et ex eis duae partes [2] ⟨semis⟩ lumini [3] valvarum altitudine constituantur. Haec autem dividatur in partes xII et ex eis quinque et dimidia latitudo [4] luminis fiat in imo. Et in summo contrahatur, si erit lumen ab imo ad sedecim pedis, antepagmenti III parte; xvI pedum ad xxv, superior pars luminis contrahatur antepagmenti parte IIII; si ab [5] pedibus xxv ad xxx, summa pars contrahatur antepagmenti parte vIII. Reliqua, quo altiora erunt,

2 ad perpendiculum videntur oportere conlocari. Ipsa

[1] videatur *rec*: videantur *H*. [2] partis *H add. Rode.*
[3] lumini *Joc*: lumine *H*.
[4] latitudo *H*ᶜ altitudo *a. c. H.*
[5] ad pedibus *H et a. ras. S.*

[1] These were usually of fine joiners' work.

the riverside, as by the Nile in Egypt, it ought to seem to regard the banks of the river. Likewise if the edifices of the gods are about the public thoroughfares, they are to be so arranged that the passers-by can look aside, and make their reverence in full view.

CHAPTER VI

ON THE DOORS OF TEMPLES

1. THE following are the rules for doorways to temples and their architraves. First we must determine of what style they are to be. For the styles of doorways are these : Doric, Ionic, Attic.

Of these (as concerns the Doric) the proportions are found to be of the following character. The top of the cornice which is put above the upper architrave, is made level with the tops of the capitals of the columns which are in the pronaos. The opening of the doorway is to be so determined that the height of the temple from the pavement to the panels of the ceiling is to be divided into $3\frac{1}{2}$ parts, and of these $2\frac{1}{2}$ in height are to be fixed for the opening of the folding doors.[1] Let this in turn be divided into 12 parts and of these let $5\frac{1}{2}$ be the breadth of the opening at the bottom. Let it be diminished at the top a third of the width of the architrave, if the opening be not more than 16 feet high; if from 16 to 25 feet, let the upper part of the opening be contracted 1/4 of the architrave; from 25 to 30 feet, 1/8 of the architraves. Higher openings should have perpendicular sides. 2. The architraves [2] themselves

[2] This term is used in modern building to denote the mouldings at the side of the door as well as at the top.

autem antepagmenta contrahantur in summo suae
crassitudinis XIIII parte. Supercilii crassitudo, quanta
antepagmentorum in summa parte erit crassitudo.
Cymatium faciundum est antepagmenti parte sexta;
proiectura autem, quanta est eius crassitudo. Scul-
pendum est cymatium lesbium cum astragalo. Supra
cymatium quod erit in supercilio, conlocandum est
hyperthyrum crassitudine supercilii, et in eo scal-
pendum est cymatium doricum, astragalum lesbium
sima scalptura. Corona plana cum cymatio; pro-
iectura autem eius erit quanta altitudo. Supercilii,
quod supra antepagmenta inponitur, dextra atque
sinistra proiecturae sic sunt faciundae, uti crepidines
excurrant et in ungue ipso cymatio coniungantur.

3 Sin autem ionico genere futura erunt, lumen altum
ad eundem modum quemadmodum in doricis fieri
videtur. Latitudo constituatur, ut altitudo dividatur
in partes duas et dimidiam, eiusque partis unius ima
luminis [1] fiat latitudo. Contracturae ita uti in dori-
cis. Crassitudo antepagmentorum ⟨ex⟩ [2] altitudine
luminis in fronte XIIII parte, cymatium huius crassi-
tudinis sexta. Reliqua pars praeter cymatium divi-
ditur in partes XII. Harum [3] trium prima corsa fiat
cum astragalo, secunda quattuor, tertia quinque, et
eae [4] aeque corsae cum astragalis circumcurrant.
4 Hyperthyra [5] autem ad eundem modum componan-
tur quemadmodum in doricis pro ratis [6] pedibus.
Ancones, sive parotides [7] vocantur, excalpta dextra
ac sinistra praependeant ad imi supercilii libra-

[1] ima luminis G simalum in his H. [2] ex add. Kr.
[3] harum Joc : horum x. [4] et eae Ro : ex ea H.
[5] hyperthyra Joc : hypetra H. [6] pro ratis Ro : protis H.
[7] parotides Schn : protides H.

[1] Lit. " ear-pieces."

are to be contracted 1/14 part of their width at the top. The height of the lintel is to be the same as that of the architraves at the top. The cymatium (ogee) should be made one sixth of the architrave, projecting the amount of its thickness. It is to be carved in the Lesbian form with an astragal. Above the cymatium of the lintel, the frieze is to be placed as deep as the lintel; and on it is to be carved a Doric cymatium and a Lesbian astragal in low relief. Over this the cornice is to be carved without ornament and with a cymatium; its projection is to be as much as its height. To the right and left of the lintel, which is placed above the jambs, projections are to be made so that the bases run out, and are exactly joined to the cymatium with a mitre.

3. If the doorways are to be of the Ionic style, the opening must be of a height determined as in the Doric style. Let the breadth be determined, so that the height is divided into $2\frac{1}{2}$ parts, and let the breadth of the opening at the bottom be one part. The contractions are to be as in the Doric. The width of the architrave is to be 1/14 of the height of the opening in front; the cymatium is to be 1/6 of the width of the architrave. The remainder, excluding the cymatium, is divided into 12 parts. The first fascia with the astragal is to be three parts of these; the second, of four parts; the third, of five parts. The fasciae with the astragal are to run evenly round the architrave. 4. The tops of the doorways are as in the Doric style, with the proportionate dimensions. Brackets (or, as they are called, *parotides* [1]) are to be carved right and left and to hang over to the level of the bottom of the

mentum, praeter folium. Eae habeant in fronte
crassitudinem ⟨ex⟩ antepagmenti [1] tribus partibus,
in imo quarta parte graciliore quam superiora.

Fores ita compingantur, uti scapi cardinales sint ex
latitudine luminis totius XII parte. Inter duos scapos
tympana ex XII partibus habeant ternas partes.
5 Inpagibus [2] distributiones ita fient, uti divisis alti-
tudinibus in partes v duae superiori, tres inferiori
designentur. Super medium medii inpages conlo-
centur, ex reliquis alii in summo, alii in imo com-
pingantur. Altitudo inpagis fiat tympani tertia
parte, cymatium sexta parte inpagis. Scaporum
latitudines inpagis dimidia parte, item replum de
inpage dimidia et sexta parte. Scapi, qui sunt
secundum antepagmentum,[3] dimidium inpagis consti-
tuantur. Sin autem valvatae erunt, altitudines ita
manebunt, in latitudinem adiciatur amplius foris
latitudo. Si quadriforis futura est, altitudo adi-
ciatur.
6 Atticurge [4] autem isdem rationibus perficiuntur,
quibus dorica. Praeterea corsae [5] sub cymatiis in
antepagmentis circumdantur, quae ita distribui
debent, uti antepagmenti [6] praeter cymatium ex
partibus VII habeant duas partes. Ipsaque non fiunt
clathrata [7] neque bifora sed valvata, et aperturas
habent in exteriores partes.

Quas rationes aedium sacrarum in formationibus
oporteat fieri ⟨doricis⟩,[8] ionicis corinthiisque operibus,

[1] antepagmenti *Joc*: -tis *H*.
[2] inpagibus *ed*: inpaginibus *H*.
[3] secundum antepagmentum (*Baldus*): ante secundum
pagmentum *H*.
[4] atticurge *Nohl*: adtigurges *H*. [5] gorsae *H*.
[6] antepagmenti *Ro*: ante pagmenta *H*.
[7] clathrata *ed. Ven*: caelostrata *H*. [8] *add. ed. Fl*.

lintel, with the leaf below that level. Their width on the face is two thirds of the architrave, being one fourth more slender at the bottom than the upper parts.

The doors are to be so put together that the hinge stiles [1] are 1/12 of the breadth of the whole opening. The panels between the two stiles are to have 3 parts out of 12 in width. 5. For the rails, the distribution shall be such that, taking the height to be of 5 parts, two are assigned to the upper portion, 3 to the lower portion. Let the middle rails be placed above the centre; of the others one set are at the top of the doors, the others at the bottom. The width of the rail is to be one third of the panel; the cymatium 1/6 of the rail. The breadth of the inner stiles is to be half the rail, and the cover-moulding 2/3 of the rail. The stiles against the architrave are made one half the rail. If the doors are folding, the heights remain the same; but let the breadth of the opening be increased. If the doors are fourfold, let the height be increased.

6. Attic doors are made of the same proportions as the Doric, the fasciae, however, are carried round under the cymatia in the architraves, and ought to be so arranged that of the architrave, exclusive of the cymatium, they have 2 parts out of 7. They are to be without lattice-work and are not to have hinges folding inwards, but to fold outwards on sockets.[2]

As far as I could attain, I have set forth, as on approved lines, the methods which ought to be

[1] The uprights of the door, containing the panels, with " rails " as the cross-pieces.

[2] Juv. IV. 63, *facili patuerunt cardine valvae.*

quoad potui attingere, veluti legitimis moribus
exposui. Nunc de tuscanicis dispositionibus, quem-
admodum institui oporteat, dicam.

VII

1 Locus, in quo aedis constituetur, cum habuerit in
longitudine sex partes, una adempta reliquum quod
erit, latitudini detur. Longitudo autem dividatur
bipertito, et quae pars erit interior, cellarum spatiis
designetur, quae erit proxima fronti, columnarum
dispositione relinquatur. Item latitudo dividatur in
2 partes x. Ex his ternae partes dextra ac sinistra
cellis minoribus, sive ibi alae[1] futurae sunt, dentur;
reliquae quattuor mediae aedi attribuantur. Spatium,
quod erit ante cellas in pronao, ita columnis desig-
netur, ut angulares contra antas, parietum extre-
morum regione, conlocentur; duae mediae e regione
parietum, qui inter antas et mediam aedem fuerint,
ita distribuantur; et inter antas et columnas priores
per medium isdem regionibus alterae disponantur.[2]
Eaeque sint ima[3] crassitudine altitudinis parte VII;
altitudo tertia parte latitudinis templi; summaque
columna quarta parte crassitudinis imae[4] contrahatur.
3 Spirae earum altae[5] dimidia parte crassitudinis fiant.
Habeant spirae earum plinthum ad circinum, altam
suae crassitudinis dimidia parte, torum insuper cum

[1] alae *Joc*: aliae *H*.
[2] alterae disponantur *Joc*: altera aedis ponatur *H*.
[3] eaeque sint ima *Joc*: aeques intima *H*.
[4] imae *Joc*: ima *H*. [5] altae *Joc*: alia *H*. .

followed in planning temples of the Doric, Ionic and
Corinthian orders. Now I will speak of the Tuscan
style and the method to be employed therein.

CHAPTER VII

ON THE TUSCAN STYLE

1. LET the site on which the temple is to be built
be six parts in length; five parts are to be assigned
to the breadth. Now the length is to be divided in
two. The interior half is to be marked out by the
dimensions of the sanctuary; the part on the front
is to be left for the portico with its columns.
2. Further, let the width be divided into 10 parts. Of
these let three parts each on the right and left be
given to the lesser sanctuaries, or alternately to the
wings; the remaining four parts are to be given to
the central shrine. Let the space which is before
the sanctuaries in the forecourt be planned for the
columns, in such a way that the corner columns are
put opposite the pilasters, in line with the ends of
the walls. The two middle columns are to be in
line with the walls which are between the wings and
the middle shrine. Between the pilasters and the
columns in front, additional columns are to be put
half way in line with them. At the bottom these
are to have a diameter 1/7 of the height. (The
height is to be one third of the width of the temple.)
The top of the column is to be diminished 1/4 of
the diameter at the bottom. 3. The bases are to
be made half a diameter high. Let the bases have
their plinths circular and half the height of the

239

apophysi [1] crassum quantum plinthus. Capituli
altitudo dimidia crassitudinis. Abaci latitudo quanta
ima crassitudo columnae. Capitulique crassitudo
dividatur in partes tres, e quibus una plintho, quae
est in abaco, detur, altera echino, tertia hypotrachelio
4 cum apophysi. Supra columnas trabes compactiles
inponantur ut altitudinis modulis is, qua magnitudine
operis postulabuntur.[2] Eaeque trabes conpactiles
ponantur ut eam habeant crassitudinem, quanta
summae columnae erit hypotrachelium, et ita sint
conpactae subscudibus et securiclis, ut conpactura
duorum digitorum habeant laxationem. Cum enim
inter se tangunt et non spiramentum et perflatum
venti recipiunt, concalefaciuntur et celeriter putre-
5 scunt. Supra trabes et supra parietes traiecturae
mutulorum parte IIII altitudinis columnae proiciantur;
item in eorum frontibus [3] antepagmenta figantur.[4]
Supraque id tympanum fastigii structura seu de
materia conlocetur. Supraque eum fastigium, colu-
men, cantherii, templa ita sunt conlocanda, ut
stillicidium tecti absoluti tertiario respondeat.

VIII

1 FIUNT autem aedes rutundae, e quibus aliae mono-
pteroe sine cella columnatae constituuntur, aliae
peripteroe dicuntur. Quae sine cella fiunt, tribunal
habent et ascensum ex sua diametro tertiae partis.

[1] apophysi *rec* : apopysi *H*.
[2] postulabuntur *Joc* : postulabantur *H*.
[3] frontibus *Gc* : prontibus *H*. [4] ficantur *H*.

[1] Round moulding.
[2] The curving away of the shaft against the base.
[3] Necking. [4] *Tribunal.*

base, with a torus [1] and *apophysis* [2] as deep as the plinth. The height of the capital is to be half a diameter. The width of the abacus is as great as the diameter of the column at the base. The height of the capital is to be divided into three parts, of which one is to be given to the plinth or abacus, one to the echinus or ovolo, the third to the hypotrachelium [3] with the apophysis. 4. Above the columns, beams are to be placed bolted together, of such proportionate depth as shall be demanded by the magnitude of the work. And these coupled beams are to have a thickness equal to the hypotrachelium at the top of the column, and they are to be so coupled with dowels and mortices that the coupling allows an interval of two inches between the joists. For when they touch one another and do not admit a breathing space and passage of air, they are heated and quickly decay. 5. Above the beams and walls the mutules are to project 1/4 of the height of the column. On the front of these, casings (antepagmenta) are to be fixed and above them the tympanum of the gable either of stone or wood. Above this the ridge-piece, rafters, and purlins, are to be so placed that the pitch of the roof is one in three.

CHAPTER VIII

ON CIRCULAR TEMPLES

1. CIRCULAR temples are also built, of which some are monopteral built with columns but not enclosing a cella; others are peripteral. Those which are without a cell have a raised floor [4] and a flight of steps one third of the diameter in height. Above

Insuper stylobata columnae constituuntur tam altae,
quanta ab extremis parietibus est diametros stylo-
batarum, crassae altitudinis suae cum capitulis et spiris
decumae partis. Epistylium altum columnae crassi-
tudinis dimidia parte. Zophorum et reliqua, quae
insuper inponuntur, ita uti in III [1] volumine de sym-
metriis scripsi.

2 Sin autem peripteros ea aedes constituetur, duo
gradus et stylobata ab imo constituantur. Deinde
cellae paries conlocetur cum recessu eius a stylobata
circa partem latitudinis quintam, medioque valvarum
locus ad aditus relinquatur [2]; eaque cella tantam
habeat diametrum praeter parietes et circumitionem,
quantam altitudinem columna. Supra stylobata
columnae circum cellam isdem symmetriisque
3 disponantur. In medio tecti ratio ita habeatur, uti,
quanta diametros totius operis erit futura, dimidia
altitudo fiat tholi praeter florem; flos autem tantam
habet magnitudinem, quantam habuerit columnae
capitulum, praeter pyramidem. Reliqua, uti supra
scripta sunt ea, proportionibus atque symmetriis
facienda videntur.

4 Item generibus aliis constituuntur aedes ex isdem
symmetriis ordinatae et alio genere dispositiones
habentes, uti est Castoris in circo Flaminio et inter
duos lucos Veiovis, item argutius Nemori Dianae

[1] tertio *Joc* : quarto *H*.
[2] relinquatur *S*ᶜ : relinquantur *H*.

[1] Cf. terminal on mausoleum of Hadrian (Winckelmann
History, II. iv. Ib.) now replaced by angel.

[2] Lanciani *RE* 443. This was in the Doric order, apparently.
Platner 102.

[3] This temple was between the Capitol and the Arx. Ovid
Fasti III. 437. Burn, *Rome* 196. Platner 548.

the pedestal (stylobate) the columns are put of such a height as is the diameter of the pedestals from side to side; the diameter is to be 1/10 of the height including the capitals and bases. The architrave is to be half a diameter high. The frieze and the other members which are placed above are to follow the proportions given in the third book.

2. But if the temple is peripteral, two steps and the stylobate are to be built from the foundation; then the wall of the cella is to be built set back from the edge of the stylobate about 1/5 of the width. In the middle is to be left an opening with folding-doors for the approach. The cella within the walls and colonnade, is to have a diameter equal to the height of the column. On the stylobate, let columns be disposed round the cella and of the same proportions. 3. In the middle let the proportions of the roof be such that the height of the dome, apart from the terminal, is half the diameter of the whole work. Let the terminal have the magnitude of the capital of the column in addition to the pyramid (on which the flower [1] rests). The other parts are to be constructed of the proportions and symmetries as is above described.

4. Further, temples of other orders are laid out and built with the same symmetries, yet having the arrangements of another order than the Tuscan: such as the temple of Castor [2] in the Circus Flaminius, of Veiovis [3] between the Two Groves, and with more subtle proportions the temple of Diana Nemorensis [4]

[4] Of this temple, considerable remains were excavated in 1885 by Lord Savile: *Catalogue of Nemi Collection*, Nottingham.

columnis adiectis dextra ac sinistra ad umeros pronai.
Hoc autem genere primo facta est, uti est Castoris in
circo, Athenis in arce et in Attica Sunio Palladis
Minervae. Earum non aliae sed eaedem [1] sunt
proportiones. Cellae enim longitudinibus duplices
sunt ad latitudines [2] uti reliquae; ex is omnia [3] quae
solent esse in frontibus, ad latera sunt translata.
5 Nonnulli etiam de tuscanicis generibus sumentes
columnarum dispositiones transferunt in corinthiorum
et ionicorum operum ordinationes, et quibus [4] in locis
in pronao procurrunt antae, in isdem e regione cellae
parietum columnas binas conlocantes efficiunt tuscani-
corum et graecorum operum communem ratiocina-
6 tionem. Alii vero removentes parietes aedis [5] et
adplicantes ad intercolumnia pteromatos,[6] spatii
sublati efficiunt amplum laxamentum cellae; reliqua
autem proportionibus et symmetriis isdem conser-
vantes aliud genus figurae nominisque videtur
pseudoperipterum procreavisse. Haec autem genera
propter usum sacrificiorum convertuntur. Non enim
omnibus diis isdem rationibus aedes sunt faciundae,
quod alius alia varietate sacrorum religionum habet
effectus.
7 Omnes aedium sacrarum ratiocinationes, uti mihi
traditae sunt, exposui ordinesque et symmetrias
eorum partitionibus distinxi, et quorum dispares sunt
figurae et quibus discriminibus inter se sunt dispara-

[1] eaedem *S* : eadem *H G*.
[2] latitudines *Joc* : altitudines *H*.
[3] omnia *Turnebus* : reliqua exisona *H*.
[4] et quibus *Schn* : equibus *H*. [5] aedis *G^e* : aedes *H*.
[6] pteromatos *ed. Fl* : pleromatos *H*.

with columns added right and left on the sides of the pronaos. The first temples built in the manner of that of Castor in the Circus, were those of Pallas (Minerva) in the Acropolis [1] at Athens, and at Sunium in Attica, of the same and not different proportions. For like the others, the cells are double in length compared to the breadth. In these temples also, all the features which are customary on the front are transferred to the flanks. 5. For some taking the arrangements of the columns from the Tuscan style, transfer them to the design of Corinthian and Ionic buildings. And where the pilasters run forward in the forecourt, they place *two* columns in line with the walls of the cella and produce a system common to Tuscan and Greek forms of building. 6. Others again, removing the walls of the shrine and putting them in the intercolumniations of the colonnade,[2] produce a large extension of the cella by the space thus gained; keeping the other parts, however, of the same proportions and symmetries, they seem to have created another kind of plan and of name, the pseudoperipteral. The styles of building vary to suit the needs of sacrifice. For temples are not to be built to all the gods in the same styles. For the several gods by the variety of their worship give rise to different religious effects.

7. I have set forth all the plans of temples as they have been taught me, and have distinguished in detail their orders and symmetries, the difference of their forms and the details by which they are dis-

[1] The Parthenon.
[2] As at the Maison Carrée at Nimes. This really is the starting point of the Palladian style.

tae, quoad potui significare scriptis, exposui. Nunc
de areis deorum inmortalium,[1] uti aptam constitu-
tionem habeant ad sacrificiorum rationem, dicam.

IX

ARAE spectent ad orientem et semper inferiores
sint conlocatae quam simulacra quae fuerint in aede,
uti suspicientes divinitatem, qui supplicant, et sacri-
ficant, disparibus altitudinibus ad sui cuiusque dei
decorem componantur. Altitudines autem earum
sic sunt explicandae, uti Iovi omnibusque caelestibus
quam excelsissimae constituantur, Vestae Terrae
Marique[2] humiles conlocentur. Ita idoneae his
institutionibus explicabuntur in meditationibus are-
arum[3] deformationes.

Explicatis[4] aedium sacrarum compositionibus in
hoc libro, insequenti de communium operum redde-
mus distributionibus explicationes.

[1] d. immortalium immo potius demonum S.
[2] matrique ed : marique H.
[3] ararum G : arearum H. [4] explicantis H.

tinguished from one another, as far as I could indicate by writing. Now I will speak of the precincts of the immortal gods so that they may have an arrangement suitable for the purposes of sacrifice.

CHAPTER IX

ON ALTARS

LET the altars look to the east[1] and be always placed lower than the images which shall be in the temple; so that those who pray and sacrifice may look up to the divinity from various levels as becomes each man's god. The levels of the altars to Jupiter and the host of heaven are so to be contrived that they may be placed as high as possible; to Vesta, Earth and Sea[2] they are to be made low. By these methods the planning of the precincts will be suitable in practice.

In this book the planning of temples has been explained. In the next book we shall give explanations about the arrangement of public buildings.

[1] The altar was outside the temple, in the precincts.
[2] Sea completes the four elements: air, fire, earth, water.

BOOK V

LIBER QUINTUS

1 Qui amplioribus voluminibus, imperator, ingenii
cogitationes praeceptaque explicaverunt, maximas
et egregias adiecerunt suis scriptis auctoritates.
Quod etiam vel in nostris quoque studiis res pateretur, ut amplificationibus auctoritas et in his praeceptis augeretur; sed id non est, quemadmodum
putatur, expeditum. Non enim de architectura sic
scribitur uti historia aut poemata. Historiae per se
tenent lectores; habent enim novarum rerum varias
expectationes. Poematorum vero carminum metra
et pedes, ac verborum elegans dispositio et sententiarum inter personas distinctas, versuum pronuntiatio
prolectando sensus legentium perducit sine offensa
2 ad summam scriptorum terminationem. Id autem
in architecturae conscriptionibus non potest fieri,
quod vocabula ex artis propria necessitate concepta
inconsueto sermone obiciunt sensibus obscuritatem.
Cum ergo ea per se non sint aperta nec pateant
eorum in consuetudine nomina, tum etiam praeceptorum late evagantes [1] scripturae, si non contrahentur, et paucis et perlucidis sententiis explicentur,
frequentia multitudineque sermonis inpediente incertas legentium efficient cogitationes. Itaque occultas nominationes commensusque e membris

[1] late vagantes *G* : lata evagantes *H*.

[1] For this meaning *cf. Vulg.* II. Thess. ii. 2.

BOOK V

PREFACE

1. MEN, Caesar, who in more ample volumes unfold the notions and rules suggested by their talent, add to their writings very great and unusual authority. Indeed even in our studies, the topic would allow this: namely, that in this treatise also, amplification would afford greater weight of authority. But that is not so convenient as it is thought. For writing about architecture is not like a history, or poems. Histories, of themselves, hold the reader. For they offer the varied prospects of novelty. Again in poems, the measures and feet of the music and the nice arrangement of words and opinions, the recital of verses distributed among the several characters, entice the thoughts [1] of the reader and, without hindrance, lead him on to the very close of the book. 2. But in architectural compositions this cannot take place. For the terms, used by the special necessity of the craft, by their unfamiliar sound seem obscure to the perception. Since therefore they of themselves are not obvious, nor is the nomenclature clear by customary use, so further the casual expression of rules—unless they are collected and explained in a few lucid phrases—renders uncertain the notions of the reader: for repetition and a cumbrous style are a hindrance. And while I enumerate, in accordance with the parts of buildings,

operum pronuntians, ut memoriae tradantur, breviter
exponam; sic enim expeditius ea recipere poterunt
3 mentes. Non minus cum [1] animadvertissem dis-
tentam occupationibus civitatem publicis et privatis
negotiis, paucis iudicavi scribendum, uti angusto
spatio vacuitatis ea legentes breviter percipere
possent.

Etiamque [2] Pythagorae quique [3] eius haeresim
fuerunt secuti, placuit cybicis rationibus praecepta
in voluminibus scribere, constitueruntque cybum
ccxvi [4] versus eosque non plus tres in una conscrip-
4 tione oportere esse putaverunt. Cybus autem est
corpus ex lateribus aequali latitudine planitiarum
perquadratus.[5] Is cum est iactus, quam in partem
incubuit, dum est intactus, inmotam habet stabili-
tatem, uti sunt etiam tesserae quas in alveo ludentes
iaciunt. Hanc autem similitudinem ex eo sumpsisse
videntur, quod is numerus versuum, uti cybus, in
quemcumque sensum insederit, inmotam efficiat ibi
memoriae stabilitatem. Graeci quoque poetae comici
interponentes e choro canticum diviserunt spatia
fabularum. Ita partes cybica ratione facientes
intercapedinibus levant auctorum pronuntiationis.[6]

5 Cum ergo haec naturali modo sint a maioribus
observata animoque advertam inusitatas et obscuras
multis res esse mihi scribendas, quo facilius ad sensus
legentium pervenire possint, brevibus voluminibus

[1] cum *G* : eum *H*. [2] etiamque *Joc* : etiam qui *H*.
[3] quique *G* : quinque *H*. [4] ccxvi *Joc* : cc. &. l. *H*.
[5] perquadratum *Joc* : -tus *H*.
[6] pronunciationis *H* (*c* = *t* insc. 235 A.D.).

the obscure terms and measurements, I will expound
them briefly so that they may be remembered. For
thus the mind will be able to receive them more
conveniently. 3. None the less, perceiving the state
to be overstrained by public and private business, I
decided that I must write briefly so that the reader
might understand in his scanty leisure.

Pythagoras also, and those who followed his sect,
decided to write their rules, cube fashion, in their
volumes, and fixed upon a cube—216 lines [1]—and
they thought that not more than three cubes should
be in one treatise. 4. Now a cube is a body with all
its sides squared and their surfaces equal. When a
cube is thrown, on whatever part it rests, it retains
its stability unmoved so long as it is untouched, like
the dice which players throw in a tray.[2] Now this
analogy they seem to have taken from the fact that
this number of verses, like a cube upon whatever
sense it falls, makes the memory there stable and
unmoved. Greek comic poets also, interposing the
canticum [3] sung by the chorus, divided the spaces
of their plays. Thus making the parts cube fashion,
they relieve by intervals the delivery of the author's
words.

5. Since then, these things have been observed
by our forefathers in the order of nature, and I
find that I must deal with topics unfamiliar and
obscure to the many, I decided to write in short
compass, that they might more easily reach the

[1] *H* gives 250 (250 = 2 × 125 = a double cube; *cf.* Apollo's
mathematical problem, Book IX. pref. 13). This gives 750
lines as the usual length of a book, *e.g.* of Homer.

[2] This seems to be quoted from Varro, Gell. I. xx. 6.

[3] The sung portions which separate the dialogue.

iudicavi scribere; ita enim expedita erunt ad intelle-
gendum. Eorumque ordinationes institui, uti non
sint quaerentibus separatim colligenda, sed e corpore
uno et in singulis voluminibus generum haberent
explicationes. Itaque, Caesar, tertio et quarto
volumine aedium sacrarum rationes exposui, hoc
libro publicorum locorum expediam dispositiones.
Primumque forum uti oporteat constitui dicam, quod
in eo et publicarum et privatarum rerum rationes per
magistratus gubernantur.

I

1 GRAECI in quadrato amplissimis et duplicibus porti-
cibus fora constituunt crebrisque columnis et lapideis
aut marmoreis epistyliis adornant et supra ambula-
tiones in contignationibus faciunt. Italiae vero
urbibus non eadem est ratione faciendum, ideo quod
a maioribus consuetudo tradita est gladiatoria
2 munera in foro dari. Igitur circum spectacula
spatiosiora intercolumnia distribuantur circaque in
porticibus argentariae tabernae maenianaque su-
perioribus coaxationibus conlocentur; quae et ad
usum et ad vectigalia publica recta erunt disposita.

Magnitudines autem ad copiam hominum oportet
fieri, ne parvum spatium sit ad usum aut ne propter

[1] There is probably a reference here to readers in a public
library, such as that of Pollio on the Palatine, of which
Varro was the first Director. Suet. *Julius* xliv.

[2] Forum at Tegea is square, Paus. VIII. 48.

[3] Double colonnades at Elis, Paus. VI. 24.

[4] Burn, *Rome* 90, Suet. *Julius* x. 1.

perception of the reader. For so they will be convenient for understanding. And I fixed their arrangement so that the inquirer [1] has not to collect them, one by one, but that from one corpus and in the several books they might get the explanations of the several subjects. And so, Caesar, in the third and fourth volume, I explained the plans of temples; in this book I will set forth the arrangements of public places. And first I will say how the forum should be planned, because in it business, both of a public and private nature, is controlled by the magistrates.

CHAPTER I

ON THE FORUM AND BASILICA

1. The Greeks plan the forum on the square [2] with most ample double [3] colonnades and close-set columns; they ornament them with stone or marble architraves, and above they make promenades on the boarded floors. But in the cities of Italy we must not proceed on the same plan, because the custom of giving gladiatorial shows in the forum has been handed down from our ancestors.[4] 2. For that reason more roomy intercolumniations are to be used round the spectacle; in the colonnades, silversmiths' shops [5]; and balconies, rightly placed for convenience and for public revenue, are to be placed on the upper floors.

The dimensions of the forum ought to be adjusted to the audience lest the space be cramped for use,

[5] Or "bankers," offices previously occupied by schoolmasters, Liv. III. 44.

inopiam populi vastum forum videatur. Latitudo
autem ita finiatur uti, longitudo in tres partes cum
divisa fuerit, ex his duae partes ei dentur; [1] ita enim
erit oblonga eius formatio et ad spectaculorum
3 rationem utilis dispositio. Columnae superiores
quarta parte minores quam inferiores sunt consti-
tuendae, propterea quod oneri ferendo quae sunt
inferiora firmiora debent esse quam superiora. Non
minus quod etiam nascentium oportet imitari
naturam, ut in arboribus teretibus, abiete, cupresso,
pinu, e quibus nulla non crassior est ab radicibus,
dein decrescendo proceditur in altitudinem naturali
contractura peraequata nascens ad cacumen. Ergo
si natura nascentium ita postulat, recte est consti-
tutum et altitudinibus et crassitudinibus superiora
inferiorum fieri contractiora.

4　　Basilicarum loca adiuncta foris quam calidissimis
partibus oportet constitui, ut per hiemem sine mo-
lestia tempestatium se conferre in eas negotiatores
possint. Earumque latitudines ne minus quam ex
tertia, ne plus ex dimidia longitudinis constituantur,
nisi si loci natura inpedierit et aliter coegerit symme-
triam commutari. Sin autem locus erit amplior in
longitudine, chalcidica in extremis constituantur, uti
5 sunt in Iulia Aquiliana. Columnae basilicarum tam
altae, quam porticus latae fuerint, faciendae videntur;
porticus, quam medium spatium futurum est, ex
tertia finiatur. Columnae superiores minores quam
inferiores, uti supra scriptum est, constituantur.

[1] ei dentur *Joc* : iubentur *H*.

[1] Public halls with nave, aisles, clerestory, later sometimes
used as churches.

[2] Probably erected by Julius Caesar.

or else, owing to a scanty attendance, the forum should seem too large. Now let the breadth be so determined that when the length is divided into three parts, two are assigned to the breadth. For so the plan will be oblong, and the arrangement will be adapted to the purpose of the spectacles. 3. The upper columns are to be a quarter less than the lower ones; because the lower columns ought to be stronger for bearing weight than the upper ones. Not less one ought also to imitate the natural growth of trees, as in tapering trees, the fir, the cypress, the pine, of which everyone is thicker at the roots. Then diminishing it rises on high, by a natural contraction growing evenly to the summit. Therefore since the nature of growing plants so demands, things are rightly arranged both in height and thickness, if the higher are more contracted than the lower.

4. The sites of basilicas [1] ought to be fixed adjoining the fora in as warm a quarter as possible, so that in the winter, business men may meet there without being troubled by the weather. And their breadth should be fixed at not less than a third, nor more than half their length, unless the nature of the site is awkward and forces the proportions to be changed. When the site is longer than necessary, the committee rooms are to be placed at the end of the basilica, as they are in the Basilica Julia [2] at Aquileia. [3] 5. The columns of basilicas are to be of a height equal to the width of the aisle. The aisle is to have a width one third of the nave. The columns of the upper story are to be less than those below as herein above specified. The parapet

[3] Important commercial town near Venice.

Pluteum, quod fuerit inter superiores et inferiores columnas, item quarta parte minus, quam superiores columnae fuerint, oportere fieri videtur, uti supra basilicae contignationem ambulantes ab negotiatoribus ne conspiciantur. Epistylia zophora coronae ex symmetriis columnarum, uti in tertio libro diximus, explicentur.

6 Non minus summam dignitatem et venustatem possunt habere conparationes basilicarum, quo genere Coloniae[1] Iuliae Fanestri conlocavi curavique faciendam, cuius proportiones et symmetriae sic sunt constitutae. Mediana testudo inter columnas est longa pedes cxx, lata pedes lx. Porticus eius circa testudinem inter parietes et columnas lata pedes xx. Columnae altitudinibus perpetuis cum capitulis pedes l, crassitudinibus quinum, habentes post se parastaticas altas pedes xx, latas[2] pedes ii s, crassas i s, quae sustinent trabes, in quibus invehuntur porticuum contignationes. Supraque eas aliae parastaticae pedum xviii, latae binum, crassae pedem, quae excipiunt item trabes sustinentes cantherium et porticum, quae sunt summissa infra testudinem,
7 tecta. Reliqua spatia inter parastaticarum et columnarum trabes per intercolumnia luminibus sunt relicta. Columnae sunt in latitudine[3] testudinis cum angularibus dextra ac sinistra quaternae, in longitudine, quae est foro proxima, cum isdem angularibus octo, ex altera parte cum angularibus vi,[4] ideo quod mediae duae in ea parte non sunt positae, ne inpediant aspectus pronai aedis Augusti, quae est in medio latere parietis basilicae conlocata spectans

[1] colonie *G* : columniae *H*. [2] latas *ed* : latae *H*.
[3] latitudine *G* : altitudine *H*. [4] vi *H S* : sex *G*.

between the upper and lower columns ought to be one fourth less than the upper columns, so that people walking on the first floor may not be seen by persons engaged in business. The architraves, friezes and cornices are to be designed in accordance with the columns, as we have prescribed in the third book.

6. At the Julian Colony of Fano,[1] I let out for contract and superintended the building of a basilica not inferior to these in dignity and grace. Its proportions and harmonies are as follows: There is a vaulted nave between the columns 120 feet long and 60 broad. The aisle between the columns of the nave and the outside wall, is 20 feet wide. The columns are of an unbroken height, including the capitals, of 50 feet with a diameter of 5 feet. Behind them adjoining the aisle are pilasters 20 feet high, 2½ feet wide and 1½ feet thick. These carry the beams under the flooring. Above, there are pilasters 18 feet high, 2 feet wide and 1 foot thick, which take the beams which carry the principals of the main roof, and the roofs of the aisles which are lower than the vaulting of the nave. 7. The space which remains in the intercolumniations, above the pilasters and below the tops of the columns, admits the necessary lighting. In the width of the nave counting the angle columns right and left, there are four columns at each end. On the side adjoining the forum, there are eight, including the angle columns. On the other side there are six, including the angle columns. The two columns in the middle are omitted, so as not to obstruct the view of the pronaos of the Temple of Augustus which is situated in the middle of the side wall of the basilica and

[1] Founded by Augustus, see p. 317 n.

8 medium forum et aedem Iovis. Item tribunal quod
est in ea aede, hemicycli schematis [1] minoris curva-
tura formatum; eius autem hemicycli in fronte est
intervallum pedes XLVI, introrsus curvatura pedes XV,
uti, qui apud magistratus starent, negotiantes in
basilica ne inpedirent. Supra columnas ex tribus
tignis bipedalibus conpactis trabes sunt circa conlo-
catae, eaeque ab tertiis columnis quae sunt in in-
teriore parte, revertuntur ad antas quae a pronao
procurrunt, dextraque et sinistra hemicyclium tan-
9 gunt. Supra trabes [2] contra capitula ex fulmentis
dispositae pilae sunt conlocatae, altae pedes III, latae
quoqueversus quaternos. Supra eas ex duobus tignis
bipedalibus trabes everganeae circa sunt conlocatae.
Quibus insuper transtra [3] cum capreolis columnarum
contra corpora et antas et parietes pronai conlocata [4]
sustinent unum culmen perpetuae basilicae, alterum
10 a medio supra pronaum aedis. Ita fastigiorum du-
plex tecti nata [5] dispositio extrinsecus tecti et inte-
rioris altae testudinis praestat speciem venustam.
Item sublata epistyliorum ornamenta et pluteorum
columnarumque superiorum distributio operosam
detrahit molestiam sumptusque inminuit ex magna
parte summam. Ipsae vero columnae in altitudine
perpetua sub trabe testudinis perductae et magnifi-
centiam inpensae et auctoritatem operi adaugere
videntur.

 [1] scematis *H*. [2] trabes *H*.
 [3] transtra *rec*: trasta *H*. [4] collocata *Joc*: -tae *H*.
 [5] pectinata *Bondam*: tectinata *H*. Cic. *Q.F.* III. i. 14.

faces the middle of the forum and the Temple of
Jupiter. 8. The tribunal which is in the former
temple, is in the shape of the segment of a circle.
The width of the segment in front is 46 feet; its
depth is 15 feet; so that those who come before the
magistrates may not interfere with persons on
business in the basilica. Above the columns are
beams made of three 2 foot joists bolted together.
These return from the third column on either side
of the opening to the antae of the pronaos, and
adjoin the curve of the tribunal right and left.
9. Above the beams vertically over the capitals,
piers are placed on supports, 3 feet high and 4 feet
square. Above them, beams formed of two 2 foot
joists, carefully wrought, are carried round the
basilica. Thereon over against the shafts of the
columns, and the antae and walls of the pronaos,
cross-beams and struts support the whole ridge of
the basilica, and a second ridge running out from
the middle of the main ridge, over the pronaos of
the temple. 10. Thus there arises from the roof a
double arrangement of gables. This gives a pleasing
effect both to the exterior of the roof and to the
high vaulting within. Further, we dispense with
the ornaments of the entablatures and the provision
of the upper columns and parapets. We are
relieved from laborious details and escape a large
expenditure, while the carrying up of the columns
without a break to the beams of the vault [1] seems to
give a sumptuous magnificence and impressiveness
to the work.

[1] This anticipates the Palladian use of columns as in the
Redentore at Venice.

VITRUVIUS

II

1 AERARIUM, carcer, curia foro sunt coniungenda,
sed ita uti magnitudo symmetriae eorum foro re-
spondeant. Maxime quidem curia in primis est
facienda ad dignitatem municipii sive civitatis. Et
si quadrata erit, quantum habuerit latitudinis dimidia
addita constituatur altitudo; sin autem oblonga
fuerit, longitudo et latitudo componatur, et summae
compositae [1] eius dimidia pars sub lacunaris [2] alti-
2 tudini detur. Praeterea praecingendi sunt parietes
medii coronis ex intestino opere aut albario ad dimi-
diam partem altitudinis. Quae si non erunt, vox
ibi disputantium elata in altitudinem intellectui non
poterit esse audientibus. Cum autem coronis prae-
cincti parietes erunt, vox ab imis morata priusquam
in aera elata dissipabitur, auribus erit intellecta.

III

1 CUM forum constitutum fuerit, tum deorum inmor-
talium diebus festis ludorum expectationibus [3] eli-
gendus est locus theatro quam saluberrimus, uti in
primo libro de salubritatibus in moenium conloca-
tionibus est scriptum. Per ludos enim cum coniu-
gibus et liberis persedentes delectationibus detinentur
et corpora propter voluptatem inmota patentes

[1] compositae G^c: -ta H.
[2] lacunaris H: cf. socis = sociis; operaris = operariis
(*Pompeii*).
[3] expectator *idem quod* spectator.

[1] *Albarium* is the finishing coat of stucco.

CHAPTER II

ON THE TREASURY, PRISON, AND CURIA

1. The treasury, prison, senate-house are to adjoin the forum but in such a way that their scale and proportion answers to that of the forum. In the first place especially the senate-house is to be built with a view to the dignity of the municipality or city. If it be square its height must be one and a half times its width; but if it be oblong, let the length and breadth be added together and let half of the total amount be given to the height under the ceiling. 2. Moreover the interior walls are to be surrounded half way up with cornices of fine joiners' work or plaster [1] at half their height. If this is not done, the voice of the disputants rising upwards cannot be understood by the audience. When, however, the walls are girt with cornices, the voice, being delayed by the lowest parts before it rises into the air and is scattered, will be perceived by the ear.

CHAPTER III

ON THE SITE OF THE THEATRE

1. When the forum has been settled, a site as healthy as possible is to be chosen for the exhibition of plays on the festivals of the immortal gods, according to the instructions given in the first book for the healthy disposition of the city walls. For at the play citizens with their wives and children remain seated in their enjoyment; their bodies motionless with pleasure have the pores opened.

habent venas, in quas insiduntur aurarum flatus, qui,
si a regionibus palustribus aut aliis regionibus vitio-
sis [1] advenient, nocentes spiritus corporibus infundent.
Itaque si curiosius eligetur locus theatro, vitabuntur
2 vitia. Etiamque providendum est, nene impetus
habeat a meridie. Sol enim cum implet eius ru-
tunditatem, aer conclusus curvatura neque habens
potestatem vagandi versando confervescit et candens
adurit excoquitque et inminuit e corporibus umores.
Ideo maxime vitandae sunt his rebus vitiosae regiones
3 et eligendae salubres. Fundamentorum autem, si in
montibus fuerit, facilior erit ratio; sed si necessitas
coegerit in plano aut palustri loco ea constitui, solida-
tiones substructionesque ita erunt faciendae, quem-
admodum de fundationibus aedium sacrarum in
tertio libro est scriptum. Insuper fundamenta
lapideis et marmoreis copiis gradationes ab substruc-
4 tione fieri debent. Praecinctiones ad altitudines
theatrorum pro rata parte faciendae videntur, neque
altiores quam quanta praecinctionis itineris sit lati-
tudo. Si enim excelsiores fuerint, repellent et
eicient in superiorem partem [2] vocem nec patientur [3]
in sedibus suis, quae [4] supra praecinctiones, verborum
casus certa significatione ad aures pervenire. Et ad
summam ita est gubernandum, uti, linea cum ad
imum gradum et ad summum extenta fuerit, omnia
cacumina graduum angulosque tangat; ita vox non

[1] viciosis *H*. [2] eicientem superiorem partem *H*.
[3] pacientur *H*. [4] *H om. verbum.*

[1] By preference theatres were excavated in the side of a
hill as at Dougga near Carthage. Greek theatres are often
on the hill side; Roman theatres, on the level.
[2] Vitruvius often uses a singular verb referring to the main

On these the breath of the wind falls, and if it comes from marshy districts or other infected quarters, it will pour harmful spirits into the system. If therefore special care is taken in choosing a site, infection will be avoided. 2. Care also is to be taken, lest it be open to attacks from the south. For when the sun fills the circuit of the theatre, the air being enclosed within the curved space and not having the opportunity of circulating, revolves and becomes heated; hence it blazes, burns up, draws out and reduces the moisture of the body. Thus sites which are faulty in these respects are especially to be avoided, and healthy sites chosen.[1] 3. If the theatre is [2] on a hillside, the construction of the foundations will be easier. But if they have to be laid on level or marshy ground, piles and sub-structures must be used as we have written in the third book concerning the foundations of temples. Above the foundations, the stepped seats ought to be built up from the substructure in stone or marble. 4. The curved level gangways, it seems, should be made proportionately to the height of the theatre; and each of them not higher at the back, than is the breadth of the passage of the gangway. For if they are taller, they will check and throw out the voice into the upper part of the theatre. Neither will they allow the endings of words to come with a clear significance to the ears of the people in their seats above the gangways. In brief the section of the theatre is to be so managed that if a line is drawn touching the lowest and the top rows, it shall also touch the front angles of all the rows. Thus the

topic. It is unnecessary, here as elsewhere, to correct the MSS.

5 inpedietur. Aditus complures et spatiosos oportet disponere, nec coniunctos superiores inferioribus, sed ex omnibus locis perpetuos et directos sine [1] inversuris faciendos, uti, cum populus dimittatur de spectaculis, ne comprimatur, sed habeat ex omnibus locis exitus separatos sine inpeditione.

Etiam diligenter est animadvertendum, ne sit locus surdus, sed ut in eo vox quam clarissime vagari possit. Hoc vero fieri ita poterit, si locus electus 6 fuerit, ubi non inpediantur resonantia. Vox autem ut spiritus fluens aeris, et actu sensibilis auditu. Ea movetur circulorum rutundationibus infinitis, uti si in stantem aquam lapide inmisso nascantur innumerabiles undarum circuli crescentes a centro, quam latissime possint, et vagantes, nisi angustia loci interpellaverit aut aliqua offensio, quae non patitur designationes earum undarum ad exitus pervenire. Itaque cum interpellentur offensionibus, primae redundantes insequentium disturbant designationes. 7 Eadem ratione vox ita ad circinum efficit motiones; sed in aqua [2] circuli planitiae in latitudine moventur, vox et in latitudine progreditur et altitudinem gradatim scandit. Igitur ut in aqua undarum designationibus, item in voce cum offensio nulla primam undam interpellaverit, non disturbat secundam [3] nec

[1] sine *rec* : siue *H*.　　　　[2] ininaquā *H*.
[3] secundā *G* : -dum *H*.

[1] *actu* is an Aristotelian term, = actual.
[2] This comparison is made by the Stoics, Dio L. VII. 158; Plut. *Plac. Phil.* IV. xix. 4.

voice will not be checked. 5. Many and spacious
stepped passages must be arranged between the
seats; but the upper ones ought to be discontinuous
with the lower. Everywhere, each passage (upper
or lower) must be continuous and straight without
bends; so that when the audience is dismissed from
the spectacle, it may not be cramped, but may find
everywhere separate and uninterrupted exits.

Great care is also to be taken that the place chosen
does not deaden the sound, but that the voice can
range in it with the utmost clearness. And this can
be brought about if a site is chosen where the passage
of sound is not hindered. 6. Now the voice is like a
flowing breath of air, and is actual[1] when perceived
by the sense of hearing. It is moved along innumer-
able undulations of circles; as when[2] we throw a
stone into standing water. Innumerable circular
undulations arise spreading from the centre as wide
as possible. And they extend unless the limited
space hinders, or some obstruction which does not
allow the directions of the waves to reach the
outlets. And so when they are interrupted by
obstacles, the first waves flowing back disturb the
directions of those which follow. 7. In the same
way the voice in like manner moves circle fashion.
But while in water the circles move horizontally
only, the voice both moves horizontally and rises
vertically by stages.[3] Therefore as is the case with
the direction of the waves in water, so with the
voice when no obstacle interrupts the first wave,
this in turn does not disturb the second and later

[3] The Stoics noted that the undulations of sound moved
" spherically " through the air, and not merely horizontally.
Plut. *loc. cit.*

insequentes, sed omnes sine resonantia perveniunt
8 ad imorum et ad summorum aures. Ergo veteres
architecti naturae vestigia persecuti indagationibus
vocis scandentis[1] theatrorum perfecerunt gradationes,
et quaesierunt per canonicam mathematicorum et
musicam rationem, ut, quaecumque vox esset in
scaena, clarior et suavior ad spectatorum perveniret
aures. Uti enim organa in aeneis lamminis aut
corneis *echeis*[2] ad cordarum[3] sonitum claritatem
perficiuntur, sic theatrorum per harmonicen ad
augendam vocem ratiocinationes ab antiquis sunt
constitutae.

IV

1 HARMONIA autem est musica litteratura obscura et
difficilis, maxime quidem quibus graecae litterae non
sunt notae. Quam si volumus explicare, necesse est
etiam graecis verbis uti, quod nonnullae eorum latinas
non habent appellationes. Itaque ut potuero quam
apertissime ex Aristoxeni scripturis interpretabor et
eius diagramma subscribam finitionesque sonituum
designabo, uti, qui diligentius attenderit, facilius
2 percipere possit. Vox enim mutationibus cum
flectitur, alias fiat acuta, alias gravis; duobusque
modis movetur, e quibus unus effectus habet continu-
atos, alter distantis. Continuata vox neque in finitio-
nibus consistit neque in loco ullo, efficitque termina-
tiones non apparentes, intervalla autem media

[1] vocis scandentis G^e: voces scandentes *H*.
[2] ἠχείοις *Schn*: haeae sic *H*.
[3] corda Petr. 66, 7; sonitum *gen. nl.*

[1] As reverberators.

waves, but all reach the ears of the top and bottom rows without echoing. Therefore the ancient architects following nature's footsteps, traced the voice as it rose, and carried out the ascent of the theatre seats. By the rules of mathematics and the method of music, they sought to make the voices from the stage rise more clearly and sweetly to the spectators' ears. For just as organs which have bronze plates [1] or horn sounding boards are brought to the clear sound of string instruments, so by the arrangement of theatres in accordance with the science of harmony, the ancients increased the power of the voice.

CHAPTER IV

ON HARMONY

1. HARMONY is an obscure and difficult branch of musical literature especially for persons unacquainted with Greek. If we wish to explain it we must use Greek words and some of these have no Latin renderings. Therefore I shall translate (as well as I can) from the works of Aristoxenus [2] subjoining his diagram, and I shall indicate the definitions of the musical notes, so that an attentive reader can the more easily understand. 2. For when the voice is changed and modulated it may sometimes become high, sometimes low. It moves in two manners, of which one is continuous, the other by intervals. For the continuous voice neither stops in definite notes nor indeed anywhere, and comes to no clear endings. There are, however, intervals apparent between one

[2] Pupil of Aristotle. Some of his musical works have come down.

parentia, uti sermone cum dicamus : sol lux flos vox.
Nunc enim nec unde incipit nec ubi desinit, intelle-
gitur ; sed quod ex acuta facta est gravis et ex gravi
acuta, apparet auribus. Per distantiam autem e
contrario. Namque cum flectitur, inmutatione vox
statuit se in alicuius sonitus finitionem, deinde in
alterius, et id ultro citro crebre faciendo constans
apparet sensibus, uti in cantionibus cum flectentes
vocem varietatem facimus. Modulationis itaque
intervallis [1] ea cum versatur, et unde initium fecit et
ubi desiit, apparet in sonorum patentibus finitionibus,
mediana autem patentia intervallis obscurantur.

3 Genera vero sunt modulationum tria : primum
quod Graeci nominant *harmoniam*, secundum *chroma*,
tertium *diatonon*. Est autem harmoniae modulatio
ad artem concepta, et ea re cantio eius maxime
gravem et egregiam habet auctoritatem. Chroma
subtili sollertia ac crebritate modulorum suaviorem
habet delectationem. Diatoni vero, quod naturalis
est, facilior est intervallorum distantia. In his tribus
generibus dissimiles sunt tetrachordorum disposi-
tiones, quod harmonia tetrachordorum et tonos et
dihesis habet binas (dihesis autem est toni pars
quarta ; ita in hemitonio duae diheses sunt conlo-
catae) ; chromati duo hemitonia in ordine sunt
composita, tertium trium hemitoniorum est inter-
vallum ; diatono [2] toni duo sunt continuati, tertium
hemitonium finit tetrachordi magnitudinem. Ita in

[1] intervalles *H*. [2] *add. Lor.*

[1] That is taking definite notes at definite intervals.

[2] Or " enharmonic," introduces quarter tones as when we
divide the interval between E and F.

[3] Introduces more subtle intervals even than the quarter
tone.

sound and the next; as when we say: *sol lux flos vox.*
For now it is not perceived whence it begins nor
where it ceases. But that it passes from high to low,
and from low to high, is heard by the ears. The
case is opposite with intervals. For when the voice
is modulated, the voice in changing is directed first to
one determinate sound and then to another. Doing
this often backwards and forwards it appears consis-
tent [1] to the sense of hearing, as when in singing we
modulate the voice in various ways. When therefore
the voice is modulated by intervals, the manifest
limits of the notes make clear where it begins and
where it breaks off; but the notes within the
intervals, although clear in themselves, are not
heard.

3. The kinds of modulation are three: first that
which the Greeks call *harmonia*; second *chroma*;
third *diatonon*. Now harmonic modulation [2] is arti-
ficially constructed; singing in this style has a very
solemn and impressive influence. Chromatic [3] modu-
lation, by the refinement and " closeness " of its
transitions, produces an impression of more sweet-
ness. The diatonic modulation is closer to nature
and has a more easy distance of its intervals. In
these three scales, the arrangements of the tetra-
chords differ. The harmonic scale has two tones in
the tetrachord and two quarter-tones. (Now two
quarter-tones make a semitone.) The chromatic
tetrachord [4] has two consecutive semitones and the
third interval is of three semitones. The diatonic
tetrachord [4] has two consecutive tones, and the third
interval—a semitone—completes the amount of the

[4] *e.g.* C D E F.

tribus generibus tetrachorda ex duobus tonis et
hemitonio sunt [1] peraequata, sed ipsa cum separa-
tim uniuscuiusque generis finibus considerantur,
dissimilem habent intervallorum designationem.
4 Igitur intervallo tonorum et hemitoniorum et
tetrachordorum in voce divisit natura finitque
terminationes eorum mensuris intervallorum quanti-
tate, modisque certis distantibus constituit qualitates,
quibus etiam artifices qui organa fabricant, ex natura
constitutis utendo comparant ad concentus con-
venientes eorum perfectiones.
5 Sonitus, qui graece *phthongi* [2] dicuntur, in unoquo-
que genere sunt x et VIII, e quibus VIII sunt in tribus
generibus perpetui et stantes, reliqui x, cum commu-
niter modulantur, sunt vagantes. Stantes autem sunt,
qui inter mobiles sunt interpositi. Continent tetra-
chordi coniunctionem et e generum discriminibus
suis finibus sunt permanentes; appellantur autem sic:
proslambanomenos,[3] hypate hypaton,[4] hypate meson,[5]
mese, nete synhemmenon,[6] paramese, nete diezeug-
menon,[7] nete hyperbolaeon. Mobiles autem sunt, qui
in tetrachordo inter inmotos dispositi in generibus
ex [8] locis loca mutant; vocabula autem habent haec:
parhypate hypaton, lichanos hypaton, parhypate
meson, lichanos meson, trite synhemmenon, ⟨paranete
synhemmenon,⟩[9] trite diezeugmenon, paranete die-

[1] sunt *G*: *om. H.* [2] pthongi *H.*
[3] iros lambanomenos *H.* [4] hypate hypato *H.*
[5] hypatemeson *G*: hypateon meson *H.*
[6] nete synemmene *H.* [7] diezeucmene *G.*
[8] ex *Ro*: et (&) *H.*
[9] *add. Joc., qui haec omnia correxit.*

[1] *e.g.*: in modern music the *quantity* of the intervals in
major and minor scales is the same, but the *quality* of major
and minor is different.

tetrachord. Thus in the three scales the tetrachords are equivalent to two tones and a half, but when they are considered separately within the limits of each scale, they vary in the arrangement of the intervals. 4. Therefore by the intervals of tones, semitones, and tetrachords, nature has divided and defined their limits for the voice, measuring them by the *quantity* of the intervals; and has fixed their *quality* [1] in certain distinct modes. Craftsmen who make instruments use these proportions which nature has fixed, and make perfect their instruments with a view to suitable concords.[2]

5. Sounds (which in Greek are called *phthongi*) are eighteen in number for each kind.[3] Of these, eight are perpetually fixed in the three kinds; the remaining ten, when they are modulated in common, are found to vary. Now those are fixed which are interposed between the variable sounds; they determine the combination of the tetrachord, and in accordance with the differences of the kinds remain in their own limits. Their names are these: proslambanomenos; hypatè hypatōn; hypatè mesōn; mesè; nētè synhēmmenōn; paramesè; nētè diezeugmenōn; nētè hyperbolaeōn. Those sounds are shifting which are arranged in the tetrachord between the fixed sounds, and change from place to place in the three kinds. Their names are these: parhypatè hypatōn; lichanos hypatōn; parhypatè mesōn; lichanos mesōn; tritè synhēmmenōn; paranētè synhēmmenōn; tritè diezeugmenōn; paranētè die-

[2] This is heard in the adjustment of the tones of pianos so as to fit all scales (temperament).

[3] The figure will indicate the meaning of these technical terms: Plate F.

zeugmenon, trite hyperbolaeon, paranete hyper-
6 bolaeon. Ei autem qua moventur, recipiunt virtutes
alias ; intervalla enim et distantias habent crescentes.
Itaque parhypate, quae in harmonia distat ab hypate
⟨dimidium⟩[1] hemitonium, in chroma tramutata[2]
habet hemitonium. Qui[3] lichanos in harmonia
dicitur, ab hypate distat hemitonium, in chroma
translata progreditur duo hemitonia, in diatono distat
ab hypate tria hemitonia. Ita x sonitus propter
translationes in generibus efficiunt triplicem modu-
lationum varietatem. Tetrachorda autem sunt quin-
7 que : primum gravissimum, quod graece dicitur
hypaton, secundum medianum, quod appellatur
meson, tertium coniunctum, quod *synhemmenon* dicitur,
quartum disiunctum, quod *diezeugmenon* nominatur,
quintum, quod est acutissimum, graece *hyperbolaeon*
dicitur. Concentos quos natura hominis modulari
potest, graece quae *synphoniae* dicuntur, sunt sex :
diatessaron, diapente, diapason, et disdiatessaron, et
8 disdiapente, et disdiapason. Ideoque et a numero
nomina ceperunt, quod, cum vox constiterit in una
sonorum finitione ab eaque se flectens mutaverit
et pervenerit in quartam terminationem, appellatur
diatessaron, in quintam diapente[4] [in sextam diapason
in octavam et dimidiam diapason et diatessaron, in
nonam et dimidiam diapason diapente, in XII dis-
9 diapason]. Non enim inter duo intervalla, cum
chordarum sonitus aut vocis cantus factus fuerit, nec
in tertia aut sexta aut VII[5] possunt consonantiae
fieri, sed, uti supra scriptum est, diatessaron et

[1] *add. Mar.* [2] chromatra mutata *H. cf.* tranatare.
[3] quae *Lor* : qui *H.* [4] *sqq. del. Wilmanns.*
[5] septem *H* : VII *ed.* : septima e_2.

zeugmenōn; tritè hyperbolaeōn; parenētè hyper-
bolaeōn. 6. But those sounds which shift, gain
various qualities; for they have increasing intervals
and distances. Thus the parhypatè which in the
enharmonic is half a semitone from the hypatè, has
a semitone when it is changed to the chromatic.
What is called lichanos in the enharmonic kind, is
distant a semitone from the hypatè; transferred to
the chromatic, it advances two semitones; in the
diatonic, it is distant three semitones. Thus the
10 sounds, because of their transpositions in the three
scales, produce a triple variety of modulation.
7. Now the tetrachords are five: the first is the lowest
which in Greek is called *hypaton*; the second is the
middle which is called *meson*; the third which is
joined to these is called *synhēmmenon*; the fourth
being separated is called *diezeugmenon*; the fifth which
is the highest is called in Greek *hyperbolaeon*. The
concords (in Greek *symphoniae*) which the human
voice can modulate are six: diatessaron (fourth);
diapente (fifth); diapason (octave); disdiatessaron
(octave and fourth); disdiapente (octave and fifth);
disdiapason (two octaves). 8. These have taken
their names from numbers. For when the voice has
rested in one fixed sound, and then modulates and
changes from itself, and comes to the fourth sound it
is called diatessaron; when it comes to the fifth, it
is called diapente; [to the eighth, diapason; to the
eleventh, diapason with diatessaron; to the twelfth,
diapason with diapente to the fifteenth disdiapason].
9. For concords cannot arise between two intervals,
when the sound of strings or the song of the voice is
uttered, nor between three or six or seven; but, as
we wrote above, the diatessaron and diapente up to

275

diapente et ex ordine disdiapason convenientiae
ex natura vocis congruentis habent finitiones. Et
ei coventus[1] procreantur ex coniunctione sonituum,
qui graece *phthongi* dicuntur.

V

1 ITA ex his indagationibus mathematicis rationibus
fiant vasa aerea pro ratione magnitudinis theatri,
eaque ita fabricentur, ut, cum tangantur, sonitum
facere possint inter se diatessaron diapente ex ordine
ad disdiapason. Postea inter sedes theatri constitutis
cellis ratione musica ibi conlocentur ita, uti nullum
parietem tangant circaque habeant[2] locum vacuum
et ab summo capite spatium, ponanturque inversa et
habeant[2] in parte, quae spectat ad scaenam, suppo-
sitos cuneos ne minus altos semipede; contraque eas
cellas relinquantur aperturae inferiorum graduum[3]
2 cubilibus longae pedes duo, altae semipede. Desig-
nationes autem eorum, quibus in locis constituantur,
sic explicentur. Si non erit ampla magnitudine
theatrum, media altitudinis transversa regio desig-
netur et in ea tredecim cellae duodecim aequalibus
intervallis distantes confornicentur, uti ea echea[4]
quae supra scripta sunt, ad neten[5] hyperbolaeon
sonantia[6] in cellis quae sunt in cornibus extremis,
utraque parte prima conlocentur, secunda ab extremis

[1] *cf.* coventio *S. C. Bacch.*
[2] locum . . . habeant *bis ponit H.*
[3] graduu *G* : gradibus *H.*
[4] ea echea *Joc* : eae echo *H.*
[5] netent *H.* [6] sonentia *H.*

the disdiapason are concords which have limits arising from the nature of the voice. And these concords are produced from the conjunction of sounds which in Greek are called *phthongi*.

CHAPTER V

ON SOUNDING VASES IN THEATRES

1. Hence in accordance with these enquiries, bronze [1] vases are to be made in mathematical ratios corresponding with the size of the theatre. They are to be so made that, when they are touched, they can make a sound from one to another of a fourth, a fifth and so on to the second octave. Then compartments are made among the seats of the theatre, and the vases are to be so placed there that they do not touch the wall, and have an empty space around them and above. They are to be placed upside down. On the side looking towards the stage, they are to have wedges put under them not less than half a foot high. Against these cavities openings are to be left in the faces of the lower steps two feet long and half a foot high. 2. The planning of them and the places in which they are to be are to be thus set forth. If the theatre is not of large dimensions, in the middle of the height, a transverse line is to be drawn. In that, thirteen cavities separated by twelve equal distances are to be arched over, so that those vases above referred to, giving the note of the nētè hyperbolaeōn, may be placed at each end; second from the end, vases of the nētè diezeug-

[1] Earthenware vases, apparently for this purpose, have been found in ancient theatres, but not bronze vases.

diatessaron ad neten diezeugmenon,[1] tertia diatessaron ad paramesen,[2] quarta ad neten synhemmenon, quinta diatessaron ad mesen, sexta diatessaron ad hypaten meson, in medio unum diatessaron ad
3 hypaten hypaton. Ita hac ratiocinatione vox a scaena uti ab centro profusa se circumagens tactuque feriens singulorum vasorum cava excitaverit auctam claritatem et[3] concentu convenientem sibi consonantiam. Sin autem amplior erit magnitudo theatri, tunc altitudo dividatur in partes IIII, uti tres efficiantur regiones cellarum transverse designatae, una harmoniae, altera chromatos, tertia diatoni. Et ab imo quae erit prima, ea ex harmonia conlocetur,
4 ita uti in minore theatro supra scriptum est. In mediana autem prima in extremis cornibus ad chromaticen hyperbolaeon habentia sonitum ponantur, in secundis ab his diatessaron ad chromaticen diezeugmenon, in tertiis ad chromaticen synhemmenon,[4] quartis diatessaron ad chromaticen meson, quintis diatessaron ad chromaticen hypaton, sextis ad paramesen, quod et in chromaticen hyperbolaeon diapente et ad chromaticen meson diatessaron habeant consonantiae com-
5 munitatem. In medio nihil est conlocandum, ideo quod sonitum nulla alia qualitas in chromatico genere symphoniae consonantiam potest habere. In summa vero divisione et regione cellarum in cornibus primis ad diatonon hyperbolaeon fabricata vasa sonitu ponantur, in secundis diatessaron ad diatonon ⟨diezeugmenon⟩,[5] tertiis[6] ad diatonon synhemmenon,

[1] diezeugmenon *Joc* : synhemmenu *H*.
[2] ad paramesen *Perr* : adnethen ad paramesen *H*.
[3] et *Joc* : ex *H*.
[4] in tertiis ad chrom. synhemmenon *Lor* : in tertiis diatessaron ad chrom, synhemmenu *H*.
[5] *add. ed. Ven.*
[6] tertiis ad diatonon *Lor* : tertiis diatessaron ad diatonum *H*.

menōn at an interval of one fourth from the last;
third from the end at the paramesè (another fourth);
the fourth set of vases at the nētè synhemmenōn;
the fifth at the mesè (interval of a fourth); the sixth
set at the hypatè mesōn (interval of a fourth); in the
middle one vase at the hypatè hypatōn. 3. Thus by
this calculation the voice, spreading from the stage as
from a centre and striking by its contact the hollows
of the several vases, will arouse an increased clearness
of sound, and, by the concord, a consonance harmonis-
ing with itself. But if the theatre is larger, then the
height is to be divided into 4 parts, so that three lines
of cavities are drawn crosswise, one enharmonic, a
second chromatic, the third diatonic. The first from
the bottom is to be arranged for the enharmonic kind
as described above for the smaller theatre. 4. In
the middle series on the extreme wings, the first vases
are to be put with a note of the chromatic hyper-
bolaeon; in the second cavities at the interval of
a fourth, the chromatic diezeugmenon; in the third
the chromatic synhēmmenon; in the fourth cavities,
at the interval of a fourth, the chromatic meson; in
the fifth at the interval of a fourth the chromatic
hypaton; in the sixth the paramesè, which has a
fifth interval to the chromatic hyperbolaeon, and an
interval of a fourth to the chromatic synhēmmenon.
5. In the centre nothing is to be put, because no
other quality of sound has a share in the concords of
the chromatic kind. In the top [1] division and line
of cavities, vases are to be put in the extreme wings,
made to sound the diatonic hyperbolaeon; in the
second at the interval of a fourth the diatonic die-
zeugmenon; in the third the diatonic synhēmmenon;
in the fourth (at the interval of a fourth) the

[1] See Plate F.

quartis diatessaron ad diatonon meson, quintis diatessaron ad diatonon hypaton, sextis diatessaron ad proslambanomenon, in medio ad mesen, quod ea et ad proslambanomenon diapason et ad diatonon hypaton

6 diapente habet symphoniarum communitates. Haec autem si qui voluerit ad perfectum facile perducere, animadvertat in extremo libro diagramma musica ratione designatum, quod Aristoxenus magno vigore et industria generatim divisis modulationibus constitutum reliquit, de quo, si qui ratiocinationibus his attenderit, ad naturas vocis et audientium delectationes facilius valuerit theatrorum efficere perfectiones.

7 Dicet aliquis forte multa theatra quotannis Romae facta esse neque ullam rationem harum rerum in his fuisse; sed errabit[1] in eo, quod omnia publica lignea theatra tabulationes habent complures, quas necesse est sonare. Hoc vero licet animadvertere etiam ab citharoedis qui, superiore tono cum volunt canere, avertunt se ad scaenae valvas[2] et ita recipiunt ab earum auxilio consonantiam vocis. Cum autem ex solidis rebus theatra constituuntur, id est ex structura caementorum, lapide,[3] marmore, quae sonare non possunt, tunc echeis[4] hae rationes sunt

8 explicandae. Sin autem quaeritur, in quo theatro ea sint facta, Romae non possumus ostendere, sed in Italiae regionibus[5] et in pluribus Graecorum civitatibus. Etiamque auctorem habemus Lucium Mummium qui diruto theatro Corinthiorum ea aenea

[1] errabit *Phil* : erravit *H*. [2] valbas *H*.
[3] lapido *H*. [4] echeis *Ro* : exhis *H*.
[5] regionibus *Joc (rec)* : regiones *H*.

[1] *cf*. Plate F.
[2] These were wooden erections. Pompey was attacked for building a permanent stone theatre. Similarly the temporary

diatonic meson; in the fifth at the interval of a fourth at the diatonic hypaton; in the sixth at the interval of a fourth the proslambanomenos; in the middle the mesè, between which and the proslambanomenos is an octave, and a fifth to the diatonic hypaton. 6. If anyone wishes to bring all this to execution, let him note at the end of the book a diagram[1] drawn in accordance with the method of music, which Aristoxenus, employing a sound and careful method, has left to us arranged with the modulations according to their kinds. If he attends to these calculations, he will the more easily be able to erect theatres adapted to the nature of the voice and the pleasure of the audience.

7. Someone will say, perhaps, that many theatres[2] are built every year at Rome without taking any account of these matters. He will be mistaken in this. All public wooden theatres have several wooden floors which must naturally resound. We can observe this also from those who sing to the zither, who when they wish to sing with a louder tone, turn to the wooden scenery, and, with this help, gain resonance for their voice. But when theatres are built of solids, that is of rubble walling, stone or marble which cannot resound, the use of bronze vases is to be followed. 8. But if you ask in what theatre this is done, we cannot show any at Rome, but we must turn to the regions of Italy, and to many Greek cities. We find a precedent in Lucius Mummius[3] who destroyed the theatre at Corinth, and transported

structures had been attacked for affording seats to the spectators who were thereby encouraged to spend the day in idleness. Tac. *Ann.* XIV. 20.

[3] B.C. 146.

Romam deportavit et de manubiis ad aedem Lunae
dedicavit. Multi etiam sollertes architecti, qui in
oppidis non magnis theatra constituerunt, propter
inopiam fictilibus doleis ita sonantibus electis hac
ratiocinatione compositis perfecerunt utilissimos
effectus.

VI

1 IPSIUS autem theatri conformatio sic est facienda,
uti, quam magna futura est perimetros imi, centro
medio conlocato circumagatur linea rutundationis,[1] in
eaque quattuor scribantur trigona paribus [2] lateribus;
intervallis extremam lineam circinationis,[3] tangant,
quibus etiam in duodecim signorum caelestium
astrologia [4] ex musica convenientia astrorum ratio-
cinantur. Ex his trigonis cuius latus fuerit proxi-
mum scaenae, ea regione, qua [5] praecidit curvaturam
circinationis, ibi finiatur [6] scaenae frons, et ab eo loco
per centrum parallelos linea ducatur, quae disiungat
2 proscaenii pulpitum et orchestrae regionem. Ita
latius factum fuerit pulpitum quam Graecorum,
quod omnes artifices in scaena [7] dant operam, in or-
chestra autem senatorum sunt sedibus loca designata.
Et eius pulpiti altitudo sit ne plus pedum quinque,
uti, qui in orchestra sederint, spectare possint
omnium agentium gestus. Cunei spectaculorum in
theatro ita dividantur, uti anguli trigonorum, qui

[1] rutundationes *H*. [2] partibus *H*.
[3] circinnationes *H*. [4] astrologia *Lor*: astrologi *H*.
[5] qua *Joc*: quae *H*. [6] finiantur *H*. [7] caena *H*.

[1] On the Aventine, destroyed in the Neronian fire. Tac.
Ann. XV. 41. Platner 320.

these bronze vessels to Rome, and dedicated them, from the spoils, at the temple of Luna.[1] Further many clever architects, who in towns of moderate size have built theatres, have chosen, for cheapness' sake, earthenware vessels with similar sounds, and arranging them in this way have produced very useful effects.

CHAPTER VI

ON THE PLANNING OF THEATRES

1. THE plan [2] of the theatre is to be thus arranged: that the centre is to be taken, of the dimension allotted to the orchestra at the ground level. The circumference is to be drawn; and in it four equilateral triangles are to be described touching the circumference at intervals (just as in the case of the twelve celestial signs, astronomers calculate from the musical division of the constellations). Of these triangles the side of that which is nearest the scene, will determine the front of the scene, in the part where it cuts the curve of the circle. Through the centre of the circle a parallel line is drawn which is to divide the platform of the proscenium from the orchestra. 2. Thus the stage will be made wider that that of the Greeks because all the actors play their parts on the stage, whereas the orchestra is allotted to the seats of the senators.[3] The height of the stage is not to be more than 5 feet, so that those who are seated in the orchestra can see the gestures of all the actors. The blocks of seats in the theatre are so to be divided that the angles of the

[2] Plate G shows the plan of a small theatre.
[3] The Greek chorus was in the orchestra.

currunt circum curvaturam circinationis,[1] dirigant
ascensus scalasque inter cuneos ad primam praecinc-
tionem; supra autem alternis itineribus superiores
3 cunei medii dirigantur. Hi autem, qui sunt in imo et
dirigunt scalaria, erunt numero VII; reliqui quinque
scaenae designabunt compositionem : et unus medius
contra se valvas regias habere debet, et qui erunt
dextra sinistra, hospitaliorum designabunt composi-
tionem, extremi duo spectabunt itinera versurarum.
Gradus spectaculorum, ubi subsellia componantur,
gradus ne minus alti sint palmopede,⟨ne plus pedem⟩[2]
et digito sex; latitudines eorum ne plus pedes duo
4 semis, ne minus pedes duo constituantur. Tectum
porticus, quod futurum est in summa gradatione
cum scaenae altitudine libratum perspiciatur, ideo
quod vox crescens aequaliter ad summas gradationes
et tectum perveniet. Namque si non erit aequale,
quo minus fuerit altum, vox praeripietur ad eam
5 altitudinem, quam perveniet primo. Orchestra inter
grados[3] imos quod diametron habuerit, eius sexta
pars sumatur[4], et in cornibus, utrumque aditus eius
mensurae perpendiculum interiores sedes praeci-
dantur, et quae praecisio fuerit, ibi constituantur
itinerum supercilia; ita enim satis altitudinem
6 habebunt eorum confornicationes. Scaenae longi-
tudo ad orchestrae diametron duplex[5] fieri debet.
Podii altitudo ab libramento pulpiti cum corona et
lysi duodecumam orchestrae diametri. Supra podium

[1] circinationis G : -nes H. [2] add. Joc.
[3] gradus G. [4] summatur H. [5] dupl& H.

[1] Lit. " sighted."

triangles which run round the curve of the circle
indicate the ascents and the steps between the blocks
to the first circular passage. Above, the upper blocks
of seats are arranged with alternate staircases facing
the middle of the lower blocks. 3. The angles which
are on the ground floor of the theatre and determine
the staircases will be 7 in number. The remaining
5 will indicate the arrangement of the stage. One in
the middle should have the palace doors opposite to
it. Those which are to the right and left, will
indicate the apartments provided for strangers. The
furthest two will regard the direction of the revolving
scenes. As to the rows of the auditorium where the
seats are placed, the seats are not to be lower than
16 inches nor more than 18. The width is not to be
more than $2\frac{1}{2}$ feet nor less than 2 feet. 4. The roof of
the colonnade, which is to be built on the top row of
steps, is to be so planned [1] as to be level with the top
of the back wall of the stage, because thereby the
voice will rise evenly until it reaches the top seats
and the roof. For if the roof is not level, the lower it
is, to that extent the voice will be interrupted, at the
height which it reaches first. 5. As to the orchestra,
a sixth part is to be taken of its diameter between the
lowest steps. On the wings at either side of the
entrance, the inmost seats are to be cut back to a
perpendicular height equal to that sixth. Whatever
the amount of this cutting off is, fixes the spring of
the arch over the passages. In this way their vault-
ing will have sufficient height. 6. The length of the
stage must be twice the width of the orchestra. The
height of the pedestal of the back wall above the level
of the stage, along with the cornice and moulding,
is to be one twelfth of the diameter of the orchestra.

columnae cum capitulis et spiris altae quarta parte
eiusdem diametri; epistylia et ornamenta earum
columnarum altitudinis quinta parte. Pluteum in-
super cum unda et corona inferioris plutei dimidia
parte. Supra id pluteum columnae quarta parte
minore altitudine sint quam inferiores; epistylium et
ornamenta earum columnarum quinta parte. Item
si tertia episcenos futura erit, mediani plutei sum-
mum sit dimidia parte; columnae summae media-
narum[1] minus altae sint quarta parte; epistylia cum
coronis earum columnarum item habeant altitudinis
quintam partem.

7 Nec tamen in omnibus theatris symmetriae ad
omnis rationes et effectus possunt respondere, sed
oportet[2] architectum animadvertere, quibus propor-
tionibus necesse sit sequi symmetriam et quibus ad
loci naturam aut magnitudinem operis temperari.
Sunt enim res quas et in pusillo et in magno theatro
necesse est eadem magnitudine fieri propter usum,
uti gradus, diazumata, pluteos, itinera, ascensus, pul-
pita, tribunalia et si qua alia intercurrunt, ex quibus
necessitas cogit discedere ab symmetria, ne in-
pediatur usus. Non minus si qua exiguitas copiarum,
id est marmoris, materiae reliquarumque rerum,
quae parantur in opere defuerint, paulum demere
aut adicere, dum id ne nimium inprobe fiat sed cum
sensu, non erit alienum. Hoc autem erit, si archi-
tectus erit usu peritus, praeterea ingenio mobili
sollertiaque non fuerit viduatus.

[1] columnae summae medianarum *rec*: columnae summae
media parte columnae summae medianarum *H*.
[2] oportere *H G*.

[1] *Tribunalia* : for magistrates.

Above the pedestal, the columns with capitals and
bases are to be of a height equal to one quarter of the
diameter; the architrave and ornaments, one fifth
part of their height. The parapet above, with its
base and cornice, is to be one half of the lower parapet
(or pedestal). Above the parapet are to be columns
one fourth less in height than the lower ones; the
architrave and ornaments a fifth of those columns.
If there is to be a third order, the top parapet is to be
half of the middle one. The top columns are to be
one quarter less in height than the middle; the archi-
traves with the cornices are also to have one fifth
of the height of those columns.

7. Nevertheless it is not in all theatres that the
dimensions can answer to all the effects proposed.
The architect must observe in what proportions
symmetry must be followed, and how it must be
adjusted to the nature of the site or the magnitude
of the work. For there are details which must be of
the same dimensions both in a small, and in a large
theatre, since their use is the same. Such are the
steps, the semi-circular passages, the parapets, the
ordinary passages, the steps up, the height of the
stage, the boxes[1]; and whatever else occurs to
compel us to depart from proportion in the interest of
convenience. Similarly if scantness[2] of materials,
such as marble, timber and other supplies, meet us in
the work, it will not be inappropriate to make slight
additions or deductions, provided this is done with
taste and so as to avoid a clumsy effect. Such will be
the result, if the architect in addition to being ex-
perienced, is not devoid of a versatile mind and
technical skill.

[2] *Exiguitas*, by anacoluthon, lacks its verb: its equivalent
defuerint supplies *fuerit*.

8 Ipsae autem scaenae suas habent rationes explicitas ita, uti mediae valvae ornatus habeant aulae regiae, dextra ac sinistra hospitalia, secundum autem spatia ad ornatus comparata, quae loca Graeci *periactus* dicunt ab eo, quod machinae sunt in his locis versatiles trigonos habentes in singula tres species ornationis, quae, cum aut fabularum mutationes sunt futurae seu deorum adventus, cum tonitribus repentinis ea versentur mutentque speciem ornationis in frontes. Secundum ea loca versurae sunt procurrentes, quae efficiunt una a foro, altera a peregre

9 aditus in scaenam. Genera autem sunt scaenarum tria : unum quod dicitur tragicum, alterum comicum, tertium satyricum. Horum autem ornatus sunt inter se dissimili disparique ratione, quod tragicae deformantur columnis et fastigiis et signis reliquisque regalibus rebus; comicae autem aedificiorum privatorum et maenianorum [1] habent speciem profectusque [2] fenestris dispositos imitatione communium aedificiorum rationibus; satyricae vero ornantur arboribus, speluncis, montibus reliquisque agrestibus rebus in topeodi [3] speciem deformati.

VII

1 In Graecorum theatris non omnia isdem rationibus sunt facienda, quod primum in ima circinatione, ut in latino trigonorum IIII, in eo quadratorum trium

[1] moenianorum *H*.
[2] prospectus *ed. Ven* : profectus *H*.
[3] *cf.* topia Book VII. v. 2.

[1] The periaktos on the spectator's right represented the locality of the action : on the left, foreign parts.

8. The scenery itself is so arranged that the middle doors are figured like a royal palace, the doors on the right and left are for strangers. Next on either side are the spaces prepared for scenery. These are called *periaktoi* in Greek (revolving wings) from the three-sided machines which turn having on their three sides as many kinds of subject. When there are to be changes in the play or when the gods appear with sudden thunders, they are to turn and change the kind of subject presented to the audience. Next to these the angles of the walls run out which contain the entrances to the stage one from the public square [1] and the other from the country. 9. There are three styles of scenery: one which is called tragic; a second, comic; the third, satyric. Now the subjects of these differ severally one from another. The tragic are designed with columns, pediments and statues and other royal surroundings; the comic have the appearance of private buildings and balconies and projections with windows made to imitate reality, after the fashion of ordinary buildings; the satyric settings are painted with trees, caves, mountains and other country features, designed to imitate landscape.

CHAPTER VII

ON GREEK THEATRES

1. In the Greek theatres [2] some things are done differently. Firstly, in the orchestra, the angles of three squares touch the circumference, whereas in the Roman theatre we have the angles of four

[2] Louis Dyer "Vitruvius' account of the Greek stage," *J.H.S.* XII. 356 ff.

anguli circinationis lineam tangunt, et cuius quadrati
latus est proximum scaenae praeciditque curvaturam [1]
circinationis, ea regione designatur finitio proscaenii.
Et ab ea regione ad extremam circinationem cur-
vaturae parallelos linea designatur, in qua consti-
tuitur frons scaenae, per centrumque orchestrae
proscaenii regione parallelos [2] linea describitur, et
qua [3] secat circinationis lineas dextra ac sinistra, in
cornibus hemicycli centra signantur. Et circino
collocato in dextra ab intervallo sinistro circumagatur
circinatio ad proscaenii sinistram [4] partem; item
centro conlocato in sinistro cornu ab intervallo
dextro circumagitur ad proscaenii dextram partem.[5]
2 Ita tribus centris hac descriptione ampliorem habent [6]
orchestram Graeci et scaenam recessiorem minoreque
latitudine pulpitum, quod *logeion* [7] appellant, ideo
quod ⟨apud⟩ [8] eos tragici et comici actores in scaena
peragunt, reliqui autem artifices suas per orchestram
praestant actiones; itaque ex eo scaenici et thyme-
lici graece separatim nominantur. Eius loci altitudo
non minus debet esse pedum x, non plus duodecim.
Gradationes scalarum inter cuneos et sedes contra
quadratorum angulos dirigantur ad primam prae-
cinctionem, a praecinctione inter eas iterum mediae
dirigantur, et ad summam quotiens praecinguntur,
altero tanto semper amplificantur.

[1] curvatura *H*. [2] per allelos *H*.
[3] qua *Phil* : quae *H*. [4] sinistram *Mar* : dextram *H*.
[5] item centro . . . dextram partem *post* ampliorem habent
H : *transp. Joc.*
[6] *restituit Joc.* [7] λογεῖον *Joc* : longion *H*.
[8] *add. rec.*

triangles. In the Greek the line of the proscenium (or stage) is drawn along the side of the square which is nearest to the scenery, where it cuts the circumference. On the same side, parallel to this a line is drawn to touch the outside of the circle, and on this the front of the scenery is marked out. Through the centre of the orchestra a line is described parallel to the proscenium; where it cuts the circumference right and left, centres are marked at the ends of the semi-circle. Fixing the centre of the compasses on the right, with a radius equal to the distance of the left point, a circle is drawn to the left side of the proscenium. In the same way, the centre is fixed on the left and with a radius equal to the distance of the right, a circle is drawn to intersect the right side of the proscenium. 2. Thus the Greeks have a wider orchestra, drawn from these three centres. The scenery is more recessed. The stage is narrower: this they call *logeion* (speaking-place), for the reason that the tragic and comic actors deliver their speeches on the stage. The other artists carry on their action in the orchestra. Hence the Greek gives them separate names: stage players and chorus (*scaenici* et *thymelici*). The height of the stage is not to be less than ten feet, nor more than twelve. The staircases between the lowest blocks of seats are to be arranged opposite the several angles of the squares up to the first horizontal gangway; between the tops of the first staircases, higher flights are to be put at halfway intervals along the gangway. And generally speaking, they are to be doubled in number when a gangway is reached.

VIII

1 CUM haec omnia summa cura sollertiaque explicata
sunt, tunc etiam diligentius. Est enim advertendum,
uti sit electus [1] locus, in quo leniter adplicet se vox
neque repulsa resiliens incertas auribus referat
significationes. Sunt enim nonnulli loci naturaliter
inpedientes vocis motus, uti dissonantes, qui graece
dicuntur *catechountes*,[2] circumsonantes, qui apud eos
nominantur *periechountes*,[3] item resonantes, qui dicun-
tur *antechountes*,[4] consonantesque, quos appellant
synechountas.[5] Dissonantes sunt, in quibus vox
prima, cum est elata in altitudinem, offensa superiori-
bus solidis corporibus repulsaque residens in imo
2 opprimit insequentis vocis elationem; circumso-
nantes autem, in quibus circumvagando coacta ex-
solvens in medio sine extremis casibus sonans ibi
extinguatur incerta verborum significatione; reso-
nantes vero, in quibus, cum in solido tactu percussa
resiliant, imagines exprimendo novissimos casus
duplices faciant auditu; item consonantes sunt, in
quibus ab imis auxiliata cum incremento scandens
egrediatur ad aures disserta [6] verborum claritate. Ita
si in locorum electione fuerit diligens animadversio,
emendatus erit prudentia ad utilitatem in theatris
vocis effectus. Formarum autem descriptiones inter
se discriminibus his erunt notatae, uti, quae [7] ex
quadratis designentur, Graecorum habeant usus,

[1] uti sit electus *Joc*: utiselectos *H*.
[2] caticontes *H*. [3] periechontes *H*.
[4] antechontas *H*. [5] synechontas *H*.
[6] disserta *H*. [7] ut quae *Joc*: itaque *H*.

CHAPTER VIII

ON ACOUSTICS

1. Now that all these matters are set forth with careful skill, diligent consideration must be given. For we must choose a site in which the voice may fall smoothly, and may reach the ear with a definite utterance and without the interference of echoes. For there are some places which naturally hinder the passage of the voice: the dissonant which the Greek call *katechountes;* the circumsonant which are named by them *periechountes;* the resonant also which are called *antechountes;* the consonant which they name *synechountes.* The dissonant places are those in which the voice, when first it rises upwards, meets solid bodies above. It is driven back, and settling down, overwhelms the following utterance as it rises. 2. The circumsonant are those in which the voice moves round, is collected and dissipated in the centre. The terminations of the words are lost and the voice is swallowed up in a confused utterance. The resonant are those in which the words, striking against a solid body, give rise to echoes and make the termination of the words double to the ear. The consonant also are those in which the voice reinforced from the ground rises with greater fulness, and reaches the ear with clear and eloquent accents. Thus if careful observation is exercised in the choice of sites, such skill will be rewarded by the improved effect of the actors' voices. To sum up, the outlines of the plans will be marked by these differences among themselves, namely, those plans follow Greek usage which are designed from squares; the Roman

latine paribus [1] lateribus trigonorum. Ita his prae-
scriptionibus qui voluerit uti, emendatas efficiet
theatrorum perfectiones.

IX

1 Post scaenam porticus sunt constituendae, uti, cum
imbres repentini ludos interpellaverint, habeat
populus, quo se recipiat ex theatro, choragiaque
laxamentum habeant ad comparandum. Uti sunt
porticus Pompeianae, itemque Athenis porticus
Eumeniae Patrisque Liberi fanum et exeuntibus e
theatro sinistra parte odeum, quod Themistocles
columnis lapideis dispositis navium malis et antemnis
e spoliis Persicis pertexit (idem autem etiam incen-
sum Mithridatico bello rex Ariobarzanes restituit);
Smyrnae Stratoniceum; Trallibus [2] porticus ex
utraque parte, ut [3] scaenae, supra stadium; ceterisque
civitatibus, quae diligentiores habuerunt architectos,
2 circa theatra sunt porticus et ambulationes. Quae
videntur ita oportere conlocari, uti duplices sint
habeantque exteriores columnas doricas cum epis-

[1] paribus *Joc* : raribus *H*.
[2] Trallibus *ed* : trabibus *H*. [3] est *Kr* : ut *H*.

[1] Lit. "in the Roman manner," *cf.* ionice, Book VII.
pref. 12.
[2] χορηγία Arist. *Poet.* 14. 2.
[3] No remains above ground. The statue of Pompey of the
Palazzo Spada found near.
[4] Eumenes II. of Pergamus. The colonnades connected the
Theatre with the Odeum.
[5] The temple of Dionysus Eleuthereus adjoined the theatre,
Paus. I. 20.
[6] The present Odeum was built about 160 A.D.

theatres,[1] from equilateral triangles. Whoever uses these rules, will be successful in building theatres.

CHAPTER IX

ON COLONNADES AND PASSAGES BEHIND THE SCENES

1. BEHIND the stage, colonnades are to be planned so that when the play is interrupted by sudden showers, the audience may have a place of refuge; the colonnades may also furnish room to set up the stage machinery.[2] At Rome there are the Colonnades of Pompey[3]; at Athens there are the Colonnades of Eumenes,[4] the Temple of Bacchus,[5] and as you leave the theatre, on the left-hand side there is the Odeum.[6] This[7] Themistocles planned with stone columns and completed with masts and yards from the Persian spoils. It was burnt in the Mithridatic War[8] and King Ariobarzanes[9] restored it. At Smyrna is the Colonnade of Stratonice.[10] At Tralles there are colonnades above the stadium on either side, like those of a theatre. In other cities also which have had skilful architects there are colonnades and walks adjoining the theatres. 2. These, it appears, should be so planned that they are double,[11] having Doric columns on the outside finished with

[7] Completed by Pericles. Plut. *vit.* 13.
[8] Athens taken by Sulla B.C. 86.
[9] Ariobarzanes Philopator, king of Cappadocia *c.* 60 B.C., entrusted the work to Roman architects, C. and M. Stallius, *cf.* Wilm. 1941. *I.G.* III. 541.
[10] Tac. *Ann.* III. 63.
[11] As in Colonnade of Octavius, Plin. *N.H.* XXXIV. 13; Platner 426. This had Corinthian capitals.

tyliis et ornamentis ex ratione modulationis [1] per-
fectas. Latitudines autem earum ita oportere fieri
videntur, uti, quanta altitudo columnae fuerit
exteriores, tantam latitudinem habeant ab inferiore
parte columnarum extremarum ad medias et a
medianis ad parietes qui circumcludunt porticus
ambulationes. Medianae autem columnae quinta
parte altiores sint quam exteriores, sed aut ionico
3 aut corinthio genere deformentur. Columnarum
autem proportiones et symmetriae non erunt isdem
rationibus quibus in aedibus sacris scripsi; aliam
enim in deorum templis debent habere gravitatem,
aliam in porticibus et ceteris operibus subtilitatem.
Itaque si dorici generis erunt columnae, dimetiantur [2]
earum altitudines cum capitulis in partes xv. Ex eis
partibus una constituatur et fiat modulus, ad cuius
moduli rationem omnis operis erit explicatio. Et in
imo [3] columnae crassitudo fiat duorum modulorum;
intercolumnium quinque et moduli dimidia parte;
altitudo columnae praeter capitulum xiiii modulo-
rum; capituli altitudo moduli unius, latitudo modu-
lorum duorum et moduli sextae partis. Ceteri
operis modulationes, uti in aedibus sacris in libro iiii
4 scriptum est, ita perficiantur. Sin autem ionicae
columnae fient, scapus [4] praeter spiram et capitulum
in octo et dimidiam partem dividatur, et ex his una [5]
crassitudini columnae detur; ⟨spira⟩ [6] cum plintho
dimidia crassitudine constituatur [7]; capituli ratio ita
fiat, uti in libro tertio est demonstratum. Si corinthia
erit, scapus et spira uti in ionica; capitulum autem,
quemadmodum in quarto libro est scriptum, ita

[1] modulationes *H*. [2] demetriantur *H*.
[3] in imo *Joc* : in primo *H*. [4] scaphus *H*.
[5] una *G* : *om. H*. [6] *add. Joc*.

architraves and ornaments in due proportion. The
width of the colonnades should be arranged as follows.
Taking the height of the outer columns, this will give
the width from the lower part of the outer columns
to the middle columns and from the middle columns
to the walls which surround the walks of the colon-
nades. The middle columns are to be designed one
fifth higher than the outer ones, and either in the
Ionic or Corinthian style. 3. The proportions and
symmetries of the columns will not be calculated in
the same way as I have described for sacred edifices.
In the temples of the gods dignity should be aimed
at; in colonnades and other similar works, elegance.
And so if the columns are in the Doric style, their
height including the capitals is to be divided into
15 parts of which one is to be the module. The
planning of the whole work is to be calculated to this
module. The thickness of the column at the foot is
to be of two modules. The intercolumniation is to
be 5 1/2 modules. The height of the column excluding
the capital is to be 14 modules. The height of the
capital is to be one module; the width 2 1/6 modules.
The proportions of the rest of the work are to be com-
pleted as laid down in the fourth book for sacred
edifices. 4. But if the columns are Ionic, the shaft
apart from the base and capital is to be divided into
8 1/2 parts and of these one is to be given to the
diameter of the column. The base, with the plinth,
is to be of half the diameter. The capital is to be
designed as set forth in the third book. If the
column is Corinthian, the shaft and base are to be as
in the Ionic, but the capital is to be proportioned as

7 constituatur *ed* : -antur *H*.

habeant rationem. Stylobatisque adiectio quae fit
per scabillos [1] inpares,[2] ex descriptione, quae supra
scripta est in libro tertio, sumatur. Epistylia,
coronae ceteraque omnia ad columnarum rationem ex
scriptis voluminum superiorum explicentur.

5 Media vero spatia quae erunt subdiu inter por-
ticus, adornanda viridibus videntur, quod hypaethroe
ambulationes habent magnam salubritatem. Et
primum oculorum, quod ex viridibus subtilis [3] et
extenuatus aer propter motionem corporis influens
perlimat speciem et ita auferens ex oculis umorem
crassum, aciem tenuem et acutam speciem relinquit [4];
praeterea, cum corpus motionibus in ambulatione
calescat, umores ex membris aer exsugendo inminuit
plenitates extenuatque [5] dissipando quod plus inest
6 quam corpus potest sustinere. Hoc autem ita esse
ex eo licet animadvertere, quod, sub tectis cum sint
aquarum fontes aut etiam sub terra palustris abun-
dantia, ex his nullus surgit umor nebulosus, sed in
apertis hypaethrisque locis, cum sol oriens vapore
tangat mundum, ex umidis et abundantius excitat
umores et exconglobatos in altitudinem tollit. Ergo
si ita videtur, uti in hypaethris locis ab aere umores
ex corporibus exsugantur molestiores, quemadmodum
ex terra per nebulas videntur, non puto dubium esse,
quin amplissimas et ornatissimas subdiu hypae-
thrisque [6] conlocari oporteat in civitatibus ambula-
7 tiones. Eae autem uti sint semper siccae et non

[1] scabillos *H* : scabillum *Am. Ps.* 98. 5.
[2] inpares *Joc* : inpartes *H*. [3] subtilis *G* : subtiles *H*.
[4] relinquit *G* : -quid *H*. [5] extenuatique *H*.
[6] hypetrisque *H*.

[1] The Romans suffered severely from inflamed eyes. There
were eye-doctors, *ocularii*.

set forth in the fourth book. The addition to the stylobates is to be made by unequal ordinates in accordance with the description which is given above in the third book. The architraves, cornices and other features are to be arranged to suit the columns in accordance with the previous books.

5. The open spaces which are between the colonnades under the open sky, are to be arranged with green plots; because walks in the open are very healthy, first for the eyes,[1] because from the green plantations,[2] the air being subtle and rarefied, flows into the body as it moves, clears the vision, and so by removing the thick humour from the eyes, leaves the glance defined and the image clearly marked. Moreover, since in walking the body is heated by motion, the air extracts the humours from the limbs, and diminishes repletion, by dissipating what the body has, more than it can carry. 6. We can perceive that this is so from the fact that when springs of water are under cover, or there is underground a marshy flow, no moist vapour rises. In places open to the air and sky, when the rising sun touches the world with its warmth, it draws the moisture from moist sites even more abundantly, gathers it together and raises it above. Therefore if it appears that in open places the more troublesome moisture is sucked out from the body, as it is seen to be drawn from the earth through the clouds, I do not think it is doubtful but that in cities extensive and ornate parades should be placed in the open, and exposed to the sun. 7. In order that these walks may be

[2] Gardens depended rather upon shrubs and trees than upon flowers for effect; in this, resembling modern Italian gardens.

lutosae, sic erit faciendum. Fodiantur et exinaniantur quam altissime. Dextra atque sinistra structiles cloacae fiant, inque earum parietibus qui ad ambulationem spectaverint, tubuli instruantur inclinati fastigio. In cloacis his perfectis compleantur ea loca carbonibus, deinde insuper sabulone eae ambulationes sternantur et exaequentur. Ita propter carbonum raritatem naturalem et tubulorum in cloacas instructionem excipientur aquarum abundantiae, et ita siccae et sine umore perfectae fuerint ambulationes.

8 Praeterea in his operibus thensauri sunt civitatibus in necessariis rebus a moribus constituti. In conclusionibus enim reliqui omnes faciliores sunt apparatus quam lignorum. Sal enim facile ante inportatur, frumenta publice privatimque expeditius congeruntur, et si defit, holeribus, carne seu leguminibus defenditur, aquae fossuris puteorum et de caelo repentinis tempestatibus ex tegulis excipiuntur. De lignatione quae maxime necessaria est ad cibum quoquendum,[1] difficilis et molesta est apparatio, quod
9 et tarde conportatur et plus consumitur. In eiusmodi temporibus tunc eae ambulationes aperiuntur et mensurae tributim singulis capitibus designantur. Ita duas res egregias hypaethra[2] ambulationem[3] praestant, unam in pace salubritatis, alteram in bello salutis. Ergo his rationibus ambulationum explicationes non solum post scaenam theatri, sed etiam omnium deorum templis effectae magnas civitatibus praestare poterunt utilitates.

[1] quoquendum *H*. [2] hypaethroe *Ro* : hypetra *H*.
[3] ambulationes *ed* : -nem *H*.

[1] *a moribus H* = ἔθει.

always dry and free from mud, the following measures should be taken. They are to be dug and emptied out as deeply as possible. Drains are to be constructed right and left. In the walls of these, which are on the side of the parade, pipes are to be fixed inclined to the drains. When this is complete, the place is to be filled with charcoal; then above this the walks are to be covered with sand and levelled. Thus by the natural porosity of the charcoal, and by the insertion of the pipes, the overflow of the water will be taken off. Thus the parades will be dry and without moisture.

8. Moreover in these buildings, custom [1] included depots for stores required by the cities. In times of siege,[2] the provision of everything else is more easy than that of wood. Salt is easily brought in beforehand. Corn is quickly gathered by the community and by individuals. If it fails, provision can be made with green vegetables, meat or beans. Water is obtained by the digging of wells; in sudden storms it is received from the sky by the roof tiles. But the provision of fire-wood, which is most necessary for cooking food, is difficult and troublesome. For it takes time to collect and is used in large quantities. 9. In times of siege the walks are thrown open, and wood is distributed to each citizen according to his tribe. Thus walks in the open air serve two outstanding purposes: health in time of peace, and security in war. In this way the laying out of walks, not only behind the stage of the theatre but also for the temples of all the gods, can furnish cities with great advantages.

[2] Vitruvius may have in view the famous siege of Marseilles, 49 B.C.

VITRUVIUS

Quoniam haec nobis satis videntur esse exposita, nunc insequentur balinearum dispositionum demonstrationes.

X

1 PRIMUM eligendus locus est quam calidissimus, id est aversus ab septemtrione et aquilone. Ipsa autem caldaria tepidariaque lumen habeant ab occidente hiberno, si autem natura loci inpedierit, utique a meridie, quod maxime tempus lavandi a meridiano ad vesperum est constitutum. Et item est animadvertendum, uti caldaria [1] muliebria et virilia coniuncta et in isdem regionibus sint conlocata; sic enim efficietur, ut in vasaria et hypocausis communis sit eorum utrisque. Aenea supra hypocausim tria sunt componenda, unum caldarium, alterum tepidarium, tertium frigidarium, et ita conlocanda, uti, ex tepidario in caldarium quantum aquae caldae exierit, influat de frigidario in tepidarium ad eundem modum, testudinesque alveolorum ex communi
2 hypocausi calfaciantur. Suspensurae caldariorum ita sunt faciendae, ut primum sesquipedalibus tegulis solum sternatur inclinatum ad hypocausim, uti pila cum mittatur, non possit intro resistere, sed rursus redeat ad praefurnium ipsa per se; ita flamma facilius pervagabitur sub suspensione. Supraque

[1] calcaria *H.*

[1] Plate H.
[2] Gymnastic exercises were taken immediately before or after the bath.
[3] These rules are followed in the Stabian Baths at Pompeii, Plate H.

Since these topics seem to us to be enough explained, there will now follow a description of the planning of baths.[1]

CHAPTER X

ON BATHS

1. FIRSTLY a site must be chosen as warm as possible, that is, turned away from the north and east. Now the hot and tepid baths are to be lighted from the winter west; but if the nature of the site prevents, at any rate from the south. For the time of bathing [2] is fixed between midday and evening. We must also take care that the hot baths for men and for women are adjacent and planned with the same aspects. For in this way it will follow that the same furnace and heating system will serve for both baths and for their fittings. Three bronze tanks are to be placed above the furnace: one for the hot bath, a second for the tepid bath, a third for the cold bath.[3] They are to be so arranged that the hot water which flows from the tepid bath into the hot bath, may be replaced by a like amount of water flowing down from the cold into the tepid bath. The vaulted chambers which contain the basins, are to be heated from the common furnace. 2. The hanging floors [4] of the hot baths are to be made as follows: first the ground is to be paved with eighteen inch tiles sloping towards the furnace, so that when a ball is thrown in it does not rest within, but comes back to the furnace room of itself. Thus the flame will more easily spread under the floor. On this pavement, piers of

[4] This system of heating is said to have been invented by L. Sergius Orata c. 100 B.C. Plin. N.H. IX. 168.

laterculis besalibus pilae struantur ita dispositae, uti
bipedales tegulae possint supra esse conlocatae;
altitudinem autem pilae habeant pedes duo. Eaeque
struantur argilla cum capillo subacta, supraque con-
locentur tegulae bipedales quae sustineant pavi-
3 mentum. Concamarationes vero si ex structura
factae fuerint, erunt utiliores; sin autem contig-
nationes fuerint, figlinum opus subiciatur. Sed hoc
ita erit faciendum. Regulae [1] ferreae aut arcus
fiant, eaeque uncinis ferreis ad contignationem sus-
pendantur quam creberrimis; eaeque regulae sive
arcus ita disponantur, uti tegulae sine marginibus
sedere in duabus invehique possint, et ita totae con-
camarationes in ferro nitentes sint perfectae.
Earumque camararum superiora coagmenta ex
argilla cum capillo subacta liniantur; inferior [2] autem
pars, quae ad pavimentum spectat, primum testa
cum calce trullizetur,[3] deinde opere albario sive
tectorio poliatur. Eaeque camarae in caldariis si
duplices factae fuerint, meliorem habebunt usum;
non enim a vapore umor corrumpere poterit materiem
contignationis, sed inter duas camaras vagabitur.
4 Magnitudines autem balneorum videntur fieri pro
copia hominum; sint ita conpositae. Quanta longi-
tudo fuerit tertia dempta, latitudo sit, praeter
scholam [4] labri et alvei. Labrum utique sub lumine
faciundum videtur, ne stantes [5] circum suis umbris
obscurent lucem. Scholas autem labrorum ita

[1] regula *H*. [2] inferior *Fav*: interior *H*.
[3] trulizetur *G*: tulizetur *H*. [4] scolam *H*.

eight inch bricks are to be built at such intervals
that two foot tiles can be placed above. The piers
are to be two feet high. They are to be laid in clay
worked up with hair, and upon them two foot tiles
are to be placed to take the pavement. 3. The
vaulted ceilings will be more convenient if they are
made of concrete. But if they are of timber, they
should be tiled underneath, in the following fashion.
Iron bars or arches are to be made and hung on the
timber close together with iron hooks. And these
rods or arches are to be placed so far apart that the
tiles without raised edges may rest upon, and be
carried by them; thus the whole vaulting is finished
resting upon iron. Of these vaulted ceilings the
upper joints are to be stopped with clay and hair
kneaded together. The under side, which looks to
the pavement below, is to be first plastered with
potsherds and lime pounded together, and then
finished with stucco [1] or fine plaster. Such vaulting
over hot baths will be more convenient if it is made
double. For the moisture from the heat cannot
attack the wood of the timbering but will be dis-
persed between the two vaults. 4. Now the size of
the baths is to be proportioned to the number of
persons, and is to be thus arranged. Apart from the
apse containing the bathing tub and the basin in
which it stands, the breadth is to be two thirds of
the length. The bathing tub should be placed
under the light so that the bystanders do not obscure
the light with their shadows. The apses for the

[1] The worker in stucco, *albarius tector*, could not only work
up a smooth surface for fresco painting, *opus tectorium*, but
moulded raised ornaments and figures. Tert. *Idol.* 8.

[5] circumstantes e_2 *Joc.*

fuerit oportet spatiosas, uti, cum priores occupaverint
loca circum, spectantes reliqui recte stare possint.
Alvei autem latitudo inter parietem et pluteum ne
minus sit pedes senos, ut gradus inferior inde auferat
5 et pulvinus duos pedes. Laconicum sudationesque
sunt coniungendae tepidario; eaeque quam latae
fuerint, tantam altitudinem habeant ad imam curva-
turam hemisphaerii.[1] Mediumque lumen in hemi-
sphaerio[2] relinquatur, ex eoque clypeom aeneum
catenis pendeat, per cuius reductiones et dimissiones
perficietur sudationis temperatura. Ipsumque ad
circinum fieri oportere videtur, ut aequaliter a medio
flammae vaporisque vis per curvaturae rutundationes
pervagetur.

XI

1 Nunc mihi videtur, tametsi[3] non sint italicae consue-
tudinis palaestrarum aedificationes,[4] traditae tamen,
explicare et quemadmodum apud Graecos consti-
tuantur, monstrare.[5] In palaestris peristylia quad-
rata sive oblonga ita sint facienda, uti duorum
stadiorum habeant ambulationis circuitionem, quod
Graeci vocant *diaulon,*[6] ex quibus tres porticus sim-
plices disponantur, quarta quae ad meridianas
regiones est conversa, duplex, uti, cum tempestates

[1] hemisperii *H.* [2] hemisperio *H.*
[3] tametsi *ed* : iam etsi *H.*
[4] aedificationes *G* : -nis *H S.*
[5] constituantur . . . disputare possint *ex hoc loco inseruit
Galiani infra post* pervenire.
[6] diaulam *H.*

[1] *fuerit* subj. dependent on *oportet,* which governs *scholas.*
[2] Yet there is a palaestra in the Stabian baths at Pompeii.
Strictly, however, the palaestra (wrestling school) is part of
the gymnasium, which latter is here described.

bathing tubs should be [1] spacious so that when the
first comers have taken their places, the others
watching their turn may stand conveniently. Now
the width of the basin between the wall and the
parapet, should be not less than six feet, from which
the lower step and the " cushion," are to take two
feet. 5. The domed sweating chamber should
adjoin the tepid bath. The height to the springing
of the dome should be equal to the width. In the
middle of the dome a light is to be left. From this
a bronze tray is hung with chains; by the raising and
lowering of the tray from the opening, the sweating
is adjusted. The tray should be circular, so that the
force of the flame and the heat may be diffused
equally from the centre over the rounded curve.

CHAPTER XI

ON THE PALAESTRA

1. ALTHOUGH the building of the palaestra is not
a usual thing in Italy,[2] the method of construction
has been handed down. It seems good therefore to
explain it and show how the palaestra is planned
among the Greeks. Square or oblong cloisters [3] are
to be made [4] with a walk round them of two furlongs
(this walk the Greeks call *diaulos*). Three of the
sides are to be single colonnades; the fourth which
has a south aspect is to be double, so that when rain

[3] Or peristyles. Herod's Temple at Jerusalem was sur-
rounded by a double colonnade of white marble columns
except on the south which was quadruple and two stories high.
The eastern colonnade was called Solomon's Porch.
[4] *sint facienda*, a duplicated jussive.

ventosae sint, non possit aspergo in interiorem partem
2 pervenire. Constituantur autem in tribus porticibus
exhedrae [1] spatiosae, habentes sedes, in quibus
philosophi, rhetores reliquique, qui studiis delec-
tantur, sedentes disputare possint. In duplici autem
porticu conlocentur haec membra: ephebeum in
medio (hoc autem est exhedra amplissima cum
sedibus) tertia parte longior sit quam lata; sub
dextro coryceum, deinde proxime conisterium, a
conisterio in versura porticus frigida lavatio, quam
Graeci *loutron* [2] vocitant; ad sinistram ephebei
elaeothesium, proxime autem elaeothesium frigi-
darium, ab eoque iter in propnigeum in versura
porticus. Proxime autem introrsus e regione frigi-
darii conlocetur concamerata sudatio longitudine
duplex quam latitudo, quae habeat in versuris ex
una parte laconicum ad eundem modum, uti quam
supra scriptum est, compositum, ex adverso laconici
caldam lavationem. In palaestra peristylia,[3] quem-
admodum supra scriptum est, ita debent esse
3 perfecta distributa. Extra autem disponantur por-
ticus tres, una ex peristylo exeuntibus, duae dextra
atque sinistra stadiatae, ex quibus una quae spec-
taverit ad septentrionem, perficiatur duplex amplis-
sima latitudine, altera simplex, ita facta, uti in par-
tibus, quae fuerint circa parietes et quae erit ad
columnas, margines habeant uti semitas non minus
pedum denum mediumque excavatum, uti gradus
sint in descensu marginibus sesquipedem ad plani-
tiem, quae planities sit non minus pedes XII; ita

[1] exedrae *H*. [2] lytron *H*.
[3] perstylia *H*.

[1] Perfecta distributa *H*.

is accompanied by gales, the drops may not reach the inside. 2. On the other three sides, spacious *exhedrae* (apsidal recesses) are to be planned with seats where philosophers, teachers of rhetoric and other studious persons can sit and discuss. In the double colonnade, however, these provisions are to be made. In the centre there is to be the *ephebeum* (a large apsidal recess with seats for young men) a third longer than it is wide; on the right the *coryceum* (for exercise with the quintain); next to this the *conisterium* (for athletes to powder themselves); adjoining the conisterium at the angle of the colonnade the cold bath which the Greeks call *loutron*; at the left of the ephebeum, the *elaeothesium* (for athletes to oil themselves); next to this is the cold room from which the furnace-room is entered at the angle of the colonnade. Adjoining this on the inside in line with the cold room, a vaulted sweating-room is to be placed, twice as long as it is broad, having in the angle of the colonnade the *Laconicum* (domed sweating room) constructed as before described (c. x 5), and opposite this a warm bath. In the palaestra, the cloisters ought to be thus completed and arranged.[1] 3. Outside the palaestra three colonnades are to be arranged; the first, as you go out of the peristyle; right and left of this, two colonnades with running tracks. Of these three the one which has a north aspect, is to be built double and very wide; the others are to be single. On the sides which adjoin the walls and those which adjoin the columns, they are to have borders ten feet wide to serve as paths. The middle part is to be excavated with steps down from the paths to the level track a foot and a half below, and the track is to be not less than 12 feet

qui vestiti ambulaverint circum in marginibus, non
4 inpedientur ab unctis[1] se exercentibus. Haec autem
porticus *xystos* apud Graecos vocitatur, quod athletae
per hiberna tempora in tectis stadiis[2] exercentur.[3]
Proxime autem xystum et duplicem porticum
designentur hypaethroe[4] ambulationes, quas Graeci
paradromidas, nostri xysta appellant, in quas per
hiemem ex xysto sereno caelo athletae prodeuntes
exercentur. Faciunda[5] autem xysta sic videntur,
ut sint inter duas porticus silvae aut platanones,[6] et
in his perficiantur inter arbores ambulationes ibique
ex opere signino stationes. Post xystum autem
stadium ita figuratum, ut possint hominum copiae
cum laxamento athletas[7] certantes spectare. Quae
in moenibus necessaria videbantur esse, ut apte dis-
ponantur, perscripsi.

XII

1 De opportunitate autem portuum non est praeter-
mittendum sed, quibus rationibus tueantur naves in his
ab tempestatibus, explicandum. Hi autem natural-
iter si sint bene positi habeantque acroteria sive pro-
munturia procurrentia, ex quibus introrsus curvaturae

[1] unctis *Salmasius*: cunctis *H*.
[2] stadiis *H* : studiis *Hᵉ G*.
[3] *hinc postposuit Schn.* faciunda autem . . . stationes
post . . . prodeuntes exercentur.
[4] hypaethroe *Ro*: hypetro eae *H G*.
[5] faciunda . . . stationes *huc transposuit Galiani.*
[6] platanones et *Joc*: platanon esset *H*.
[7] athl&an *H*.

wide. Thus persons who walk about on the paths in their clothes will not be disturbed by the athletes who use oil. 4. Such a colonnade is called *xystos* by the Greeks, whose athletes take exercise in the winter on covered tracks. Next to the covered track and the double colonnade walks in the open are to be planned (which the Greeks call *paradromides* and our people xysta). When it is fine weather in winter, the athletes come into the open and take exercise here. The xysta ought to be so laid out that there are plantations or groves of plane trees between the two colonnades. Here walks are to be made among the trees with spaces paved with cement.[1] Behind the xystum, the *stadium* (sports ground) should be so planned that large crowds can comfortably see the competitors. I have now enumerated the buildings required within the city walls and their suitable disposition.

CHAPTER XII

ON HARBOURS AND SHIPYARDS

1. IT remains to deal with the suitable arrangement of harbours,[2] and to explain by what means, in these, ships are protected from stormy weather. There are great advantages if they are well placed by nature and have headlands (acroteria) jutting out, behind which bays or creeks are formed owing to the nature of the place. For round these colonnades

[1] *Opus signinum* composed of lime, sand and pounded pottery, which set as hard as stone.

[2] Timoxenus wrote on harbours, Aesch. *Persae* 306 *schol.*

sive versurae ex loci natura fuerint conformatae, maximas utilitates videntur habere. Circum enim porticus sive navalia[1] sunt facienda sive ex porticibus aditus ⟨ad⟩[2] emporia, turresque ex utraque parte conlocandae, ex quibus catenae traduci per machinas possint.

2 Sin autem non naturalem locum neque idoneum ad tuendas ab tempestatibus naves habuerimus, ita videtur esse faciendum, uti, si nullum flumen in his locis inpedierit sed erit ex una parte statio, tunc ex altera parte structuris sive aggeribus expediantur progressus, et ita conformandae portuum conclusiones. Eae[3] autem structurae, quae in aqua sunt futurae, videntur sic esse faciendae, uti portetur pulvis a regionibus, quae sunt a Cumis continuatae ad promunturium Minervae, isque misceatur, uti in

3 mortario duo ad unum respondeant. Deinde tunc in eo loco, qui definitus erit, arcae stipitibus robusteis et catenis inclusae in aquam demittendae destinandaeque firmiter; deinde inter ea ex trastilis inferior pars sub aqua exaequanda et purganda, et caementis ex mortario materia mixta, quemadmodum supra scriptum est, ibi congerendum, donique[4] conpleatur structurae spatium, quod fuerit inter arcas. Hoc autem munus naturale habent ea loca, quae supra scripta sunt.

Sin autem propter fluctus aut impetus aperti pelagi destinae arcas non potuerint continere, tunc ab ipsa terra sive crepidine pulvinus quam firmissime struatur, isque pulvinus exaequata struatur planitia

[1] sive navalia *rec* : sivenalia *H.* [2] *add. Joc.*
[3] eae *H* : hae *G.* [4] denique *H* : compleantur *H.*

[1] Used at Cyzicus A.D. 365. Amm. XXVI. viii. 8.

either docks are to be made, or approaches from the colonnades to the warehouses. On either side towers are to be built from which chains [1] (across the harbour) can be drawn by machinery.

2. But if we have no natural harbour suitable for protecting ships from a stormy sea, we must proceed as follows. If there is an anchorage on one side without any river mouth to interfere, piers are to be constructed on the other side by masonry or embankments in order to form an enclosed harbour. The masonry which is to be in the sea must be constructed in this way. Earth [2] is to be brought from the district which runs from Cumae to the promontory of Minerva,[3] and mixed, in the mortar, two parts to one of lime. 3. Then in the place marked out, cofferdams,[4] formed of oak piles and tied together with chains, are to be let down into the water and firmly fixed. Next, the lower part between them under the water is to be levelled and cleared with a platform of small beams laid across and the work is to be carried up with stones and mortar as above described, until the space for the structure between the dams is filled. Such is the natural advantage of the places described above.

But if on account of the breakers or the violence of the open sea, the supports cannot uphold the dams, then a platform is to be laid, as firmly as possible, starting from the edge of the shore or from a breakwater. This platform is to be laid with a level top

[2] Pozzuolana is a brown volcanic ash which, mixed with lime, sets under water. A similar ash is also found near Rome.

[3] Sorrento.

[4] " The concrete was to be lowered into the sea in *caissons* to form the foundation of the piers." The mole at Puteoli was an example. Stuart Jones *Companion* 156.

minus quam dimidiae partis, reliquum quod est
4 proxime litus, proclinatum latus habeat. Deinde ad
ipsam aquam et latera pulvino circiter sesquipedales
margines struantur aequilibres ex planitia, quae est
supra scripta; tunc proclinatio ea impleatur harena
et exaequetur cum margine et planitia pulvini.
Deinde insuper eam exaequationem pila quam magna
constituta fuerit, ibi struatur; eaque, cum erit
extructa, relinquatur ne minus duos mensis, ut
siccescat. Tunc autem succidatur margo quae
sustinet harenam; ita harena fluctibus subruta
efficiet in mare pilae praecipitationem. Hac ratione,
quotienscumque opus fuerit, in aquam poterit esse
progressus.
5 In quibus autem locis pulvis non nascitur, his
rationibus erit faciendum, uti arcae duplices relatis
tabulis et catenis conligatae in eo loco, qui finitus
erit, constituantur, et inter destinas creta in eronibus¹
ex ulva palustri factis calcetur. Cum ita bene calca-
tum et quam densissime fuerit, tunc cocleis rotis
tympanis conlocatis locus qui ea septione finitus
fuerit, exinaniatur sicceturque, et ibi inter septiones
fundamenta fodiantur. Si terrena erunt, usque ad
solidum, crassiora quam qui murus supra futurus
erit, exinaniatur sicceturque et tunc structura ex
6 caementis calce et harena compleatur. Sin autem
mollis locus erit, palis ustilatis alneis aut oleagineis
configantur et carbonibus compleantur, quemad-
modum in theatrorum et muri fundationibus est
scriptum.² Deinde tunc quadrato saxo murus ducatur
iuncturis quam longissimis, uti maxime medii lapides

¹ *Eronibus harenae plenis* Plin. *N.H.* XXXVI. 96.
² Book X. v and vi.

(towards the sea) less than half its width; towards the shore, it is to have a sloping side. 4. Then towards the water and on the side of the platform construct margins projecting about one and a half feet level with the top mentioned above. Then the overhanging part is to be filled up underneath with sand and made level with the margin and the surface of the platform. Next, a pillar of the size appointed is to be built upon the levelled surface, and when it is finished, it is to be left to set for two months. The margin which keeps up the sand is to be cut away: thus the sand is washed away by the waves and causes the pillar to fall into the sea. In this way, as often as it is necessary, the pier is carried further into the water.

5. Where, however, the earth in question is not found, we must proceed as follows. Double coffer-dams bound together with planks and chains are to be put in the place marked out. Between the supports, clay in hampers[1] made of rushes is to be pressed down. When it is well pressed down and as closely as possible, the place marked out by the enclosure is to be emptied with waterscrews and waterwheels[2] with drums, and so dried. Here the foundations are to be dug. If the foundations are on the sea bottom, they are to be emptied and drained to a greater width than the wall to be built upon them, and then the work is to be filled in with concrete of stone lime and sand. 6. But if the bottom is soft the foundations are to be charred piles of alder and olive filled in with charcoal, as prescribed for the foundations of theatres and the city walls. The wall is then raised of squared stone with joints as long as possible, so that the middle stones may be

coagmentis contineantur. Tunc, qui locus erit inter murum, ruderatione sive structura compleatur. Ita erit uti possit turris insuper aedificari.

7 His perfectis navaliorum ea erit ratio, ut constituantur spectantia maxime ad septentrionem; nam meridianae regiones propter aestus cariem, tineam, teredines reliquaque bestiarum nocentium genera procreant alendoque conservant. Eaque aedificia minime sunt materianda[1] propter incendia. De magnitudinibus autem finitio nulla debet esse, sed faciunda ad maximum navium modum, uti, etsi maiores naves subductae fuerint, habeant cum laxamento ibi conlocationem.

Quae necessaria ad utilitatem in civitatibus publicorum locorum succurrere mihi potuerunt,[2] quemadmodum constituantur et perficiantur, in hoc volumine scripsi; privatorum autem aedificiorum utilitates et eorum symmetrias insequenti volumine ratiocinabor.

[1] materienda H. [2] potuerunt G : poterunt H.

well tied together by the jointing. The inside of the wall is then to be filled in with rubble or masonry. Thus it may be possible for a tower to be built upon it.

7. Subsequently the shipyards are to be built and with a northern aspect, as a rule. For southern aspects because of their warmth generate dry rot, wood worms and ship worms with other noxious creatures, and feed and maintain them. Further, such buildings should have very little wood in them because of fire. As to their dimensions no rule should be laid down. They are to be made to take the largest vessels; so that even if such vessels are drawn ashore, they may have a roomy berth.

In this book I have described how the works required for public purpose in cities are to be planned and carried out. The next book[1] will consider the requirements of private buildings and their due proportions.

[1] Vitruvius probably published his work at intervals; hence these cross-references throughout. Additions to the main body of the work seem to have been made on the publication of the several books: Book V. i. 8, 9 is an instance.

VITRUVIUS

BOOKS I—V

INDEX OF ARCHITECTURAL TERMS

NOTE.—This index is limited to terms used or implied by Vitruvius. He wrote in the vernacular as distinguished from the literary idiom, and with a view to practice. Comparison with inscriptions both Greek and Latin shows that there was a traditional technical language used by builders, and it is fairly represented by the Latin text of *H.* Latin terms are in italics. Where they correspond closely to the corresponding English terms, they are sometimes left untranslated.

319

INDEX OF ARCHITECTURAL TERMS

320

INDEX OF ARCHITECTURAL TERMS

321

INDEX OF ARCHITECTURAL TERMS

DIAL OF WINDS [Book I. vi. 12. **H.**

The dotted lines A–B and A–C mark the shadows as taken before and after the midday shadow A–F. D is the intersection of circles struck from B and C in order to give the meridian shadow, and D–E gives the meridian line.

(VITRUVIUS) PLAN OF TOWN [Book I. vi.

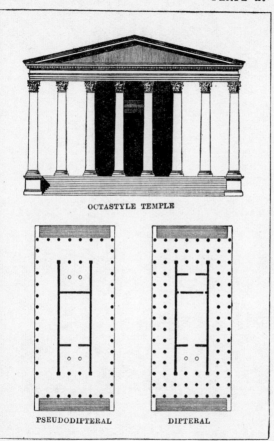

OCTASTYLE TEMPLE

PSEUDODIPTERAL DIPTERAL

Book III. ii. 6.

PLATE C.

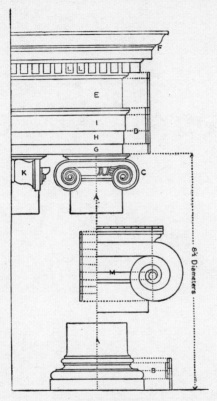

IONIC ORDER

Book III. v.

A. Shaft.
B. Base.
C. Capital.
D. Architrave.
E. Frieze.
F. Cornice.

G. Fascia.
H. „
I. „
K. Volute.
L. Dentils.
M. Volute to a larger scale.

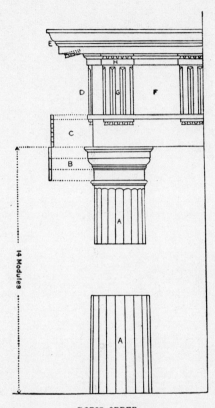

DORIC ORDER

Book IV. iii.

A. Shaft.
B. Capital.
C. Architrave.
D. Frieze.

E. Cornice.
F. Metope.
G. Triglyph.
H. Capital of Triglyph.

PLATE X

NOTES OF SCALES.

Book V. iv. 5.

Proslambanomenos.

HYPATON.

Hypate. ⎫
Parhypate. ⎬
Lichanos. ⎭

 MESON.

Hypate. ⎫

Parhypate. ⎬

Lichanos. ⎭

Mese.

SYNHEMMENON.
Trite. ⎫

Paranete. ⎬

Nete. ⎭

Paramese.

DIEZEUGMENON.
Trite. ⎫

Paranete. ⎬

Nete. ⎭

HYPERBOLAEON.
Trite. ⎫

Paranete. ⎬

Nete. ⎭

Fixed Notes: Breves.
Movable Notes: Crotchets.

TUNING OF TOP
ROW OF VASES.

Book V. v. 2.

Hyperbolaeon.

Diezeugmenon.

Synhemmenon.

Meson.

Hypaton.

Proslambanomenos.

Mese.

Proslambanomenos.

Hypaton.

Meson.

Synhemmenon.

Diezeugmenon.

Hyperbolaeon.

The above notes have
tails to the right.

HARMONICS

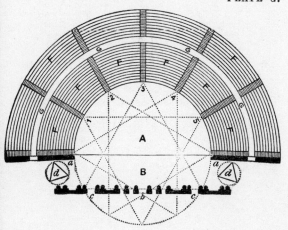

ROMAN THEATRE ACCORDING TO VITRUVIUS

Book V. vi.

A. Orchestra. B. Stage. *a-a.* Front of stage. *b.* Royal door. *c.* Side doors. *d.* Revolving scenes. 1-5. Staircases. F. Blocks of seats. G. Level gangway.

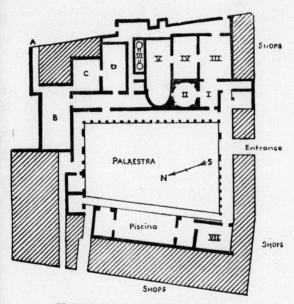

PLAN OF THE STABIAN BATHS, POMPEII

Book V. x and xi.

MEN'S BATHS.	WOMEN'S BATHS.
I. Ante-room.	A. Entrance.
II. Frigidarium.	B. Apodyterium.
III. Apodyterium.	C. Tepidarium.
IV. Tepidarium.	D. Caldarium.
V. Caldarium.	
VI. Furnace.	
VII. Apodyterium.	

PRINTED IN GREAT BRITAIN BY
RICHARD CLAY AND COMPANY, LTD.,
BUNGAY, SUFFOLK.

THE LOEB CLASSICAL LIBRARY

VOLUMES ALREADY PUBLISHED

Latin Authors

AMMIANUS MARCELLINUS. Translated by J. C. Rolfe. 3 Vols.

APULEIUS: THE GOLDEN ASS (METAMORPHOSES). W. Adling-ton (1566). Revised by S. Gaselee.

ST. AUGUSTINE: CITY OF GOD. 7 Vols. Vol. I. G. H. McCracken. Vol. VI. W. C. Greene.

ST. AUGUSTINE, CONFESSIONS OF. W. Watts (1631). 2 Vols.

ST. AUGUSTINE, SELECT LETTERS. J. H. Baxter.

AUSONIUS. H. G. Evelyn White. 2 Vols.

BEDE. J. E. King. 2 Vols.

BOETHIUS: TRACTS and DE CONSOLATIONE PHILOSOPHIAE. Rev. H. F. Stewart and E. K. Rand.

CAESAR: ALEXANDRIAN, AFRICAN and SPANISH WARS. A. G. Way.

CAESAR: CIVIL WARS. A. G. Peskett.

CAESAR: GALLIC WAR. H. J. Edwards.

CATO: DE RE RUSTICA; VARRO: DE RE RUSTICA. H. B. Ash and W. D. Hooper.

CATULLUS. F. W. Cornish; TIBULLUS. J. B. Postgate; PER-VIGILIUM VENERIS. J. W. Mackail.

CELSUS: DE MEDICINA. W. G. Spencer. 3 Vols.

CICERO: BRUTUS, and ORATOR. G. L. Hendrickson and H. M. Hubbell.

[CICERO]: AD HERENNIUM. H. Caplan.

CICERO: DE ORATORE, etc. 2 Vols. Vol. I. DE ORATORE, Books I. and II. E. W. Sutton and H. Rackham. Vol. II. DE ORATORE, Book III. De Fato; Paradoxa Stoicorum; De Partitione Oratoria. H. Rackham.

CICERO: DE FINIBUS. H. Rackham.

CICERO: DE INVENTIONE, etc. H. M. Hubbell.

CICERO: DE NATURA DEORUM and ACADEMICA. H. Rackham.

CICERO: DE OFFICIIS. Walter Miller.

CICERO: DE REPUBLICA and DE LEGIBUS; SOMNIUM SCIPIONIS. Clinton W. Keyes.

CICERO: DE SENECTUTE, DE AMICITIA, DE DIVINATIONE. W. A. Falconer.

CICERO: IN CATILINAM, PRO FLACCO, PRO MURENA, PRO SULLA. Louis E. Lord.

CICERO: LETTERS to ATTICUS. E. O. Winstedt. 3 Vols.

CICERO: LETTERS TO HIS FRIENDS. W. Glynn Williams. 3 Vols.

CICERO: PHILIPPICS. W. C. A. Ker.

CICERO: PRO ARCHIA POST REDITUM, DE DOMO, DE HARUSPICUM RESPONSIS, PRO PLANCIO. N. H. Watts.

CICERO: PRO CAECINA, PRO LEGE MANILIA, PRO CLUENTIO, PRO RABIRIO. H. Grose Hodge.

CICERO: PRO CAELIO, DE PROVINCIIS CONSULARIBUS, PRO BALBO. R. Gardner.

CICERO: PRO MILONE, IN PISONEM, PRO SCAURO, PRO FONTEIO, PRO RABIRIO POSTUMO, PRO MARCELLO, PRO LIGARIO, PRO REGE DEIOTARO. N. H. Watts.

CICERO: PRO QUINCTIO, PRO ROSCIO AMERINO, PRO ROSCIO COMOEDO, CONTRA RULLUM. J. H. Freese.

CICERO: PRO SESTIO, IN VATINIUM. R. Gardner.

CICERO: TUSCULAN DISPUTATIONS. J. E. King.

CICERO: VERRINE ORATIONS. L. H. G. Greenwood. 2 Vols.

CLAUDIAN. M. Platnauer. 2 Vols.

COLUMELLA: DE RE RUSTICA. DE ARBORIBUS. H. B. Ash, E. S. Forster and E. Heffner. 3 Vols.

CURTIUS, Q.: HISTORY OF ALEXANDER. J. C. Rolfe. 2 Vols.

FLORUS. E. S. Forster; and CORNELIUS NEPOS. J. C. Rolfe.

FRONTINUS: STRATAGEMS and AQUEDUCTS. C. E. Bennett and M. B. McElwain.

FRONTO: CORRESPONDENCE. C. R. Haines. 2 Vols

GELLIUS, J. C. Rolfe. 3 Vols.

HORACE: ODES AND EPODES. C. E. Bennett.

HORACE: SATIRES, EPISTLES, ARS POETICA. H. R. Fairclough.

JEROME: SELECTED LETTERS. F. A. Wright.

JUVENAL and PERSIUS. G. G. Ramsay.

LIVY. B. O. Foster, F. G. Moore, Evan T. Sage, and A. C. Schlesinger and R. M. Geer (General Index). 14 Vols.

LUCAN. J. D. Duff.

LUCRETIUS. W. H. D. Rouse.

MARTIAL. W. C. A. Ker. 2 Vols.

MINOR LATIN POETS: from PUBLILIUS SYRUS to RUTILIUS NAMATIANUS, including GRATTIUS, CALPURNIUS SICULUS, NEMESIANUS, AVIANUS, and others with "Aetna" and the "Phoenix." J. Wight Duff and Arnold M. Duff.

OVID: THE ART OF LOVE and OTHER POEMS. J. H. Mozley.

Ovid: Fasti. Sir James G. Frazer.

Ovid: Heroides and Amores. Grant Showerman.

Ovid: Metamorphoses. F. J. Miller. 2 Vols.

Ovid: Tristia and Ex Ponto. A. L. Wheeler.

Persius. Cf. Juvenal.

Petronius. M. Heseltine; Seneca; Apocolocyntosis. W. H. D. Rouse.

Plautus. Paul Nixon. 5 Vols.

Pliny: Letters. Melmoth's Translation revised by W. M. L. Hutchinson. 2 Vols.

Pliny: Natural History. H. Rackham and W. H. S. Jones. 10 Vols. Vols. I.–V. and IX. H. Rackham. Vols. VI. and VII. W. H. S. Jones.

Propertius. H. E. Butler.

Prudentius. H. J. Thomson. 2 Vols.

Quintilian. H. E. Butler. 4 Vols.

Remains of Old Latin. E. H. Warmington. 4 Vols. Vol. I. (Ennius and Caecilius.) Vol. II. (Livius, Naevius, Pacuvius, Accius.) Vol. III. (Lucilius and Laws of XII Tables.) (Archaic Inscriptions.)

Sallust. J. C. Rolfe.

Scriptores Historiae Augustae. D. Magie. 3 Vols.

Seneca: Apocolocyntosis. Cf. Petronius.

Seneca: Epistulae Morales. R. M. Gummere. 3 Vols.

Seneca: Moral Essays. J. W. Basore. 3 Vols.

Seneca: Tragedies. F. J. Miller. 2 Vols.

Sidonius: Poems and Letters. W. B. Anderson. 2 Vols.

Silius Italicus. J. D. Duff. 2 Vols.

Statius. J. H. Mozley. 2 Vols.

Suetonius. J. C. Rolfe. 2 Vols.

Tacitus: Dialogues. Sir Wm. Peterson. Agricola and Germania. Maurice Hutton.

Tacitus: Histories and Annals. C. H. Moore and J. Jackson. 4 Vols.

Terence. John Sargeaunt. 2 Vols.

Tertullian: Apologia and De Spectaculis. T. R. Glover. Minucius Felix. G. H. Rendall.

Valerius Flaccus. J. H. Mozley.

Varro: De Lingua Latina. R. G. Kent. 2 Vols.

Velleius Paterculus and Res Gestae Divi Augusti. F. W. Shipley.

Virgil. H. R. Fairclough. 2 Vols.

Vitruvius: De Architectura. F. Granger. 2 Vols.

Greek Authors

Achilles Tatius. S. Gaselee.

Aelian: On the Nature of Animals. A. F. Scholfield. 3 Vols.

Aeneas Tacticus, Asclepiodotus and Onasander. The Illinois Greek Club.

Aeschines. C. D. Adams.

Aeschylus. H. Weir Smyth. 2 Vols.

Alciphron, Aelian, Philostratus: Letters. A. R. Benner and F. H. Fobes.

Andocides, Antiphon, Cf. Minor Attic Orators.

Apollodorus. Sir James G. Frazer. 2 Vols.

Apollonius Rhodius. R. C. Seaton.

The Apostolic Fathers. Kirsopp Lake. 2 Vols.

Appian: Roman History. Horace White. 4 Vols.

Aratus. Cf. Callimachus.

Aristophanes. Benjamin Bickley Rogers. 3 Vols. Verse trans.

Aristotle: Art of Rhetoric. J. H. Freese.

Aristotle: Athenian Constitution, Eudemian Ethics, Vices and Virtues. H. Rackham.

Aristotle: Generation of Animals. A. L. Peck.

Aristotle: Metaphysics. H. Tredennick. 2 Vols.

Aristotle: Meterologica. H. D. P. Lee.

Aristotle: Minor Works. W. S. Hett. On Colours, On Things Heard, On Physiognomies, On Plants, On Marvellous Things Heard, Mechanical Problems, On Indivisible Lines, On Situations and Names of Winds, On Melissus, Xenophanes, and Gorgias.

Aristotle: Nicomachean Ethics. H. Rackham.

Aristotle: Oeconomica and Magna Moralia. G. C. Armstrong; (with Metaphysics, Vol. II.).

Aristotle: On the Heavens. W. K. C. Guthrie.

Aristotle: On the Soul. Parva Naturalia. On Breath. W. S. Hett.

Aristotle: Categories, On Interpretation, Prior Analytics. H. P. Cooke and H. Tredennick.

Aristotle: Posterior Analytics, Topics. H. Tredennick and E. S. Forster.

Aristotle: On Sophistical Refutations.
On Coming to be and Passing Away, On the Cosmos. E. S. Forster and D. J. Furley.

Aristotle: Parts of Animals. A. L. Peck; Motion and Progression of Animals. E. S. Forster.

ARISTOTLE: PHYSICS. Rev. P. Wicksteed and F. M. Cornford. 2 Vols.

ARISTOTLE: POETICS and LONGINUS. W. Hamilton Fyfe; DEMETRIUS ON STYLE. W. Rhys Roberts.

ARISTOTLE: POLITICS. H. Rackham.

ARISTOTLE: PROBLEMS. W. S. Hett. 2 Vols.

ARISTOTLE: RHETORICA AD ALEXANDRUM (with PROBLEMS. Vol. II.) H. Rackham.

ARRIAN: HISTORY OF ALEXANDER and INDICA. Rev. E. Iliffe Robson. 2 Vols.

ATHENAEUS: DEIPNOSOPHISTAE. C. B. GULICK. 7 Vols.

ST. BASIL: LETTERS. R. J. Deferrari. 4 Vols.

CALLIMACHUS: FRAGMENTS. C. A. Trypanis.

CALLIMACHUS, Hymns and Epigrams, and LYCOPHRON. A. W. Mair; ARATUS. G. R. MAIR.

CLEMENT of ALEXANDRIA. Rev. G. W. Butterworth.

COLLUTHUS. Cf. OPPIAN.

DAPHNIS AND CHLOE. Thornley's Translation revised by J. M. Edmonds; and PARTHENIUS. S. Gaselee.

DEMOSTHENES I.: OLYNTHIACS, PHILIPPICS and MINOR ORATIONS. I.–XVII. and XX. J. H. Vince.

DEMOSTHENES II.: DE CORONA and DE FALSA LEGATIONE. C. A. Vince and J. H. Vince.

DEMOSTHENES III.: MEIDIAS, ANDROTION, ARISTOCRATES, TIMOCRATES and ARISTOGEITON, I. AND II. J. H. Vince.

DEMOSTHENES IV.–VI.: PRIVATE ORATIONS and IN NEAERAM. A. T. Murray.

DEMOSTHENES VII.: FUNERAL SPEECH, EROTIC ESSAY, EXORDIA and LETTERS. N. W. and N. J. DeWitt.

DIO CASSIUS: ROMAN HISTORY. E. Cary. 9 Vols.

DIO CHRYSOSTOM. J. W. Cohoon and H. Lamar Crosby. 5 Vols.

DIODORUS SICULUS. 12 Vols. Vols. I.–VI. C. H. Oldfather. Vol. VII. C. L. Sherman. Vols. IX. and X. R. M. Geer. Vol. XI. F. Walton.

DIOGENES LAERTIUS. R. D. Hicks. 2 Vols.

DIONYSIUS OF HALICARNASSUS: ROMAN ANTIQUITIES. Spelman's translation revised by E. Cary. 7 Vols.

EPICTETUS. W. A. Oldfather. 2 Vols.

EURIPIDES. A. S. Way. 4 Vols. Verse trans.

EUSEBIUS: ECCLESIASTICAL HISTORY. Kirsopp Lake and J. E. L. Oulton. 2 Vols.

GALEN: ON THE NATURAL FACULTIES. A. J. Brock.

THE GREEK ANTHOLOGY. W. R. Paton. 5 Vols.

GREEK ELEGY AND IAMBUS with the ANACREONTEA. J. M. Edmonds. 2 Vols.

THE GREEK BUCOLIC POETS (THEOCRITUS, BION, MOSCHUS). J. M. Edmonds.

GREEK MATHEMATICAL WORKS. Ivor Thomas. 2 Vols.

HERODES. Cf. THEOPHRASTUS: CHARACTERS.

HERODOTUS. A. D. Godley. 4 Vols.

HESIOD AND THE HOMERIC HYMNS. H. G. Evelyn White.

HIPPOCRATES and the FRAGMENTS OF HERACLEITUS. W. H. S. Jones and E. T. Withington. 4 Vols.

HOMER: ILIAD. A. T. Murray. 2 Vols.

HOMER: ODYSSEY. A. T. Murray. 2 Vols.

ISAEUS. E. W. Forster.

ISOCRATES. George Norlin and LaRue Van Hook. 3 Vols.

ST. JOHN DAMASCENE: BARLAAM AND IOASAPH. Rev. G. R. Woodward and Harold Mattingly.

JOSEPHUS. H. St. J. Thackeray and Ralph Marcus. 9 Vols. Vols. I.–VII.

JULIAN. Wilmer Cave Wright. 3 Vols.

LUCIAN. 8 Vols. Vols. I.–V. A. M. Harmon. Vol. VI. K. Kilburn.

LYCOPHRON. Cf. CALLIMACHUS.

LYRA GRAECA. J. M. Edmonds. 3 Vols.

LYSIAS. W. R. M. Lamb.

MANETHO. W. G. Waddell: PTOLEMY: TETRABIBLOS. F. E. Robbins.

MARCUS AURELIUS. C. R. Haines.

MENANDER. F. G. Allinson.

MINOR ATTIC ORATORS (ANTIPHON, ANDOCIDES, LYCURGUS, DEMADES, DINARCHUS, HYPEREIDES). K. J. Maidment and J. O. Burtt. 2 Vols.

NONNOS: DIONYSIACA. W. H. D. Rouse. 3 Vols.

OPPIAN, COLLUTHUS, TRYPHIODORUS. A. W. Mair.

PAPYRI. NON-LITERARY SELECTIONS. A. S. Hunt and C. C. Edgar. 2 Vols. LITERARY SELECTIONS (Poetry). D. L. Page.

PARTHENIUS. Cf. DAPHNIS and CHLOE.

PAUSANIAS: DESCRIPTION OF GREECE. W. H. S. Jones. 4 Vols. and Companion Vol. arranged by R. E. Wycherley.

PHILO. 10 Vols. Vols. I.–V.; F. H. Colson and Rev. G. H. Whitaker. Vols. VI.–IX.; F. H. Colson.

PHILO: two supplementary Vols. (*Translation only.*) Ralph Marcus.

PHILOSTRATUS: THE LIFE OF APOLLONIUS OF TYANA. F. C. Conybeare. 2 Vols.

PHILOSTRATUS: IMAGINES; CALLISTRATUS: DESCRIPTIONS. A. Fairbanks.

PHILOSTRATUS and EUNAPIUS: LIVES OF THE SOPHISTS. Wilmer Cave Wright.

PINDAR. Sir J. E. Sandys.

PLATO: CHARMIDES, ALCIBIADES, HIPPARCHUS, THE LOVERS, THEAGES, MINOS and EPINOMIS. W. R. M. Lamb.

PLATO: CRATYLUS, PARMENIDES, GREATER HIPPIAS, LESSER HIPPIAS. H. N. Fowler.

PLATO: EUTHYPHRO, APOLOGY, CRITO, PHAEDO, PHAEDRUS. H. N. Fowler.

PLATO: LACHES, PROTAGORAS, MENO, EUTHYDEMUS. W. R. M. Lamb.

PLATO: LAWS. Rev. R. G. Bury. 2 Vols.

PLATO: LYSIS, SYMPOSIUM, GORGIAS. W. R. M. Lamb.

PLATO: REPUBLIC. Paul Shorey. 2 Vols.

PLATO: STATESMAN, PHILEBUS. H. N. Fowler; ION. W. R. M. Lamb.

PLATO: THEAETETUS and SOPHIST. H. N. Fowler.

PLATO: TIMAEUS, CRITIAS, CLITOPHO, MENEXENUS, EPISTULAE. Rev. R. G. Bury.

PLUTARCH: MORALIA. 15 Vols. Vols. I.–V. F. C. Babbitt. Vol. VI. W. C. Helmbold. Vol. VII. P. H. De Lacy and B. Einarson. Vol. IX. E. L. Minar, Jr., F. H. Sandbach, W. C. Helmbold. Vol. X. H. N. Fowler. Vol. XII. H. Cherniss and W. C. Helmbold.

PLUTARCH: THE PARALLEL LIVES. B. Perrin. 11 Vols.

POLYBIUS. W. R. Paton. 6 Vols.

PROCOPIUS: HISTORY OF THE WARS. H. B. Dewing. 7 Vols.

PTOLEMY: TETRABIBLOS. Cf. MANETHO.

QUINTUS SMYRNAEUS. A. S. Way. Verse trans.

SEXTUS EMPIRICUS. Rev. R. G. Bury. 4 Vols.

SOPHOCLES. F. Storr. 2 Vols. Verse trans.

STRABO: GEOGRAPHY. Horace L. Jones. 8 Vols.

THEOPHRASTUS: CHARACTERS. J. M. Edmonds. HERODES, etc. A. D. Knox.

THEOPHRASTUS: ENQUIRY INTO PLANTS. Sir Arthur Hort, Bart. 2 Vols.

THUCYDIDES. C. F. Smith. 4 Vols.

TRYPHIODORUS. Cf. OPPIAN.

XENOPHON: CYROPAEDIA. Walter Miller. 2 Vols.

XENOPHON: HELLENICA, ANABASIS, APOLOGY, and SYMPOSIUM. C. L. Brownson and O. J. Todd. 3 Vols.

XENOPHON: MEMORABILIA and OECONOMICUS. E. C. Marchant.

XENOPHON: SCRIPTA MINORA. E. C. Marchant.

IN PREPARATION

Greek Authors

ARISTOTLE: HISTORY OF ANIMALS. A. L. Peck.
PLOTINUS: A. H. Armstrong.

Latin Authors

BABRIUS AND PHAEDRUS. Ben E. Perry.

DESCRIPTIVE PROSPECTUS ON APPLICATION

===

London WILLIAM HEINEMANN LTD
Cambridge, Mass. HARVARD UNIVERSITY PRESS